PENGUIN BOOKS

THE GIRL IN THE PICTURE

DENISE CHONG is the author of the spell-binding memoir *The Concubine's Children: Portrait of a Family Divided.* Translated into seven languages and soon to be made into a feature film, it was awarded the 1995 Edna Staebler Award for Creative Non-Fiction, the 1994 City of Vancouver Book Prize and the Van City Book Prize; it was also shortlisted for a Governor General's Award and the Hubert Evans Non-Fiction Prize. She was a contributor to the anthology *Who Speaks for Canada? Words That Shape a Country.* Most recently, Denise edited *The Penguin Anthology of Stories by Canadian Women.* She lives in Ottawa with her husband and two children.

For Michael, Christopher & Judy,
with love, peace and forgiveness.

Kim Phuc (signature)

Nov. 11, 2000.

the Girl
in the
Picture

THE KIM PHUC STORY

DENISE CHONG

Penguin Books

PENGUIN BOOKS
Published by the Penguin Group
Penguin Books Canada Ltd, 10 Alcorn Avenue, Toronto, Ontario, Canada M4V 3B2
Penguin Books Ltd, 27 Wrights Lane, London W8 5TZ, England
Penguin Putnam Inc., 375 Hudson Street, New York, New York 10014, U.S.A.
Penguin Books Australia Ltd, Ringwood, Victoria, Australia
Penguin Books (NZ) Ltd, CNR Rosedale and Airborne Roads, Albany,
Auckland 1310, New Zealand

Penguin Books Ltd, Registered Offices: Harmondsworth, Middlesex, England

First published in Viking by Penguin Books Canada Limited, 1999
Published in Penguin Books, 2000

1 3 5 7 9 10 8 6 4 2

Author representation: Westwood Creative Artists
94 Harbord Street, Toronto, Ontario M5S 1G6

Manufactured in Canada

CANADIAN CATALOGUING IN PUBLICATION DATA

Chong, Denise
The girl in the picture: the Kim Phuc story

ISBN 0-14-025553-2

I. Kim Phuc. 2. Vietnamese Conflict, 1961–1975.
3. Vietnam–Biography. I. Title.

DS556.93P42C46 2000 959.704'3'092 C00-931627-2

Visit Penguin Canada's website at www.penguin.ca

For my mother, who understands

FAMILY TREE

Grandfather Kiem —— **Grandmother Tao**

— *Tiem* (daughter); married, five children

— *Nu* (daughter) b. 1934; married *Tung* b. 1929

 — *Loan* (daughter) b. 1952; married *Nang*

 — *Ngoc* (son) b. 1955; married *Tho*

 — *Dung* (daughter) b. 1958

 — *Tam* (son) b. 1960; *injured in napalm attack*

 — *Kim Phuc* (daughter) b. 1963; *injured in napalm attack*

 — *Loc* (son) b. 1965

 — *Phuoc* (son) b. 1968

 — *Loi* (son) b. 1973

 — *Tai* (son) b. 1976; *died in infancy*

— Son (*died in infancy*)

— *Anh* (daughter); married; *injured in napalm attack*

 Ten children, including:

 — *Danh* (second child, son); *died in napalm attack, aged three*

 — *Cuong* (third child, son); *died in napalm attack, aged nine months*

— Son (*died in infancy*)

— *Be* (daughter); unmarried

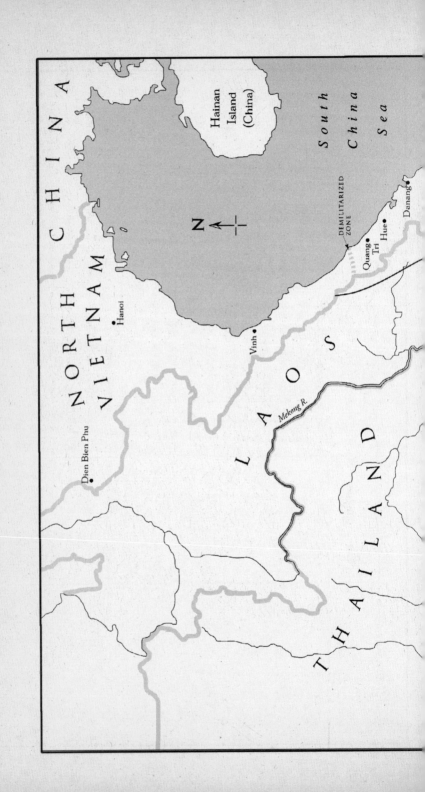

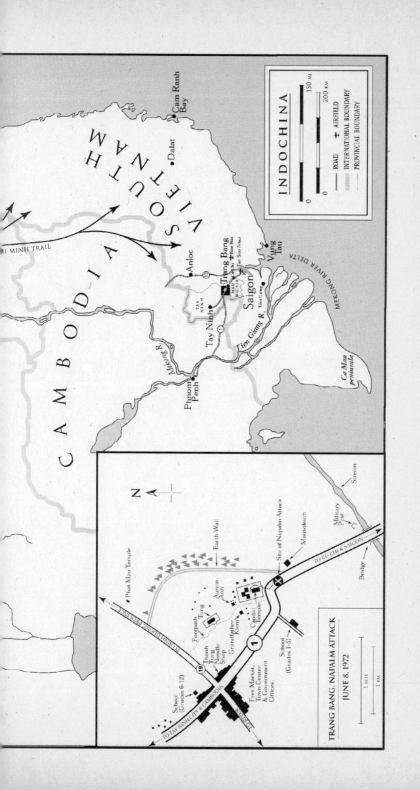

INDOCHINA

0 [scale] 150 MI
0 [scale] 200 KM

ROAD
AIRFIELD
INTERNATIONAL BOUNDARY
PROVINCIAL BOUNDARY

SOUTH VIETNAM

Cam Ranh Bay

Dalat

HO CHI MINH TRAIL

CAMBODIA

Anloc

Trang Bang

Tay Ninh

Saigon

Vung Tau

MEKONG RIVER DELTA

TAY NINH

Mekong R.

Phnom Penh

Tien Giang R.

Tien Giang

Ca Mau peninsula

N

Phat Mau Temple

Earth Wall

Auntie Anh

Footpath Tung

Grandfather Kem

Stream

Military Post

Site of Napalm Attack

Mausoleum

TO CU CHI & SAIGON

Bridge

Capital Temple

TO TAY NINH CITY & CAMBODIA

Thanh Tung Noodle Shop

Free Market, Town Center & Government Offices

School (Grades 1-5)

School (Grades 6-12)

RAILROAD

TRANG BANG, NAPALM ATTACK

JUNE 8, 1972

1 MILE

1 KM

the Girl in the Picture

THE KIM PHUC STORY

FOREWORD

THE PICTURE OF KIM PHUC REMAINS among the indelible images from the Vietnam war. Taken on June 8, 1972, it appeared on front pages of newspapers all over the world that year, and it has been reproduced innumerable times since. George Esper, the Associated Press's last bureau chief in Saigon, who stayed until the Communists ordered all remaining foreign journalists out, spoke with me about the power of the picture and its impact on the Vietnam war: "It captures not just one evil of one war, but an evil of every war," he said. "There were many casualty pictures, but this one was haunting. . . . In her expression was fear and horror, which was how people felt about war. This picture showed the effects of war, and how wrong and destructive it was. People looked at it and said, 'This war has got to end.'"

As cameras do, this click of the shutter froze a moment in history, so that the girl in it was forever a girl. But time did not stand still for the Vietnam war. It would continue for Americans for another year, for the Vietnamese, three. Its end is documented in

the annals of history—the signing of the Paris ceasefire accord; the last evacuation helicopter lifting off the rooftop of the American embassy in Saigon; South Vietnam's broadcast of surrender on Radio Saigon; the first North Vietnamese tank crashing through the gates of the Presidential Palace. However, the torment of war does not end so easily. And, as many struggle still with why the Vietnam war happened and why it ended the way it did, that chapter of America's history will remain unfinished.

The girl in the picture was anonymous when the image of her moved on the AP wire service, but within two days, a reporter had put a name to her. Kim Phuc recovered from her burns, and passed from childhood into adulthood. And so came a chance, by way of this book, and with the added clarity of time, to revisit through the lens of her life what the war was for an ordinary peasant in South Vietnam and what the end of it wrought, *and* to examine the impact of the picture on her life. Refocusing my sights beyond the frame of the famous picture was easier upon discovering, literally, the *next* recorded frame of her life, taken by David Burnett, who missed the famous shot because he was reloading film as she ran by. It shows her from behind, continuing down the road. A journalist—perhaps Alexander Shimkin, who was killed in the war one month later—runs alongside, his arm outstretched behind her. The humanity of his gesture seems to mute the horror of her charred skin.

Kim's life was shaped by others wanting to pull her back into focus. Once the Communist regime "rediscovered" her as the subject of a photograph famous in the West, the photograph itself became the commanding, organizing presence in her life. She was used for propaganda, but at the same time, she was an *acceptable* living symbol of wartime suffering. For one thing, the splash of the napalm missed her face and her hands, so that her scars could be hidden under clothing. The horror of injuries inflicted by napalm—a weapon manufactured in the United States and first

put to widespread use in the Vietnam war—is more powerful and, perversely, more palatable to contemplate when left to the imagination. For another, she was South Vietnamese, injured by her own side, and so she served as a reminder that the accidents of war can also be its atrocities.

In being interviewed for this book, Kim was a willing, if not always comfortable subject. She grew up in a climate of war. Except for the Americans, friend and foe looked alike, so the less one talked and knew, the safer one would be. The war was confusing—all the more so for a child. Kim was born into war, was nine when injured in the napalm strike and only twelve when the war ended. From then until she was twenty-nine, when she defected to the West in 1992, she lived under a Communist regime and in a political culture where all information is regarded as sensitive.

Kim's defection allowed her to talk openly, but it also presented a difficulty when it came to my research. Early word on the grapevine after her defection was that she was persona non grata in Vietnam. Consequently, when I went to Vietnam in 1996, I neither interviewed nor asked to interview Communist authorities (not only would the regime likely have refused my requests, but it might well have denied me a visa into the country). Instead, I entered Vietnam on a tourist visa and, making do for interpreters by using those who had once worked with Americans in South Vietnam but who hadn't spoken English since, I quietly interviewed Kim's family, friends and former neighbors there. Thus, the Communist officials in the pages of this book are voices reconstructed from memories of others; until Vietnam is a more open society, that is the best that can be done. I also went to Cuba, where the Vietnamese regime sent Kim to university. Again, I traveled on a tourist visa, and did similar research there.

The reader might find it helpful to have Vietnamese names explained. Because of their few and common surnames, the Viet-

namese use as the identifying name the *proper* name rather than the surname. The latter is rarely used and often known only to immediate family. By way of example, Pham Van Dong, at one time Vietnam's prime minister, after the first reference in the text, is referred to by his proper name, Dong. Western practice, in contrast, would be to refer to him by his surname, Pham. Finally, two comments on the written Vietnamese in the text. For simplicity, I have omitted the diacritical marks that indicate a word's pronunciation and, therefore, particular meaning. And I have often combined syllables into one word, though in Vietnamese, each syllable is a separate word. Thus, though Vietnam is actually two words, it is combined here as one.

CHAPTER ONE

KIM EASED BACK A CORNER OF THE bedroom window curtains. Only from there could she see signs of life outside. The windows of the living room looked at the brick wall of the house next door. Though a skylight in that room made the concession to light, the feeling in the second-floor apartment of the duplex was one of claustrophobia, echoing that of the one-way, one-lane street on which the Bui family lived, in a poor, congested neighborhood tucked in behind the smaller of Toronto's two original China-towns. However, from the bedroom window, if one lifted one's eyes over the unbroken line of parked cars and the jumble of flat and peaked roofs opposite, one could take in a view of Toronto's modern downtown skyline.

Kim's eyes swept the sidewalk for anybody watching the duplex. Then the uncovered porch below. Nobody. But the evidence remained: a crushed pop can and the telltale red-and-white carton of a Kentucky Fried Chicken lunch from the outlet at the top of the street. Yesterday evening at dusk, she and Toan, believing

they had entered their apartment unseen by coming up the back stairs, had looked from this window, and noticing the pop can and carton left behind, had come to the same conclusion—the two women they had just met on the sidewalk had been staking out their address for some time that day, at least long enough to get hungry. One of them had a camera. Kim had cautioned her husband against opening the front door to remove the refuse. This much she knew: the long lens of a camera can see a lot.

The night before, Kim had gone to bed in an agitated state. She had called Michael Levine, the lawyer acting as her agent, who was handling her publicity, including requests from the media. "If those women try to get into your house," he'd said, "call the police." The image of men in uniform made Kim anxious, and that night, she had one of her recurring war nightmares. Sometimes they involved bombs, sometimes mortar fire or gunfire. But always she is a child. That night it began with her standing amidst a group of chatting soldiers. An argument broke out among them. Gunfire erupts. "We have to get out!" Kim screams. She runs, terrified of being killed. But as she runs, she tires, and she doesn't know how she will keep going.

As usual, she woke to escape death. Feeling stone cold, she did as always: she shook Toan awake. "Hold me," she whispered. When her tears stopped, as usual, she found she was consoling him: "It's okay. I have to suffer like that."

Toan left to go job hunting, picking up the pop can and carton on his way out. Kim turned her mind to the unfolding day: the colleague of the photographer, or rather, the one without a camera, had agreed, as Kim had asked, to call Kim's lawyer. "After you call him, after that I can work with you," Kim had told her. All that day, Kim found herself waiting for the telephone to ring, expecting Levine to call to say that the two women had requested an interview. Not even her usual hour of Spanish-language daytime TV soaps could distract her from the questions

that paced back and forth across her mind. How did the two women know her address? Why had they been waiting all day on the sidewalk? The day came to an end, marking the beginning of the weekend, when Levine's law office would be closed.

By Sunday, Kim was relieved to have church to occupy her mind. The word of God made her forget all her worries. The family's church was in Ajax, an hour away from Toronto by the church van service, and no one there but the pastor knew of Kim's history. Since she and Toan were the only Vietnamese in the congregation, it seemed unlikely that her past would even come up. On Sundays, they attended both the morning and evening services, spending the interval at the home of a friend from the congregation.

After the first service, she and Toan went to collect their eleven-month-old son, Thomas, from the church daycare.

Kim felt an urgent tap on her shoulder. It was another father. "Your picture is in the newspaper!" he exclaimed.

The man, who was responsible for buying newspapers for the church's reading room, held up a Toronto tabloid, *The Sunday Sun*. It was that day's edition, March 19, 1995. "*The photograph that shocked the world*" shouted the front page, above a picture of a young girl, naked and running in terror. There was another headline, "*Child of war is a woman living in Metro*," alongside another picture, one of Kim, wearing the coat she'd been wearing all week.

Kim lifted her eyes from the newspaper. Clearly, the two women had got the photo they'd come looking for. "Yes," she said. "I am the girl in the picture."

THE NEWSPAPER THAT BROKE THE NEWS— that the subject of one of the famous pictures from the Vietnam war now lived in the West—was *The Mail on Sunday*, a British

tabloid. It syndicated the story to, among others, Toronto's *Sunday Sun*, which played it across pages two and three. Accompanying the article were photographs of Kim and Toan pushing their baby in a stroller on a Toronto street, and of Kim's parents in front of their mud hut in Trang Bang, Vietnam. The article began:

> To her neighbors in a working-class area of Toronto, she is just another young mother, anonymous and hesitant. But to the world, she will remain forever the human symbol of the pointless brutality and savage cost of the Vietnam war. Next month it will be 20 years since the futile American military campaign finally ended . . .
>
> Of all the countless photographs and films which captured that terrifying and bloody war, one potent and compelling image remains: of a young girl, naked and terrified, screaming in pain as she flees a napalm attack on her family's village, Trang Bang, 40 miles from Saigon.
>
> Today Phan Thi Kim Phuc is a woman of 32. Once exploited by the Vietnamese for anti-capitalist propaganda, wheeled out by the Marxist regime as painful proof of American colonialism, she is now living in hiding in the West, a defector from the Communists who have manipulated her almost all her life . . .

The breaking story was picked up by international wire services. Within a couple of days, Kim's telephone began to ring, and didn't stop. In short order, she tired of hearing callers, complete strangers all, asking to speak to Kim Phuc. She took to letting the telephone ring, leaving Toan—if he was home—to answer and

give out the telephone number of Kim's agent. Upon the insistent ringing of the door buzzer, the couple would go to the front window to spy on the person below. Invariably, it was a journalist—or so Kim assumed, judging by the camera bag over a shoulder or the notebook in hand. Often there was a waiting taxi. Eventually, getting no answer, the journalist would leave.

Night and day, the couple kept the curtains drawn on the front window. Kim grew afraid to leave the house for fear that it was being watched, or that someone lay concealed, waiting for an opportunity to take her picture. Whenever the buzzer sounded, she tried to keep the baby quiet, and to avoid stepping where the wooden floor would creak. Sleep did not release Kim from her anxiety but rather plunged her into the darkness of her recurring nightmares. Exhausted, she spent entire days in her turquoise dressing gown.

This was not the scenario she had contemplated when, a few months earlier, she had made the decision that, in order to help support the family, she would reemerge from her private life and sell her story; it would be her "work." She had gone for advice to Nancy Pocock, a lifelong social activist well into her eighties. Kim and Toan, like many Vietnamese and Salvadoran refugees in Canada, called her "Mother Nancy."

"Mom, I want to stop being quiet. Please, how can I do that?" Kim had asked her.

Nancy had a family friend who knew a prominent Toronto entertainment lawyer, but before making the introduction, she had first wanted to make certain that Kim understood something: once she invited publicity, there would be no going back.

"Yes, I know. I cannot be quiet again," Kim had said.

But after a month of jangled nerves and recurring nightmares, Kim was having second thoughts. She worried that plans made with her agent to have the media pay for publicity might be for naught, that, like those two women from the British tabloid,

the media would try to get a story and pictures of her without paying a cent. She felt as though the journalistic hounds would make her into a victim all over again. "The accident of those two women on the sidewalk," she lamented to Toan, "was like a bomb falling out of the sky."

CHAPTER TWO

ROUTE 1, THE HIGHWAY RUNNING northwest from Saigon and over the border of South Vietnam with Cambodia to Phnom Penh, was a time-honored trading route. By the early 1960s, traffic along it was a parade across generations: creaking oxcarts, jitneys and bicycles, aging French Citroëns, three- and four-wheeled truck-buses, late-model Honda and Lambretta motorscooters and shiny new GMC trucks. War in South Vietnam—first with the French and now with the Americans—only enhanced commercial profits: all manner of goods and drink and cigarettes bought in Cambodia could be peddled for several times the price in Saigon.

Such commerce provided a convenient cover for guerrilla activities of insurgents and resistance fighters plotting against the regime in Saigon. Indeed, this corridor had echoed for decades with their footsteps. Geography and politics also combined effortlessly in their favor. Northwest of South Vietnam's capital, the terrain is a large plain formed by the merging of two

river systems, the Mekong, the great river of Indochina (present-day Vietnam, Cambodia and Laos), and the Dong Nai. The plain is elevated enough (unlike the Plain of Reeds to the southwest of the capital) to remain above water during the rainy season, affording year-round passage. It gives rise to a line of scattered and densely forested peaks, bowler-like in their shape. Nearer and over the border, the vegetation turns into subtropical jungle, so thick as to be impenetrable by sunlight. The mountains were natural guerrilla bases and staging grounds for terrorist strikes, while the jungle provided ideal hiding places and headquarters. And by crossing the border into supposedly neutral Cambodia, those collaborating against Saigon had a political sanctuary out of reach of South Vietnamese government troops.

Part of South Vietnam's national highway, Route 1 was a pothole-riddled tarmac road, two lanes wide, except where bridges narrowed it to a single lane. The last and only major town in the roughly seventy-five miles between Saigon and the Cambodian border, reached by a road that forked off Route 1, was Tay Ninh, ten miles from the border and capital of the province of the same name. In the sixty-five-mile stretch between Saigon and Tay Ninh were two "district towns." These were not urban centers but rather a collection of hamlets. Both were in the province of Hau Nghia, meaning "deepening righteousness," it was created by South Vietnam's president Ngo Dinh Diem to amalgamate the most politically troublesome districts of neighboring provinces, in which the more remote hamlets had been abandoned to guerrillas.

Coming from Saigon, the first of these district towns was Cu Chi, some eighteen miles from the capital. Twelve miles farther, halfway between Saigon and Tay Ninh, was Trang Bang. The approach to Trang Bang was marked by a bridge over a stream. From that slight elevation, several hundred yards away, the town's only landmark became visible: a twin-towered temple. A sign

warned motorists to slow to ten miles an hour to make a sharp turn. Because the ornate temple sat exactly at the turn, a lingering look was unavoidable.

Past the temple, the road straightened. Half a mile farther was a monotony of low-slung buildings housing the district government offices, a clinic, a high school and the marketplace. However, Trang Bang merited note mainly for the intersection, reached before the business district, of Route 1 with Route 19, a secondary road heading north towards the Cambodian border. Huddled on the main highway at that intersection were several ramshackle structures with corrugated tin roofs, perhaps a dozen food and drink and sweet shops serving breakfast and lunch to travelers between Saigon and the border. Among the shops here, one owned by Phan Tung was favored because of the excellent cooking of his wife, Nu.

It was to this stretch of highway, from the temple to the intersection, that the fate of the family of Tung and Nu would be tied. It was on this highway in Trang Bang that a photojournalist would take a picture of their daughter that would become one of the most famous images of the Vietnam war.

TUNG AND NU'S FIFTH CHILD AND THIRD daughter was born on April 6, 1963. She was given the name Phan Thi Kim Phuc. Phuc means "happiness" (if a male, the meaning is "blessing"). Phan was her father's family name, Thi signifies a female, and Kim, meaning "golden," was a name she shared with her two sisters. To her family, she was known as Phuc.

The year of Phuc's birth opened ominously for South Vietnam. Eight years earlier, Ngo Dinh Diem had proclaimed the area south of the demilitarized zone, which separated the Communist north from the capitalist south, the Republic of Vietnam, and installed himself as president. At the beginning of 1963, the two

sides had their first major battlefield confrontation. At Ap Bac, a village to the southwest of Saigon, Hanoi-led Communist troops, though grossly outnumbered and ill-equipped, routed South Vietnamese government troops. The inept South Vietnamese command deliberately ignored American advisers on the scene, in the knowledge that President Diem himself regarded defeat as a way to ensure continued American aid. That summer, with characteristic and undeterred brutality, Diem moved to crush a Buddhist uprising, ordering troops to fire on Buddhist demonstrators and conduct bloody raids on Buddhist temples. The protest escalated. A monk sat in the middle of a Saigon street, calmly poured gasoline on himself, struck a match and burned to death. American journalists, who had been alerted beforehand, sent the grisly image around the world.

Diem's handling of the Buddhist crisis confirmed to the American administration its distaste for the regime it supported, which it now saw as damaging the war effort. That summer, more monks resorted to self-immolation, and public clashes with police became widespread. In response, Diem declared martial law, a move that sealed his fate. His own generals murdered him and his powerful brother, Nhu. At the news of their deaths, the streets of Saigon erupted in celebration, jails emptied of political prisoners, padlocks came off nightclub doors.

Then, three weeks after Diem's murder, the assassination of President John F. Kennedy rocked the world. It would be his successor, Lyndon Johnson, who would dramatically escalate America's war effort in Vietnam, while the leadership of South Vietnam remained weakened by successive coups. Hanoi regarded the war with the Americans as the second Vietnam war. The first, the Franco–Viet Minh war, had been waged in Vietnam since the surrender of the Japanese occupiers at the end of the Second World War. The Viet Minh, an independence league founded by Ho Chi Minh (giving rise to his *nom de guerre*, He Who Enlightens), had

seized power in Hanoi from the occupying Japanese and renamed the north the Democratic Republic of Vietnam. Returning French military forces quickly regained control of Saigon and their colony in the south. At Ho's urging, the Viet Minh fought the French to prevent them from returning to the north, and as well, to drive them from the south. The Franco–Viet Minh war came to an end in 1954, when the Viet Minh overran the remote French garrison at Dien Bien Phu after a fifty-seven-day siege. Under the terms of the Geneva accord, a demilitarized zone was established, and reunification elections were to be held within two years. The United States, which had provided military and economic aid to the French in Indochina, was committed to propping up the Saigon regime. The Americans had been the sole participant to refuse to accept the Geneva accord.

In the south, Diem—ascetic, emotionally volatile, scornfully anti-Communist—refused to hold reunification elections. He was backed by the Americans, who, fearing a dominance of the Communists in the north, would not accept a reunified Vietnam. Accordingly, the Viet Minh decided to pursue reunification by resuming the conflict in the south. In 1960, southern patriots formed a resistance front against the Saigon regime and declared their solidarity with the Viet Minh. Diem dubbed the southern guerrillas Viet Cong. The name itself would emphasize their link to the Communist policies of Ho Chi Minh's coalition in Hanoi. The name stuck, replacing the term Viet Minh.

Hanoi fought this war with the Americans differently from that with the French. This time, it waged a predominantly guerrilla war, using Viet Cong commandos recruited among southerners, who relied on homemade weapons, such as mortars fashioned out of the exhaust pipes of old cars and booby traps made with sharpened bamboo. Regular North Vietnamese army units, or "mainforce soldiers," were reserved for conventional battles and to wage broad offensives. Hanoi's strategy was to infil-

trate the south by moving mainforce soldiers and military equipment and supplies across the demilitarized zone along what became known as the Ho Chi Minh Trail. The trail began as a web of rudimentary paths crossing mountain streams, damp forest and jungles infested with mosquitoes, deadly snakes and leeches. Its ten-thousand-mile-long route crossed into the panhandle of southern Laos, turned back into the highlands of South Vietnam, then cut into Cambodia astride its border with Vietnam, ending about sixty to seventy miles northwest of Saigon.

In a plan to cut off supply routes to the south, and to rout the Communists from their southern headquarters, American planes bombed the Ho Chi Minh Trail and sprayed herbicides to defoliate vast tracts of forests and jungle in areas bordering northeastern Cambodia. In 1965, Johnson ordered the first bombing raids over North Vietnam, in hopes of deterring Hanoi from pursuing the war and reunification. That year, he also sent the first American combat troops into South Vietnam.

In Phuc's earliest childhood, the modern firepower of war was unseen and unheard in Trang Bang. Battlefield confrontations took place far in the southern Mekong Delta and the central highlands. In Trang Bang, as in Saigon and in America, the public's impression of the distant war was not of gore but of monotony and repetition.

ALONG ROUTE 1, DAILY LIFE WAS LITTLE changed from the time of the French war. Even the government police maintained the same checkpoints from one war to the next. The guerrillas had their old ways of sabotage at favored locations. They obstructed roads with homemade mines, took out bridges, conducted ambushes and assassinations. In places like Trang Bang, the district authorities, unable to maintain electrical power after repeated acts of sabotage by the Viet Cong,

decided not to make repairs until the war was over. Anyone traveling knew the one unbreakable rule: they could follow their normal routine by daylight, but the night belonged to the Viet Cong.

Each hamlet or collection of hamlets defined its "safe" area; everything beyond this would be unpatrolled by local public security forces. The delineation of these inhabited areas was most apparent in an aerial view. Trang Bang's ended on one side where rice paddies gave way to a natural line of thick growth of bamboo and flame trees, on another side at the river, and, where there were not these natural boundaries, the line was marked by a three-foot-high row of mounded earth. Only the desperately poor, who could not choose where they lived, did not heed these borders. The poorest of any hamlet were always the street vendors, always women—usually abandoned by husbands—who lugged their wicker hampers from dawn until after midnight, selling snacks in the town. Their children were the ones in rags and bare feet, with dirty faces, who didn't go to school but instead spent their days calling into doorways hawking fresh eels and catfish that they caught in the river.

Of Phuc's parents, Nu's family had its roots in Trang Bang. Nu's father, Du Van Kiem, was a middle-class peasant. He inherited from his father, who had worked for a French engineering company on a rubber plantation, seventy-five *mau* (about twelve acres) of land on the eastern edge of Trang Bang. In Trang Bang, Grandfather Kiem was best known for his allegiance to his family and to his religion, Caodai. This cult, confined to the provinces ringing Saigon, was founded by a civil servant under the French regime in the mid-1920s, and its name comes from a Taoist term meaning "high tower." The religion took the term *Caodai* to refer to God, a heavenly being which the cult depicted with a mystical eye, representing the universal conscience. The eye adorns Caodai temples in the way that the cross does Roman

Catholic churches.

At the time of its founding, Caodai was one of several rural movements agitating against the peasant's declining lot and loss of a voice in everyday affairs under French colonial rule. Other political or quasi-political organizations were the fledgling Indochinese Communist Party and the Buddhist sect Hoa Hao. Caodai purported to offer the final revelation of all world religions and of world history. As a doctrine, and in its religious practices, it was mainly an adaptation of the three Eastern religions, relying heavily upon Taoism and its belief in spirits and the occult, incorporating Buddhism and Confucianism, and venerating their respective deities. Borrowing a little here and a little there, the religion took advantage of the popularity of spiritualism in Europe in the 1930s and consulted, through mediums and sorcerers, a host of deceased world figures—Lenin, Jesus Christ, Victor Hugo, Joan of Arc, Louis Pasteur and William Shakespeare. Modeling its organization after the Catholic Church, it established a Holy See and installed as its pope, known as the *Ho Phap*, a man named Pham Cong Tac, one of the religion's founders.

The Holy See, with its great cathedral-like yellow stone temple, a mystical eye in every window on all four sides, was two and a half miles outside the town of Tay Ninh. On the three most important anniversaries in the religious calendar, the birthdays of Buddha, Jesus Christ and the *Ho Phap* (after he died, the anniversary of his death was celebrated), followers of Caodai and their families came from far and wide to the Holy See. Ceremonies at the great temple were a spectacle of color and pomp, presided over by the pope and a ranking of cardinals, archbishops, bishops and priests, as well as numerous religious, legislative and administrative ritual servants, in robes of designated colors. Some thirteen hundred adepts, all in white, the color of worship, filled the temple, the women and girls wearing the *ao dai*, the diaphanous, full-length,

high-necked tunic slit to the waist worn over silk pants.

Grandfather Kiem became a ritual servant, often presiding over weddings and funerals and mediating local disputes. His wife, Grandmother Tao, adopted vegetarianism, a practice required of priests; normal minimum religious practice for Caodaists was to eschew meat for ten days each lunar month. When a call went out for adherents to build local temples, Grandfather Kiem donated one-third of his land for a temple in Trang Bang. In 1948, the pink- and saffron-colored temple that stood prominently at the town's eastern edge opened its doors. Daily temple rituals were four times a day, at six in the morning, noon, six in the evening and midnight. Religious law required followers to make one daily act of obeisance before an altar, which could be at home. Attendance at the temple was expected only twice monthly, on the first and fifteenth of every month.

Other than as a benefactor of Caodai, Grandfather Kiem was best known for his prized pomelos. Finicky to grow and time consuming to tend, these were trees of the well-to-do. Those who bought his fruit at the market, finding that its juiciness fulfilled the promise of its evenly grainy skin, often found their way to his door, asking to buy a graft from a tree. Grandmother Tao was the model of the rural tradition of the laboring, uneducated farm wife who works long hours to allow her husband a life of scholarly leisure. The couple had six children: two sons died young, while four daughters survived.

Phuc's mother, Nu, was their second-born daughter. It was she who inherited Grandmother Tao's talent for cooking. One of the teenage Nu's daily chores, which she performed sitting on the ground outside the house, was to grind rice into liquid flour that could then be steamed and made into either *banh trang*, a rice-paper wrap, or *banh canh*, the soft rice noodles put in soup. She caught the eye of a passing truck driver. Phan Tung, who lived in a nearby hamlet, was a young man with a high school

education, blessed with charm and humor. While driving his aunt's three-wheeled truck and looking for paying passengers traveling to and from Saigon, he noticed the girl hard at work turning the millstone. It crossed his mind how much he liked eating *banh canh*. He appraised the girl's looks: "So-so," he decided. Seeing the house behind her to be of wood and brick, he surmised that she must come from a good family. He was the younger of two brothers and had lost his father when he was two. With his ever-astute ability to sense opportunity, Tung had a friend introduce them. In 1951, they married. He was twenty; she was seventeen.

Living under the same roof as his in-laws, and knowing his new wife's desire to have her own home, Tung told Nu: "The taste of your *banh canh* is very good. People will pay for it." Noodle soup is the most popular and basic Vietnamese daily fare, eaten as a snack or a meal in itself, especially at breakfast and lunch, but also at any time of the day or night. While any family can make it, few bother, choosing instead to patronize the street vendors. Putting her husband's prediction to the test, Nu hefted a shoulder pole to the market. She squatted there with dishes and utensils in front of a charcoal brazier and offered fresh, thin noodles in a steaming, clear broth, flavored with a dash of fermented fish sauce, made from anchovies and salt, and served with a plate of garnishes: bean sprouts and chilies, wedges of lime and sprigs of mint and basil.

After three years, Nu had saved enough to raise a one-room wood-and-brick house in the shadow of her parents' home. One year later, a baby was born to Nu, and thereafter, every two or three years, yet another—alternating girl, boy. The midwife in attendance each time was her sister, Auntie Anh. Because Nu worked seven days a week, upon the birth of her firstborn, a daughter, she and Tung took in a distant relative, Great Uncle Don, as a manservant and to help care for the children. The

arrangement suited Great Uncle; his elderly father's new wife had cast him out of the house. Because of the demands of the shop, Nu weaned her babies at two weeks on a diet of sweetened liquid rice, breastfeeding them only at the end of the day.

The year she and Tung moved into their own home, Nu was able to stop peddling soup in the market and, instead, open a noodle soup stall. She rented space on the southeast corner of the intersection on Route 1. The southeast locations were the most desirable, as the wide right turning there onto the secondary road afforded ample room for vehicles to park. On one side of her stall was a lemon meringue pie and coffee stall, on the other, a newspaper vendor. The sign she raised above her shop said "Chao Long Thanh Tung," which combined, in a way pleasant to the ear, her husband's name Tung (Thanh signifies male) with the local specialty soup, *chao long*. This is a rice congee made from a stock of pork hock, liver and heart and flavored with gelled pork blood, which turns it a rich reddish-brown. Nu offered fare that was available up and down the strip. However, Nu's other fare, in particular, the soft thinness of Nu's *banh canh* served in a soup delicately fragrant, and the transparency of her *banh trang* offered with the freshest lettuce, leanest pork and finest julienned vegetables, showed both a respect for the healthy eating that epitomized the luxury of the south and a sensuous regard for color, taste and texture. Not once did Nu have to burn a paper figure to chase the evil spirits that keep away business.

Profits accumulated. Nu traded in the low bamboo stools that sat inches off the ground for regular stools and tables. She expanded into an adjacent stall. Grandmother Tao helped with shopping and trimming vegetables—she stopped short of cooking meat on account of her vegetarianism. Nu's youngest sister, Auntie Be, did the heavy chores of cleaning and carrying water from the well. Nu expected her children, upon reaching seven or eight years of age, to run errands at the market before and after

school, and eventually, to help serve customers. Occasionally, Tung helped serve or worked the cash, but generally he avoided the shop, disliking the noise and commotion.

After seven years, in 1960, Nu was able to buy the space. In 1962, with the arrival in Vietnam of the Americans, business abounded and profits soared. The massive infusion of American military aid doubled and tripled wages, turning southerners overnight into consumers with a frenzy for spending. Nu expanded her shop into a ten-table, eighty-stool establishment. It took on an air of permanence: where once the floor was packed earth, now it was redone in smooth cement; gone were the bamboo stools and tables, and in their place were carved matching ones of wood. The cooking, once done on a charcoal brazier, was now done in commercial-sized cast-iron pots, and customers ate from porcelain dishes rimmed in gold, the pots and dishes bought from Cambodian traders. On her busiest days, Nu served as many as four hundred bowls of soup and one thousand rice-paper wraps.

Making *banh canh* delivered its ultimate reward in 1967. By then, Tung and Nu had six children, three girls and three boys, who doubled up in hammocks that hung everywhere. Nu had made profits enough to realize every peasant's ambition and dream: to build a worthy house that would honor the family's past and secure its future. The couple decided to build their new house nearby, to stay near the family. Three of Nu's four sisters, along with Grandfather Kiem and Grandmother Tao, lived as if within a family compound. The first sister, Auntie Tiem, had moved upon her marriage to the town of Tay Ninh. The second, Auntie Anh, and her husband had built an unassuming house next door to her parents, as Tung and Nu had done. The fourth sister, Auntie Be, deemed unmarriageable because she was afflicted with seizures, lived at home. Grandfather Kiem and Grandmother Tao presided as patriarch and matriarch to more than kin. In his generosity,

Grandfather Kiem invited Caodai families driven from their homes by the bombing in Tay Ninh province to squat on his lands. At any given time, he hosted ten or twelve peasant families, each having put up the typical peasant's hut: framed in palm fronds and filled in with mud, with a floor of pounded earth and a roof of thatch, two doorways and no windows. When the families moved on, new ones would take their place.

Tung and Nu purchased two and a half acres several minutes farther down the footpath. Tung enclosed their new property with a high iron fence. The family watched as their new house took shape. Constructed in the modern way, with masonry walls and a roof of ceramic tile, it would not be vulnerable to fire like their old wood-and-brick house or the typical peasant's mud-and-thatch house, which also heated up during the day and leaked during heavy rains. But its ornate roof lines, fine wood-working in the doors and wrought-iron grilles over the windows would also honor traditional design.

Instead of the usual two entrances, it had seven. Instead of one room, three: a front reception room; a cavernous back room, which was the family's private living quarters, where partitions would enclose four sleeping areas; and a third room behind that for the hearth. A few steps out the back was a cement outbuilding housing a French squatting toilet and a cistern for washing and showering. Separating the front room from the back was a breezeway with a floor of smooth cement that extended into a patio around the entire outside. The old house would have fit several times over into the new.

The interior of the house was finished and furnished to reflect a family nourished by success. The floor was of red tiles. Carved beams crisscrossed the vaulted ceilings. Columns, formed out of single trees, fluted and hand-painted, stood four across in the reception room, and in the back room, four across and three deep. In the old home, the bamboo furniture had to be replaced every

few years. The new house was to have furniture of wood. The only item the family could afford to have made of teak, a wood from the north that becomes darker and shinier with each generation of use, was the new *van*, the centerpiece of every home, which was by night a bed and by day a divan, and during festivities, a platform for a feasting table. The new ancestral altar was inlaid with mother-of-pearl, and the bench before it was carved and embossed with fans. A local furniture-maker was engaged to make beds, armoires, mirror frames and benches of *cam lai*, the sturdy, blond wood that was the choice of the nouveaux riches of the south, which Tung and Nu had to travel one province over to buy. There would be other modern touches, such as cushions on the benches. Tung also purchased a generator to power a pump to bring water from the well into the house. It would also run the new refrigerator and television. Finally, Tung and Nu had a *ham* dug inside the house, lined with thick cement, the entrance to which was a hole in the back wall of the family's living quarters. Though the *ham* was designed to be a bomb shelter, they never expected to use it for its intended purpose; they built it in deference to the fad among the wealthy home-builders in the south.

By his calculation, Tung had ascended to the position of Trang Bang's third-richest peasant. The other two, who lived nearer the business district, were herbalists who made their money dispensing Chinese herbal medicines and patent medicines from Saigon. Both had fine houses. Both owned cars—one had three—while Tung had only just purchased the family's first motorscooter. Regardless, all three would only ever be farmers; there was no other station in hamlet life. The difference was that the well-off farmer and his descendants might never again have to work in the fields. And so, it gave neither Tung and Nu nor their children discomfort to recall the familiar child's taunt to decry another's humble standing: "Your mother is nothing but a noodle soup maker!" Much had been built on the profits of Nu's cooking.

TUNG AND NU CHOSE WHAT THEY BELIEVED to be an auspicious day to move from their old home to the new: Tet, the Vietnamese lunar New Year, when the ancestral spirits return from heaven for their annual three-day visit with the family. In the Western calendar, the eve of Tet in 1968 corresponded to January 30. By then Tung and Nu were ready for the festivities. The new house was resplendent. The four pillars on the raised veranda were festooned with garlands of fragrant flowers. Ornamental peach blossoms in polychrome pots had been coaxed to blossom for the holiday. A riot of pomelos, mangos and bananas spilled from a multitude of baskets. To welcome the ancestral spirits, the double-louvered doors of the three front entrances were fastened back. Paper charms hung from the lintels to ward off errant evil spirits who might bring bad luck.

For days, Great Uncle had been directing all hands, including the children, to decorating, inside and out, top to bottom. Tung had adorned the ancestral altar and dusted off the photographs of the dead there. For the past week, Nu had been at the hearth, preparing the traditional glutinous rice cakes, sweet soups and candied fruits.

In the front reception room, Tung and Nu, Great Uncle and the couple's six children, ranging in age from two years old to fifteen, awaited the midnight hour. When the clock struck, Tung, as the male head of the household, would greet the spirits arriving from heaven by placing the rice cakes and soybean soup on the ancestral altar, beside the lighted incense and beneath the photographs there. He would offer prayers to the spirits of ancestors, and they would bless the celebrations, and the feasting could begin. This Tet, might not the spirits render a favorable verdict on the conduct of the family over the past year, so that their good luck could continue?

Just short of midnight came rapid-fire reports from somewhere distant in the town. Somebody prematurely setting off firecrackers,

family members assumed, the usual overexuberance. The crackle of small explosions grew, and then, a loud *crump* split the night air, followed by the sound of a shell hitting nearby treetops.

"*Phao kick!*" someone screamed, recognizing the sound of mortar fire. "Hurry! Hurry! Into the *ham*!" The adults herded the uncomprehending children through to the back of the house and lowered them into the hole in the back wall there.

"*WAR HITS SAIGON!*" BLARED THE HEADLINE of a newspaper in Washington, D.C. Americans watching the television news on the evening of January 31 saw gunfights and shelling on the streets of the capital of South Vietnam. The news showed the Communists attacking a target that was thought to be invulnerable: the American embassy. At three o'clock on the morning of Tet in Saigon, nineteen Viet Cong commandos had broken through the defenses of the compound. Not until six and a half hours later, with the bodies of five Americans and the Viet Cong invaders bloodying the ground, had American troops secured the embassy.

In what would become known as the Tet Offensive, the Communists struck in a surprise countrywide attack. The first surprise was that they had chosen to do so during the holiday of Tet, normally a time of truce imposed by the Communists themselves. The second was that this was an *urban* offensive, displaying the enemy's ability to reach from the countryside into the cities, a strength of the enemy heretofore not only unknown but unimaginable. Small teams of Viet Cong commandos attacked more than one hundred towns, including provincial capitals and district towns, across South Vietnam. It was only to the northernmost of South Vietnam's forty-three provinces that Hanoi sent mainforce soldiers from North Vietnam. So unthinkable was it that the Viet Cong could penetrate Saigon that the Amer-

icans had left the city's defenses to the South Vietnamese forces.

Television newscasts of the Tet Offensive brought the once distant war into the living rooms of America. In the Communists' attack on the embassy in Saigon, Americans saw an enemy menacing the doorstep of American power. The second day of the offensive produced one of the war's most unforgettable and disturbing images. A cameraman with the National Broadcasting Corporation (NBC) and a photographer with the Associated Press (AP) news agency recorded on a Saigon street the city's chief of police, a general, summarily executing a flinching Viet Cong suspect with a point-blank shot to the head.

In most towns, the offensive was over in hours, or, as in Saigon, days. In Trang Bang, isolated mortar and sniper fire would continue to surprise for a few days, like leftover firecrackers. The bloodiest and longest battle of the offensive would be for the imperial city of Hue in the central highlands. American and South Vietnamese government troops would not recapture the city for twenty-six days, during which time ruthless Viet Cong teams would search house to house, rounding up and executing some three thousand civilians.

While the Communists suffered horrifically high casualties in the Tet Offensive and failed in their objective to spur southerners into a general uprising, where the offensive succeeded was in shattering the American public's belief in its own government's pronouncements that the war was being won. American correspondents in Saigon had long been annoying the U.S. administration by daily documenting the war in intimate images of violence and death and loss, rather than of military bravura. However, the American public had largely been in favor of engagement at the start of the war, and continued to feel that way even as casualties mounted and Americans came home in body bags. The American media's coverage of the offensive forced the public to begin its own agonized moralizing about the *kind* of

war America had got itself mired in, and to rethink the nation's involvement.

Within two months of the Tet Offensive, President Johnson, citing the public's divided reaction to the war, made the dramatic announcement that he was not standing for reelection. He began a process of peace talks in Paris and instituted plans to reduce American troop strength in Vietnam (1968 saw American troop strength peak at half a million). That summer would be marred by the assassination of Democratic presidential candidate Senator Robert Kennedy, and by antiwar protesters rioting outside the Democratic convention hall in Chicago. The American electorate sent Richard Nixon to the White House, on the strength of his campaign promising a "secret plan" to end America's war in Vietnam.

PHUC WOULD REMEMBER NOTHING OF THE family's life in the old house or of the Tet Offensive. Her memories began in the new house, when she was almost five. Her family's move there was delayed two weeks in order to repair shrapnel damage from mortar fire, replace roof tiles and patch pockmarked walls. Their first home improvement was to reinforce the *ham* with best-quality American steel. All manner of imported supplies, originally destined for American military warehouses in South Vietnam or for use by the South Vietnamese military, readily found their way onto local black markets.

A day in the life of the "big house" began before dawn. At half past one, after about three hours' sleep, Nu would ease herself out of the *van*, careful not to disturb her sleeping husband and the youngest baby there. On her way out the back door, she picked up a pair of flat baskets. She made her way by a fire lamp that Great Uncle had made by filling a yard-long piece of thick bamboo with rendered pork fat. Nu would head for the market to buy her day's

requirements of *banh canh* (to keep up with demand for her soup, she bought fresh noodles, but she continued to make her own *banh trang*, the rice-paper wraps), water chestnuts, bean sprouts, tofu, carrots, cucumbers and lemon grass, before heading for the shop back along the highway. Grandmother Tao joined her in the predawn, helping to chop and cut. The bamboo curtain was raised at five in the morning for the first customers.

Long after the laziest roosters had woken, Phuc and her siblings rose for the day. Their father, Tung, was sometimes already about the village, doing whatever it was that men of leisure and prestige did—share strong tea, read a classic Chinese or Vietnamese folktale, gamble with cards, smoke; the latter two were pastimes for which he had a particular fondness. Tung, Nu and Great Uncle shared the outdoor chores. The family raised pigs for market. The pens in the back held one hundred sows, and roaming freely were a few chickens and ducks. And then there was the garden. The more than one hundred fruit trees on their property produced guava—to be precise, forty-two were guava trees; their crunchy, tart fruit, sprinkled with salt, was a local favorite—pomelo, jackfruit, sapota, mango, pineapple, coconuts, longan, green-skinned oranges, lemon and lime. Tung also experimented with fruits considered exotic in Vietnam, such as peaches. Only papaya and banana plants required no care; skill and patience were needed to make the other fruit trees produce. Palm fronds had to be tied around tree trunks to deter rats; worms that had bored into plants had to be removed; shade plants had to be cultivated to keep small plants from wilting.

It fell to the old man, Great Uncle, to get the children off to school. For their breakfast, he collected eggs from the chickens and picked *rau mau* from the garden, a herb that went well with cooked chick embryos. All the children liked best what they chose on their own, so Great Uncle gave them *dong* to pay the passing peddlers, whose hampers had on offer still-warm baguettes, sweet

egg breads and a favorite, sticky rice mixed with grated coconut, sugar and grilled sesame seeds. When the four older siblings flew out the door, books under their arms, left behind were Phuc and the youngest, a baby.

Phuc would wave goodbye to the old man, push open the wrought-iron gate and skip down the footpath that dodged banana plants and rose up over the bumpy roots of shade trees. A few minutes later, she'd be at Grandmother Tao's. She and the neighborhood children and a cousin whiled away mornings in Grandfather Kiem's pomelo grove. They played at being buyers and sellers at the market, using leaves for money. The boys saw tree branches as guns they could use in games of war. The girls left them to it, instead reenacting princess roles from Vietnamese folk legends. Mid-morning, Grandmother Tao, back from the noodle shop, would offer a treat of a cooked sweet or a dessert-drink mixed with crushed ice. Around noon, Great Uncle's voice summoned Phuc home. She would arrive to a table already laid with rice and, typically, roasted chicken or grilled fish and fresh-picked vegetables from the garden.

As the afternoon sun baked the day in growing idleness, play shifted indoors. The younger neighborhood children and cousins, together with those who went only mornings to school (full days started in the third grade), congregated in the big house. The old man would take the baby, along with whichever young ones wanted to nestle alongside, into a hammock and rock and sing them to sleep. Whenever the old man himself fell asleep, Phuc teased him by dropping salt onto his lips or dripping water from the hose into his belly button, so that he would chase her around the garden. The arrival of the afternoon rains announced the children's favorite pastime: standing naked in the downpour off the roof of the breezeway so that the current of warm water sent them sliding on their backsides along the smooth cement floor. Great Uncle summoned them for a late-afternoon snack of

fruit. Often, the family bought an entire pedicab's load of fruit that they didn't grow, such as watermelons.

In the last light of day, the children wanted Great Uncle to entertain them with ghostly stories. In their eyes, the old man had proven the existence of ghosts when he had convinced a boy's spirit to come down from a jackfruit tree and return to the boy's body. Children loved to climb these trees. The boy found unconscious under one in Tung's garden was assumed to have reached for a ripened fruit—which, individually, could weigh as much as thirty pounds—and fallen. The boy lay in a worsening fever for three days and nights before Great Uncle's incantations worked.

"When I was a young boy, I'd heard that ghosts frequented the village by the bamboo forest, near the main road, but I didn't believe it," went one of the old man's stories. "One day at dusk, I rode my bicycle there. Suddenly, pedaling became more and more difficult. It was as if I were double-riding somebody. I dared not look behind. When my feet could not turn the pedals any more, I threw my bicycle down and ran." By now, the children would be whimpering. "I ran until I could run no more. I looked back to see a face without a body, of a woman with flowing hair." The whimpering would turn to screams, amid cries for another story.

Nu arrived home as early as dusk. If business at the shop had been hectic late into the afternoon, by the time she rolled down the bamboo blind and anchored it across the entrance, overturned the stools and swept under the tables, it would be dark. A measure of her fatigue was how she arrived: if by pedicab, she was left to nap for twenty minutes; if by foot, she delved energetically into outside chores. Each late afternoon, the pigs had to be watered and fed their third meal of the day (if Tung was readying them for market, they were fed a fourth at midnight). Their pens had to be hosed out and their next day's slop prepared by boiling the scraps delivered from the noodle shop, together with paddy

(unthreshed rice) and the heads, bones and entrails of oxen bought from a nearby factory.

After dinner, the children did their homework. Then most of them settled in with the neighbors and relatives who had come to watch television. The eldest, Loan, went out evenings to visit friends. Nu sat down to tally the day's receipts from the shop, and to settle accounts with her direct suppliers of rice, salt, rendered pork fat and pork meat. They made daily deliveries to the shop and came by the house each evening to collect payment. Later, Grandmother Tao arrived to help Nu grind rice into liquid and make the next day's *banh trang*. One woman would pour the liquid onto a sizzling pan, puffing it into a crepe. The other would take the crepes and hang them on a bamboo rack; the humidity of the night air would prevent them from drying hard. A couple of hours later, the two women would bag them for the shop. Grandmother Tao left for her own bed and Nu turned to ironing or laundry that was piled up, or housecleaning she wanted to get to. Sometimes she opted to defer sleep until the next evening, if, by then, it was already nearly time for the next day to begin.

IN THE IDYLL OF HER EARLY CHILDHOOD, Phuc believed her sole obligations were to enjoy herself and, like "a princess in the big house," to receive playmates. She lived up to her name, ever happy. Adults commented on her smile; in a country where smiles are brilliant, hers dazzled.

Though she did not know it, the war was steadily, ominously insinuating itself into her daily life. Even in the calm of Grandfather Kiem's pomelo grove, the noise of war from twenty miles away, on the South Vietnam–Cambodia border, would echo across the skies. The *boo-oom* of the bombs dropped from American B-52s, flying at an altitude of six miles, would be followed by a sudden, violent quiver of leaves of the trees in the grove. Phuc

and her playmates would unconsciously turn their heads, no more startled, however, than if a bird's pecking had dropped a ripe guava to the ground.

The children's first sense of an enemy came through encounters with the unknown. Once, at Grandmother Tao's call to come for their daily treat, the line of children making for her door ended in a near pileup as the first of them came to a sudden halt. The children looked one to the other, taking in the meaning of a footprint in the dirt made by a sandal cut from a used tire. "*Viet Cong came last night!*" one whispered. Someone shrugged, and the lot of them ran inside, saying nothing more.

While the enemy was invisible, government soldiers were not. The sight of them, handsome in their uniforms, was woven like a shiny thread into the fabric of Phuc's childhood. Her first memory of soldiers was of a handful who once shared the family's home for several nights. Her brothers enjoyed a game of soccer with them, while she herself was enthralled by their demonstration of how they ironed their uniforms and folded them with crisp creases. There had been four family members who worked for the military: Auntie Anh's husband worked in one of the Hau Nghia provincial offices, where all senior administrative positions came under military authority; and Auntie Tiem's husband and their two sons were government soldiers. Early on in the war, the eldest son was killed in combat. What Phuc remembered most of the funeral was the yellow-and-red silk flag of South Vietnam draping the casket, and the smart-looking soldiers that turned out in deference to Auntie Tiem's husband, who bore the rank of captain.

After the Tet Offensive, the Saigon regime sought to supplement the country's defenses. Along with lowering the age of "voluntary" service to eighteen (Americans had been sending eighteen-year-old recruits into battle for the past three years), it organized a countrywide program of recruitment and training of local self-defense forces. These forces, established at the provin-

cial and district level, were called "regional" and "popular" forces. Often they were the ones that Saigon sent to the front lines instead of the regular national army. Foreign war correspondents in Saigon dubbed the self-defense forces "Ruff Puffs," a reference to how poorly trained and equipped they were compared to the regular army.

The new district military outpost in Trang Bang was located just east of the bridge over the stream on Route 1. Locals referred to it as the "American office," though at any given time the sole American there would have been either the military or civilian adviser, who might have been attached to one or more offices in the field. From time to time, South Vietnamese soldiers were in barracks there, living in tents under three cement canopies.

Walking to and from her elementary school, which was across the highway from the Caodai temple, Phuc sometimes encountered soldiers in twos or threes, walking into town for something to eat, or going back to barracks.

"*Chau Chu!*" Phuc would call out, addressing each as "Uncle."

It was her eldest sister, Loan, who brought a government soldier into the family. Petite, with long shiny hair, and the oval face and delicate mouth considered classic hallmarks of beauty, Loan was also one of the town's best-dressed girls, her *ao dais* made from colorful silk that Nu bought from Cambodian salesmen. A soldier in barracks in Trang Bang whom Loan met at the noodle shop professed his love for her. Many boys had already done so; Nang's was the first she returned.

Nang, whose only family were his father and younger sister in Danang, became a regular at the family's house on his days off. An interpreter for the South Vietnamese regular army, his English was good enough that he could provide a running commentary on television programs rebroadcast from the West. He kept Loan's younger siblings in supply of their favorite Western candy, Wrigley's gum.

Nang introduced to the family the first and only Americans they'd met: two fair-haired, strapping American soldiers. Every time he brought them home with him, by the time they reached the house, there would be a crush of children in attendance. "Hello *My!*" the Americans would call out to Phuc, singling her out to put on their shoulders. *My*, an American soldier's nickname for Vietnamese girls, was a play on two of its several meanings, "America" and "beautiful." It was the nickname Tung and Nu had given Phuc at birth, since it can also mean "newborn kitten," which her tiny helplessness brought to mind. Whenever the Americans visited, they would lift Phuc and the children higher than they could climb into the jackfruit trees. They'd plunk them into army-issue sacks made in America of sturdy nylon and hold sack races.

Within weeks, Nang was asking Tung for permission to marry his daughter. Tung thought Loan, at sixteen, too young; she had just completed the tenth grade and was enrolled in a teacher-training course. Disconsolate at being refused, Nang attempted suicide with an overdose of pills, which caused Tung to relent. As social convention demanded, he and Nu held a celebration that overstated their social standing and lasted three days (only the poor could use the excuse of the fates of the harvest to shorten it). The bride and groom took their places at the feast on a heart-shaped stage, made of palm fronds and bedecked with flowers, built in front of the veranda. To feed seventy guests, Nu did not have to borrow a single item.

Hardly had the new son-in-law moved in when he was transferred to a combat division in Tay Ninh province, close enough that he could come home on days off and during any lulls in action. His and Loan's firstborn, a son, heralded a season of babies. Auntie Anh had her second, a son. And Tung and Nu had a seventh, a fourth son. So unplanned was this arrival that Nu's sixth-born and third son, at age four, was still on the breast.

Phuc was seven and in the second grade when she felt the first stab of the sorrow of war, and for the first time witnessed grief. Her brother Tam burst into her classroom. "Brother-in-law is dead!" he told her. She ran home after him, sobbing and afraid at the prospect of seeing Nang's body. There was no body. Phuc saw Loan, crying and unable to stop her small son's wailing. Adults standing around were talking of how the boy must have known of his father's murder; since the day before, he had been crying inconsolably. Two soldiers from Nang's unit, who delivered Nang's dog tags and watch to Loan, had told of how, the day before, the Viet Cong had ambushed his barracks, tossing a grenade through a window and killing him as he lay sleeping in his hammock.

A day later the flag-draped casket arrived and was placed in the house before a shrine honoring Caodai. For three days, professional mourners sang to musical accompaniment before the bier. On the third day after the burial, the family prayed at the grave for Nang's soul to depart for the ancestral altar. Tung placed his dead son-in-law's picture on the altar with those of the family's ancestors, in hopes that his spirit would be appeased and not become evil or resentful, as could happen with those who die prematurely or horribly.

Seven days after Nang's death, his father and sister arrived from Danang. They had come immediately upon receipt of Tung's telegram. A loud argument ensued. Nang's father wanted his only son returned to the ancestral birthplace, but did not have the money to bring the body back. Tung gave in, saving face because the first of the memorial ceremonies honoring the departed (on the eighth day, followed by the fourteenth, the forty-ninth, and the hundredth day, after which only the anniversary is celebrated) had yet to be observed. He paid for the exhumation and transport of the body to Danang, and for Loan and her son to accompany the body there. Loan returned to

Trang Bang alone. Her father-in-law had asked that she leave his grandson behind, especially as she was two months pregnant and would soon have his son's second child to keep her company.

There was one small consolation for Loan in her husband's death, in that he had died for the Saigon regime. As a legitimate war widow, she could openly grieve and receive condolences, as well as a government army widow's pension. Other fathers, husbands or sons who had slipped away to join the Viet Cong did not come home for years, if at all. Without word, their families wondered if they had died. Often when confirmation of death did come, no body followed. Or if there was a body, the families held no funeral. Neighbors whispered about so and so "crying with the door shut" or "crying on the inside."

No one knew that, in a few short years, roles would be reversed, and being on the winning or losing side of the war would be all that mattered.

CHAPTER THREE

Two Vietnamese sayings capture the attempt of the Vietnamese peasant to influence fate, and the futility of trying. One is ancient, the other modern. The first goes: "Sell distant kin, buy close neighbors." The second describes the trial of the peasant's life under conditions of guerrilla war, as being "caught between the sticky rice and the bean."

Since their earliest beginnings, the Viet people have faced the question of where to place their allegiance, near or far. In the first century, the famous Trung sisters led a rebellion against the ruling Chinese. It failed, but touched off almost a millennium of struggle for independence. Nine centuries later the Chinese would be driven out, and it would take nine more for the Vietnamese to extend, both by conquest and resettlement, their empire down the length of the 1,000-mile, S-shaped peninsula that is modern-day Vietnam. The natural north-south axis already had the effect of dividing kin, but division was formalized three times in three centuries: first in the eighteenth century,

again during the rule of the French in the late nineteenth century, and then, some six decades later, upon the end of the Franco–Viet Minh war.

With the resumption of war under the Americans, allegiances returned to what they had been during the war with the French, clandestine. Those united against the Saigon regime were either infiltrators from the north or southerners joining the resistance. The latter lived as commandos in the jungle or among the people, leading dangerous double lives at virtually every level of society, from Saigon down to the smallest hamlet, from the army and police to corporations and the media.

The average peasant cared nothing for politics and wanted only to be left alone. At most, he leaned to whichever side harassed him less. However, both the Saigon government and the Viet Cong sought to force him to declare his sympathies at the very least, by day and by night. He was, as the saying went, caught between the two, between the sticky rice and the bean—a favorite daily fare made by steaming glutinous white rice with black beans inside a banana leaf, which, once cooked, are inseparable. And so it was for the peasant, living entrapped and beholden to both sides. Any notion of choice of allegiance was nothing but a pretense.

KIM PHUC'S FAMILY HAD INHERITED THEIR peasant sympathies in the war from choices made in her grandparents' generation. The decision of Grandfather Kiem and Grandmother Tao to follow Caodai aligned peasant with priest in a popular peasant movement with its own political affiliations (at its peak in the early 1950s, one in eight South Vietnamese were Caodai). Like other powerful, quasi-political organizations at the time, including the Buddhist sect of Hoa Hao, the Caodai organization maintained a large army, serving their own organization. When war broke out with the French, the Caodai played it both

ways: they made a fragile alliance with the Viet Minh and at the same time gave qualified support to the French, in exchange for preserving autonomy in lands they controlled around the Holy See in Tay Ninh and in areas of the Mekong Delta where they held important military posts. In the last years of the Franco–Viet Minh war, the Caodai alliance with the Viet Minh collapsed and the sect made a deal with the French. In exchange for arms, they protected French posts in Tay Ninh, and in return, the French allowed the Caodai to function autonomously in Tay Ninh province, even to levy their own taxes. The Caodai were able to drive the Viet Minh from that province and, for a few years, peacefully build an economic empire.

In the province of Hau Nghia, which fell outside the Caodai stronghold in Tay Ninh, the teenage Tung, upon graduation from high school, hoped to escape recruitment by the Viet Minh by going to college in Saigon. Instead, the French targeted him to spy on the Viet Minh on visits home. There, he was coerced by the Caodai army to drop out of school. In the two years before he married Nu, and for the first two years of their marriage, he drove his aunt's truck as a cover for trips into the forest, on the orders of the Caodai army, to embalm Viet Minh dead, to prepare them for their journey home. He was released from his duties when the Caodai's alliance with the Viet Minh collapsed. Yet more upheaval came to the Caodai with Diem's 1955 rise to power in the newly proclaimed South Vietnam, when he sought to eliminate by force the Caodai and other political-religious sects. Diem had Caodai dignitaries hunted down and arrested, and absorbed their army into the government's. The *Ho Phap* fled to Cambodia and died in exile there in 1959. When Diem was murdered in 1963, the Holy See fell back into Caodai hands, but by then the empire had shrunk considerably. However, some six thousand of the Caodai army, who had neither surrendered nor been captured, continued to protect the lands around the Holy See itself.

It was inevitable that Nu and the Viet Cong would cross paths. From the first day she rented space on Route 1, her routine was the same, day in and day out. Once she left her sleeping household and stepped out the back door, her shadow joined the others who haunted the night. The only thing that could frighten her was an encounter with a shiftless ghost, among them her dead son-in-law's. She was ever afraid it might be lurking at the perimeter of the property, not satisfied by the picture on the altar.

After the Tet Offensive, the Communists' strategy was to keep the pressure on the Saigon regime by stepping up an economic offensive against the capital. The commercial ribbon of Route 1 was an obvious target for such tactical warfare. Fearing for Nu's safety in the hour of the Viet Cong, Great Uncle made her a firelamp to identify her as a peasant with legitimate business in the night. Blinded by her own light, often Nu didn't see the Viet Cong—who camouflaged themselves by wearing black pajamas and, as well, blackening their faces—until she brushed shoulders with one. Sometimes, all she caught by the light of her lamp was a checkered, black-and-white scarf, the trademark *khan ran* worn by the southern revolutionary. Once on the highway, Nu extinguished her lamp to better look for tomb-like hillocks, which were often set in potholes; one had to be careful to avoid the trip wire that would set off the mine or grenades inside. Often she had to detour around crude barricades erected of debris and broken furniture.

When Tung and Nu raised their new house, the Viet Cong noticed. It was a safe bet that such a big house, with a pillared veranda, surrounded by a fence with a wrought-iron gate, would abound in basics like rice and salt, and essentials like soap, bandages and medicines. The North Vietnamese imported these supplies from Communist China, but they did not make it far down the Ho Chi Minh Trail, so that southern guerrillas had to rely on local villagers. For the Viet Cong's purposes, Tung's house was also conveniently located at the edge of the town's "safe" area,

where visiting Viet Cong could melt back into the sanctuary of thick forest growth beyond.

The night visitors always announced their arrival at the big house in the same way. Out of the darkness came a voice: "Mother, please open the gate." The Viet Cong appealed to the peasants as either Mother, Uncle, Brother or Sister.

Someone went quickly to unlock the gate, if not Nu or Tung, Great Uncle. Usually, it was a teenage boy standing there, looking horribly thin. "We are so hungry. Please, can we have some rice?"

Sometimes, instead of seeking supplies, the night visitors came to shelter their wounded. "Mother, we have a package for you to keep," would come the voice from the gate.

Someone would lead them to the back door and through to the *ham*. The wounded, injuries wrapped in bloodied rags, would be lowered inside. If the required dressings or medicines were not on hand, Tung or Great Uncle made a trip to the market. The next evening, the Viet Cong would return for their own.

Daylight announced a different routine. The government military and police would arrive to find traffic already backed up, waiting for them to remove barricades, or defuse explosives, or set up detours. The police also conducted frequent roadblocks, suspecting all loads—from trussed-up pigs to tomatoes—of concealing weapons or supplies for the Viet Cong. It was the military who put up the propaganda signs that were everywhere in the south. On Route 1, east of the Caodai temple, there were two. One recited the four ways to say "No" to the Communists: deny them supplies, refuse to harbor them, isolate them with silence, and deny them means of livelihood. The other, accompanied by a drawing of a black-pajama-clad figure running in front of a building in flames, warned: "The Communists, the Viet Cong and the North Vietnamese have killed Catholics and Buddhists and they will destroy your homes and your economy!"

The military's patrols through the footpaths of the hamlet,

ostensibly to search for any Viet Cong hiding in peasant homes, were infrequent and casually conducted. On one of the rare times that soldiers did come down the footpath by the Caodai temple, the *ham* at Tung's house harbored a wounded Viet Cong. Hearing the neighbors greet the approaching soldiers, Nu lined up the children at home, oldest to youngest, in front of the veranda. Two of them, Loan's second-born and her own youngest, were still babes in arms. Nu suggested to the soldiers what they took to be obvious: "No Viet Cong would hide here. The children would be frightened and would cry!"

Of her children, only Loan and Ngoc, the two eldest, were in the know about the night visitors. They too kept their silence, both outside and within the family. Talk might be overheard and repeated by the younger children. The risk of retribution was great from both sides. Should the government arrest one of the family as a suspected Communist, they would be better able to withstand interrogation and torture if they could truthfully deny knowledge of the activities or sympathies of other family members. Should they inform on the Viet Cong to the government, the consequences were unthinkable. In the jungle, the Viet Cong could not trouble with prisoners; execution was easier.

THE AMERICAN PUBLIC WANTED TO GIVE Richard Nixon time to carry out his "secret plan" to end America's war in Vietnam, but few knew that their president would be so single-minded about his own role in the war. He talked peace; he pledged to continue American troop reductions; and one of his first acts as president in 1969 had been to send his national security adviser, Henry Kissinger, to Paris, to meet representatives of the Saigon government and the Viet Cong. Privately, however, Nixon had no intention of being the first American president to lose a war. Nguyen Van Thieu, who, since 1967, had

held the presidency in South Vietnam, continued to frustrate America's efforts both to wage war and to seek peace. Nixon would remain convinced that the only way to force the North Vietnamese to negotiate for peace in the face of American troop withdrawals, and to buy time for the South Vietnamese to prepare to wage war without the Americans, was to make war audaciously, not wind it down.

By the time Nixon entered office, thirty thousand Americans had died fighting the war; ten thousand more would die there during his first year as president. Though American public support for the war had already reached its high tide before he took office, he was able to play upon the ambivalence of what he called the "silent majority" that patriotically supported the president and felt alienated from the antiwar movement; regarding it as a home for agitators, even Communists. However, no matter where one's sympathies lay, no American could fail to be stunned by the revelations in 1969 of American atrocities in Mylai village the year before. After a failed mission in 1968 to rout Viet Cong, an American infantry unit slaughtered as many as five hundred Vietnamese civilians, including children and babies. The massacre at Mylai exposed deep-rooted problems and deteriorating morale among American troops in Vietnam, one-third or more of whom were addicted to drug use.

Nixon himself broke the biggest story of the Vietnam war since the Tet Offensive. On April 30, 1970, he went on national television to report that, four days earlier, he had sent American ground troops, together with South Vietnamese forces, into Cambodia to give chase to North Vietnamese Communists. Nixon claimed success in his purpose: to demonstrate America's resolve as the world's most powerful nation. In fact, North Vietnamese intelligence had anticipated the American-led assault into Cambodia in time for the Communist units to flee their jungle hideouts. The uproar Nixon expected, even relished, from the antiwar

movement came. The president had extended the ground war, and furor erupted on American campuses. Tragedy struck. At Kent State University, National Guardsmen fired on a crowd of students, killing four and wounding nine. The television footage and news photograph of an anguished teenager kneeling over a body brought home the senseless tragedy of a pointless war.

Even returning Vietnam veterans joined in the campus and street demonstrations that followed. Congress acted, banning American troops from both Cambodia and Laos. With fewer options, Nixon's professed policy towards the war became "Vietnamization": handing America's responsibility for fighting the Communists to the South Vietnamese.

AFTER THREE YEARS IN OFFICE, NIXON had reduced American troop strength in Vietnam to one-quarter what it had been after his election. Casualities fell correspondingly. In one week in July 1971, the American weekly death toll in Vietnam fell to an all-time low of eleven, compared to more than three hundred when fighting was at its most intense. But as the number of American casualties in the ground war plummeted, South Vietnamese casualties began to soar. In the United States, war reporting fell from the front pages of newspapers and from nightly television newscasts: Vietnamese killing other Vietnamese evidently did not interest the American public.

Foreign correspondents in Vietnam also recognized that it was time to move on. The heyday of covering the American war had been its earliest years when few abroad cared about what was happening and people needed to be told, and again during the Tet Offensive when, finally, the deaths and violence and inhumanity they had been documenting for years hit home with Americans. They had mourned colleagues killed on assignment and wondered each time, "Why them, and not me?" They left

believing their days of reporting the war that continued with no end or solution in sight to be over.

The job of following the war in Vietnam fell to those in military intelligence. In the fall of 1971, as the dry season approached, as usual, they went on heightened alert. In the south they were expecting some coordinated action from the Communists in early 1972, when the ground would still be dry and easy for men and equipment to maneuver over. The following wet season would halt any broad action, as, once the rains start, usually by May, the ground is either under water or muddy. The Communists had launched no action in the south since the Tet Offensive. The questions on the minds of those in the South Vietnamese regime were whether, after the death of seventy-nine-year-old Ho Chi Minh in 1969, others would carry on his fight to unite the country, and whether the American air strikes over the Ho Chi Minh Trail had deterred the North Vietnamese from resupplying men and equipment to the south.

The answers came on March 30, 1972. That day, Hanoi gave the order to Communist mainforce troops, concealed and coiled in their southern hiding places since the previous November, to attack. Dubbed by the Americans the Easter Offensive, the scale of the Communist onslaught was awesome. It would break over three weeks and in three successive waves: from the demilitarized zone into the northernmost provinces of South Vietnam; across the central highlands to the coast; and, in the biggest surprise to southern military intelligence, advancing from Cambodia to within sixty miles north of Saigon, to the provincial capital Anloc.

The aim of the Communists was political: to put on an impressive display of military strength that would force concessions from the Americans in the peace process. The offensive was a test of the South Vietnamese forces as, by this time, the American presence on the ground in combat troops and advis-

ers had all but evaporated. By the spring of 1972, scheduled American troop withdrawals had cut the total at year's end in 1971 by half, leaving fewer than seventy thousand in Vietnam. Of those, only six thousand were combat troops, with severely restricted duties. Of the remainder, only a few were advisers— spread thinly, with only one or two at the provincial level, and rarely any below at the district level—leaving mainly aviation and supply and support personnel.

In their counteroffensive, the South Vietnamese relied on American air support to make the difference. Nixon did not disappoint: one day after the Communist offensive began, he ordered massive retaliatory b-52 bombing strikes in North Vietnam and the mining of its main port, Haiphong.

The Communists were ready for battle; the passing days and weeks in hiding had only heightened the desire of northern soldiers to, if necessary, die for their cause. In contrast, the largely untried and undisciplined South Vietnamese command and infantry, without American combat troops to steel their nerve, proved unable to stand up to the Communists' attack. The Communists had planned for the usual quick strike and withdrawal, but to their own surprise, in the first two waves of assault, they were able to hold territory and to launch a sustained attack. In the northernmost provinces, the South Vietnamese command preferred to retreat rather than fight. Thousands of soldiers, joined by terrified civilians, fled south along the coastal route, taking relentless fire from North Vietnamese artillery and American warships alike. In the highlands, government forces failed to go to the support of local self-defense forces. But for the Communists' stopping short, the South Vietnamese might well have lost half the country.

The only place government troops put up a strong resistance was at Anloc. The Communists, hindered by American bombing strikes from resupplying their troops, resolved to lay a bitter siege. It was not until mid-May that it appeared that the government

garrison there was going to hold. But the siege dragged on, fighting spilling over from Anloc, depending on where retreating Communist soldiers surfaced to attack, creating so-called "hot spots." By June, military intelligence in the south could only guess what the Communists were going to do with their divisions in Anloc: pull back to Communist headquarters astride the Cambodian border; amass for a major drive on Saigon; or tie up government forces to deter them from their ultimate responsibility, that of defending approaches to the capital.

AS THE EASTER OFFENSIVE BROKE, THE only daily foreign journalistic presence on the ground in Saigon was provided by the two main competing wire services, the Associated Press (AP) and United Press International (UPI). However, head offices had pared back regular staff. Ready to pick up the slack were the freelancers and stringers referred to as "Saigon-hires," including those foreigners who came to Vietnam because they hankered for an Asian adventure and those who had come to work at aid and other jobs during the American era and chose to stay.

Early on in the offensive, according to playback reports (which report the use of wire service material by subscriber newspapers), it was apparent that the AP bureau in Saigon was losing ground to UPI on the picture side. To bolster its coverage, the AP head office in New York sent in Horst Faas, its chief photographer in Southeast Asia, based in Singapore. The German-born Faas was among the handful of correspondents who had covered the Vietnam war in its earliest days. Having already made his reputation as a combat photographer in the Congo, he had come to Vietnam in 1962. He would stay until 1970 and win a Pulitzer prize, America's highest journalistic honor, for his work there.

It was newsmen like Faas who early on in covering the war had seen the advantage of hiring Vietnamese: they came cheap and spoke the language, they had the contacts, and they knew the terrain. In Saigon they ran errands on motorbikes and worked in the darkrooms, and on the battlefield they carried television equipment and shot photos. They shared responsibilities with the writers. Just as no reporter left the office without a camera round his neck, when the "shooters" came back in, the writers relied on them for their observations and notes. Faas's Vietnamese free-lancers were busiest during the frenzy of the Tet Offensive. Stringers were hiking up to the AP's office on the fourth floor of the Eden Building on Rue Pasteur (the South Vietnamese had renamed it Nguyen Hue Boulevard, but some names from the French era persisted), bringing in as many as eighty to one hundred rolls of film a day. From those rolls, Faas might have bought three or four pictures, or more typically one. He had so many Vietnamese stringing for him then that the Saigon press corps called them "Faas's army." The name suited: he himself was every bit the general—a big man, weighing more than two hundred pounds, with an appropriately gruff manner.

On the evening of June 7, more than two months into the Easter Offensive, Faas was having a routine chat with one of the AP's staff photographers, asking where he was planning to go for the next day's pictures. The photographer was twenty-four-year-old Huynh Cong Ut, better known as Nick Ut. Nick knew where he didn't want to go—back to Anloc. Because fighting had cut the highway, the only way to get there was by helicopter. Every combat journalist, even the most hardened, had an almost morbid fear of chopper travel. Nick was superstitious; on his last ride to Anloc, he had counted one too many thirteens: the helicopter's number was 113, and there were thirteen passengers on board. As the pilot dodged anti-aircraft fire, Nick had looked down at the landscape strewn with rotting human carcasses and

pitted with gaping bomb craters and prayed to Buddha. *Not even animal life can survive here*, he'd told himself. The pictures he brought back revealed the grimness of life under siege: South Vietnamese soldiers, out of food and water, sustaining themselves on Vietnamese snake liqueur.

Nick had another idea. He wanted to go up Route 1, to check out what he'd heard on the grapevine about a hotspot of fighting up there. A friend, Le Phuc Dinh, a cameraman for NBC, had heard from a district military chief that fighting near Trang Bang had cut the highway for the past two days. The chief, a Major Cuong, was known among the foreign press: he was savvy enough to blow his own horn, and they regarded him as a seasoned military man, because most of the districts in Hau Nghia that his "Ruff Puffs" had to defend were hard-core Viet Cong. "You ought to come up here tomorrow," he had told Dinh, "because there's going to be a big fight."

"Okay," Faas told Nick, "you go take a look there tomorrow."

Nick arranged for the AP driver to swing the van by the office the next morning after curfew lifted, at six. Going by car wasn't Nick's preferred mode of travel. His Honda motorscooter could be pushed to speeds of fifty miles an hour, could weave in and out of traffic, past slow-moving oxcarts, could detour easily where roads were cut. But Nick didn't know what awaited up Route 1, and riding on a motorscooter made one an easy target for a sniper.

Even as he waited curbside, Nick's thoughts were turning to the end of that day's work, to being back in Saigon in time to change his clothes and meet up with his girlfriend, go out with her to dinner and a club, try to forget what he would have seen that day.

A PORTRAIT OF ONE OF NICK'S OLDER brothers, Huynh Cong La, hung on the wall above the dryer for

photographic negatives in the AP office. The entire AP bureau had turned out, along with many of the Saigon press corps, to La's funeral in 1965. La had been hired by Faas in 1963 at the age of twenty-six. The handsome La had already made a name in movies, and was known in particular for directing and acting in the film *Eye of the Lover* (he got his nickname, *My*, from his movie-star fans). From the start, Faas recognized La as a gifted photographer, and saw that his intelligence and charisma, and his better-than-average ability in English, allowed him to move with ease among the American and South Vietnamese military commands.

Some time after the funeral, La's widow, nineteen-year-old Arlette, went to Faas and asked if the AP could do something for La's kid brother. She'd brought Nick along. He was almost seventeen, and a dropout after six years of schooling. Faas took one look at the short, skinny kid she had brought along, and thought he looked to be about ten.

"Go back to school. Go home to your family," Faas told him.

"AP my family now, I want take picture, too," Nick replied.

In a family of ten sons and one daughter, tenth-born Nick was the older of two boys still left at home with their widowed mother. As long as Nick wasn't in school, he was a target for recruitment by both the Viet Cong and the government. As it turned out, the eleventh-born answered Nick's call to enlist in the government army; conveniently, their mother had named them both "Ut," meaning last-born.

La, the seventh-born, had brought Nick to Saigon to live with him and his wife, in hopes that he'd pick up some English and, like him, find work with a Western news agency. Every night, La brought back beat-up old cameras to teach Nick how to operate them. As well, he brought home stacks upon stacks of blowups of combat shots; he could talk for hours about their photographic merits. He had lectured passionately about the senselessness of

war and spoken of how pictures that showed its horrors could help end it.

Nick already had in his mind's eye the evil of war. Growing up in Long An in the Mekong Delta, he had shrunk from many a dead body, hours old but already grotesquely bloated in the heat. He'd seen severed heads impaled on bamboo poles, a smoked cigarette stuck between the lips—a last defiling to identify the dead as Viet Minh.

One fall day in 1965, La came home and told his wife that a photographer volunteering for the AP had been killed. Bernard Kolenberg, back in Vietnam for only one week after a stint of several weeks earlier that year with an American newspaper, had died in the crash of a South Vietnamese military plane. "I'm going to be next," La told Arlette, marking himself for death.

Eight days later, La's prediction came true. He had returned to the front lines in the Mekong Delta, where he'd been wounded by machine-gun fire three months before. While covering a fight between South Vietnamese troops and the Viet Cong, he was hit in the chest and arm. He was waiting to be evacuated by helicopter when the Viet Cong overran the makeshift aid station and finished off the wounded.

Despite Faas's initial refusal to hire Nick, Arlette persisted. Finally, Faas let Nick run errands for the darkroom technician. Nick kept taking home old cameras to practice shooting. He started by taking photographs around the home, and of Arlette's maid, then tried taking pictures from the window of the AP van, of people in motion, of passing traffic on Saigon streets. Faas moved one of his pictures on the wire: a cigar-smoking Vietnamese kid buffing the boot of an American GI. But his big break came the morning there was no photographer in to act on a tip that came to Faas: yet another protesting Buddhist monk was going to set fire to himself. Faas sent Nick, who came back in triumph with close-ups of the monk aflame, then the charred body,

sitting upright, then slumped over. Faas rejected frame after frame: "These pictures are ugly," he told Nick. "Newspapers won't publish these. A better picture would be somebody covering the body, people in the background looking on, crying."

Under the tutelage of Faas and another AP colleague, Henri Huet, Nick became a skilled combat photographer. From the start, Nick believed that his older brother's fate, an early death, awaited him. That belief drove him to go where the action was, to not come back until he had a picture he was happy with.

In Nick's fifth year of covering combat he was wounded. He was covering a ground incursion into Cambodia, and took shrapnel in the stomach from a rocket. But his closest brush with death came one year later, when he missed being among the tally of dead when a helicopter flown by the South Vietnamese air force crashed over the Laotian jungle in early 1971, killing all eleven on board. Four were foreign photographers, including the legendary Larry Burrows from *Life* magazine, their assignment to cover the first major test of Vietnamization, a South Vietnamese foray—without American advisers or troops—against North Vietnamese troops in southern Laos (it would fail; South Vietnamese troops suffered heavy losses and had to retreat). Nick had been among the journalists waiting out days of bad weather for the go-ahead for the chopper flight to tour South Vietnamese bases before joining up with the most forward of South Vietnamese ground troops. At the last moment, Henri Huet asked Nick for his seat, explaining that he wanted to get in a last assignment before taking R&R leave in Hong Kong. It was Huet who first called him Nick, and so the young photographer took the name for his own, in memory of his mentor.

Arlette grew afraid that she'd lose Nick to the war. Another brother of La's, who'd arrived from the battlefield just in time to throw himself on her husband's casket at the funeral, had died in combat months later. Arlette herself was superstitious. Her house

address in Saigon was 1010, and La had been killed on the tenth day of October. She talked to her mother-in-law about what else Nick might do. The old woman depended on Nick for financial help to hire laborers to work her fields, and to pay the taxes exacted by the government and the "donations" asked for by the Viet Cong. "Ut loves taking pictures," she replied.

ON THE EVENING OF JUNE 5, A NIGHT VISITOR came to Tung and Nu's house. He was the leader of several Viet Cong commandos. "Mother, do not move away from your house," he told Nu. "Visitors are building tunnels. You can move your family to the forest when we complete our work." This was not a request but an order. "Do not go into the town. There are government soldiers gathering there. If you go there, you will bring everybody trouble!"

When news had first broken of the Easter Offensive, people across the south feared a repeat of the Tet Offensive, that the Communists would "strike everywhere." In Trang Bang, houses began to empty as people chose to flee, mostly to Saigon. The way Tung and Nu saw it, their family was too large to move and had nowhere to go. Auntie Tiem in Tay Ninh had no room for them, and they knew no one in Saigon. The noodle shop still had customers, and the animals required daily care. Besides, the house and possessions represented their life's investment. The family decided to stay, to gamble that fate would play out in their favor.

The offensive had not been a complete surprise. Some weeks before, an infiltrator from Hanoi had visited Nu in her shop. By her physique, Nu was certain she was a northerner. The girl asked Nu to observe movements of the South Vietnamese military along Route 1. Nu saw no choice but to keep accurate count. What if she was being tested?

That afternoon, the girl returned.

"Mother, did you have the usual customers this morning?"

Nu gave her tallies, how many trucks, moving in what direction.

As Nu expected, she was asked to assume greater risks. A contact, never the same, came bearing a basket: "Mother, here are some areca nuts." Sliced, boiled and sundried, smeared with a lime paste, the nut was a stimulant that also kept the mouth from going dry. Inside the basket was concealed a message, which Nu was supposed to hand off upon hearing a code word. Other times, the contact would give Nu an address and she would have to deliver the message. As Nu could neither read nor be away from the shop without arousing suspicion, she had to enlist Tung. The Viet Cong showed their appreciation, once bringing her a basket of large betel leaves which, fresh, were ideal for wrapping food and, dried, made all-purpose household cloths. Once, wrapped inside one was a Viet Cong flag pin of a yellow star against a split background of blue and red. The star represented the people, the blue, the peaceful north, the red, the bloody south.

The visitors were building their tunnels right under the family's house. Throughout the night, muffled sounds of mechanical punching came from beneath the room housing the hearth. Cracks began to appear in the floor.

Around midnight, the leader came to Nu. "Mother, we need the doors of your house." As they began to unhinge each of the seven doors, including the double-louvered ones on the three front entrances, Nu called out angrily, "Don't do that!" She was ignored. Seeing through the open doorways piles of guns and ammunition, Tung and Nu made the decision to move sooner rather than later. They prepared to make for the Caodai temple, deciding that it was best to stay near the house, so that someone could come back for food and medicines, to care for the pigs and to guard against looting. They also didn't want to go far for fear

of running into government night patrols, which would most certainly be out if, as the Viet Cong said, government soldiers were setting up a position in town. Another reason not to go far was Great Uncle; his chronic stomach problems had flared up and it was all he could do to take a few steps. Tung and Nu rigged up a hammock to support him as he walked, and then they woke the younger children, who had slept through the noise.

Nine-year-old Phuc rubbed her eyes and saw that it was still dark. "Oh, Ma!" she said, happy to see Nu. "Why haven't you gone to the shop?!"

"Shh! Ask nothing!"

Phuc saw a black-clad figure in the doorway and began to cry.

"Don't worry," the Viet Cong assured her. "We are here for a visit only."

Nu requested permission to leave the house, citing the need to seek help for the old man's worsening pains. The leader gave no argument. In the darkness, the family half ran, half stumbled down the footpath. Five minutes later, they slipped through the gate in the rear grounds of the temple and headed for an out-building there behind the main building, normally used for social functions and to house visiting dignitaries from the Holy See.

Inside, the family found several neighboring families encamped, some thirty people in all, mostly women and children. Among them were Grandmother Tao, Auntie Be, Auntie Anh and her three children. Auntie Anh's husband was away in the province, and Grandfather Kiem was at the Holy See in Tay Ninh, where he often stayed for weeks at a time. Inside were also eight or ten government soldiers. The one with the two-way radio fired questions at the latest arrivals: Did they know where Viet Cong were hidden? "They are everywhere!" How many were they? "We don't know! There are many!" The soldiers let it be. "We are waiting for the big attack," they said.

The morning of June 6 was announced by the distant rattle of

small arms fire. The first sound of mortar fire sent everyone scrambling for the makeshift *hams* in the dormitory rooms opposite the open foyer, one for the women and children, one for the men, echoing the segregation in the main temple. The *hams* were piled-up sandbags with timbers laid across the top.

It soon became evident to all that the fighting was in the town's business district. The soldiers relaxed. The children played, running back and forth across the foyer. At lunchtime, the women cooked rice for their families in the small kitchen off it.

Late in the afternoon, after a long silence, suggesting either a lull in the fighting or an end to it, one woman asked permission to go to her house for food for her family. The soldiers shrugged, offering no opinion. The woman left, and Nu decided she would go to tend the pigs at home. Along the footpath, she met the same woman running back. "If you stay in your house you will die!" the woman yelled. "The government is going to attack here with rockets!"

When American combat troops first arrived in Vietnam in 1965, the U.S. command agonized about "rules of engagement" in this war without a front. Among their unwritten rules was one that allowed bombing strikes to be called in on South Vietnamese villages if American forces had received even a single round of sniper fire from the general vicinity. While many American consciences were troubled about civilians being fair game under dubious conditions, the South Vietnamese military command had no similar qualms.

Nu turned back. She was almost at the temple outbuilding when an incoming shell struck the ground in front of her, and she was half buried under a spray of dirt. A couple of minutes later, unhurt, she got up and scurried inside. Nothing more happened that day, but the soldiers kept the crowd encamped for a second night.

By the morning of June 7, the fighting had moved from the business district of the town to its eastern edge. So close were the

rockets and shells exploding that the terrified villagers feared for their homes. The air in the crowded *hams* was so stale that people had to take turns by the air holes. Late afternoon again brought a lengthening silence. Worried about the pigs going yet another day without food and water, Nu asked for permission to go home. Too dangerous, said the soldiers, pointing out that the South Vietnamese army had moved a unit of soldiers into positions near the temple and that the Viet Cong could be anywhere.

ON THE MORNING OF JUNE 8, ON ROUTE 1 just past Cu Chi, Nick and his driver encountered refugees clogging the road, heading east. Women carried babies, women and men shouldered poles balancing a hodgepodge of clothing and pots and pans, children carried babies and led water buffalo on ropes. The old and injured rode on oxcarts. The location of Trang Bang was obvious by the heavy smoke hanging in the air above it and the planes circling the skies. The sound of Soviet- and Chinese-made weapons confirmed the presence of mainforce North Vietnamese soldiers. Immediately, Nick knew why the skirmish had gone on as long as it had. The enemy's rocket-propelled grenades, recoilless rifles and anti-aircraft guns were the kind of portable artillery that could fire from a fair distance and still inflict serious damage.

Short of the town, traffic was stopped behind concertina barbed wire stretched across the road. Ut flashed his *bao chi* pass to the military police, identifying him as a journalist. He could go no farther than the small elevated bridge. Several soldiers and journalists stood there. Like Nick, the journalists were in battle fatigues, bought from Saigon street markets. The uniforms made it easier for them to move freely among the army.

As the morning progressed, more than a dozen foreign newsmen arrived. Besides Nick, there was the NBC cameraman who'd

given Nick the tip about the fighting, Le Phuc Dinh. He was there with correspondent Arthur Lord. A second television crew belonged to the British Independent Television Network (ITN), with correspondent Christopher Wain. Among the print reporters was Fox Butterfield of *The New York Times*. There were at least three other photographers: a competitor from UPI who, like Nick, was Vietnamese; David Burnett, a stringer for *Life*; and Alexander Shimkin, a former Peace Corps worker turned free-lancer. Three British journalists, among them William Shawcross for *The Sunday Times*, arrived by chance: the roadblock had way-laid their plans to take a sight-seeing trip to the Holy See.

Major Cuong, whose word put out the night before had brought several journalists from Saigon, was on the bridge. "I decided not to use air strikes yesterday," the major told Fox But-terfield. "Many soldiers asked me to use air, but the villagers were against it. One air strike and the whole village is gone." He cred-ited government forces with having driven the Viet Cong, on the first and second days of fighting, from the marketplace to the eastern edge of town, near the temple.

The objective on this third day of fighting was to drive the Viet Cong into the treeline, and therefore out of town, so that the highway could be reopened. The plan that day was to launch a ground assault with air support. It did not need to be said that government troops would have been unwilling to take on even a small Communist unit without such support.

Two or three times that morning, South Vietnamese planes came in on bombing runs. These were mainly A1-E Skyraiders, the outmoded, propeller-driven, low-flying aircraft that the Americans gave to the South Vietnamese early on to use as train-ing planes for combat missions. The runs were in tandem. The first plane would drop high-explosive bombs intended to blow covers off bunkers or tunnels; the second would deliver napalm, to burn or suffocate anyone still alive. A couple of times that

morning, helicopter gun ships came in to fire into the treeline to respond to anti-aircraft fire. Ground assaults followed the bombing runs: government soldiers, moving single file, swung caterpillar-like in wide arcs through waist-high grass in the fields. Nick got shots of airplanes coming in. He shot soldiers on their bellies aiming grenade-launchers and firing machine guns, and soldiers rushing out the wounded on stretchers. These were the same images he'd recorded hundreds of times before.

The crowd at the roadblock, many of whom had been stopped there three days, was like an audience at a state fair. At the sound of an approaching aircraft, they would stand, violently engaged by the explosions and fires half a mile away. In between times, mothers and big sisters busied themselves picking lice out of the hair of little ones. As if the lulls were intermissions, a boy peddled ice cones from his bicycle to the line of stalled traffic. Some of the crowd, crouched in the shade of their vehicles, snacked on bananas or savored the sticky, sweet pulp of the last of the star apples of the season.

THE CROWD ENCAMPED INSIDE THE OUT-building found the third morning of fighting to be alternately deafeningly loud and terrifying and deathly silent and calm. The air was acrid with the smell of high explosives. They saw only what was visible from the *hams*, through the windows and door-way on three sides of the building. They heard the drone of air-planes, the beating of helicopter rotors, the burst of shells, the staccato of machine-gun fire. So near did explosives drop to the temple grounds that branches and tree trunks, chunks of walls and rooftops of nearby houses landed inside the perimeter fence, or bounced off the walls and roof of the outbuilding.

Two or three times that morning, without warning, the world seen through the windows was transformed into luminous red.

When a recognizable reality came back into view, fire was leaping through the air, across treetops; even the ground seemed wet with it. "Fire is falling from heaven!" cried the villagers.

A soldier explained the napalm bomb: "When you see the fire, the bomb has already fallen."

In the silent lulls, sometimes the crowd caught sight of uniformed North Vietnamese soldiers dragging wounded colleagues to safety. It was the first time many had seen "soldiers from Hanoi." Reassured by the presence of government soldiers to protect them, they also agreed that it was unthinkable that either the Communists or the government would attack a holy place.

LATE THAT MORNING, THE JOURNALISTS noticed the darkening skies. The clouds had formed a low-lying blanket. The typical afternoon downpour of the wettest summer months began. The photographers and television cameramen covered their equipment with army-issue rain ponchos, bought in Saigon markets. The photographers cast about to see if anyone was thinking about calling it a day: the cloud cover would mean a halt in air strikes and, therefore, ground assaults.

"What do you think today's picture is?"

They compared notes: refugees on the road, people fleeing the town. Other journalists who'd arrived later that morning had run into the aftermath of a firefight in a hamlet east of Trang Bang.

"Maybe I'll go early today."

"What time?"

Some said one o'clock, others two at the latest. Talk turned to where to go tomorrow for pictures.

Ut took from his camera bag his lunch of French cheese and a baguette sandwich. He decided that leaving any time before three could still be considered early, but that he'd aim for two,

because of the heavy refugee traffic. One o'clock came and went without a break in the cloud cover. Some of his colleagues left, presuming that the Communists and the Viet Cong would also take advantage of the weather to retreat and leave the town. The rain continued. A soldier began washing his jeep, taking pails of water from the stream.

THE CHILDREN INSIDE THE OUTBUILDING, enlivened by food in their tummies, were running around. During the last three days, Phuc had taken Auntie Anh's second child under her wing. The chubby three-year-old, Danh, was her favorite cousin.

There was sudden excitement when a black bird found its way into the building. Danh chased it, snatching it out of the air.

Adult voices cried out in alarm. "Don't touch it! Let it go!"

"Danh! Let it go!" Phuc called out to her cousin.

The boy released the bird but was disconsolate about losing a plaything. Even as the bird found its way outside, the adults were shaking their heads: "A bird inside is bad luck."

PERHAPS AN HOUR OR MORE AFTER IT HAD begun, the rain stopped. The wind began to clear the clouds. Here and there, bright sunlight poked through a sky still dirtied by black smoke from the morning's bombings and fires. A small observation aircraft circling in the northeastern sky began an approach. Dipping low above the treeline behind the temple, it fired two phosphorous rockets that spewed white smoke upon impact. Immediately, several government soldiers ran out from a masonry building, originally a mausoleum for two village chiefs, outside the temple gates. Some dashed onto the temple grounds and popped violet- and mustard-colored smoke grenades. The

colorless smoke fired by the observation plane marked the enemy; the colored smoke, popped by those on the ground, identified the South Vietnamese forward position. Perhaps as much as one hundred and fifty yards separated the opposing positions. What happened next was up to the pilots on the bombing missions.

THE SOLDIERS INSIDE THE OUTBUILDING suddenly came to life. Some were stringing together curses. An argument broke out among them, apparently about the meaning of the smoke. Suddenly, they turned to the confused villagers: "Get out! Everybody get out! They are going to destroy everything!"

Tung assembled his children and their cousins, instructing them all to make for the "American base." He sent out the littlest and oldest first. Grandmother Tao and Auntie Anh, carrying her nine-month-old son and her other two children, including three-year-old Danh, were with the first runners. Next, he sent out the middle children, including Phuc and two of her brothers. Then, the oldest siblings. Some of the panicking soldiers had already run out with the first of the villagers. Others who remained behind barked at the stragglers, trying to hurry them. "Run! Run fast, or you will die!" Among the last to go were Tung, who ran out with his youngest in his arms, and Nu. She stopped to scoop up Loan's daughter, who, too scared to run any farther, had stopped in her tracks.

The thirty to forty soldiers and civilians sketched a ragged line from the outbuilding, past the side and front of the temple, through its main gate and onto Route 1. How they appeared from the air through the lens of a dirty, partly clearing sky is debatable.

NICK LOOKED AT HIS WATCH. IT WAS WELL after one o'clock. *I have this shot*, he told himself, staying put as a

South Vietnamese Skyraider approached. Changing his mind, he scrambled out of the embankment and onto the road. *I'll get a couple more*, he thought, *then I'm going home.*

Quickly, it became apparent that the plane was off course to hit the white smoke and had crossed into government lines. Having miscued on that most elementary of maneuvers, instead of aborting his run, the pilot dipped into a dive and dropped two bombs. No explosion came; the bombs were duds. Fox Butterfield shouted in disgust and anger: "The pilot must be out of his mind! Was the guy drinking last night?!"

Some moments later, a second Skyraider came in on an approach even more off target than the first, its course aligning with the bridge on the highway. It dipped in a kind of corkscrew motion, a maneuver normally used when under fire. "Oh shit!" Butterfield, incredulous that the second pilot was going to drop his bombs, flattened himself to the ground, as did some of the others at the bridge, soldiers and journalists alike.

Nick did not move from the road. He kept his camera lens trained. Dinh, the NBC cameraman, kept his camera rolling. With him, because his equipment was wired to the camera, was his soundman, a Vietnamese freelancer hired for the day. So low did the plane dip that anyone on the road could plainly see its South Vietnamese identification, red stripes on yellow. There was another unwritten "rule of engagement" that the Americans had established early in the war: no fire was to be directed at unarmed Vietnamese *unless they were running.* Anyone running could be assumed to be fleeing Viet Cong, and therefore fair game. However frightened Nick and his colleagues were by what the pilot was about to do, they followed the essential rule of conduct when covering combat during a bombing run: stand still, and lift your face towards the pilot.

CHAPTER FOUR

ONCE THE BOMBS HAD FALLEN FROM the Skyraider, Nick swung his lens down. In his mind, he had already composed the shot: silhouetted figures in uniform on the road in the foreground; the twin towers of the temple against an expanse of sky as the background. He had time. Hard bombs drop heavily to the ground, but the lighter napalm canisters tumble end over end, making forward progress as they head earthward.

Upon impact, the napalm ignited in a fierce explosive splash across the highway and the fields on either side. Flame shot upwards. Shades of saffron, blood, fire and sunset filled the viewfinder. "Oh, my god! So beautiful!" In that instant, Nick was sorry that he was shooting black-and-white instead of color.

Even from a distance of several hundred yards, the blast of heat was as if a door had opened on an immense brick furnace. Fire rolled and roiled out of the treetops. Heavy, dirty black smoke swirled skyward. Gradually, as ash rained down, the scene was recast in shades of gray. The darker rooftops of the twin

spires of the temple rose mirage-like beyond the obliterated road and fields in between.

Faint shouts and screams could be heard.

"Jesus! People have been bombed!" someone yelled out. It was Shimkin, the Peace Corps worker who'd once documented human rights violations. He was the first to run forward. Other journalists followed, some cradling telephoto lenses. One among them, ITN's Christopher Wain, called his crew back. "Hang on, guys. There's another plane up there. We don't want to be a statistic." Even as he spoke, a third plane circling the area was departing.

The first discernible figures, rendered against the smoke like a child's drawing of stick-men on a dirty pane of glass, were a half dozen or so women and children and a small black dog. A boy carried a child on his hip; two girls clutched jute sacks. The same stunned emptiness was in the eyes of human and animal, as if they did not comprehend what they had run from, or what they were running to. They found a curious reception—journalists and soldiers dressed alike in battle fatigues, some pointing long lenses, which, from a distance, can look like gun barrels.

Two stragglers appeared. One woman was ahead of the other, on the left edge of the road; the second woman was on the right, by habit, keeping out of the way of vehicles. The face of the first bore a wounded expression of tragedy witnessed. She carried a baby, its face and scalp smudged black, facing forwards. It was alert, even cute, as it bounced to her hurried steps.

"My god . . ." The same cry of revulsion escaped from several mouths, and all eyes went to the woman lurching up the road.

An old lady, her face torn with anguish, struggled forward with the limp weight of a child's naked, blackened body in her arms. Her baggy black trousers slapped at her ankles, and with every flat-footed step charred skin flapped or fell from the child's limbs.

"*Nguoi oi! Chay di dau nhu vay ne troi? Chay di dau nhu vay ne troi?*"

The old lady's Vietnamese was lost on most of the journalists. She seemed to be speaking to the child in her arms, in its dying moments.

Allan Downes, the cameraman with Wain, turned to him. "I can't shoot this," he said. "London isn't going to use this."

"You let London sort that out!" shouted Wain, forcibly turning Downes's shoulders so that he stayed with the woman as she moved past.

The news photographers knew this was the day's picture. They clicked frame after frame until there was no film left in their cameras. Already, they were thinking of the editing, of finding the frame that separated life from death. The living better convey the horror of war; the dead have no expression.

NEVER A FAST RUNNER, PHUC HAD FALLEN A step or two behind her two brothers, one older, one younger than her. Once on the highway, she heard the drone of a low-flying airplane, and, curious, she turned her head to look. She had never before seen a plane so close. Without breaking her stride, she watched it drop four bombs before it passed from sight.

From the moment she had left the outbuilding, with her baby clutched to her chest, Auntie Anh had worried about young Danh's progress. While her seven-year-old daughter had run nimbly ahead, it wasn't long before three-year-old Danh's chubby legs began to give out. Auntie Anh was relieved when a soldier running by scooped up the little boy.

The villagers fleeing the outbuilding had thought the violet and mustard smoke markers inside the temple grounds marked the bombing target, and once they were out of the main gate, they thought themselves safe. Soldiers in the command post in the

yellow masonry building knew better what to expect, since it was they who had popped the colored smoke markers to indicate their own position and that of those taking refuge in the out-building. After the first plane dropped its bombs off course, the South Vietnamese commander at the post there got on his radio, trying frantically to stop the second plane's bombing run.

There was a deafening pop. Auntie Anh's baby was thrown from her arms, and she buckled at the knees. Instinctively, she clutched at the back of her left leg. The fingers on that hand instantly fused, from coming into contact with the gob of jellied napalm burning there. The soldier who had picked up Danh took a direct hit of enough napalm that it incinerated him and left the child with devastating burns. Grandmother Tao found the black-ened body that was her grandson and carried him farther. A man named Dao, still dressed in the white worn for Caodai worship, had seen Auntie Anh pitch forward. He came across her baby lying face down on the road, and he screamed out in anger: "They are bombing children and babies!" He found a woman to bring the baby to safety, then went back into the spreading fires and swirling smoke.

Phuc was struck with such force from behind that she fell face first to the ground. Oddly, she felt unafraid, only curious, the same reaction she had had when she'd turned at the drone of the airplane and watched it unload its bombs. She did not wake up to what was happening until fire enveloped her. Fear took over. She would not know that she had got to her feet, had pulled at the neck of her burning clothes—in the way one would in discomfort on a hot day—and that what was left of them fell away. Her first memory of the engulfing fires was the sight of flames licking her left arm, where there was an ugly, brownish-black gob. She tried to brush it off, only to scream out at the pain of the burn that had now spread to the inside of her other hand.

In that instant, Phuc knew she had touched burned flesh. She

had taken a hit of napalm to her left side, on the upper part of her body. It incinerated her ponytail, burned her neck, almost all of her back and her left arm. As if a spirit leaving her body, Phuc saw herself burned and pitied. She saw others looking at her, heard them saying: "Oh, that poor wounded girl, look how ugly she is."

She came back to herself only when she heard the voice of her brother, Tam, cutting through the smoke. She saw him and her younger brother moving ahead of her, and realized she should stay with them, she should keep running. She tried to, but a tremendous fatigue and weariness overtook her, and as an intense heat seemed to eat her from the inside out, she felt desperately thirsty.

Tung and Nu, both surprised to have found themselves among the living, feared for their children ahead. Disoriented in the fire and smoke, they heard Phuc's terrified cries but could not find her. They saw her two brothers, then, finally, saw her stumbling, as if she were about to collapse. Tung was paralyzed by fear. Nu tried to set down her granddaughter, but the hysterical girl clung to her. Nu saw Dao, the figure in white, and screamed out. "My daughter! Help my daughter!" Then, a rising wall of searing heat forced her and Tung back. The last sight Nu had of her children ahead was of her son Tam pulling at Phuc to help keep her on her feet. Phuc's voice kept replaying in Nu's mind: "Oh, Ma, it's too hot, too hot!"

SEVERAL MINUTES HAD PASSED SINCE THE old lady carrying the charred child had emerged, with every camera on hand having recorded the horror on film. Many journalists there had the same thought: a day that had held waning promise of a story had produced a close-up portrait of war. Whatever the military explanation for the mistaken napalm strike, this much they knew: in every war there are "friendly" casualties, one side mistakenly killing their own soldiers or civilians

—most journalists there had been caught in friendly fire. But rarely do casualties come walking into view, while journalists, like an audience, are waiting for something to happen. Some photographers, having used the last frames in their cameras on the old lady and the child, began to rewind their films and reload another. Leicas and Nikons in those days were finicky, and unless rewinding and reloading were done slowly, they could easily jam. Others among the journalists had turned their minds to making haste for Saigon. No one entertained the thought that others might walk out of the inferno.

"... *nong qua, nong qua!*" A child's cry pierced the emptiness.

Of the soldiers and journalists who heard the cry, perhaps only the Vietnamese understood it: "... too hot, too hot!" Among those who went running forward were NBC's Dinh together with his soundman, and Nick. Nick reached for the last of four cameras he had in his bag. Keeping a loaded camera in reserve was a quirk of his; never did he want to have to live with the regret of a great picture, but no film to take it.

A half dozen children came running out. A girl held a small boy by the hand. Another, perhaps four or five years old, ran while turning his head to look behind him. The oldest among them was a boy of about twelve in a white shirt and dark shorts. He cursed coarsely: "*Du me may bay bo-bomb!*" Seeing what he thought to be soldiers, he changed his curses from "Fuck the plane that dropped the bomb to try to kill my sister!" to "*Em tao chay! Cuu em toi voi!*", a plea to "Help my sister!"

A screaming girl came running, naked, her arms held limply outwards.

Christopher Wain, the ITN journalist, put his hand out to bring her to a stop. From behind, the extent of her burn was apparent. Her body radiated heat, and chunks of pink and black flesh were peeling off. Nick came forward, repeating in English her request for water. Someone put a canteen to her lips. Other

soldiers began to empty theirs over her still burning flesh. Nick went to get a poncho to cover the girl's nakedness.

A tall man in white came up to Nick and Dinh. Realizing that they were both journalists and therefore would have transport, the man beseeched them to take his "daughter" to hospital. The nearest one was in Cu Chi, on their way to Saigon.

Nick, shaking violently at what he had witnessed, talked it over with Dinh, deciding who, between them, would take the girl. Each was in a hurry to get back to Saigon. Each had his own deadline. Nick had to worry about the competition from UPI. The NBC crew had to get back so the correspondent could record the voice track for his news story, then take both raw film and the recorded track out to Saigon's Tan Son Nhut airport to meet their regular daily shipment, bound eventually for New York.

It was decided that Nick would take the girl. As he was leading her to the AP van, the man in white brought forward another victim. This woman, unlike the girl, was unable to walk without help. Nick felt torn between trying to do the humane thing, helping the woman and the girl, and trying to be professional about his job and getting back to Saigon as quickly as possible. The hour was getting dangerously late. There would be refugees on the road to slow the van, time lost stopping at the hospital. The later it got, Nick realized, the more he was putting not only his own but the driver's life at risk, should they have the misfortune to be out on the road at nightfall, in the hour of the Viet Cong.

THE CROWD AT THE BRIDGE DISPERSED. THE last villagers emerging from the strike went up the road, while the soldiers tended to their own wounded and the journalists raced to file their stories. One stopped to try to console Shimkin, who was on his knees, weeping. "Leave me alone," he insisted. (One month later, stringing for *Newsweek,* Shimkin would be killed by

a grenade when he and a colleague mistakenly wandered over Communist lines while covering battles from the offensive still going on in the central highlands.)

Off the road in a field, ITN's Christopher Wain was doing a stand-up. Without time himself to comprehend the full tragedy of that afternoon, he closed his piece with: "... One of the biggest-selling souvenirs from Saigon is the engraved Zippo lighter. As one of the engravings says, 'Sorry about that!'"

Among the last correspondents to leave for Saigon was Fox Butterfield. Still reeling at the series of military mistakes he had seen the South Vietnamese air force make in what was an otherwise inconsequential firefight, he wanted to find out how many of their own soldiers they had killed. Once the fires had burned away so that he could get by the bombed-out area, he made his way forward.

A soldier, seeing the foreigner, screamed out "South Vietnamese air force Number 10!" borrowing GI numbered slang, in which, on a scale of one to ten, ten indicates the worst. The temple and the nearby masonry building, along with two armored personnel carriers parked in the field beside it, were covered in the solidifying brownish syrup and grayish-white threads of napalm. Soldiers rushed to tear burned pants and shirts and yank boots off half a dozen or more fallen colleagues. Among the soldiers were civilians, including parents looking for their children. The first army jeeps appeared on the scene to load the military's dead and wounded. The army refused to take civilian casualties. A policeman came by on a jeep, but he too ignored villagers' pleas to take their wounded to hospital. He couldn't, he said, without orders from his superior.

THE DRIVE BACK TO SAIGON ALONG ROUTE 1 with the two burn victims was nerve-racking. Not even the rush

of air through open windows could dissipate the gut-wrenching stench of burned flesh. The driver had to swerve around refugees, making it a bumpy ride. With each scream from the wounded girl, Nick urged the driver to make haste, then turned around to try to reassure her: "We'll be at the hospital very soon."

Some forty-five minutes later, the van pulled up to Bac Ha Hospital in Cu Chi. "Please, help them," said Nick to the surprised nurse as he and the driver left behind the two victims. "Sorry, we cannot stay, we have to leave."

Night was already falling. Windows glowed with lamplight. Fortunately, once past Cu Chi, the refugee traffic disappeared and the van made good time to Saigon. Nick's thoughts turned to his rolls of film. He appealed to Buddha: *Please, let my pictures be in focus, don't let the light metering be over or under.* Since leaving Trang Bang, he had not stopped perspiring. In his head, he heard *napalm, napalm.* His dilated pupils saw everything within a halo of red. To tame his anxiety, he told himself: *If not, I will say to myself, bad luck.*

AN OLDER JAPANESE MAN, A CIGARETTE hanging from his mouth, stood under a street lamp in Saigon. It was the AP's darkroom technician, known as Jackson. He saw the AP van pulling up to the curb and threw his butt to the ground.

"Nicky, what do you have today?"

"My film is very important today."

They went upstairs and the technician disappeared into the darkroom. Nick paced to steady his nerves.

Ten minutes later, Jackson came out with several negative strips to put in the dryer. A couple of minutes later, he took them to the light table.

Nick joined him there. He breathed easier. "I have very good pictures of napalm today."

"Where?"

The technician moved a magnifying glass over the strips.

"Oh my god . . . " He looked up in horror. "Nicky, what happened?"

THE DEADLINE THE TECHNICIANS WORKED to was the hour booked each evening with Radio Saigon, when the bureau would relay its pictures by radio wave to the AP bureau in Tokyo. From Tokyo, they were sent by satellite to New York. Pictures sent from Saigon in the early evening made the next day's papers in America. The day's work was not done until Tokyo sent confirmation that the pictures had been received. On a clear night without interference, a single picture could be transmitted in as little as eleven or twelve minutes. Often, it took longer, or had to be resent.

Because things didn't get busy until late, everyone would take a late, long lunch. Most went home over the lunch hour, sometimes for a siesta. By the time Nick came back from Trang Bang, only Jackson was in. That day, Faas had gone to lunch with reporter Peter Arnett, another veteran Vietnam correspondent and Pulitzer prize–winner for his work there, whom the AP's head office had also sent in to bolster coverage of the Easter Offensive. The two were at their old haunt, the restaurant at the Hotel Royale, which served Corsican fare. In the early days of the war, the two would meet there with sensitive sources in the American military at a table concealed behind Chinese screens.

Nominally, the picture editor on duty that day was Carl Robinson. However, he conceded authority to Faas. Head office had been less than happy with the recent output of the Saigon bureau, which was why Faas had been sent in. Some of the unspoken blame had to fall on Robinson and his inexperience. Besides, Robinson, a Saigon-hire, owed his job to Faas. The son of a

Methodist minister, Robinson had come to Vietnam at twenty to be a community development officer for the American aid agency USAID. Full of youthful enthusiasm when he started, five years later, discouraged by the debacle of the Tet Offensive, he quit. He met Faas in a bar in Saigon and confided his disillusionment with American policy towards Vietnam. He had no desire to return to live in the United States, and he was engaged to a Vietnamese woman whose family was in Saigon. Faas hired him on the spot.

Robinson arrived back from lunch to find Jackson had started editing the day's pictures. To save time, editing was done from negatives rather than contact sheets. The editor identified his initial choices by hole-punching those frames at the edges. That way, even in the darkroom the technician could feel which frames were to be developed. These would then be developed into 5 x 7 prints, from which the final selection would be done.

Either Robinson or Jackson pointed out to the other the notable frame of the girl, running naked into the camera's eye. Jackson remarked that certainly no newspaper in Japan would run it. The two didn't have to discuss whether or not it was a usable picture; the AP's policy was clear: no frontal nudity.

Together they examined the prints. Robinson was impressed by the sequence of shots: from the plane that delivered the napalm to the explosion and the villagers emerging in the aftermath. He and Jackson agreed on two or three that should go out.

Faas, back from lunch, started the re-edit—a routine AP procedure. Robinson and Jackson stood beside him at the light table. One of them pointed to the frame on one of the negatives strips of the naked girl. Because it had not been punched, there was no print. "There's this one," one of them said, "but we can't use it."

Faas examined the frame. "Damn!" he exclaimed. He himself printed the negative. Carefully, he maneuvered a piece of paper between the enlarger and the photographic paper, in order to even out the high contrasts created by the glaring subtropical light.

The mood in the office, transformed by the unspoken tension of going against the rules, was no longer routine. Once the print was done, the job of composing the caption was Robinson's. He began typing: "South Vietnamese forces follow terrified children fleeing down Route 1, near Trang Bang, South Vietnam, June 8, after a misplaced napalm strike. Girl at center had ripped off her burning clothes. She suffered back burns. The firebomb was dropped by a South Vietnamese Skyraider plane." Done, he pulled the glue-backed paper out of the typewriter, trimmed it, licked the back and affixed it to the bottom of the print.

Someone in the office remarked that the shadows on the girl's body gave the appearance of pubic hair where there was none. Faas called over a technician, telling him to bring his paintbox of white and grays. The technician set to work, and when he was done, there were compliments on his artistry and guffaws all around. A messenger left with the picture for Saigon Radio.

As happened every early evening, correspondents from other news organizations dropped into the AP office. Fox Butterfield came in to see what pictures the AP had transmitted that would go with his story, focusing on the military effect of the mistake on the South Vietnamese soldiers' zeal to fight. Only the day before, South Vietnamese planes had mistakenly bombed their own paratroopers in My Chanh, north of Hue, killing nine and wounding twenty-one. Butterfield was pleased that the AP had sent out a picture of the napalm exploding on the highway. He saw that it had also sent out one of the girl, but saw no need to revise his story to include mention of her.

Life photographer David Burnett also came by. He had an arrangement with the AP to "soup" his film, meaning that the technician there would develop it into strips of negatives that he himself could then edit from. Burnett saw the shot of the girl. "Sure beats the shit out of anything I got," he said. Burnett had been reloading his camera when the last group of children had

run out. He would always remember Faas's compliment to Nick in response: "You did good work today, Ut."

That evening Faas waited around. He had been prepared to "raise hell" if the desk in New York killed the picture. He didn't have to.

THE NIGHT OF JUNE 8 FELL MOURNFULLY IN Trang Bang. The South Vietnamese command maintained its soldiers in their positions and told villagers to take to a nearby field.

When the last fires from the napalm had died away, Tung and Nu had been able to account for all their children but Phuc. Dao, the neighbor in white, told them what had happened, that the journalists were going to drop her and Auntie Anh at the hospital in Cu Chi, on their way to Saigon.

In the muddy field, the living and the dead of the family awaited the morning's light. Danh's body was rolled in a bamboo mat, for burial in the morning. He had died within an hour of the attack. Auntie Anh's baby cried fitfully; he would die of his injuries six weeks later.

No one else suffered burns except for Tam, and his were superficial. Napalm had stuck on his clothes and he was only indirectly burned. His wounds would heal within a month.

The deaths of Auntie Anh's two children were the only known civilian deaths in the napalm attack. Years later, press reports would repeatedly make the mistake of stating that Phuc had lost two brothers in that strike.

As the night wore on, Nu became convinced that Phuc's body lay in a morgue somewhere. Tung repeated the peasants' saying: "The bullet can avoid you, but you cannot avoid the bullet." However, he tried to console his weeping wife by citing fate's benevolence: "If it had been any other bomb than a firebomb," he said, "we would all be dead now." The couple waited

for the next day to come, when they could go look for Phuc, and either visit her in hospital or, as Nu believed, bring her body home for burial.

ON JUNE 9, THE AP'S PHOTOGRAPH OF THE girl fleeing a napalm strike in South Vietnam was picked up by editors of newspapers around the world and printed on their front pages. The photograph, showing the girl running directly into the camera, would be the sole image from that angle. NBC and ITN footage that aired on their television news broadcasts showed her running past from a side angle only. NBC's cameraman and correspondent both believed that they had that frontal shot, but that the editor in Hong Kong—where the raw film was sent to be edited into a news story before being shipped to New York—had rejected those frames because of their frontal nudity. As was the practice in those days, the unused rushes were discarded rather than archived.

Several in the Saigon press corps congratulated Nick on his picture and predicted fame. They would prove right: the picture would win every major international photographic prize for that year, including the Pulitzer. Nick replied modestly to his colleagues' predictions: "I care only about doing my job and supporting my mother."

THE MORNING OF JUNE 9 UNFOLDED IN TRANG Bang with an air of resignation. Soldiers opened a detour around the burned-out highway. They began clearing the marketplace of debris from buildings that had been damaged by mortar fire. The roof of the nearby high school had been destroyed. Of Trang Bang's homes, as many as one in three was badly damaged, mostly near the temple.

Tung and Nu made their way past the scarred temple, with its singed and pockmarked walls draped in solidified napalm. The footpath was still wet in places with water that had spilled from severed plants and was littered with tailings of mortars. The bombing had exposed a network of tunnels dug by the Viet Cong.

Virtually every house had sustained some damage. Some, like Grandfather Kiem's and Auntie Anh's, were neither extensively damaged nor beyond repair. Further down the path, where there had once stood a mud-and-thatch house immediately in front of Tung and Nu's, there was now only a large crater. For years after, every rainy season, that crater would fill with water deep enough to drown in.

Tung and Nu saw that their own house, though badly damaged, still stood. The closer they came, the stronger was the stench of death that emanated from the landscape of broken masonry and tiles, severed trees and blasted earth. Nu had to hold her shawl over her nose. They went no farther than the gate. The only sound was the buzzing of flies. Nu noticed the rotting carcasses of her two swans in front of the veranda and thought how she would miss their loud shrieks, and the way they would nip at approaching strangers.

She and Tung set out on their mission to find Phuc. They joined streams of foot-weary refugees on the highway. When they reached Cu Chi, several hours later, they got nowhere at the hospital there. The staff insisted that they had not admitted either a child or a woman burned by napalm answering to the descriptions of their daughter and Auntie Anh, and would not have because their hospital had neither the facilities nor the staff to handle such burn victims. They advised the parents to try Saigon's largest hospital, the Cho Ray.

By then, day had surrendered to night and to the Viet Cong. Tung and Nu spent the night on a stranger's veranda in Cu Chi.

ON THE AFTERNOON OF JUNE 9, A MOTHER arrived at Saigon's First Children's Hospital for her daily vigil at her son's deathbed. Badly burned from firecrackers he'd found left over from Tet celebrations, he lay unconscious in an out-building there. The mother saw that he had company: a girl, also badly burned.

The small room was stifling, though the louvered shutters on the windows were open. The woman moved from one cot to the other, fanning each child in turn, shooing the flies from their faces.

The girl drifted in and out of consciousness.

"Danh!" she would cry out. "Danh, wait for me! I'll go with you!"

That evening, the woman took an offering of fruit to her pagoda and prayed to Buddha that the family of the girl would come to see their dying child on her way.

ON JUNE 10, TUNG AND NU CONTINUED ON foot to Saigon. At the Cho Ray Hospital they drew another blank and were told to try Saigon's First Children's Hospital. By then, it was dark. The couple spent a second night outdoors, this time on a stone bench. On June 11 they walked across town to their third hospital in as many days, and were met with the same denials that their daughter had been admitted. It was rare that newly burned victims of war turned up in Saigon; usually they died before even reaching the hospital nearest them.

Before they could admit defeat and begin a search of the city's morgues, Tung and Nu decided they had to conduct a search of this last hospital themselves. The eight-story building had several wings. Floor by floor, corridor by corridor and room by room, they sorted patients from crowds of relatives bathing them, changing dressings, feeding them. In desperation they lifted cast-aside bedding and looked under piles of shoes outside

each room, as if their daughter, untended, might have been pushed aside there. After several hours, they found themselves back on the ground floor.

They sat, exhausted and spent.

A cleaner came by. He set down his pail of water and began crisscrossing the floor with his mop, working his way from one side of the large reception area to the other. When he was done, he began mopping a corridor.

Tung approached the cleaner. "Excuse me, did you see a young girl brought here who was burned very badly? It would have been three days ago . . . Maybe she did not survive?"

The cleaner stood his mop in his pail and beckoned Tung and Nu to follow him to an outer corridor. Outside, he pointed to a small outbuilding with large shuttered windows and clapboard walls, peeling and bleached by the sun. "That room," he said, "is for children who will die."

TWO DAYS AFTER THE ATTACK, THE AP'S PETER Arnett, together with Nick Ut, went to Trang Bang to do a follow-up story. The story he would file would speculate on the military implications of the clash with the Communists there.

It was the picture editor, Carl Robinson, who asked for the assignment to track the girl down. He longed to get out of the picture side and write stories that he saw as being overlooked in the preoccupation with the war's military equation. His item on the wire on June 10 identified the girl as nine-year-old Phan Thi Kim Phuc, recovering at Saigon's First Children's Hospital.

That same day, two foreign reporters joined forces to track her down: Christopher Wain from ITN and Michael Blakey, a television reporter from the British Broadcasting Corporation (BBC). Both were on temporary assignment in Vietnam to cover the Easter Offensive.

With the help of the British embassy, they traced her the next day to First Children's Hospital and to the outbuilding there. Like the boy in the cot next to hers in the small room, she looked to be either unconscious or heavily sedated. A woman sat fanning her.

The reporters went straightaway to find a nurse. They demanded to know: "What's going to happen to that girl in there?"

"Oh, she die, maybe tomorrow, maybe next day."

Several telephone calls later, the two learned of a privately run American clinic that was located on the grounds of the Cho Ray Hospital, called the Barsky unit. They rang up the American embassy. An official there said the embassy had no objection to the girl being transferred, provided that the South Vietnamese foreign ministry agreed.

The official at the foreign ministry equivocated. "If this were to go ahead," he told the two journalists, "it would put the government of South Vietnam in a bad light."

Wain was incredulous. "The entire world has just seen the South Vietnamese air force bombing the hell out of their own people, and this would make it worse for you?!"

He waited, and no answer came. "So, your final word is no?" He whipped out a Bowie knife, a souvenir of Vietnamese weaponry. "Here! Why don't you do her a kindness, go round to your hospital and cut her throat now!"

After a long silence, the official conceded, saying quietly, "Okay." A couple of days later, the reporters would be at the Barsky, requesting permission to film the girl there.

AT THE BIEN HOA AIR BASE, FIFTEEN MILES north of Saigon, Captain John Plummer stopped on his way into the mess hall to pick up that day's *Stars and Stripes*, the

military newspaper for American servicemen abroad. He wanted to check on baseball scores back home.

Three months earlier, the army had cut short Plummer's home leave in Alabama. The Easter Offensive was breaking, and Plummer, on his second one-year tour of duty, was needed in Bien Hoa. His job there was to coordinate air support under joint American and South Vietnamese military command, for the military region that extended from the bottom of the Mekong Delta to provinces on the western and northern flank of Saigon and to the Cambodian border. Plummer's main task was to set up an order for the next twenty-four-hour period of B-52 strikes reserved for his area. Working from relayed information, he would determine the rough target area of ten to twelve strikes, amounting to half the daily total of the counter offensive, by locating one-mile by one-half mile "destroy boxes" on a map. Up to five hours before the scheduled strike, he would be instructed to realign the strikes from the rough target area onto priority targets. He also coordinated on a daily basis an average of 130 American air force strikes and 60 South Vietnamese air force strikes. While most were pre-planned, a few came in as "Tac-E" calls. These were calls from ground troops asking for tactical emergency air support, or, in other words, low-level air strikes. Typically, the troops had either come into sudden direct contact with the enemy or were at risk of being surrounded or overwhelmed. Planes suitable for such strikes were on standby at Bien Hoa.

Since he'd come back, Plummer had worked eighteen- to twenty-hour days. Often, with no time to return to his barracks, six miles away, he'd had to sleep in the bunker at the air base. However, he preferred to get back to his barracks. There he could knock back bourbon, which was cheap. He could drink a lot without getting drunk, and still be able to make the excuse that he'd been drinking and ought to wait longer between shifts. Each

shift ended with Plummer collapsing into his bunk and mentally signing off: "Another day of killing Cong."

Plummer now sat down with his meal tray and opened the newspaper. "*A Misplaced Bomb . . . And a Breath of Hell*" and "*Why Trang Bang? It Was in the Way!*" were the headlines over a story by the AP's Peter Arnett. Underneath were three pictures: a bomb exploding across a road; a girl, running naked, in terror; and children, the girl among them, getting help from soldiers.

Plummer choked on his coffee. He swore aloud: "That lyin' son of a bitch! He told me a cotton-pickin' lie!"

The "Tac-E" Plummer had handled from Trang Bang had been a routine call. He clearly remembered the voice of the adviser as it had come over the radio: "We're at a standstill against an enemy force in Trang Bang."

"What is the nature of your target?"

According to the adviser, the enemy was dug into a trench line at the edge of town. Plummer then acted as a go-between for the adviser and the air force command and coordinated the dispatch of aircraft from Bien Hoa. Within minutes, South Vietnamese air force planes loaded with high-explosive bombs and napalm were on their way to Trang Bang.

The rest of the call was just as routine, as Plummer remembered it. "What's your friendly situation?" he'd asked.

He knew it could be confusing. On his first tour of duty as mission commander, his unit returned what they thought to be enemy fire in the aftermath of an air strike called in by the American adviser with a South Vietnamese unit, only to hear the adviser scream on the radio: "Stop! You're shooting us!" Plummer's unit wounded twenty of the adviser's men.

The adviser replied that the "friendlies" had been evacuated. Plummer asked for confirmation; that was his practice whenever the person on the ground had not asked him to allocate an

observation plane or forward aircraft to mark the enemy's position and, therefore, the target. "Not a problem," confirmed the adviser.

Plummer recalled that the adviser came back on the radio several minutes later to say thank you. "The bombs were right on target—appreciate that a whole lot. We'll be moving in now."

Another soldier joined Plummer at his table in the mess hall. Plummer showed him the newspaper. "I put in that strike," he said, pointing to the headlines and the pictures.

"Bummer, man," the soldier said, shaking his head. "Bummer."

TUNG AND NU BRACED THEMSELVES FOR what they would find behind the door of the outbuilding. Their daughter lay on a cot in the fetal position. A gray-brown gob matted her burnt hair, her face was badly swollen, and the bandages on her wounds were fetid with infection and stuck with charred and dead skin. On the next cot was a boy, his burn wounds alive with maggots.

Nu went to their daughter, took her in her lap and rocked her, silently weeping a mother's tears.

After what seemed like a long time, the woman sitting on the end of the next cot spoke. "Who is Danh?"

Nu looked surprised. "Oh, he died one hour after he was wounded."

Through a haze, Phuc formed a single thought when she heard of her cousin's fate: ". . . to die is better."

Both Tung and Nu, upon hearing the feeble noise that came from their daughter, realized that she was conscious, that she had recognized her mother's voice.

They immediately went in search of the only doctor they'd come across in their earlier search of the hospital. They clung to his jacket—the last act of desperate parents. A glint of recognition

passed between the two men, and later they would recall being pre-university students together in Saigon.

Tung pleaded: "Please, our daughter has been left to die." Twenty minutes later, there was an ambulance at the door.

PUBLIC BUILDINGS IN SAIGON WERE DESIGNED to cope with the city's oppressive heat: corridors and stairwells are exposed to the outside; windows are large, with louvered shutters. Among the buildings of the Cho Ray was a modest, two-story building. Built with American materials to American specifications, it was sealed to accommodate central air conditioning, and windowless on its ground floor to guard against terrorists' grenades.

A picture of an eternal flame identified "Children's Medical Relief International," the New York–based foundation to help child victims of war in Vietnam. The foundation was the creation of Dr. Arthur Barsky, a pioneering American plastic surgeon, and a young lawyer named Thomas Miller. In 1968, it opened the 54-bed National Center for Plastic and Reconstructive Surgery in Saigon, better known as the Barsky unit, and across town a 120-bed Reception Convalescent Center, where patients went before and after surgery. Patients paid nothing; operating funds came from the American and South Vietnamese governments.

Dr. Barsky had first come to public prominence in 1958 when he brought to a New York hospital for surgery seventy-five disfigured victims of the atomic bomb dropped on Hiroshima. That project convinced him that it was better to bring services to the victims, and to recruit top-notch doctors and nurses from abroad to do tours of duty. South Vietnam had few modern medical facilities and a serious shortage of public doctors and nurses, made worse by low fixed government salaries and wartime inflation. (Medical staff would spend only as much time at the

hospital as was necessary to collect their pay, leaving them more time free to earn quick money in other ways, such as buying and selling untaxed tobacco.) In 1972, Vietnam had one government-paid doctor per forty thousand people; by comparison, the figure for the United States was one per six hundred. The country had almost no specialists. In 1972, there was one fully trained Vietnamese anesthesiologist for the civilian population in the south. Certainly only the wealthy could afford plastic surgery, which they paid for privately, often out of the country.

The Barsky's admissions policy was to *select* candidates for one-time plastic surgery; follow-up surgery was beyond its resources. It maintained a waiting list of 370. One day a week, doctors from the Barsky conducted ten rotating clinics—one in Saigon, nine in provinces where the impact of war was harshest. From the start, it was difficult to draw the line. Who was more legitimately a victim of war: The child who took a high-velocity missile in the face or the one who stepped on a homemade booby trap? The child with a congenital deformity from malnutrition in a country bombed and sprayed with defoliants or the child burned in an explosion of a kerosene cooker fueled by pilfered American jet fuel? Without surgery, each would have his lifetime cut short.

On the afternoon of June 11, the head nurse on duty was a pretty woman named Lien Huong. When the ambulance arrived carrying a seriously burned girl accompanied by her parents, she called for the hospital administrator, Joyce Horn, an American. Her first inclination was to send the ambulance to another Saigon hospital. It was only the second time in the Barsky's history that one had shown up unannounced. The first time, the Barsky had sent the ambulance away but, in a show of compassion, had sent a nurse over daily to help in the child's care. Horn saw that this victim was a "fresh burn"—a burn less than seventy-two hours old. Odds were such a burn victim would die anyway, and were

the Barsky to admit her, Horn knew that, because of the intensive nursing care necessary, the Barsky would be able to accept fewer other patients, its resources stretched to the utmost.

Nurse Huong became hysterical at the prospect of turning the girl away. "Don't send her away!" she pleaded to Horn. "If we do that, the girl will die!" There wasn't a hospital in the entire country, the Barsky included, that had a sterile, equipped burn unit to handle such casualties. Hospitals in Vietnam treated burn victims who had already *survived* their fresh burns.

The nurse ran to find the doctor on duty. That afternoon, it was Dr. My, one of five Vietnamese doctors to work at the Barsky. Perhaps especially because she was in a profession dominated by men, Dr. My took pride in quietly adhering to rules and procedures and avoiding anything that would "make noise," the Vietnamese term for making trouble.

Dr. My went to investigate. The girl on the makeshift stretcher was crying. "She's suffering!" Dr. My gasped. Given the pain and shock of her burn, she could barely believe the girl was conscious. "We will try to help your daughter," she told the distraught parents.

God love Dr. My for doing this, the hospital administrator said to herself as she had the girl taken into one of the unit's two operating theaters, the only sterile rooms in the building.

As America's war effort in Vietnam waned, the horrors of the war receded from the public's mind. Government funding for social and health projects in Vietnam dried up. In late 1971, the government had begun a two-year phase-out of all such funding. In raising money to keep the Barsky going, the foundation had to stress its apolitical philosophy. And the unit worked hard to emphasize its medical mission, to keep the children above politics and politics out of its

daily affairs. Its administrator stood firm against allowing Central Intelligence Agency operatives to interrogate children there. As one doctor said a decade later, "We knew damned well we were taking care of kids of the Viet Cong, but it never occurred to anyone to say, 'You can't come here because you're from the other side.'"

The Barsky's parent foundation in New York eventually bowed to the necessity of putting a human face on suffering to help sell its cause. In early 1972, it authorized a television crew to shoot a documentary at the Barsky. *The Gooks*, by Pierre Gaisseau, co-produced by the foundation and the Canadian Broadcasting Corporation, graphically portrayed several victims: a seven-year-old blinded by rocket fragments; orphan brothers aged three and four, one with gangrene of the face, the other with an empty eye socket and one cheek gone so that the tongue and back of the throat were visible; a seven-month-old baby's burned hands blobs of scar tissue; an eight-year-old paralyzed by a machine-gun bullet.

On June 15, 1972, four days after Kim Phuc was admitted to the Barsky, the foundation publicly endorsed a statement by a Democratic senator, William Proxmire, chairman of the Senate Appropriations Subcommittee on Foreign Operations. The senator announced his support for an appropriation of $550,000 to build a second Barsky hospital in Vietnam, in addition to the $160,000 already budgeted that year for operating funds for the existing one. The senator's statement read, in part:

> Last week on the front of nearly every newspaper I saw there was one of the most heartbreaking photographs to come out of Vietnam. A little girl who had ripped off her clothing that had been set afire by napalm ran in pain and terror along with other children. Her arms were swung out to relieve the pain of

her burned flesh. The little girl in the picture was sent to the Center for Plastic and Reconstructive Surgery. Her name, it was reported, is Phan Thi Kim Phuc. She is 9 years old. Her brother burned by the same bombing, died [*sic*]. Doctors at the Center predict that Kim Phuc will recover from her burns . . .

. . . Little Kim was not burned and her brother was not killed by American planes. South Vietnamese bomber pilots misplaced the napalm drops in trying to rout out North Vietnamese troops entrenched around her hometown of Trang Danh [*sic*] near Saigon. . . . So how much is $715,000? It's about 28 loads of 500-pound bombs for a B-52. It's less than one tenth the original cost of a B-52 . . .

. . . Unfortunately, there are more than just one Kim Phuc. . . . This is one Senator who feels that the costs of a fraction of one bomber, a few bombs is little enough for American taxpayers to bear to help these innocent children. An addition of $715,000 will be more than offset by the cuts to be made in military assistance."

The appropriation bill went nowhere.

In the opinion of Western doctors who had worked in war-torn South Vietnam when the Barsky unit first opened, the child victims of war there in need of reconstructive surgery numbered at least 100,000. In the six years that the Barsky unit operated, until it closed upon the surrender of the south in 1975, it would treat an average of 1,200 children annually, the average age of whom was eight. One would become famous.

CHAPTER FIVE

Napalm, first used in flame-throwers during the Second World War, is a highly lethal weapon when dropped from an airplane. The bomb explodes and fragments, and the burning jellied napalm (the name comes from its combination of naphthenic and palmitic acids) sticks to whatever it lands on. Its burns at 800 to 1,200 degrees Celsius (by comparison, water boils at 100 degrees Celsius) and for a long time. A big enough mass of burning napalm will consume the full thickness of skin; gone instantly are hair follicles, sweat glands and sensory nerve endings. In such a third-degree burn, the burned area appears red, mushy and oozing. If the napalm continues to burn downwards, feeding on fat, muscle and other deep tissue, the injury has the severity of a fourth- or fifth-degree charring.

Napalm wounds were to the Vietnam war what bayonet wounds had been to the First World War. Doctors did not expect to be called upon to treat the victims of a napalm burn, as they were more likely to die than need medical aid. The chances of

surviving a burn from any cause depend on how much of the body surface is burned; more than 10 to 15 percent constitutes a major burn and wreaks havoc with all organs and body functions. Those victims taking a direct hit of a mass of napalm will suffer burns to at least 25 percent of their bodies. One-third of them will die within a half hour of their burns or of asphyxiation. Many have spread the napalm themselves in trying to remove it from their skin or clothes, or in stripping off burned clothes.

Phuc sustained burns to the severity of third degree or worse to 30 to 35 percent of her body surface. Those burned areas included almost her entire back, reaching around on her left side to her chest, the back of her neck and into her hairline, and her entire left arm. Lesser burns resulted from burning napalm that splashed from her clothes onto her right arm, buttocks and stomach. The inside of her right hand was also burned from where it touched napalm on her other arm, and she had singeing to her left cheek and both ears. Life or death for such major burn victims depends on making it within twenty-four hours, seventy-two at the most, to not just any hospital but one with the facilities and staff to stabilize the fresh burn victim.

IN THE OPERATING THEATER AT THE BARSKY, Dr. My's first life-saving imperative was to give Phuc some pain relief. Shock is the greatest danger to a burn victim, and pain alone can cause it. Even the smallest napalm burn is intensely painful. Equally urgent was to find a vein to transfuse blood and other fluids, which has to be done continuously for at least a week. The loss of bodily fluids, not only blood and plasma but body proteins (which leak out where there is no skin to contain them), can also produce shock and, as well, organ failure.

The doctor used Nu's blood, finding it a match. Her parents' murmurs of thanks to Caodai when the blood began to flow into

her was one of Phuc's last memories before losing consciousness. Tung stayed behind for another night, and only Nu went on her way. Before she left, a nurse insisted that she take some nourishment to compensate for having donated blood. She was offered a meal—a steak if she wanted it. Finally, but reluctantly, she accepted a glass of milk, though it too was food she was unaccustomed to. Later that evening, she alighted from the bus in front of the Caodai temple in Trang Bang, took a few steps down the footpath and fainted from exhaustion.

THE NEXT DAY, TUNG RETURNED TO TRANG Bang to help Nu with the grim task of cleaning up their house and land. They found three Viet Cong dead: one in a tunnel opening in the garden; two in the house, one of them in his machine-gun nest, the leader having chained him at the ankle there to ensure that he fought to his death. Tung and Nu waited until night to drag the bodies, one at a time, to a vacant corner of Grandfather Kiem's land and bury them there. While the departing Viet Cong had not taken these fallen comrades, they had tried to carry away Nu's treadle sewing machine, which would have been invaluable in the deprivation of the jungle. It must have proved too heavy; Nu found it nearby, at the edge of the property.

The job of removing the putrid and rotting animal carcasses was one that could be done by daylight. It took three men, Tung and two others he hired, to load each pig carcass into a burlap sack that normally held one hundred kilograms of rice, and then drag it away to be buried. Not all the pigs could be accounted for; some, like many of the chickens and ducks, had escaped from the garden during the fighting. Others in the town who chanced upon them captured them and slaughtered them for meat. Nu had found a few pigs alive, badly dehydrated and near death.

After a last salute to her "war veterans," she put them out of their misery. So haunted was she by how the animals had suffered that she vowed never again to raise pigs for slaughter. The pens would sit empty and unrepaired for as long as she and Tung owned the house and land.

Clearing the garden of mortar tailings, bomb fragments and shrapnel proved tedious and dangerous. Every fruit tree was damaged in some way: singed, splintered, pitted with shrapnel or severed at the base. Tung and Nu feared unseen risks, especially buried and unexploded bombs and grenades. Nu was unable to find anyone in town willing to take on the job. She finally asked someone whom the town regarded as a "half-wit." He spent several days at it without incident. Concerned about chemical contamination of the soil, Tung and Nu condemned the vegetable garden and orchard to wasteland. The garden would self-seed; Nu later harvested the tops of greens, but dared not touch root vegetables. Many of the fruit trees proved resilient; within a year shoots sprouted from severed trunks. Some would produce flowers and—long after the family moved from the house—bear fruit as they once had.

Nu and Tung scrubbed the walls and floors of the house of spattered human blood and guts. They cleared the *ham*, still damp and musty with blood, of old bandages and dressings. They saved canned goods from America that the Viet Cong had left, originally probably pilfered or privately traded to the Communists by corrupt South Vietnamese. They carted out a bed and some armoires damaged beyond repair. The family told neighbors to help themselves to broken furniture as fuel for their hearths. Months later, Great Uncle was still picking up slivers of shrapnel in the house, and tending to the cuts they inflicted on the children.

The outside of the house was a sorry sight, with gaping holes in the roof and empty doorways. Few doors had survived their

use as tunnel coverings. Machine-gun fire had pierced walls. In the following weeks, officials from the provincial office of Hau Nghia came to Trang Bang to assess war damage to property and pay compensation. Under this program, begun by the Americans and ceasing with their departure, homeowners could receive maximum damages equivalent to about forty dollars American. Tung received ninety sheets of sheet metal, each measuring three feet by six feet, and three weeks' supply of rice for his household—all in all, a fraction of what he would spend repairing the house and of losses suffered.

AT THE END OF A WEEK'S CLEANUP, TUNG and Nu returned to see Phuc. However, Nu found she could hardly bear to stand at the door of her daughter's room for the stench of dead and rotted flesh.

The parents found a foreigner anxiously awaiting them. From what they understood, he represented a humanitarian aid agency that wanted to evacuate their daughter from South Vietnam to West Germany for treatment there. Neither Tung nor Nu realized that hospital care at the Barsky was possibly the best available in Vietnam, or that the nurses would work to save their daughter's life. (Had this been a regular hospital, a patient's relatives would have provided the nursing and stayed on hand to pay for medicines and, if necessary, bribes. They knew only that so far they had been asked to pay nothing, not even for the ambulance.)

Tung and Nu had both been fixated on the idea that their daughter was going to die. Since the napalm attack, their only appeals had been to the benevolence of Caodai. Tung had turned to the official prayer book for "Crisis Rites" covering accidents, sickness and death. Nu's reaction to the foreigner's offer was that if they wanted their daughter to live, they should take it up. She left immediately for Trang Bang to retrieve the necessary

documents, but she returned to find Tung adamantly opposed. "I cannot visit Phuc's tomb if it is so far away," he said.

Tung stayed behind in Saigon in a deathwatch at his daughter's side. His bed was a bench on the hospital grounds, which he staked by hanging a washcloth and clothes on a nearby tree. Nu visited only on those Saturdays when Loan could relieve her at the noodle shop. More often than not, she sent another member of the family, or she found someone else in the town already going to Saigon to bring Tung a basket of cooked food and a packet of money for the week.

Phuc remained in critical condition for thirty to forty days. More than 80 percent of severely burned patients succumb to infection or other complications before that. For weeks, the main concerns were to keep up her strength as her body battled progressive malnutrition (brought on by the leakage of body proteins) and to rid her body of the toxic poisons of infection from charred tissue circulating in her body. Infection is an ever-present threat, and where it cannot be checked, amputation is the only option.

The daily cleansing of a burn patient inflicts pain that defies description. One of the Barsky's surgeons, American Dr. Mark Gorney, described the physical pain of the daily procedure as the most intense known to human beings. In his words, it inflicts a "wound to the soul" and is akin to being "flayed alive."

Tung forced himself to watch, finding each time harder than the last. At eight o'clock each morning, the doctor on rounds would examine Phuc. Then the nurses would come for her, to take her to a special burn-case bathtub. The tub—normally used at the Barsky to soften and slough off skin grafts that did not take and had to be redone—was filled with a surgical soap solution and warm water. The nurses undid Phuc's old dressings, then took a hand-held showerhead to chip away at dead and infected skin and tissue, using scissors if necessary, all the while trying to

ignore the inhuman screams escaping from Phuc. Removing dead tissue is necessary to ward off infection and to allow new tissue to regenerate. Finally, they applied a fresh topical antibiotic preparation and new dressings.

When Loan visited, she fainted at her sister's screams. Only the first time Phuc was immersed in the burn-case bathtub, when the three-day-old dressings had to be removed, was anesthetic used. Its repeated use, day after day, is not possible. Other painkillers, such as Demerol, eventually lose their effectiveness; the pain and terror have to be endured. A nurse gave Tung a stern warning: "We haven't got nurses enough to care for visitors, too!"

Years later, when the Vietnamese nurses would remember Phuc, they would call up the image of her father, parked in a chair by her bedside. Most patients at the Barsky were from the provinces, their families far away. Often one or both parents had died or been killed by war, and they were cared for by older siblings. In their entire stay at the Barsky, many patients did not have a single visitor. However, day in and day out, Tung sat beside Phuc's bed, focused on listening to her breathing. If it sounded faint, he stood up to check to see if she was still alive. The occasional moan from her would send him into a panic, worried that he had drifted off. He stayed after normal visiting hours, waiting until the nurses were about to turn off the lights in the ward. If they were hovering, Tung left. None of the nurses was aware that he retreated only to a bench outside in the night air. But if the nurses were occupied elsewhere, he hid himself under Phuc's bed. He explained to Nu: "If she dies in the night, I'll be there to take her home to be buried."

One day, in the third month of Tung's bedside vigil, he was standing there looking at his daughter when he saw what he was certain was a deliberate effort on her part to open her eyes.

He leaned forward. "Phuc," he whispered, "do you know your father?"

There was no reply. He asked again.

"Know."

It was just one word, but the next morning, Tung took a bus to Trang Bang. He went directly to the noodle shop: "Phuc has come back to herself!" he told Nu. She wept to hear that their daughter's spirit had chosen to stay with her body. Yet, Nu felt torn. After believing for weeks that her daughter was going to die, she wondered what kind of life she would have. Nu voiced aloud her prayer to Caodai: "If Phuc is going to be ugly and deformed, better that she dies than lives. If she lives but is not normal, then let God take her."

It would be a couple of days before Phuc could manage more than one word—at first little more than a feeble "Drink," to which Tung would respond by spooning water into her mouth. Finally, Tung spoke the words that he'd been saving for weeks: "Phuc, you have life, first, because you received your mother's blood; and second, because your mother and I prayed to Caodai."

"*Phat Mau*," Phuc replied, naming the Holy Mother of the religion. In 1969, Caodaists in Trang Bang had built a "mother" temple to worship her. This modest temple was located down the road from the food and drink shops on Route 19 towards Cambodia. Phuc's parents took these first words from their young daughter after weeks of hovering between life and death as a sign that she saw the shining path of Caodai even more clearly than they.

IN THE THREE MONTHS SINCE THE ATTACK on Trang Bang, Nick Ut had spent much of his time covering the waning Easter Offensive. The Communists had held areas of the central highlands into midsummer, and of the northernmost provinces into the fall. One day, along with picture editor Carl Robinson, he took a trip up Route 1 and pulled off at the Caodai temple outside Trang Bang. Supposing them to be journalists, an

inevitable crowd gathered. The adults pestered them for news of the fighting, and the children for a bonbon, gum or a pen with colored ink. Nick asked for directions to the home of Kim Phuc's father. He presented Tung with an 8 x 10 photograph of his daughter running from the napalm attack.

Nick said what he'd come to say: "My picture made me famous. I wanted to say thank you."

Tung, who'd been shown the picture by foreign journalists visiting the Barsky, showed it to Nu. Nu cried until she thought she would go blind. They put it away in a drawer of an armoire. Tung would find he could go ten days, maybe fifteen, before he was drawn back to the image. Less often, Nu felt the same need to gaze upon it. When she did, she would ask her husband to retrieve it, so that he might sit beside her as her tears flowed.

Their wounded daughter, the picture, and the ideals and rituals of Caodai swirled together, lending singular meaning to Tung and Nu's earthly existence. Up until the napalm attack, the family had been strong but not devout Caodaists. They were Caodaist by family tradition, having inherited their religion from their own parents. Above their ancestral altar, they had framed a picture of the deities worshipped by Caodai. They obeyed the minimum religious requirement, prostrating themselves to Caodai at one of the four ritual times each day. Tung, joined by his son Ngoc and Great Uncle, all in their religious whites, would gather at the family's altar. It was part ritual, part entertainment. They would strike the gong three times, light the incense, and kneel in worship. Then, to the accompaniment of percussion instruments, they would chant the prayers.

After Phuc's injury, no matter how busy Nu was, she visited either the main temple or the mother temple once a day. Tung himself paid homage by remaining at Phuc's side in Saigon. Unless Nu sent word that he was needed in Trang Bang, he remained there until she returned home for good, almost thirteen

months later. To Phuc's parents, her injury became a marker of when the family's fate had turned. Exactly how they did not yet know. They relied on Caodai's infinite wisdom to decide the extent of their own and their daughter's earthly suffering. Much depended on how disfigured she would be and how her health would be affected, but they expected to have to care and provide for her for the rest of their lives. How much redemptive suffering she and they would have to endure, and how much benevolence they could bestow upon her from the spirit world once they were gone, depended on the measure of the balance of good and bad in their lifetimes, past and present. Only Caodai could determine that. There was but one way to sway Caodai in their favor, and that was for all of them to be better disciples.

AS THE EASTER OFFENSIVE WOUND DOWN, the mood of the American public towards Vietnam hardened. Americans wanted to be free of the torment of war. In late July 1972, the United States Congress caught up with that mood. It legislated a scenario for the pullout of the last of the American troops in Vietnam upon the release of American prisoners of war. President Nixon got the message: get a peace deal and bring a quick end to America's war.

Nixon was in the midst of his reelection campaign when, in October, Henry Kissinger achieved a breakthrough in talks in Paris with the North Vietnamese negotiator. Le Duc Tho, the commander overseeing both the Communist troops and the insurgents in the south, got Kissinger to acquiesce and agree to allow Communist troops, upon ratification of a cease-fire, to remain in areas of the south that they controlled: about 25 percent of the territory of South Vietnam. Tho in turn dropped the north's demand for the resignation of South Vietnamese President Thieu.

Kissinger took the tentative agreement he and Tho had worked out to Saigon. Predictably, he found it difficult to win over the indecisive Thieu, whose sole objective was to delay the departure of the Americans and stall the Communists. Without the decisive factor of American air power, the military odds in the south favored the Communists, who had more fighting will, despite being outnumbered by the South Vietnamese ground troops five to one.

As the Americans showed resolve to push for an accord, the Communists and the Saigon regime skirmished to seize as much territory as possible in the south, anticipating that a cease-fire accord would be followed by political settlement of the conflict.

Outside of Saigon, which remained curiously removed from the immediacy and threat of war, a sure sign that the government was losing its grip was the appearance of Viet Cong in broad daylight. In Trang Bang, the sight of neighbors scattering to the open fields raised the alarm: Viet Cong were approaching. Haste was essential: one wanted to avoid capture by the Viet Cong, but at the same time, being seen in one's home with them could provoke arrest for sheltering the Communists. Great Uncle would collect the children, on the way out grabbing some packets of dehydrated rice (such pilfered American army rations remained readily available) that would sustain them until it was safe to return to their home. They all ran as if for their lives, hoping to reach the safety of an open field before they were spotted running by the government military or police. "Halt!" was an order that had to be obeyed; to run implied guilt and could invite a shot to the back.

While peace talks went on in Paris, a new chapter of war was opening in contested district towns like Trang Bang. After the Communist attack there in June, nearby hamlets were targeted by both the Viet Cong and the South Vietnamese military. That

fall, three or four times, artillery barrages damaged houses anew. Always the *phao kick* came from beyond: sometimes fired by the Viet Cong, sometimes the South Vietnamese military. On rare occasions, a helicopter made several passes and a voice broadcast a warning: "Leave your houses! If you stay, you will die!" When the barrage was over, the helicopter would return, broadcasting a call for all Viet Cong to surrender to authorities. Surprise was usually the government's tactic. Typically, the district command, often miles away, acting on intelligence that certain peasant homes were occupied by Viet Cong or being used as safe houses, simply fired off ordnance enough to give an impression of strength. Hitting any particular target was unimportant.

Given the unpredictability of war, Tung did only the most makeshift of repairs to the house. Damage undid the restoration done after the attack in June. The costly double-louvered doors on the front entrances were not replaced. What with part of a supporting side wall fallen in and holes in walls and ceilings, one could see through almost to the rear of the house. Tung took to salvaging sheet metal and broken lengths of wood from one hopelessly damaged part of the house to shore up another, and nailing pieces of cardboard over holes. The injured house took on a forlorn look; even the potted plants in front dropped their leaves, their pots too cracked to hold water.

The intensifying war in Trang Bang forced the villagers to adroitly juggle their shows of allegiance. Loan was one person "caught between the sticky rice and the bean." Being a war widow gave her a certain credibility, and being a teacher yet more. She held down a post at the elementary school. Whenever there was artillery damage to buildings in the town, the district chief would come calling on her, asking her to make a broadcast, which played over the town's loudspeakers mounted on cement poles. Loan complied. As the Vietnamese saying goes: "A person is judged first

by the voice." The script she read condemned the Viet Cong and blamed them for the damage.

The other side targeted Loan as well. Teachers were ideal liaison agents for the Viet Cong. Most southern-based commandos were uneducated or poorly educated, having had no chance to go to school or having dropped out; either way, they were likely to have spent their entire youth in the forest. One night, a "night visitor" showed up at Tung's house to "escort" Loan into the forest. She was assigned one of the most dangerous of liaison jobs: to read aloud the accounting of the crimes of a prisoner before he or she was executed. Loan dared not refuse the Viet Cong. A colleague—a woman who had been Phuc's second grade teacher—had refused, and word was that her name was on a Viet Cong death list. She fled to Saigon. One time, the bloodied body of a teenage boy was deposited at the doorstep of his parents' home. Another time, a body was found among the charred remains of a thatch house. Rumor was that both the dead had wanted to leave the Viet Cong. To avoid playing too closely to any one side, Loan sought to make herself available only irregularly to the Viet Cong. She took to staying overnight from time to time with friends in the business district, which, being nearest the government offices, had no night visitors. In all, the Viet Cong came for her four times.

That fall, there were two serious incidents suggesting that the Tung family had not proved its loyalty to either side. Both were at Nu's shop.

During one morning's normal rush, as usual, early-risers were looking for lunch. An army truck pulled off the road, and hungry soldiers climbed out. Some twenty soldiers were heading into Nu's shop when two grenades exploded in their midst. Seventeen soldiers were killed. Of Nu's four children helping to serve at the time, only Ngoc was injured, taking a sliver of shrapnel in his thigh. The police speculated that someone riding by on a

motorscooter had thrown the grenades. No witnesses came forward, and police made no arrests.

The second incident was weeks later. This time, Nu's customers were mostly a large family from Saigon. They had stopped on their way to the town of Tay Ninh where a party was being held to celebrate the engagement of their son. Chauffeurs awaited them. A huge explosion collapsed half the shop, burying the customers in chunks of roof, walls, furniture, dishes. Nineteen people were killed. Among the injured, Loan was scalded by broth she had been carrying. Nu's left forearm was pitted with burns, she was dazed, and her hearing was damaged.

That afternoon, Loan hurried to Saigon to find her father.

"Ma has been arrested!" she told him, explaining that the provincial military police had taken Nu away in a truck. Back in Trang Bang, Tung explained to the children: "Your mother had to go to Saigon, so I am at home."

Seventeen of the nineteen killed in the second blast at the noodle shop had been from the engagement party. The other two deaths roused the government's ire. One victim was a civil servant, recently transferred from Saigon to head the Hau Nghia district information and education department. The other was his military escort; no high-ranking official traveled without one. A bicycle left parked at that corner of the shop where the two were seated had its frame packed with plastic explosives.

The truck, with Nu in the rear unable to see out, rattled along for roughly two hours before arriving at a provincial detention center. Nu was led into a building and marched into a small, bare room, which held about a dozen other prisoners, male and female. No one came to see if she needed medical attention.

In the morning, a guard summoned her for interrogation. She sat on a chair, facing her questioners.

"Who put the bicycle there?"

"I don't know."

"Tell us who put it there!"

Daily, the routine was the same. She was returned to a solitary cell, and the next morning, it began all over again. Her interrogators shouted at her, and the more she denied any knowledge, the more they tried to goad her into confessing her sympathies for the Communists. "You care only for the Viet Cong! You feed them; you look after them! Confess!" When she showed no inclination to do so, the interrogators called for their "tools." They used clubs to strike her legs, attached electrical prods and clips to her fingertips. The worst was a bucket of water poured down her throat while a cloth was placed over her nostrils, which gave her a sensation of suffocating.

Nu kept her wits about her. "I know nothing," she insisted.

Using her contacts, and those of the husband of Auntie Anh, in the provincial office, Loan found out where her mother was being held. When Loan could get away, she brought cooked food to her mother, and, upon seeing her blistered arm, medication and bandages. Three weeks passed. One morning, instead of being led to interrogation, Nu was escorted to the front gate, where she was left. Loan was there.

"What did you have to pay to get me out?" Nu asked. Her daughter shook her head, holding to the code of silence.

THROUGH LATE SUMMER AND INTO THE FALL at the Barsky, on any given day, Tung's biggest problem was smuggling into the ward a treat of fruit or candy for Phuc. The Barsky strictly forbade outside food, because of the stringent need to avoid risk of infection. As well, diet management is critical to the convalescence of a burn patient. It pleased Tung to see Phuc's growing appetite. He'd sneak her a bonbon or two, and share with her a soursop, the green fruit with white sticky pulp

and large black seeds, which had a short season, and which he knew to be his daughter's favorite. The Vietnamese nurses played along, feigning anger when they found an errant candy wrapper or black seed.

Once Phuc's burned areas remained clear of infection and her strength rebounded enough, skin grafting began. The process, which taxes the patient's strength, inflicts pain anew. Each patch of donor skin excised from the patient for grafting exposes underlying tissue to the air, which is equivalent to inflicting a first- or second-degree burn injury. The donor site has to be dressed and kept clear of infection if it is to heal. If the grafted skin covering the burned areas gets infected and does not take, then the graft has to be sloughed off in the burn bath, and donor sites robbed for a second try. Phuc's skin grafting operations proved routine, a tribute as much to the surgeon's skills as to the nursing care.

Decades later, when the adult Kim Phuc figured prominently in the eye of international media, more than one Western doctor would be publicly credited with having done her surgery. At the time of the war, the foreign doctors who rotated through the Barsky became aware of the fame of the photograph only when they chanced upon it at home, months or often years after the fact. Many of the patients they treated at the Barsky could have fit the description of a child needing extensive skin grafts to her upper body. The person who rightly should have stepped forward to take the credit was Dr. My, the same doctor who broke the Barsky's rules by accepting Kim Phuc as a patient. However, Dr. My, who left South Vietnam for the United States at the end of the war, did not want the limelight, and did not want to disabuse Kim Phuc of the belief that foreigners were the ones who had helped her. Besides, Vietnamese surgeons at the Barsky were technically under the supervision of Western doctors. And Dr. My recognized that, were it not for the special circumstances of Phuc's admittance, she likely would not have

remembered that she had operated on her, so heavy was the surgical schedule.

Even as Phuc's skin grafts healed, treatment remained agonizingly uncomfortable. To prevent new skin from fusing where it shouldn't—her neck to her chest, and her arm to her sides—she was put in traction and immobilized in a body cast. Finally, when the cast came off, she began physiotherapy, for which increasing pain is a measure of success. Flexibility had to be restored to grafted skin (it continually tightens as it fuses to the body), deadened nerve endings and muscles buried in scar tissue reawakened, and function restored to extremities. Phuc also had to build up her strength. Weeks of immobility in bed had shrunk her muscles and contracted her body. She had to relearn how to use her limbs, sit up, stand, walk, feed and dress herself.

In November 1972, after almost six months at the Barsky—Phuc held the record for the longest stay—administrator Joyce Horn prepared to send her to the foundation's convalescent center across town. Phuc pleaded to go home, saying she missed her family, and it was agreed, so long as she made periodic return visits to the center for further monitoring and physiotherapy.

Horn closed this file happily. Unlike many of the Barsky's other patients, from what she surmised, a loving and comfortable home life awaited the girl's homecoming. She'd heard talk among the Vietnamese nurses that Phuc's father was a ranking district official, so she assumed also that her family was one of both means and influence.

Most certainly, one reason Phuc survived the crucial first days was that she came from the better-off south, where food was plentiful and children were well fed, so that she was healthy at the time she was injured. Horn discharged most patients from the Barsky with more mixed emotions. Many left behind the best world they would ever know, sheltered from the true horror of their predicament by the routine of life and play there. Inside the

Barsky, a gruesomely distorted face did not matter; in the outside world it would. One teenage boy who'd lost his lower body, when asked what he was going to do upon his discharge, replied without hesitation: "Kill myself." Phuc was one of the fortunate: she had limbs that were intact, scarring that could be hidden and a face unmarred.

After Phuc's discharge, Robinson and Nick visited her in Trang Bang, and afterwards Robinson put a few paragraphs on the wire about the family's continuing misfortunes owing to the war.

Some weeks later, Joyce Horn received an unusual letter. Some community firemen in New York had raised three thousand dollars which they wanted to spend to bring Kim Phuc on a holiday there. As Horn would recall years later, the sentiment expressed was "Wouldn't it be terrific for her to have a ride on the carousel in Central Park?" "Please don't think in those terms," she wrote in reply. "This girl is lightly injured compared to most." She could not resist a mild reproach: "Don't single out one child; use your money instead to help many." She sent along the address of the Barsky's parent foundation in New York.

The AP bureau in Saigon subsequently received a letter from the same firemen, seeking assistance in relaying their monetary donation to Kim Phuc's family.

The bureau had received several letters and parcels, mostly from Americans abroad, many addressed simply to "the little girl in the picture." People sent coloring books and crayons, books to learn English, dolls, often clothing—always too big. Some enclosed an American ten-dollar bill, a twenty, as much as a fifty. In all, these donations amounted to a few hundred American dollars. Carl Robinson, the picture editor, and Nick Ut prevailed upon the bureau's helpful Vietnamese secretary to make sure Tung received the parcels and donations. As it was illegal for Vietnamese to hold American currency, the secretary, a widow who'd lost her husband on the battlefield, had to take Tung to the bank

where the AP had an account to change the dollars into *dong* before handing them over.

Robinson and Nick discussed how to assist the firemen and left the matter with the secretary in the bureau. This time, Robinson decided against writing a story for the wire. *This is one victim who is well taken care of,* he told himself. *There are other victims to think about.*

RICHARD NIXON WAS RETURNED TO THE presidency in November 1972. The business at hand remained seeking peace; Kissinger's mid-campaign declaration that "peace is at hand" had not been realized. Thieu would insist on a list of sixty-nine changes to the tentative agreement Kissinger had reached with the North Vietnamese. Their response that December was to break off talks.

Nixon's patience ran out. He wanted the cease-fire accord in place for his January inauguration. In an ultimatum to the North Vietnamese to bargain "or else," he ordered an intensive bombing campaign over North Vietnam. Beginning on December 18, and continuing until December 30, with the exception of a one-day suspension of bombing for Christmas Day, American B-52s pummeled military targets in Hanoi and in the sixty-mile corridor between the city and the north's main port of Haiphong. Public reaction in America to what became known as the "Christmas bombings" was muted; internationally, it was one of revulsion. Nine days after Nixon finally called a halt to the bombing, talks between the United States, North Vietnam and South Vietnam resumed in Paris.

AMONG FOREIGN JOURNALISTS GOING TO South Vietnam to file stories leading up to the expected Paris

cease-fire accord were two from *Stern* magazine, a major weekly based in Hamburg. Photojournalist Perry Kretz and reporter Klaus Liedtke arrived at Tan Son Nhut airport, expecting, as usual, to obtain the necessary entry visas there. They were refused entry and ordered to leave the country. Kretz's guess was that his coverage during the Easter Offensive had offended the Saigon regime; he'd photographed a soldier asleep at his machine-gun position.

As there was no plane connecting to Hamburg for three days, South Vietnamese police allowed the two journalists to go into Saigon, to wait in a hotel, under house arrest. Kretz chose the fading elegance of the Continental. The ornate nineteenth-century hotel, featured in novelist Graham Greene's *The Quiet American*, was a favorite of journalists from the early days of the American war. It was on Tu Do Street (Tu Do meaning "freedom"), formerly Rue Catinat under the French, where early war correspondents had dubbed the bars "Radio Catinat" because of the military intelligence that one could pick up there. At the Continental's terrace bar, relaxing on dark green wicker chairs on a floor of black and white tiles, cooled by ceiling fans overhead, one could still order *citron pressé*, the tart French drink.

A guard posted outside the hotel room doors of the two journalists amiably escorted them to and from the restaurant and bar. On the morning of the second day, Kretz was determined to salvage a story from the aborted trip. He approached the guard. "We want to go out," he told him. "Not for long, not far." He opened his palm to reveal an American fifty-dollar bill. The guard took it and turned his back.

The AP office was two blocks away. There, Kretz found Peter Arnett. He explained his predicament: "I've got a day and a half left. Any ideas for a story?"

Arnett didn't hesitate. "Kim Phuc is a good story."

"Who's Kim Phuc?"

"She's the girl burned by napalm."

"She's alive?!"

At each checkpoint on Route 1, Kretz and his colleague, to avoid being asked for their passports as there was no valid visa stamped inside, flashed United States Department of Defense identification cards. "Americans," the police said, waving their taxi through.

When the twin towers of the Caodai temple came into view, Kretz recognized where he was from his memory of the famous picture. They found Tung at home. Clad in shorts and an undershirt, he was atop a stool, taking a saw to level the tops of lengths of bamboo, part of a repair to a shattered wall of the badly damaged house. Tung led them to Phuc. She was behind the house with Grandmother Tao, who was squatting on the ground handwashing clothes. To Phuc's amusement, Kretz insisted on a handshake from her grandmother, ignoring the wet soapiness of her hands. The old lady relented, though the greeting was foreign to Vietnamese ways, and particularly unexpected between a man and a woman.

For Kretz, the elusive chemistry between photographer and subject was there from the start. With him, his colleague and the taxi driver, who served as interpreter, in tow, Phuc happily gave a tour of the house and the garden. She posed when asked. In front of the house, she obliged when Kretz urged her to join some boys playing with a soccer ball. There was a moment of consternation when Kretz's colleague, sweating profusely, suddenly felt faint from the heat. After a rest inside the house and a cool drink, the trio and Phuc set off down the footpath to the temple and to the road where the napalm attack had occurred. Kretz spent the better part of an hour shooting pictures there of Phuc.

He was looking through his viewfinder when he noticed that his subject's smile was no longer as broad as it had been. He lowered his camera.

"Kim!" Then, teasingly, "Don't look so sad!"

The driver and Phuc spoke together. She had become stricken with pain from the heat. The sudden onset of pain is typical for the burn victim; without sweat glands or pores in burned areas and grafted skin, and with poor circulation in constricted scar tissue, the body does a poor job of regulating its temperature. Hot and cold are abruptly, acutely felt.

Kretz saw Phuc's face cloud over. He was concerned. "What happened? What's wrong?"

"The sun is too hot for her body. Her burn wounds are giving her pain."

Kretz chided himself for his insensitivity. The only hint he'd had of Phuc's injury had come in the stiff and awkward movement of her head and arms in attempting to catch a soccer ball. Kretz was puzzled. If the girl was suffering so, why had she gone through with the shoot? As they walked back to the house, he formed his own conclusion: *She may be only a child, but she must be thinking: "Go through with it, maybe these foreigners can help me."*

At the house, Phuc went to seek the relief of a shower. Kretz asked Tung if he could photograph his daughter's burn scars. Tung winced. Kretz put his request to Phuc bluntly: "Listen, Kim. We are here now. I wasn't there when it happened. I have to see your burn. I have to see what really happened to you." Phuc obliged. She did not yet know shyness with her body; boys and girls her age and younger played naked in the rain, showered together, went around shirtless and barefoot. As Phuc showered, she was transformed. She filled cup after cup from two ceramic urns filled with water especially for her showers, letting the water cascade from the top of her head down her body.

Among the photographs that appeared in the article in *Stern* would be a stark image of Phuc looking over her shoulder at the camera. Her nakedness betrayed her suffering. The camera's eye

recorded frozen rivers of red and purplish skin, coursing angrily every which way on her back and her left arm, and volcanic eruptions of burn scars on her buttocks. On her thighs, there was clean but faint rectangular scarring, where donor skin had been lifted out. "Americans, feeling sorry for what had happened to the girl, had sent toys and letters," said the accompanying article, adding pointedly, "but she said that she'd rather have medication for the wounds on her back."

Once back in Hamburg, Kretz would find that he could not forget either the smile of the girl, or how abruptly it had faded that afternoon. He had come to journalism only lately. More than two decades earlier, he'd left his first job as a typesetter in Germany to live with relatives in New York in order to learn English. After various jobs there, including waiting tables and tending bar while studying photojournalism at night, he served with the United States navy during the Korean war. Later, he worked in the picture unit of the New York City police department, then with a news service. He was in his fourth year with *Stern*, his assignments out of Germany mostly to Indochina to cover the war.

I should have been a doctor, he told himself, a self-apology for his inability to do more for the girl that day.

ON JANUARY 27, 1973, NINETEEN DAYS AFTER diplomatic talks had resumed, the United States, North Vietnam and South Vietnam formally signed the Paris cease-fire agreement. On the same day, the defense secretary announced that the American military draft was over. But the accord did not end recruitment either by the South Vietnamese or by the Viet Cong. Nobody in Vietnam expected peace—the South Vietnamese pronouncements conspicuously avoided use of the word—only the end of American involvement and an interlude before fighting erupted again. Within one day of the

signing of the accord, each side would accuse the other of cease-fire violations.

On March 19, the last American flag was hauled down over the last American military installation in Saigon. On March 30, the last of the American military personnel in Vietnam left for home, and one day later, Hanoi released a last contingent of American prisoners of war.

With America out of the picture, foreign news agencies lost their appetite for daily coverage of the Indochina conflict. Those with bureaus in Saigon either closed them or sharply cut back staff and resources there. The focus upon horror shifted elsewhere in the world. It would allow the Americans to continue a bombing sideshow for the next several months over Laos and Cambodia—until, that is, an angry Congress finally blocked all funds for American military involvement in the region. That same summer, President Thieu would openly accuse the Communists of planning an offensive for the coming dry season. As the Communists continued to pester and grab what territory they could, Thieu counted on the Americans to intervene and come to the aid of South Vietnam should Communist troops surface openly.

To Americans, Vietnam was not so much a country as a war. For them, it had finally ended. Measure was taken of the human price Americans had paid: some 58,000 Americans had died there; 300,000 had come home wounded; nearly 600 had been captured and held in Communist hands; and 1,300 were still missing in action in Vietnam, more elsewhere in Indochina. At home in the United States, veterans among the 3 million who had served in Vietnam searched for meaning to their sacrifices. Whatever the morality of America's involvement in that conflict, the American public was sick and tired of hearing about it. That the war in Vietnam was not over, or that more Vietnamese soldiers and civilians would die, did not weigh heavily on its conscience.

At the end of the previous year, *Life* magazine published its usual "The Year in Pictures" issue. In it had been only one item related to the Vietnam war. It was a two-page spread of a portrait of a smiling ten-year-old Kim Phuc at home in Trang Bang, inset with the famous picture of her running in terror from the napalm strike. The headline: "*Kim Phuc, Memories Masked by A Smile.*"

CHAPTER SIX

LEAVING THE COCOON OF THE BARSKY unit for the world outside proved too abrupt and harsh an adjustment for Phuc's body to make. It was apparent from the moment she and her father stepped out of the gates of the Cho Ray Hospital. The pedicab ride across town from busy Cholon, the Chinese district of Saigon, to the western bus terminus exposed her body, its burned areas newly encased in thin and unstable skin, to the hot sun. Her lungs, damaged by the burn, suffered the irritation of dust blowing through the open windows of the bus. The headache she had was worsened by the jolting ride over tarmac rutted by shelling. Then, the sight of the damaged house, which she had last seen before the napalm attack, proved a shock. "You can see the sun and the moon from inside!" Phuc remarked.

Twice during Phuc's first two weeks at home, she was struck down by sudden, intense pain. The severity so alarmed Nu that she dispatched one of the family on the motorscooter to bring a doctor. Each time, the family feared the hysterical Phuc would

have been driven to madness but for the relief provided by the painkiller the doctor injected. Tung and Nu made the decision to admit Phuc, as the Barsky had intended, to its convalescent center in Saigon. While most patients would stay an average of two to three weeks there, Phuc would stay seven months. Doctors allowed her visits home for a week or two at a time, but she would not return home for good until July 1973, thirteen months after she had been injured in the napalm attack.

That the child who came home had the same happy and uncomplaining personality as before she was wounded was a testimony to her strength of character. The Vietnamese nurses themselves marveled at Phuc's constant cheerfulness. It was a quality not often seen in the littlest victims of war; some children could not bring themselves to smile even at the antics of Goofy or Donald Duck in cartoons the Barsky brought in from America. The professionalism—and even heroism—of the nurses, the same ones who inflicted on Phuc the pain of the daily burn bath, was proven by their ability to develop a trusting, loving relationship with her. Phuc's life-saving treatment was itself traumatic. No matter how much time passed, mere mention of the burn bath would send Phuc into a wordless darkness. However, with the care of the nurses, she emerged from that haze of pain, prolonged agony and isolation, re-born.

During her hospital stay, Phuc seized upon her life's ambition. The role models that she saw at the Barsky convinced her: she wanted to be a doctor. This was a lofty ambition for a girl of peasant origins. Usually, families decided their children's ambitions, in accordance with what was in keeping with their social standing. Only those in the city, with the means to send their children to the best schools, could decide who among their children would be a doctor, pharmacist, lawyer or engineer. Phuc explained her desire to her parents. "You gave me life," she told them, "but the doctors and nurses kept me alive."

THE TRANG BANG THAT PHUC FINALLY CAME home to was much changed from what she had known. Under the terms of the cease-fire accord, villagers could declare their allegiance to one side or the other, and in the northernmost provinces, many hamlets hoisted the Viet Cong flag. Throughout much of the south, especially in the district towns like Trang Bang that ringed Saigon, the Saigon regime made certain that the South Vietnamese flag fluttered from the top of, or was painted on the sides of, every public building.

Life and death had left its mark in Phuc's absence. In the year after the attack, Nu would have her eighth child, a fifth son. Auntie Anh bore obvious signs of her injury: she had a limp, and the fingers on one hand were curled, claw-like. She had left the hospital in Saigon within days of her husband finding her there, too distraught to stay upon the news that Danh had died and that the youngest was ailing. Phuc had been told in hospital of her cousins' deaths, but at home no one spoke of the loss more than a year gone by. Auntie Anh would go on to have seven more children.

Sometimes when Phuc was visiting her cousins, she would come upon her aunt lying on the bed and chanting herself into a trance. Her voice would change into one not her own as she received news from the spirit world of Danh and Cuong, the baby. Back to herself, Auntie Anh would talk of how happy she was that her two sons were together. She spoke of how the younger liked to tease the older: "How ugly you are, Danh! You are burned so much!"

In Phuc's year-long absence, her siblings had become schooled in the manner and ways of war. The vocabulary of her brothers' war games, once played with tree branches for guns, had expanded to include mortar fire, shells, rockets and grenades.

In the once proud house there was no longer room enough for all to sleep. The three open front doorways and collapsed side wall left the front room entirely exposed. The breezeway had

partly collapsed, so that hammocks could not be hung there. With only the back room for sleeping, Tung, and at least one other child, had to sleep elsewhere, usually at the home of someone minding the house for relatives who'd fled to Saigon. Loan had more or less moved into the town, coming home only during the day.

Phuc found Loan grieving. Her twenty-one-year-old sister had several friends who'd been recruited by the military at age eighteen, many of whom had died in combat or been left maimed. And shortly after Phuc returned home, she woke up one morning to find that her father had spirited her eldest brother, Ngoc, away in the night.

Their flight had been triggered by a visit days earlier. The district military chief had sent someone around to see Tung. "When your son is eighteen," they told Tung, "he must go to the military."

It wasn't more than a couple of nights later that a night visitor came to the house to see Tung as well.

"We invite your son to join us."

"My son is not home," Tung replied. He had calculated that he could stall for time; only one person stood before him. "I would like to ask his opinion first."

In the north, propaganda could sway one's sympathies. It was not so in the south. Filial piety was stronger; a son followed the side that his parents told him to, the same side as their own.

When the night visitor took his leave, Tung roused Ngoc from sleep. "The people from the forest have come for you!" Tung had already prepared clothes and bedding, a packet of money and food. Just before dawn, when the Viet Cong were most likely to have taken to their beds, Tung and Ngoc made their way west to Tay Ninh to the Holy See.

One year earlier, Tung had laid plans so that he would not have to choose to send his son to one side or the other of the war. He decided that if that day of reckoning came, he would send his

son to study Caodai. It was his wish also that Ngoc not return to hamlet life, but instead begin his married life in the city, where people were more likely to mind their own business. "I want you to escape the fate of living in a small town," was how he explained to Ngoc his purchase in Tay Ninh of a one-room house on a crowded street near the Holy See that, upon marriage, would be Ngoc's own.

Father and son presented their papers at the gate to the white-tunic-clad sentries there; each of the twelve gates of the Holy See was guarded twenty-four hours a day. Beyond the walls lay a city unto itself. Dominating the landscape was the magnificent temple to which the family, like most Caodaists, made one or more pilgrimages a year. Among the dozens of structures in its shadow were several administrative buildings, many built in the French colonial style. In addition, there were two high schools, a university, a seventy-five-bed hospital and nursery, an orphanage, an old age asylum, an orchestral practice hall, a mortuary, public works garages and several businesses, among them dressmaking and weaving shops, a bakery, a gas station, a carpentry shop, a blacksmith's forge, even a calendar factory. Several lodging houses had been constructed for the workers, who numbered more than one thousand.

The Holy See accepted Ngoc's services as a worker. In return, he would receive a room and two vegetarian meals of rice and soup each day. Other Caodai families saw the Holy See as a sanctuary for their sons as well. Blood had recently stained the inner sanctum when an unknown assailant murdered the chief of the former Caodai army, but this had been dismissed by the religion's followers as intrigue in the leadership.

When the Viet Cong returned the next night, there were two of them. "My son is following Caodai," Tung said. They left without protest.

Every two or three weeks, Tung, occasionally taking one of

the children, made a day trip to Tay Ninh to bring Ngoc extras that the temple did not supply: tea and coffee, palm sugar, condensed milk. Nu also sent along pocket money. Ngoc needed little, as he neither smoked nor drank. The decision to take him to the Holy See seemed to be the right one, as more and more of his friends went the way of the government army.

ALL THE FAMILY FELT SORRY THAT THEIR sparser life was hardest on Phuc. Tung was the one who had the most time to be attentive to her needs, and Nu appreciated her husband's fussing. *He has a particular fondness for that child*, she would tell herself. Hoping to downplay his favoritism, he placed his own welcome-home present for Phuc among the dozens of dolls and plush toys that came from well-meaning strangers abroad. His doll became Phuc's favorite. Made in Japan and battery-operated, it was the size of a toddler, and it could walk, open and shut its eyelids, talk, cry, and sing a song in English. It so terrified Grandmother Tao that it could not be brought out in her presence. More presents from abroad trickled in. Increasingly, to Phuc's disappointment, the family paid to receive a parcel only to find that a thief had already emptied it or had replaced its contents with rocks.

Nu took measure of the neighbors' first reactions to her daughter's burn disfigurement. She saw that children recoiled. Adults would shake their heads: "Poor you," they moaned to her daughter. Until family and friends got used to her disabilities, there was embarrassed silence at her clumsiness. Often, while trying to help at the noodle shop or at home, she dropped dishes. At the dinner table, when a porcelain rice bowl clattered to the floor, she looked around in surprise, unaware it had fallen from her left hand.

Nu rallied family and neighbors, old and young, to help Phuc with her exercises to rebuild strength and restore flexibility. Nu

gave instruction: she had paid close attention to how the nurses rotated Phuc's neck while trying to keep her from turning her body with it, and to how they worked her left arm, to restore flexibility at the elbow and shoulder, and individual fingers, to keep them from curling tighter. It would be some months before Phuc regained enough use and strength of her left arm and right hand to do them on her own.

Only Nu was able to withstand Phuc's cries at tight skin stretching and stiff joints pulling. Pain is a necessary part of a burn victim's rehabilitation; the more movement and flexibility gained, the more there is. A victim's rejuvenation can take as long as two or three years. Nu was firm with Phuc. "It is very painful," she agreed, "but you must do your exercises now if you don't want to be ugly forever. You must do them if you want to help yourself to live the rest of your life. I will not be with you forever."

Gradually, Phuc recovered more sensation in her limbs so that her movements betrayed her less. Instead of having to drop her mouth to the rim of her rice bowl on the table, her left hand could again raise the bowl. Slowly, she regained strength. While she would never again have the stamina or physical ability to keep up with others her age, within a year she appeared to be like any other child, running in play, riding her bicycle to school. Unless one knew of her injury, it was not easy to detect.

Phuc would have to live with the sudden onset of pain and headaches for the rest of her life. Usually, Western painkillers would be enough to keep the pain at bay. When heat flared in her body, as might happen if she was too long under the sun, she could find relief by showering. Daily, someone was charged with buying a chunk of ice that could be chipped for wrapping in a towel to be held as needed to Phuc's back, neck or head. The family was also on constant watch to see that she wasn't scratching at her left arm so that she drew blood; she could no more feel her nails raking it than she could a mosquito bite. Upon an

anguished, sharp cry from her, the closest person would come running to pound and massage her back. On the rare occasions when the pain seemed beyond control, someone went to fetch Auntie Anh, who gave Phuc the injection the doctor once had.

Phuc saw all of her family making allowances for her and sacrificing on her behalf. Of her family, she saw her mother giving the most. She saw her mother struggling to hold back her own tears at her daughter's wincing cries. "Phuc, do not cry," Nu would say. "I cannot carry your pain, but when you cry, I carry your sorrow." And so, Phuc struggled to stay dry-eyed. *I love my mom; I must not make her sorrowful.* She did not know that, once out of her daughter's sight, Nu's tears fell uncontrollably.

DURING THE WAR, SOUTH VIETNAM HAD become a nation of spenders. The South Vietnamese spent more on imported cosmetic and beauty aids than the country's entire export income. They were able to outspend the value of the country's gross domestic product, the difference funded by American aid and military expenditures. In the meantime, the foundation of its economy crumbled. Manufacturing and industrial production fell drastically and became dependent on aid-financed, imported raw materials, equipment and spare parts. This was the case even in traditional industries, such as fish-sauce making. During the tenure of the Americans, the two main industries remained, as they had been in the time of the French, beverage brewing and tobacco processing. People had flocked to the cities, but to take jobs that would last only as long as the Americans stayed. In places like Danang, which during the war was a mini-Saigon, these workers accounted for half the workforce.

The departure of the Americans from South Vietnam was equivalent to kicking out the prop that held up its economy. In their wake, the Saigon regime had to confront two serious eco-

nomic problems: urban unemployment and inflation. Among the taxes the government introduced or raised were a doubling of the tax on small traders, a 20 percent rise in the land tax and a new 10 percent value-added tax. To control inflation, the government repeatedly devalued the *dong* (twenty-one times between mid-1972 and the fall of 1974). It hit consumers with price increases: in 1973 it raised the price of rice by 55 percent, sugar by 60 percent, and gasoline by 75 percent. In Trang Bang, an increase in theft and looting in the business district marked tougher economic times. Tung and his second daughter, Dung—who had risen in responsibility as the oldest child at home—would arrive at the noodle shop just as Nu was leaving. It was their responsibility to keep watch overnight.

The cash-strapped Saigon regime—while living under the threat that, at any time, full-scale war might erupt—could not meet its military payroll. Wages went unpaid. Soldiers couldn't feed their families on what they did receive, and many were deserting. After the Americans withdrew, wrongdoing in the army, always a hotbed of corruption, ran amok. Soldiers from the highest levels on down embezzled funds and rice and supplies, stole payrolls and profited from illegal dealings. However, the cronyism and corruption began at the top, with Thieu and his relatives, and was mirrored by the Saigon elite. As the Vietnamese saying goes, "A house leaks from the roof." In a growing backlash, middle-class Saigonese, with support from students, non-Communist intellectuals and religious leaders, raised their voices in favor of Thieu's removal. The prevailing desire was for political stability, seen to be impossible to achieve with him as president.

SEVERAL MONTHS INTO THE CEASE-FIRE, THE district chief came to see Tung and Nu with an unexpected announcement. Some Americans wished to give the family a

donation. The handoff would take place in front of the Caodai temple. "We cannot meet at your house," he explained, "because of its condition." On the appointed day and hour, a convoy of nine vehicles, seven military jeeps from the province of Hau Nghia and two cars from the district, pulled off Route 1 at the temple.

There were speeches by the Vietnamese officials and by one of the two Americans there; the other was filming the presentation. The donation in *dong*, equivalent to three thousand American dollars, was from the community firemen in New York. Their wish was that the family of Kim Phuc use it to rebuild their war-damaged house.

An official invited Tung to reply.

He had barely begun—"We are a country living with war, but people from other countries are sharing"—when the whistle of an incoming mortar round interrupted him. Officials scattered to their vehicles. The one who was clutching the brown envelope of money yelled to Tung, "Because of the war, there is no point giving you the money now. After the war is over, we will give it to you!" The convoy sped off.

Later, inside the temple where Tung and Nu had sought cover, Tung was rueful. "They put the taste of money in our mouth, but we had no chance to swallow it."

That evening, footsteps woke Nu. Suspecting thieves, she removed the bundle of *dong*—that day's profits from the noodle shop—from around her waist and slid the bills under the bamboo mat beneath Phuc and the two youngest sleeping alongside. Phuc opened her sleepy eyes. Nu shushed her, wordlessly instructing her to feign sleep.

Two burly men herded the sleeping household from their beds. The intruders bound them to two separate pillars inside the house.

One brandished a gun at Nu. "The Viet Cong needs one million *dong*."

She denied having such a sum.

"The government gave you the money today! The Viet Cong needs it! Give it to us!"

Nu explained the *phao kick* that had interrupted the presentation earlier that day. The frustrated intruders began to search the house. Meanwhile, Great Uncle loosened a knot enough to free Phuc's seven-year-old brother. "Run to your grandma's house!" he told him. "Call for help!" The boy ran screaming all the way there. By the time his grandparents arrived with fire-lamps, the intruders had fled.

Later that morning, Loan, with Nu on the back of her motorscooter, set off for the provincial office of Hau Nghia, hoping to collect the donation. At Cu Chi, they continued south along a secondary road. Mortar fire forced them back. Loan eventually got word that the donation was in a Saigon bank, and that the government would give it to the family when the war was over.

ONE YEAR INTO THE CEASE-FIRE ACCORD, President Thieu declared that the country was again in a state of war. During that dry season, the Communists did not, as Thieu had predicted a year earlier, launch an offensive. Instead, during 1974, they sought only to consolidate and expand existing strongholds.

Thieu was off by only a year. The Communists planned to launch an assault not in the dry season of 1974 but in the dry season of 1975. The surprise element was that it would be directed not at the northern provinces, as South Vietnamese forces might expect, but at central Vietnam. Hanoi calculated that a decisive defeat of South Vietnamese forces there by Communist forces would put them in a position to make a final drive on Saigon during the following year's dry season.

In preparation to launch what they expected to be a two-year

offensive, the Communists began to send mainforce troops and supplies down the Ho Chi Minh Trail. The Communists also began construction of an oil pipeline to reach within seventy-five miles of Saigon, and to lay out a modern radio grid that would put Hanoi in direct contact with field units. Nowhere was their fierce attachment to the goal of victory over the south more evident than in their ten-year transformation of the Ho Chi Minh Trail from a web of primitive footpaths into an all-weather road over mountains and through jungle, able to accommodate trucks, tanks and armored vehicles. The road was also now defended by hilltop anti-aircraft emplacements, should the Americans return and resume bombing to rescue the South Vietnamese.

The South Vietnamese people did not need to be told that the country was again at war. The fighting had never really ended. At the sound of gunfire or mortar fire, Phuc, fuelled by panic, made for the *ham* even as Great Uncle was screaming at the children: "Hurry! Inside! Inside!" Always, she assumed unseen Viet Cong were firing from the forest. Adults and children alike knew that running for the *ham* was itself a gamble; the sound of mortar fire was no indication of where it was being fired from, or where it was going to land, far away or near. In its trajectory, an incoming shell could easily catch a treetop or a building and spray from that height.

The war bred in Phuc a belief that during wartime there was little use in calculating one's steps. Life, it seemed, was either chance or destiny. One day, Phuc was sitting in the noodle shop, close enough to see the phosphorescent burst of mortar fire and hear the *crump* of a shell bursting. She watched the scene unfold as if in slow motion. People broke into a run in whichever direction their feet propelled them. One woman smashed headlong into a slow-moving military truck. She picked herself up, and despite blood gushing from her head, began to run again.

Without warning, in life's syncopated dance with death, the

rhythm could shift from unhurried to frantic. One could be arguing with a sibling one minute, and be struck dead the next. Twice, there were close calls at the house. Moments after Loan had shut off the engine of the motorscooter and leaned it against the wall, a mortar round landed nearby, driving shrapnel into the scooter just as she was stepping into the side doorway. Another time, Great Uncle was lowering himself into the *ham* behind the last child when a piece of hot metal from an exploding shell bloodied his hand.

Phuc began to have recurring nightmares of war. In one, she and her brothers would be standing in the midst of soldiers in uniform. An argument would break out among them, and gunfire would erupt. In another, she would be in an unfamiliar part of town. Bombs would fall, and fires flared all around. "We have to get out!" someone would scream. And as always, she would run, terrified of being killed. Urging herself onward, she would become tired, so tired that she would not know how she could keep going.

In her waking hours, as in her nightmares, Phuc was still running from war. She wanted to stop running; she wanted whatever was making her run to stop as well. She just wanted it all to end.

THERE WAS ONLY ONE WAY TO LIVE WITH THE insidiousness of war: one had to adhere to the normal habits and tempos of one's life. Phuc wanted most, after her year in hospital, to resume a normal life, which for her was going to school with her friends. At the time of the napalm attack, she had been in the third grade. When she returned from Saigon, her former classmates were starting fifth grade. With Loan's help, as her fourth-grade teacher by day and her tutor after school, Phuc was able to finish two grades in one. By the summer of 1974, she was studying for the nationwide fifth-grade examinations. The sixth

grade was considered to mark passage from childhood to adolescence, as it was the start of middle school (grades six to twelve).

School and studying had their frustrations for Phuc. She regretted the interruption when the school, at the sound of either mortar fire or nearby fighting, sent the students home early, or even closed for a day or two. In her zeal to study, she found she suffered headaches and was beset with dizziness. Her endurance would always fall short of her desire. Burn victims might seem otherwise recovered, yet often report headaches and dizziness for which there is no apparent physiological cause. Such symptoms are seen to be related to psychological scarring.

"I don't want you to go crazy in the head from studying," Nu told Phuc. "You don't have to be the best student. Average marks are good enough."

Phuc placed sixteenth among fifth-grade students in seven district schools in and around Trang Bang. "If I hadn't been burned, I could have been number one!" she told her parents.

Her achievement bolstered her self-esteem. *I'm not a child any more. I'm getting older now,* she told herself, upon her eleventh birthday. *I have to begin to mind my appearance.* In her growing self-awareness, she would, after every shower, examine her body in the three-way mirror. She gave thanks to Caodai. *Thank god, my face was not burned. Even if my character were as good as an angel, if my face were ugly, it would be better that I had died.* She longed to wear the short sleeves other girls wore, but she knew that would never be.

Phuc decided to mark her graduation in two ways: by going to the dentist for the first time and by getting her ears pierced. Loan took her several miles by motorscooter to the nearest dentist. Auntie Anh pierced her ears, and Nu obliged her request for a pair of gold earrings. Each child in the family had gold jewelry that was his or her own—each boy had a chain and bracelet, each girl a bracelet and necklace with a heart-shaped locket—which

Nu did not allow them to wear because of her worry about gold jewelry attracting thieves and kidnappers. Given the lack of security at the house, Nu had had Tung put the jewelry, along with what savings the family had in gold bars, into safekeeping at a more secure house. The family would later find out that Tung had used the jewelry to pay off gambling debts.

THE PRESIDENCY OF RICHARD NIXON WAS inexorably weakened by the Watergate scandal that had begun with the bugging of Democratic national headquarters in the summer of 1972. "Without the Vietnam war there would have been no Watergate," one of his aides, H. R. Haldeman, would later write. One thread of Nixon's undoing was the leak of the Pentagon Papers to *The New York Times* in 1971, which had exposed the previous administration's secret policy in Indochina. That revelation had helped turn the tide of American opinion against involvement. A despondent Nixon had organized a unit (called the "plumbers" because they were supposed to plug leaks) to clandestinely investigate the man who had copied and leaked the Pentagon Papers, Daniel Ellsberg. The unit went on to other unseemly and illegal missions that, ultimately, implicated the president in the cover-up of the Watergate affair. On August 9, 1974, Nixon resigned to avoid impeachment.

The Communists saw Nixon's downfall as bringing the prize of Saigon closer. The lingering uncertainty affecting the Communists' plans for the assault in the coming spring had been whether Nixon, exercising his presidential veto to wage war in spite of the American withdrawal, would intervene with air support, congressional funding or both. One of Nixon's last acts as president was to legislate a spending ceiling on American military aid to South Vietnam for the coming year. Congress moved quickly to lower the limit from $1 billion to $700 million, sending a signal to

Nixon's successor, Gerald Ford, that it was not interested in sustaining the Thieu regime.

THE COMMUNISTS SET THE CLOCK TICKING on South Vietnam in January 1975. That month, Communist forces chose a province near Saigon, only fifty miles to the northeast of the capital, to test the resistance of government forces. The Communists easily overran the capital of that province, marking the first time ever that they had "liberated" a southern province. The ensuing American silence encouraged the Communists to proceed as planned with the main assault in the central highlands. On March 10, 1975, the Communists attacked a city in central Vietnam.

By mid-March, wire stories filed from Saigon and ripped from clattering telex machines in America reported a frenzied stampede of army and civilians down coastal routes south. No one, including the Communists, expected that government defenses would crumble so quickly; in a matter of days, half the country was practically handed to them. Old Indochina hands raced to return to Vietnam to cover what looked to be the final curtain falling on South Vietnam. President Thieu had made a fatal strategic error in ordering his forces to pull back from the central highlands to the coast. Columns of retreating troops were hemmed in. Thieu had also ordered his elite Airborne troops to Saigon, where he feared a coup attempt. Then he reversed himself, telling them to save Hue, which had been held by the Communists for twenty-six harrowing days during the Tet Offensive—but it proved too late. Hue fell on March 25, Danang on March 30. Thousands of panic-stricken soldiers and civilians waded into the sea there to reach boats. People clung to the rear stairways and wheel wells of planes, falling to their deaths.

Hanoi sensed a South Vietnamese army on the run. It aban-

doned the limited objectives of the offensive and decided to make the final military push to Saigon. The Communists knew they had, at the most, one month; come May and the start of the summer monsoon, they would have no choice but to pull back and wait for another day.

THE SOUTH VIETNAMESE MILITARY WITH-drew behind a defense line protecting the southernmost regions just above Saigon. In the second week of April, Communist forces struck thirty-five miles from the capital at Xuanloc, site of a former American military base. Government forces there put up the only stiff resistance of the counteroffensive and, well supported by the air force, were able to hold Communist forces at bay.

In Saigon, the American ambassador would be slow to evacuate Americans, as well as their non-American employees and friends, mainly because of a belief both that Saigon could be defended and that Washington would come through with money, the $700 million permitted by legislation. On April 15, Kissinger himself appealed to the Senate. Not until April 21, when Thieu went on television to resign his position to his vice-president, and at the same time complain that Gerald Ford had let down South Vietnam, did unease grow that the capital might fall. American evacuation flights began. South Vietnamese police were quick to detain and arrest any Vietnamese suspected of attempting to leave the country. Subterfuge was necessary to make it through the city streets, often in violation of curfew, past the security gate of Tan Son Nhut airport, and finally onboard waiting u.s. air force evacuation aircraft. Only those on an approved list from the United States government could leave South Vietnam.

Some of the people who had played a part in the story of Kim Phuc made it out of South Vietnam. The day after Thieu's resig-

nation, the AP evacuated Nick Ut. He told his mother that he'd be back in two weeks, or at the most one month, depending on how long it might take for government forces to secure Saigon. Nick took with him his brother's widow, Arlette, and her ten-year-old daughter. The driver of the van ferrying her and other AP dependents to the airport fooled police giving chase by stopping at a city park and pretending to have a picnic. Carl Robinson sent out his Vietnamese wife and their children, along with some of his wife's siblings, on an evacuation flight, and he himself stayed on a few days longer. The Barsky's administrator, Joyce Horn, drove one of three Ford wagon ambulances from the hospital to the airport carrying thirty-six of the unit staff and their families. Among her passengers were Dr. My and her children, and a three-year-old burn-scarred boy left at the Barsky whom nobody came for, and whom Horn would raise as her son. To get by police, all were disguised as hospital patients, smeared with blood from the Barsky's blood bank and wrapped in bandages. Some had IVs strapped to their arms, while others hobbled on crutches.

Two days after Thieu's resignation, Gerald Ford declared in a speech at Tulane University in New Orleans that there was no sense in Americans "refighting a war that is finished." Three days later, on April 26, Communist forces made a breakthrough at Xuanloc. By then, Thieu and his family had left for Taiwan, reportedly with sixteen tons of baggage, including bullion and American currency.

IN THE LAST WEEK OF APRIL, TRANG BANG took on a deserted air. Police and district authorities disappeared from sight. There was virtually no traffic on the highway, and the usual checkpoints had been abandoned. Several businesses and all the schools had closed. Nu closed her shop. "Nobody wants to eat," she said. The family retreated to their house. They huddled

in the back, kept talk to a whisper and did not cook, eating instead from stockpiled fruit and army rations of dehydrated cooked rice. If there was no sign of life, including no smoke from the hearth, overflying planes spotting for the Viet Cong would hopefully think the house was empty.

The eerie silence made Tung and Nu fear that attack was imminent. They decided to move from the house, but stay within reach for food and medicines. They made for the main Caodai temple where they found a handful of neighbors already there.

The next morning, mortar fire split the air, sending pieces of shells and rockets slamming into the front doorway and windows of the temple. The neighbors with them inside did not know what to do. The family decided to gamble on the mother temple on the other side of town. They set forth on the footpath. Just short of their house, shells crashed into the ground. "Inside! Inside!" the adults screamed. Once everyone was through the closest doorway, Nu did a head count of her children: "One, two, three, four, five . . ." She gasped. "Oh no, I lost one child! Who is missing? Who?" She did a recount, twice, before realizing that the sixth and youngest was in her arms.

On the run again, while moving past a clutch of thatch houses, Phuc spied an offering of sweet green bananas on an outside altar. She broke from her siblings to run towards it.

"Phuc!" her brother Tam yelled. "Keep going! Don't pick that up!"

"Why not? I'm hungry and I like it!" She had intended to take just one banana but instead picked up the entire bunch.

Among the crowd at the mother temple were Grandmother Tao and Nu's two sisters, with their families but without their husbands. In the next day and a half, so many villagers arrived that there wasn't enough floor space for any to lie down. Families began to run out of food.

On the second afternoon, a truck groaned to a stop outside.

Leaving the motor running, the driver shouted into the doorway, "I'm driving to Tay Ninh. Does anybody want to come?" All day the steadily growing sounds of mortar fire and gunfire had suggested a coming clash. Tung and Nu decided to make for Tay Ninh, to the house that was intended for Ngoc upon marriage. The driver of the truck was a man named Lieu, who ran a business transporting wood from the forest. Tung and Nu took up Lieu's offer, paying him in advance. They and their children climbed into the back of the truck, joining Lieu's two wives and nine children inside.

Cars and trucks, oxcarts, motorscooters, cars overloaded with people and belongings, and refugees on foot clogged the highway, fleeing in the direction of Saigon. Peasants who flagged down Lieu's truck, which had a Caodai flag and a white *ao dai* tied to its front, bought their way aboard. Lieu made it clear: no belongings. People agreed. "Lives first," they said. Incoming mortar fire caused Lieu to alternately slam on the brakes and step heavily on the gas. Several times, shrapnel rattled off the truck's metal roof, sending Lieu into a swerve. Each time the truck slowed or stopped, desperate people jumped onto the outside; some were clinging to its roof, others to its sides.

About halfway to the town of Tay Ninh, their trip was cut short. On both sides of the highway at an elevated bridge was a sea of South Vietnamese military trucks, tanks and armored personnel carriers. South Vietnamese soldiers advised Lieu that there was heavy fighting beyond. Lieu decided not to press on for several reasons: nightfall was approaching; his truck had no lights and was almost out of gas; and, with the exception of his family, most of his passengers had not eaten for days. If it came to making a run for it, neither they nor the vehicle would get far.

Lieu turned the truck around and about half a mile back took a cutoff to the tiny hamlet of Gieng-gieng. Nu had a great uncle there who she thought could help with water and food, gas for the

truck, and refuge for the night. She went to the house with a buck's head mounted over its front door. The house had been built by her great uncle's father, once a foreman on a French rubber plantation.

Uncle Thieu agreed to share his family's limited rice with her six children. Nu organized the women among the crowd to pick *rau muong*, a hollow-stemmed river spinach, which she boiled up with salt to feed everyone else. After a meal in the darkness of the garden, some thirty adults, including Nu and Tung, took shelter in two storage sheds. Some twenty children bedded down around the hearth in the back room of the house. Uncle Thieu, his wife and teenaged son slept behind a wall of sandbags in the main room.

For the next three or four days and nights, the hamlet was a haven from war. While sporadic artillery fire echoed from distant skies, the children roamed Thieu's lands, running freely between his house and the adjacent house of his married son. The adults themselves took much comfort in the impressive show of government strength half a mile down the highway towards Tay Ninh; never had they seen such a display in all the years of the war.

Uncle Thieu kept his American-made Phillips transistor radio tuned to Radio Saigon. On April 28, he reported that South Vietnam had a new president. General Duong Van ("Big") Minh, who had staged the 1963 coup against Diem that ended in his murder, was popular with peasants and was viewed as someone capable of negotiating conciliatory terms with the Communists.

EVEN AS MINH TOOK POWER, FROM ALL directions came reports of the Communists' advance on the capital. Their patrols had tested the city's defenses at its outskirts and found them in disarray; any South Vietnamese commanders who

might have provided leadership had either left the country or were scrambling to get out. The nights reverberated with the clanking of Communist tanks and the rumble of their truck convoys moving towards the capital.

On the morning of April 29, off Route 1 outside Trang Bang, in the fields east of the Caodai temple, two South Vietnamese army tanks and several trucks were arranged in a defensive position against possible enemy fire from the direction of the town's business district. A few dozen South Vietnamese soldiers were dug into foxholes. Some time before noon, an AP correspondent who had driven from Saigon up Route 1 stopped to talk to the one in command. As a couple of his soldiers cooked lunch in the shade of one of the vehicles, the major explained their final mission: "We will stand and die here," he said. "This is the front line. There's nobody farther than us and there is nobody else."

On that same day, the United States mission began its emergency pullout, staging the largest-ever helicopter evacuation on record. Hysterical and desperate South Vietnamese, claiming they had been promised an escape, begged, tried to bribe and fought to be included in evacuation plans. For eighteen hours, in worsening weather and rain, American helicopters shuttled continuously between a base near Tan Son Nhut airport and a flotilla of American ships and aircraft carriers sitting offshore. Bombing and shelling eventually forced them to evacuate instead from the seventh-floor rooftop of the American embassy. The last helicopter lifted off from the rooftop of the embassy in the early morning of April 30. Later that morning, the city's sirens sounded three times, indicating that the city was under attack.

AT FIRST LIGHT ON THE MORNING OF APRIL 30, Lieu decided to continue to the town of Tay Ninh. He siphoned enough gas from the Honda of one of Uncle Thieu's neighbors to

get his truck that far. Suddenly, incoming artillery fire pounded the hamlet. The crowd Lieu had brought, including Tung and his family, and the family of Uncle Thieu, piled into Lieu's truck and the uncle's own van. The two vehicles barreled down the road a mile or so, the uncle finally finding a place to shelter under the canopy of a large tree.

Mid-morning, Uncle Thieu called for silence. He cupped his hands over his ears, already pressed against his transistor radio, in an effort to better make out the words of Big Minh's broadcast. The general announced that he was surrendering power to the Communists and called on all South Vietnamese soldiers to lay down their weapons.

"It's over," said Uncle Thieu. "The war is over."

The children started to cheer. Twelve-year-old Phuc was delirious at the thought that she no longer had to be afraid of dying and killing, that she could be free from the stranglehold of panic, from having to second-guess the reach of death. By day, in fleeing mortar fire, and by night, in her nightmares, she had exhausted herself running from war. In her mind, its end meant the family could live normally again, could rebuild the big house and their lives in it. As she lost herself in such reverie, many adults broke down. "We lost, we lost," they said.

CHAPTER SEVEN

HALF AN HOUR AFTER THE BROADCAST of surrender, Uncle Thieu and Lieu drove with their passengers back to the uncle's hamlet. There they found villagers, young and old, spilling from their houses in celebration. Before Nu could object, her two teenagers, Dung and Tam, disappeared into the gathering crowd. At her insistence, the four younger children dutifully followed her and Tung, and Uncle Thieu and his wife, inside.

A crescendo of excited shouts came from the highway. Someone burst through the door of Uncle Thieu's house: "Come and see the Viet Cong! Come!" Thieu's wife, ignoring his order to stay behind, dashed out.

"I want to go! Please!" Phuc looked imploringly at Nu.

"You cannot."

Nu steadfastly refused to believe that the war could end so easily. She had seen not a single Communist soldier in the past few days, in contrast to the South Vietnamese military's show of strength days earlier up the highway. *This is a day like any other,*

she told herself. Not only did she refuse to give way to reckless celebration that the war might be over, she feared worse yet to come: what if the Viet Cong were behind the broadcast of surrender, their purpose to lure government soldiers and citizens onto the streets for a final bloodbath? No southerner could forget what had happened in Hue during the Tet Offensive.

At the highway, people rushed to see a passing North Vietnamese military convoy. Trucks, tanks and armored cars, camouflaged with leaves, rolled by, flying the flag of the Viet Cong. Atop them rode uniformed soldiers in pith helmets and boots. Peasants standing roadside stared with their mouths open, their eyes widening. They were stunned to see the enemy in such numbers, in uniform, and with heavy military equipment. The enemy they had known was the lone Viet Cong clad in black, with a blackened face, moving stealthily on foot in the night. The northern soldier they had derogatorily envisaged was so scrawny that, as the saying went in the south, five would fit in a papaya tree. Instead, smiling down at them were sinewy men and teenaged boys. Protected from the sun by the cover of jungle, their skin was pale and unblemished.

Phuc waited anxiously for second-hand news. Uncle Thieu's wife, breathless from having run to and from the highway, countered rumor with observation: "The Viet Cong are not ugly at all! They're handsome and strong. They're so young and fair!"

Phuc's excitement was shot with adrenaline when her sister Dung came back to report that she had just seen two North Vietnamese soldiers die, killed by a grenade.

"Wh-where did you go?!" Uncle Thieu almost choked on his own fear.

Dung had followed a crowd as far as the bridge on the highway in the direction of Tay Ninh. Uncle Thieu claimed personal acquaintance with the government's district commander and explained that he was a soldier who would die fighting before he

would surrender. Even as warning of more fighting issued from his mouth, Dung was running back outside. Human nature is to associate with victory.

The silence that suggested surrender lengthened. After lunch, Lieu announced his departure for Tay Ninh. Tung and Nu decided to continue as planned to Tay Ninh, and to shelter the family there until confirmation came that the fighting was truly over. They feared travel in the direction of Saigon to be unsafe, deciding that the Communists would most certainly meet pockets of resistance as they continued to converge on the capital.

The landscape on the way to Tay Ninh was stained with blood. In the vicinity of the bridge, dozens of bodies of soldiers from both the south and the north lay askew in death. In the middle of the junction of Route 1 with the fork that branched north into the town of Tay Ninh sat an abandoned truck of the South Vietnamese military, stacked with bodies of government soldiers. The road there was strewn with southern military gear: uniforms, helmets, leather boots, M-16 rifles, canteens and unit badges, even cigarette lighters and watches. The image conjured up was of government troops shedding any and all military identification in an effort to melt back into the civilian population.

From inside the covered back of Lieu's truck, Phuc saw North Vietnamese army trucks passing in both directions. In them, she caught her first glimpses of northern soldiers. She decided to keep her eyes averted; the sight of uniforms brought back images of war. Rocked by the motion of the truck, mile after mile on its way to Tay Ninh, she kept repeating to herself: *No more gunfire, no more bombs. No more gunfire, no more bombs.*

"RETURN TO YOUR HOMES. IF YOU DO NOT return to your home within three days, you will lose your home. Return to your homes. If you do not return to . . ."

The loudspeaker crackling forth was atop a North Vietnamese military truck. It made several passes by Ngoc's house on Future Road, the main road through the hamlet of Gate Seven, one of twelve numbered hamlets arranged concentrically around the Holy See and named for the corresponding gate in the wall that enclosed it.

The previous afternoon, the Tung family had been among the throngs of refugees and convoys of North Vietnamese trucks carrying Communist soldiers streaming into the town and outlying hamlets of Tay Ninh. The army trucks had discharged soldiers at public buildings, where they would live until their units were demobilized and they were sent back north. When those filled, the Communists knocked at the doors of private villas and spacious houses, asking occupants to "invite" the soldiers in. The family had found Ngoc's house empty, the renters gone, only some broken furniture left behind. It had electricity service, one sure sign that the Caodai zone around Tay Ninh had been blissfully free of war damage.

The family took stock of their situation. Nu would be the one to reclaim the house, as well as the family-run business. The rest of the family would remain behind in Ngoc's house and await word from Nu about the condition of the family home in Trang Bang. Should the necessary repairs be extensive, so that the family could not move back in immediately, they could live temporarily in Ngoc's house. Nu, taking the youngest, who was still on the breast, left immediately for Trang Bang.

In Gate Seven, the first days after the war's end were tranquil, but novel. Two homes near Ngoc's had room to spare for soldiers to bed down: a two-story white marble villa behind a high wall and locked gate immediately next door; and farther up the street, a grand villa belonging to the home of the family for whom Future Road was named. Heeding her mother's warning—"You might get lost!"—Phuc did not venture beyond the house and lot.

Phuc benefited, however, from Dung's curiosity. Her sister brought back details of the ways of Communist soldiers. Even their eating habits fascinated: they ate but once daily, a meal they cooked themselves of rice and various dried foods that, by their labels, came from China. The soldiers saw luxuries in what southerners took for granted: water drawn from a well, and soap. They spoke only when spoken to and answered politely all questions from the curious. They had an odd manner of keeping their eyes fixed ahead, and their lines sounded rehearsed: "I was too young to be a Communist soldier, but after I applied five times, finally I was accepted." Or, "My parents didn't allow me to be a Communist soldier, so I had to run away from home to join." No matter, the image conveyed was of young men with their sights fixed on glory. It would not take long for girls of the south to start flirting with them.

IN TRẢNG BANG, NORTH VIETNAMESE ARMY trucks were parked end to end along the strip of food and drink shops. Nu could hardly see into her shop for the soldiers milling about. The final battles of the war had haphazardly left their mark, leaving some shops unscathed, others destroyed. She saw that her shop had lost part of a front wall; a stall next to hers was obliterated. As she approached, Communist soldiers waved her away. They were using the shops as their temporary barracks but were also there to prevent looting.

Nu continued down the highway and turned off at the Caodai temple. It bore even more scars, inflicted by every weapon of war—napalm, bombs, mortar and gunfire—and yet it stood. She followed the footpath. Grandfather Kiem's and Grandmother Tao's house was serenely untouched. Auntie Anh's was damaged, but reparable.

A few steps farther on, Nu beheld a massive pile of rubble. The family home was no more. The walls and entire roof had collapsed.

There was no noise. Not even flies.

Nu saw that looters had been before her. Debris had been overturned, sorted and sifted.

The sun burned overhead.

How long she stood there weeping Nu did not know, but eventually, she became acutely aware of her clothes sticking to her back and her toes grasping at dirt. She had worn these trousers and blouse since she had fled Trang Bang. At some point during the last days on the run, she must have lost her sandals. She could not remember when she had last eaten.

For the next two days, Nu, together with her youngest, announced her presence on the side of the road directly opposite her shop. She set up a makeshift stove of three bricks arranged so that there was room underneath to burn wood and filled her stomach on sweet potato leaves picked from abandoned gardens. She had the company of other shopkeepers, nervously awaiting what the Communists would do with the capitalist south under reunification.

On the third day, a military officer acting in the name of "the people's revolutionary government" interviewed each in turn. He registered each business and owner and assessed license fees that had to be paid in order to reclaim the storefront.

"I don't have so much money—" Nu didn't see how she would pay the fee without first rebuilding and reopening her business. Panic rose in her. *We need the shop to live*, she thought.

"—I just have land."

She explained, and several days later, the official produced a document. "Sign this," he told Nu, "and you can have your shop back." Being illiterate, she did not know that with her signature she had sold the official the family's destroyed house and the land on which it sat for her license fee. And so, the family had no choice but to live apart, with the children and their father at Ngoc's house in Tay Ninh, which was at least a roof over their

heads, and Nu living and working at the noodle shop in Trang Bang. The family was resigned. "We have to eat," they said.

ON TUNG'S FIRST VISIT BACK TO TRANG BANG, he combed the rubble but was unable to find anything that looters might have overlooked. "There was not even one doll or toy left to bring to you," he told Phuc. He had looked no further after he came across a fragment of a carving of a fan, from the bench before the altar table. *Do not complain. Accept it,* he told himself.

Fortunately, in the last days of the war he had stashed some belongings at the noodle shop. Saved were the family's white garments worn for Caodai festivals, his collection of prayer books and classic folktales and romances, and a suitcase of mementos of Phuc's fame: an album with Nick Ut's picture and her medical records from the Barsky.

It would be three years before Phuc could bring herself to walk down the footpath. She had thought that, by then, a new house would stand on their property. From a distance, she saw the bombed ruins. She went no closer. *A cloud came to block the sun,* she silently lamented. *Before we had so much; now we have nothing.*

FARTHER INLAND AND EVEN FARTHER FROM the rice bowl of the Mekong Delta, Tay Ninh's heat felt much more oppressive than that of Trang Bang. Tung's family was accustomed to the green and leafy landscape of a rural setting on the edges of Trang Bang. Tay Ninh was a city, with ordered blocks, tarmac roads. Those who lived in communities around the Holy See either operated businesses in nearby Long Hoa market or worked in the city center.

In the ten square blocks of Gate Seven hamlet, dozens of

houses, most built of wood and brick, were crowded cheek by jowl. The only trees were those that homeowners strategically planted to shade their homes. Ngoc's house, built of wood with a roof of metal sheeting, betrayed the neglect of a rental property. It was falling down, in sore need of paint, and it had no shade. By day, the house heated up like an oven. By mid-morning, one had to seek relief under one of two soursop trees out back. The property also had no perimeter fence, so thieves were a constant worry. The rear lot was rough terrain, and mosquitoes were particularly troublesome. The floor of the house was pounded earth, and the bamboo furniture left behind broken and sagging. The toilet was a cement-lined hole a hundred steps to the rear of the house. Anyone using it had first to stop at the well to fill a pail to be carried along. How far the family had fallen was apparent whenever they visited Auntie Tiem three hamlets over in Gate Four. Their house in Trang Bang had once made her modest house look like that of the poor cousins; now its cement floor and the coconut palm shading its wooden roof looked like luxury.

Yet again, the family's crude living conditions took the greatest toll on Phuc. Pain had again become her insistent and demanding companion; even painkillers could not appease it. During the day, she depended on ice. At night, as the rest of the family slept fitfully in their hot, airless, cramped house, it was usually Tung who had to rush to Phuc's side to pound her back or hold ice to it.

The family's every material need or wish was Nu's to fulfill, and the list only grew longer. Painkillers for Phuc were among the essentials. Sacrifices had to be made. She could afford only two bicycles—used—one for Tung and one for Ngoc. When she could afford a third, it went to Phuc. She needed to minimize her exposure to the hot sun, and school, a mile away, was for her, a long, hot walk.

The family's adjustments to their divided life were many.
Ngoc moved back from the Holy See; immediately upon the end
of the war, the Communists had dismantled the Caodai admin-
istration there and confiscated all buildings but for the temple.
As for Nu, not only was she cut off from a daily relationship
with her children, but she could come home only if she closed
shop, which she did once a year during Tet. The children lost the
closeness of their extended family of grandparents, aunts,
uncles and cousins. The two miles to Auntie Tiem's was far
enough away that, what with school and homework, visits were
monthly at most. The family could not even be united to con-
sole each other in grief: the first year after the end of the war was
marred by two deaths. The ailing Grandfather Kiem suc-
cumbed; and Tung and Nu lost a baby born to them, their ninth
and last child. The infant was stricken with seizures and died at
three months in Trang Bang, having never met his siblings in
Tay Ninh.

While Tung's family had in common with their new neigh-
bors in Tay Ninh their religious faith, they were viewed suspi-
ciously because they had moved at war's end from Trang Bang, an
area known to have been contested during the war by the Viet
Cong. Even had Tung and his family any inclination to speak of
their past, because Tay Ninh had been a war-free zone, no resi-
dent there could fully understand what it had been like for them
during the fighting, or how it felt to find one's family home
destroyed and lives uprooted.

Once every two weeks, Tung took a bus from Tay Ninh to
Trang Bang. He went directly to the noodle shop, timing his
arrival and visit with Nu for after ten, when business slowed. He
went nowhere else. Any of his former neighbors and friends that
he did cross paths with would not so much as acknowledge an
acquaintance. He visited no family; any relatives he saw, includ-
ing Loan, were those who came to the noodle shop to help. A

constant fear for Tung was that someone might have had reason to dislike or resent him, or have found something he once said vexing. *They might be Viet Cong*, he cautioned himself, *and now in a position to take revenge.*

The night before her husband's visits, Nu stayed up to prepare a stew. So that it would keep several days, she simmered it in salted water until the water evaporated. Tung would go home either that evening—one immediate change the war's end brought was that one could travel freely at night—or the next day, with a hamper of rice and cooked food, plus a packet of money to last the family until his next visit.

As ever, Nu had found the energy to start again. She'd borrowed here and there and rebuilt her business, a table and four stools at a time. Her comforts at the shop would always be spartan: a folding bamboo cot, a nail on which she hung her clothes. When she did have a moment, usually as she fell with exhaustion onto her cot at night, she wept with regret that she had not even the time to miss her children, never mind worry about their well-being. However, to wish for a different fate was not within her nature. The Vietnamese rely on an ancient proverb to stem worry about how they will survive upheaval in their lives: "Heaven creates the elephant; heaven will make grass."

IN HONOR OF THEIR PATRIOT, THE COMMUNISTS, immediately upon their takeover of the south, renamed Saigon Ho Chi Minh City and gave its streets new revolutionary names. That the Communists' true intentions were not to share but to seize power became evident weeks into the takeover. Hanoi was plainly uninterested in a national reconciliation or the coalition of a "third force" government; many southern patriots who had joined the resistance front had believed that one of these accommodations might follow a Communist victory. Instead, as those

who had lived the secret life of a Communist agent surfaced to take control, the "liberation" of the south seemed to be a new campaign to divide the victors from the vanquished, to subjugate one to the other.

After the war, Hanoi followed the north's model for the south, creating neighborhood "cells" overseen by a leader who was both political commissar and police. Their job was to police reactionary thoughts and behavior. Conversations between more than two unrelated people were suspect. Public security agents and police, from both the military and civilian branches, were everywhere, uniformed and in plain clothes. At any time of the day or night, one was liable to enter a house without asking. In the north, the state would no more knock to come in than would a member of the family.

It became quickly and eminently clear that the Communists would trust only other Communists. Hanoi reserved positions of power—from provincial positions on down to village chief and local tax collector—for the thousands of retired Communist soldiers it sent south, or for their southern collaborators. Few if any had the qualifications to perform such jobs. The price paid for years in the forest was that few could even read or write. However, after their arrival, northerners stopped boasting about "the north, where there is everything." Many would be wide-eyed, bewildered at the sight of televisions, refrigerators and ceiling fans. Few had known the luxury of electricity. All were startled to see that southerners were better fed and clothed than any northerner, and rich enough to own motorscooters and cars, unheard of among peasants of North Vietnam. Southerners even appeared well spoken and well bred, contrary to what northerners had been taught. The typical northerner was from a village poorer than any in the south. He owned his clothes, maybe a *van,* on which to eat and sleep (but no other notable item of furniture), kitchen utensils and, maybe, a bicycle on which he rode to work.

A staple of his diet was often manioc, which if eaten too much makes the skin swell and turn yellow.

The instinct of the northerner assuming power was to grab at the riches that were there for the taking. Had the military official who had swindled Nu out of the family home not moved quickly, others would have beaten him to it. Cadres competed feverishly to either resell in the south or ship north for resale consumer goods, furnishings, air conditioners, refrigerators, machinery and equipment that had been removed from southern offices, factories and hospitals; even bathroom fixtures were stripped from hotels.

The mass indoctrination of southerners began immediately. Beneath a portrait of Ho Chi Minh, hectoring cadres from the province, district, town and hamlet tried to outdo each other, lecturing for four or five hours on the same topic: the inspiring leadership of the Communist Party, the representative of the proletariat, in the final, great patriotic victory over the imperialist Americans and the puppet regime in Saigon. Tung and Ngoc attended the thrice-weekly meetings; their cell leader seemed not to care that Great Uncle did not, as if the thinking of an old man was unimportant. In Trang Bang, Nu explained that her lateness for the first meeting was because of its early start; half-past seven was still the peak of her morning rush. The cadre there threatened her, if she were late again, with a fine or banishment to a "new economic zone"—lands covered in scrub jungle or denuded by chemical defoliants where the new regime trucked the unemployed and troublemakers. Neighboring shopkeepers would later trip over one another to be the first to report Nu's tardiness in hoisting the flag on a military holiday.

The euphemistically named reeducation program that began one month after the takeover removed what benefit of the doubt southerners were still willing to give the new regime. At first, it seemed benign; former southern soldiers were ordered to report

for thirty days' reeducation. Among those who went were the husband of Auntie Anh and the husband and son of Auntie Tiem. Thirty days passed; no one returned. Tension mounted as the regime called for reeducation not just of "false soldiers" but also of "false authorities." The net of suspicion fell on all former officials at every level of the Saigon regime, and on business people and religious leaders with real or suspected connections to the former regime or American interests. At the Holy See in Tay Ninh, police barred worshippers while they collected evidence later used to arrest religious leaders. Then it was doctors and teachers who had to report for reeducation. Teachers at Phuc's high school were told to bring food and water for three days. In the middle of the night they were loaded into military vehicles, driven three hours, then marched deep into the forest. There they were left to clear trees for road construction. On the tenth day, a teacher stepped on a mine and was killed. All came home ill but dared not register a request for medical help for fear of reprimand, or of being given tainted medicine. Only through back channels could families find out where relatives sent for reeducation were held. Many were marched to northern camps, too far for families to bring food and medicines. Some would never return. Relatives were told that they had died of an unspecified illness, or that their status was "pardoned but not freed."

Auntie Anh's husband did not return until five months later. Harsher punishment awaited Auntie Tiem's husband and son, both ranking South Vietnamese military and both suspected of having been among the Caodai military who worked at developing strategies against the Viet Cong. The husband would be held six years. Two decades on, the son was still being held.

Reeducation would not make one eligible for a job: "False thinking can take forever to correct," cadres said. Southern doctors and teachers held their jobs only until they could be replaced by others with the correct revolutionary credentials. Auntie Anh's

husband taught himself to refurbish motorscooters. Auntie Tiem's husband came home a broken man; she would have to support her three younger children by hawking sticky coconut treats to students on their way to school.

"You are excused from reeducation," authorities told Loan, acknowledging her escorted forays into the forest for the Viet Cong during the war. "But you cannot have your teaching job back." Her widow's pension was no longer payable because her husband had been a "false soldier." Only Viet Cong or Communist veterans and their families were entitled to state benefits.

Over the years, every time Loan tried to get any job on the state payroll, even a clerk's job at a state store, she was refused: "Your husband was an interpreter for America." She endured denunciations: "Anyone who worked for America sat around watching American films and eating chocolate!" At least Loan was able to say she worked at her mother's noodle shop, allowing her to avoid deportation to the new economic zones. Over the years, she would support herself and her daughter by selling, one by one, her colorful silk *ao dais*.

THE UNITED STATES CONTINUED TO REFUSE to recognize the regime in Hanoi. (Other Western countries, including Canada, had established diplomatic relations with North Vietnam upon its signing of the Paris accord.) One month after Hanoi's takeover, the United States extended to the whole of the country, including the south, the embargo that it had put in place against North Vietnam back in 1964. It also acted to block aid to Vietnam from institutions like the World Bank and the International Monetary Fund.

One effect of America's isolation of Vietnam was to hasten Hanoi's resolve to march the capitalist south down the socialist road. At first, Hanoi nationalized only those sectors and

industries owned by the former regime. But any prudent notion of waiting to see how the south would recover economically from the war was short-lived. Hanoi overlooked just how badly the south had been damaged by the war. The physical devastation alone was widespread: roads, bridges and rail lines had been bombed. The social structure had been turned upside down: cities were clogged with the dispossessed and homeless; the exodus in the last panicky days had drained the south of its educated and professional elite.

In an attitude that would prevail for the next decade, Hanoi held that the policies and structures that had worked in converting the north to socialism were good enough for the south. It ignored the stark differences between the conditions in the north and in the south during the two Communist takeovers, thirty years apart. Where northerners had been mostly rural and impoverished, southerners were mostly urban and at least middle income. Where northerners had been brought to their knees by famine caused by the ruthless and misguided policies of the occupying Japanese, southerners were mired in economic recession caused by the American withdrawal. What had worked in the north would, over the next decade, sow chaos and hasten the deterioration of the southern economy. It would encourage graft and corruption, from top- to low-level cadres. During the Saigon regime, corruption, though more notorious, had been the preserve of the elite and their cronies.

Hanoi immediately moved to bring rice distribution under the state's control, setting the purchase price at the level it was in the north. There, supply met demand. In the south, a shortfall prevailed. Farmers shunned the low price and diverted their production to the black market. Cadres at state stores did the same with state supplies there. The shortage immediately became a crisis.

Hanoi also imposed rationing on essential goods, sold through state stores and consumer cooperatives. It shut down

free markets. In those that did remain open, traders were harassed with steep license fees, taxes and fines. It took aim at the rich, seeking to rout profiteers by instituting sudden recalls of the *dong*, limiting how many old bills could be exchanged for new. The result was widespread hardship overnight. Before the first year was out, the Communists had struck at the commercial middle class by collectivizing small traders: hog farmers, tailors, shoemakers, leather-goods makers, printers, mat weavers and construction workers came under state control.

In Trang Bang, daily life had quickly become doctrinaire. Free markets evaporated before they were closed down. The state determined what was best for Nu's business. It decided her maximum daily allotments of rice, meat, soya sauce, fish sauce, sugar, salt, monosodium glutamate and other essentials. Her shopping at state stores consumed much time but yielded little. Soon, rice and meat were in short supply, or of such inferior quality that Nu couldn't bring herself to buy them. She steadfastly refused to water her soups down. *I don't want to cheat the customers,* she told herself, preferring to shut her doors early when she ran out of food to serve.

Two categories of people could ease the difficulties of the new life. The first were the former rich, with gold or valuable possessions hidden that they could sell as needed for food on the free market or the black market. The second were those on the winning side of the war, who could keep their heads up while everyone else had theirs down. They were the ones going door to door offering to buy household goods; they were the ones with access to cash, trucks to carry goods away and space at work places to store them until they could be resold. Jobs on the state payroll entitled them to a household ration booklet, and gave them ways and means to cheat or get around the system. That was of far more value than the salary, which, set according to the schedule in the north, didn't go far in the south.

Nu and her family were in the third category: everyone else, left to fend for themselves. Their choice was opening a family business or finding something to sell. As every packet of money he brought home from Nu bought less than the last, Tung and the family had to find ways to make money. He tried cultivating the finicky but fast-growing pepper plant in pots, selling the corns to middlemen. Ngoc tried pulling a flatbed trailer behind his bicycle, to transport goods and to gather wood from the forest and burn it into charcoal. He bought blocks of ice to chip and sell door to door, or he rushed out with the crowd to buy state newspapers—propaganda remained cheap—to resell as bags to wrap food. Tung and Nu conspired in smuggling coffee beans from Trang Bang to Tay Ninh, where they were in short supply and fetched a good price. Tung would sew them inside his trouser legs and hope to escape the notice of the highway police, who boarded buses and confiscated goods at will, often sharing the proceeds of their corruption with the driver.

By any comparison with the north, the south still fared well. But what was grievously painful for southerners was to remember days of plenty during the American presence. Tung and his family could remember when the *ham* in their house once stored one-hundred-kilogram sacks of the whitest rice and they had fish and meat at every meal, every day. Now, some meals were only vegetables and poor-quality rice. They once wore silks and fine printed cottons; now Nu queued at state stores for coarse cotton. Western medicines were once readily available; after the war's end, even Vietnamese-made medicines were scarce. It could take three days to get to the front of the line at a state pharmacy, only to come away empty-handed. As painful as this abrupt deprivation was the humiliation of joining lineups for inferior goods, and of having to spend so much time scrounging for basics. Each family needed at least one person full time for shopping alone, time once spent socializing, going to the temple, enjoying oneself.

Even years later, tears would well in Nu's eyes when she remembered that she had been unable to get a cadre's approval to buy the food offerings necessary for the onward journey of Grandfather Kiem's soul; that because of the expense she procrastinated too long in taking her feverish infant son to a private doctor; that she had been able to mark the marriage of twenty-year-old Ngoc to a girl named Tho with only an exchange visit of the in-laws over tea and biscuits.

"WHO LOVES CHILDREN MORE THAN UNCLE Ho?" Like every child, Phuc had been taught the words and tune of the best known of the propaganda songs that paid homage to the dead patriot Ho Chi Minh. A version sung by a children's choir played on television, on radio, on neighborhood loud-speakers. It did not take long for an unofficial version to circulate. The original went:

> Last night I dreamed of Uncle Ho
> His beard was long, his hair was gray
> I kissed him tenderly on both cheeks . . .

while the words sung under one's breath went:

> Last night I dreamed of finding a lost wallet
> In the wallet I found 4,400 dong
> I was so happy I ran and showed it to Uncle Ho
> He smiled at me. "Let's split it," he said.

And so under the Communist regime the charade of presenting one thing publicly and believing something else privately was enacted even by the children.

In the new social order, the state was, in theory, supposed to

replace all other emotional attachments: family, school, work and play, religion and traditions. The state even woke people up: at half past four every morning, the loudspeakers outside Ngoc's house burst to life with staticky martial music, while a metallic voice exhorted young and old to exercise: "4-3-2-1! 4-3-2-1!" Nightfall finally brought an end to the earsplitting din of social- ist slogans, Party directives and revolutionary music. The only acceptable culture was revolutionary. Banned were books and music deemed "socially evil and poisonous" and "unconstructive works" that made people "weak"—children's fairy tales, romantic novels, mysteries and histories of French and American involve- ment in Vietnam. Afraid to be seen with incriminating evidence, Tung built a bonfire of the classics and romances that he'd saved from destruction in Trang Bang. The terrified turned in more than was asked for—typewriters, dictionaries, even eyeglasses.

Phuc's was the first generation in the south to be schooled by the Communists. School was dramatically different in purpose and practice: all textbooks came from the north; political studies were about the life of Ho Chi Minh and the Communist Party and its "final great patriotic victory." The war was taught just as it had been and still was being taught in the north. The aggressor was America; they had set up a command in the south, brought in soldiers, airplanes, warships and weapons like toxic chemicals and napalm. The heroes were northerners; they had endured the American bombings. Examples abounded of their patriotism and love for the Communist Party: youths had offered their own bodies as machine-gun mounts, climbed on exposed places to better shoot at enemy planes; women and children had brought hot rice and soup to those manning anti-aircraft gun emplace- ments. The shorthand of these lessons? Everything the Party did was correct and good; everything the Americans and the puppet regime did was wrong and bad.

The biggest change came with the "working for socialism"

days *outside* the classroom. At the elementary school level, it was one day a week; at the high school level, two weeks out of four. Younger students came home with instructions to bring in a rake to collect leaves in the schoolyard, cleaning supplies to wash the school's walls, desks and latrines, tools to dig garden plots on school lands and plant vegetables. Older students were sent to work at various cooperatives: making chalk, repairing furniture, cutting shoes out of plastic, raising chickens, slopping out pigs.

The "working for socialism" days were the only times Phuc let it be known that she'd been injured in the war. No one knew, except perhaps the local tailor, who might have pondered the difference in measurement between her left and right sleeves. When the work was heavy and consequently, for Phuc, too tiring, or would have required her to be under the hot sun for too long, she approached her teacher. "I am wounded from the war," she'd say. "I cannot do that." The first time, by way of explanation, she'd had to raise her long sleeve to reveal her burn scar from the napalm attack; war victims were rare in Tay Ninh.

Only Phuc and her younger siblings kept any enthusiasm for school. Her older sister, Dung, soon quit. Where once high school had been a place to meet friends, it had become another arena for public scrutiny, criticism, denunciation and bullying. She dreaded her turn as class leader, when she was expected to single out classmates for bourgeois behavior: girls with long or painted nails; girls and boys engaging in frivolities like strolling about, enjoying tea or coffee, or listening to the wrong music. She was bored by the endless political studies, put off by being used as an unpaid laborer. Some parents took their children out of school. "You are learning nothing," they said. "You can work for the family instead." Dung moved to Trang Bang, where she worked in her mother's noodle shop until she married a village boy and rice farmer.

Phuc had none of her two older sisters' penchant for many, or

lively, friends. The single influence she sought in her life was religion. Ngoc's new wife, a sensitive and thoughtful girl, was devoutly Caodai. Tho and Ngoc provided Phuc with a virtuous example to emulate. Ngoc's distrust of the Communists hardened at the same time as his adherence to his religion deepened. With his hotheaded temperament and penchant for speaking his mind, he sought to impart his religious devotion to Phuc. At fourteen, she made a decision to become a more devout Caodaist, and, like Grandmother Tao, eschew meat completely.

Especially when in Trang Bang, Phuc was policed by fear. She had learned the dangers of a loose tongue. *My mother said something stupid*, she told herself, after the family had lost their land to the greedy official, *and the man from the government took advantage.* She visited no one, staying only in the shop, minding the cash. She knew her mother appreciated and trusted her at that job; whenever Tung or her siblings worked the cash, Nu's tallies at day's end were always short, because they helped themselves without telling her. Phuc was of no help cooking. Her mother had always forbidden her from the stove, and besides, Phuc would always be terrified of being burned. The sound of oil popping from a pan was enough to unnerve her; after a traumatic experience, the mind goes on permanent alert.

When Phuc tired, which was easily and often, she retreated to a stool in the corner. She waited for those moments when her mother would come over and take a stool beside her. Resting her head on her daughter's shoulder, Nu would let out a long sigh. Neither would speak. *Only my mother suffers more than me*, Phuc would tell herself.

IN THE SECOND YEAR OF THE TAKEOVER, THE noodle shop, which kept the family afloat in the sea of deprivation, was snatched away. One day, authorities removed the sign

hanging above Nu's shop. In its place, they put up one that said: "Government Eat and Drink Shop." The identical sign hung at seven other establishments on the strip. "You are an employee of the state," authorities told Nu. "Your job is to cook." The wage the state paid her was low, less than one-tenth what she had taken home when the shop was hers.

The local government sent in a manager and ten other workers. The manager took over Nu's former responsibilities for buying and ordering supplies. No longer could customers be served; the state considered that bourgeois. Customers were now required to line up, give their order and pay at the cash. The orders were passed to the cook. When the food was ready, the cook yelled out the number on the receipt and the workers carried the food to the customer with the corresponding ticket. At closing time, all but Nu would drop everything and go, leaving her to clear the last tables, upend the stools and sweep the floors. Nu asked the manager if the state could hire her mother and daughters. "They are not qualified," he replied.

They no longer look as poor as when they arrived, Nu thought to herself of the new workers, recognizing them to be among those who had arrived in Trang Bang at war's end and moved into the houses of those who had fled. She exchanged not a word with them, did not even know their names. She did not know what they were paid. She did not introduce Tung to them, and felt their cold looks whenever he visited. Husband and wife consequently felt compelled to keep their visits short, and talk to a minimum. After taking a bowl of soup—deducted, of course, from Nu's wages—Tung would leave.

Though Nu did her part as the cook, the workers seemed not to care whether customers ever got their orders. Nu fumed as steam disappeared from the bowls of broth, while workers sat around, doing nothing except maybe cleaning their fingernails, and customers sat fidgeting at tables uncleared of dirty dishes,

too nervous to complain. One day, Nu could not restrain herself. "The soup must be eaten piping hot!" she told the manager. He barked back: "You are to concentrate on cooking!" She was the shop's only steady worker; it was a revolving door of ever-changing managers and workers, with ever fewer customers.

UPON NU'S SALARY CUT, THE FAMILY SHE supported sank to depths of poverty they had not known existed. Meat and fish immediately vanished from the table. When the vegetables had to go, each meal was only rice, flavored with soya sauce or a dipping salt mixed with chilies. Under these conditions, Great Uncle fell gravely ill and took to bed. Tung nursed the old man, and when the end came, Nu cried harder than when her own father had died. The local Caodai temple that served Gate Seven stepped in to assist with funerals of the poor. It sent some young women to sing prayers, and young men to pull a dragon-shaped catafalque bearing his coffin to the burial land.

Phuc suffered from a persistent soreness in her left forearm, and knowing that the family could not afford a prescription should it be prescribed, Tung himself tried to treat it by daily rewrapping it in bandages of banana leaves. However, her arm became increasingly painful and after a week had turned an angry dark red and swelled to twice its normal size. Phuc was frantic, the pain as excruciating as any she could remember. A frightened Tung registered a request for her to see a doctor. It turned out she had an ingrown hair that had become entangled and infected beneath scar tissue. The doctor who removed it told Phuc that she needed an antibiotic. "Unfortunately," he added, "we cannot give them out for your case." It did not need to be said that such medicines were reserved for Communist cadres, who also enjoyed the privilege of quick medical attention. At the doctor's suggestion, Tung collected and crushed the leaves of a

wild plant common to Tay Ninh, mixed them with salt for use as a poultice and boiled them to make an effective, if almost unbearbly bitter, potion.

The family's worsening situation forced Phuc to rely solely on ice for pain relief. "I'm worried that Phuc will go crazy in the head from pain," Tung told Nu. Ice itself became a burdensome expense, which Tung insisted came before food for the family. Eventually he was forced to begin selling off some of the family's possessions for food. The first to go was the clock; he told the family if they needed to know the time, they could go ask the neighbors.

When the cupboard at Ngoc's house was at its barest, the household of seven, with Tho pregnant, was down to cooking one cup of rice once a day; in normal times, the household consumed four cups twice a day. To that one cup, Tho added four cups of bo-bo—normally animal feed—and several times the normal quantity of water. No one asked for a second helping; a stomach partially empty was preferable to one full on bo-bo.

Tung dared to risk asking for help from the neighbor living in the two-story white villa behind the high walls. Knowing the old man to have recently returned from reeducation, Tung gambled that he would not betray him to authorities. During the war, the neighbor had worked on a program to persuade Viet Cong deserters to come to the side of the South Vietnamese, and before that, on the American-funded program of compensation for war damage to property owners, a program Tung had once benefited from.

The old man looked at the album Tung brought over, at the news picture of a girl running from a napalm attack, the yellowed clippings and the medical file from the Barsky hospital. He wasn't sure if he'd seen the picture before, although while working for the Americans he had read foreign newspapers. He heard Tung out, about how the American firemen's donation of

three thousand dollars to the family was to have been held in a Saigon bank until the war was over. The old man said he could ask his connections in the international agencies still in Ho Chi Minh City. Or he thought his daughter, married to a South Vietnamese air force pilot, could help. The couple had left for the United States as the end came and were now living in Canada. When the neighbor summoned Phuc to come meet him, she had no inkling why. It was some weeks later that the two men quietly met again. Far too dangerous, said the neighbor, to make any inquiries from within Vietnam. The two never spoke of it again.

FORTUNATELY, A NEW MANAGER AT THE noodle shop, a reasonable man, saw that customers were staying away, and that the only tables filled were occupied by workers sitting around. He arranged to have the shop returned to Nu. To pay the new license fee, she signed over a last plot of land the family still owned in Trang Bang. Contaminated by the debris of war and hardly large enough for a vegetable plot, it was adjacent to the family's old property and had been overlooked by the military official who'd swindled her. Nu restored her husband's name to the shop, and the customers began to return.

CHAPTER EIGHT

SINCE THE WAR'S END, NGOC'S HOUSE-
hold had welcomed the annual holiday of
Tet with special anticipation. Tung and the children looked for-
ward to Nu coming home; she stayed the three days of the holi-
day and sometimes longer, depending on whether she judged the
fourth or fifth day of the new year to be the more auspicious for
the shop's first day of business. But this holiday had the added
excitement of Ngoc and Tho's newborn twins. Born prematurely,
the girls' survival had not been assured for several weeks, but now
they were thriving.

As the lunar new year of 1978 approached, Ngoc's household
was a hive of activity. Phuc was washing banana leaves to be used
to wrap and steam ceremonial glutinous rice cakes. One of Phuc's
siblings was rolling sugary rice-flour balls, another sweeping the
floor. Two younger brothers were out back, showering by pouring
water over each other. The twins lay swaddled on the floor.

A high-pitched whistle fractured the calm. An explosion tore
the air as if into pieces, followed by sounds of spraying brick and

splintering wood. Screams came from inside the house and from the garden. Two nearby houses and a school had been struck; the family's house was untouched. "*Phao kick!*" someone yelled. Phuc found herself under a bed with one of her younger brothers who remembered the routine upon hearing mortar fire. Minutes later, the distant wail of ambulance sirens could be heard in the town.

Never had the residents of Tay Ninh expected the escalation of the war that had begun with cross-border raids by the Cambodian Khmer Rouge to reach into their town, ten miles away. The mortar bombardment had come just as Hanoi had proposed terms for a cease-fire and negotiation with Cambodia. Ngoc's household stopped all preparations for Tet and went for their digging tools. Tung chose a spot for a *ham* several steps out the back door under one of the soursop trees, in the hope that its branches could offer added protection from incoming mortar rounds.

Throughout the town and its outlying hamlets, people went into a frenzy of digging. Few had experience of the firepower of war. In the war with the Americans, the town had only twice been attacked by Viet Cong or Communist forces: the first time was during the Tet Offensive; the second time, the following year, when the Viet Cong occupied a section of the town for a couple of days. Then, no one in the town had built a shelter. This time they did. In the next days, the authorities organized adults and children into digging brigades. People dug trenches, filled and hefted out bags of earth, lay timbers as a ceiling, then repacked earth over top. Throughout the town, gardens were dug open beside private homes, government offices, schools and hospitals, and pavement was ripped open at regular intervals along city roads.

Except for a few families like Tung's, most in the town were so unfamiliar with war that they did not recognize the language of shells and rockets. Some were confused: should they run away from or towards the sound? How should they pray: that it fall on

them, or away from them? Few in the town had ever seen or used a shelter. Those in charge at public buildings had no idea how to organize mass evacuations: in drills, never mind when the real bombardment came, they were the first to panic.

THE CAMBODIANS AND VIETNAMESE HARBORED a centuries-old racial antagonism dating back to the emergence of the Viet people as a nation. Much of what is southern Vietnam was chipped and ceded from the ancient Khmer kingdom; Vietnamese expansion southward came at the price of a shrinking modern-day Cambodia. America's overt extension of the Vietnam war into Cambodia and Laos—in bombing campaigns over the Ho Chi Minh Trail and ground incursions from South Vietnam—united two hereditary enemies on the same warring side: the Viet and Khmer peoples, their patriotic interests represented by the Viet Cong and the Khmer Rouge, both of which were communistic, the latter led by the mysterious Pol Pot.

A serious rift opened between the two when the Viet Cong signed the Paris accord in 1973. The Khmer Rouge felt their Vietnamese counterparts had betrayed their cause in Cambodia. The accord silenced the skies over Vietnam, but for the next seven months (until Congress barred American military involvement in Indochina) the Americans redirected their planes over Cambodia, in a last, fierce bombing campaign against supply routes into South Vietnam. In retaliation, the Khmer Rouge struck at the Vietnamese Communists' arms depots, hospitals and base camps inside Cambodia.

Events in Cambodia outraced those in Saigon. China, seeing Hanoi's advance on Saigon, maneuvered for control and influence by injecting military aid to help the Khmer Rouge push to the Cambodian capital, Phnom Penh. They entered the city on April 15, 1975, and two days later it fell. Saigon would fall two

weeks after that, but there the similarities ended. In Vietnam, Hanoi sought to bring the south in line with the socialist north. In neighboring Cambodia, Pol Pot, governing what he called Democratic Kampuchea, was singularly radical, conducting purges of opponents and committing atrocities in the name of reshaping a new Khmer society from "year zero." He turned the Khmer Rouge into an efficient, ruthless machine of murder, and Cambodia into the "killing fields."

Pol Pot's genocidal plans included killing or driving out of Cambodia all the ethnic Vietnamese. Beginning in the spring of 1977, Khmer Rouge soldiers conducted murderous raids on Vietnamese villages at and over the border with Tay Ninh province. While ethnic minorities always tend to live in border areas, the shifting of Indochinese borders over the centuries rendered these boundaries meaningless to locals. Fleeing survivors brought harrowing tales of medieval barbarity by Khmer Rouge attackers. That fall, a Hungarian journalist saw charred bamboo huts, decapitated bodies and mass graves, though Vietnamese authorities prevented him from filing a story. The state-controlled Vietnamese media maintained a façade of normal neighborly relations, partly to mask Hanoi's retaliatory strikes and defensive actions inside Cambodia's borders. In December, an elite Vietnamese army attacked from a half dozen points along the border. Six days later, on December 31, 1977, on Radio Phnom Penh, Pol Pot's government denounced Vietnam as an "aggressor" and announced that it was severing diplomatic relations. Tension opened immediately on another front in Indochina; China declared its support, backed with arms shipments, for Cambodia in its war with Vietnam.

PHUC FOUND THIS WAR HARDER ON HER nerves than the one that had marred her childhood. Because

bombardments let up only for a day or two here and there, the town had to maintain a constant defensiveness. In contrast, though the war with the Viet Cong was protracted, its guerrilla nature allowed, even required, peasants to adhere to time-honored daily rhythms. They stayed within delineated "safe" areas, knew areas to be either in control of one side or another or contested, and could count on any occupying Viet Cong to stay but a few days, then melt away. Phuc had known weapons with enormous destructive power—not only mortar fire, but planes dropping bombs and napalm. She recognized that the damage inflicted on Tay Ninh was by comparison limited, light and even superficial. But what made its townspeople jittery was fear of the unknown: being struck dead by mortar fire, or becoming a victim of the brutal Pol Pot—equally unfathomable ends.

In her own reaction to war, Phuc recognized a deepening sadness. She saw herself watching, innocently, at the age of nine, the canisters of napalm tumble end over end from the airplane, not realizing danger until fire enveloped her. At fifteen, she saw herself changed by the knowledge of physical pain and the grief of loss. Those who survive war know it has in store more cruelties than death alone.

The shelling and mortar fire came in the afternoons. Students at Phuc's high school had dug shelters in the central courtyard outside the door of their classrooms. Though mortar rounds never struck the school, injuries of sprained ankles and bruises, even broken bones, were inevitable as thirty to forty students pushed through the bottleneck of the door and fell in a pile inside the *ham*. Phuc was as frightened at being caught in the crush as being left out. Riding home after school was also nerve-racking; one had to ride quickly, yet be ready to throw down the bicycle and make for a roadside shelter.

Phuc felt safest at home, where running for the *ham* was less panicky. Her father, having curtailed his visits to Trang Bang, was

also there to help. It took several sets of hands to ready the twins for the *ham*: one to fetch their milk and bottled hot water to keep them warm, one to hand them off, another to receive them. Once inside, attention turned to more immediate dangers: rats and snakes. One student at Phuc's school died after being bitten by a snake in a shelter. Her brothers were charged with checking the *ham* several times a day, and more often during the rainy season, when it was filled with several inches of water.

Days became weeks, weeks turned into months.

The face of Tay Ninh changed. The town swelled with Vietnamese refugees from the border areas. Camps were set up for Khmer people fleeing Cambodia. The town's clinics overflowed; unemployed southern doctors and nurses were recalled. Death visited, not always leaving a body behind to bury. One of Ngoc's neighbors, a teacher working in a border village, returned after a weekend in Tay Ninh minding a sick relative and made the grisly discovery of a pile of burnt skulls, among which was most certainly that of her sister, another teacher there. Shudders went through Tay Ninh at gossip of decapitated bodies clogging tributaries of the Mekong River near the border. Immediately, Tho threw out Cambodian-caught fish, once a local mainstay and now shunned. The Vietnamese military intensified its census, mostly in Saigon, but ever more families in Tay Ninh also gave up sons to fight the war. That Hanoi's motives were more than retaliation was apparent to those who knew of the secret camps set up nearby to train a Vietnamese-led Khmer resistance army to fight Pol Pot.

LITTLE NEWS CAME TO THE WEST OUT OF Communist-ruled Indochina, and the news on Radio Phnom Penh evoked little more than remark at the oddity of Communist brethren at war with each other. However, the jostling for

domination between two Communist capitals, Hanoi and Bei-
jing, is what partly drove Vietnam that summer to join the Soviet
Union's trading bloc, COMECON (the Council of Mutual Eco-
nomic Assistance, which included as well East Germany, Poland,
Czechoslovakia, Hungary, Romania and Bulgaria). Vietnam
became the only member country, other than Cuba, outside East-
ern Europe. However, in a balancing act between the superpow-
ers, Vietnam also pursued the normalization of diplomatic
relations with the United States. On that front, negotiations that
fall in New York achieved a breakthrough. Unexpectedly, the Viet-
namese representative renounced Hanoi's demand that America
honor a secret promise made by Richard Nixon at the time of the
signing of the Paris cease-fire accord in 1973. Nixon had pledged
to North Vietnam that, were it to sign the accord, America would
pay $4.5 billion in war reparations. The dropping of the demand
by Hanoi so advanced talks on normalization that American offi-
cials, led by Richard Holbrooke, began studying the floor plans of
the villa that had been the American consulate in Hanoi during
the French colonial government as a possible location for a new
embassy there.

Then, American President Jimmy Carter abruptly shelved
normalization with Vietnam. What Vietnam did not know was
that secret normalization talks had begun that summer between
Washington and Beijing, and in those talks, China had made
known its hostility to Vietnam. Success with China was
announced in mid-December. The American public expressed
no disappointment in failure on the Vietnamese front: since
summer, American television networks had been airing disturb-
ing scenes of fleeing "boat people." Such images evoked abhor-
rence among many Americans for the Vietnamese regime,
serving as a reminder, yet again, that Vietnam was best left
behind.

BY EARLY 1978, AN ATMOSPHERE OF CRISIS hung heavily over Vietnam. Hanoi was disappointed at what it perceived as resistance on the part of southerners to the move to socialism: rationed goods were leaking to the free markets; collectives were breaking down; speculators were hoarding, particularly rice. Instead of faulting its socialist policies, Hanoi decided that tighter measures were needed. It stepped up collectivization and extended it to the agricultural sector. Then it struck what it hoped would be the body blow to remaining capitalists. One evening in late March, police raided homes and businesses in Cholon, the Chinese business district of Ho Chi Minh City, where the regime estimated half the money in circulation and most of the gold holdings in the south resided. They seized businesses, gold and securities belonging to ethnic Chinese. To gut cash holdings, the regime followed up with currency recalls. Then, it tried to force the newly dispossessed Chinese to move to the new economic zones.

Meanwhile, fear of impending war with China had sent ethnic Chinese flocking to Vietnam's border with China; even more rushed to leave when China temporarily opened it. Angry at China for backing Cambodia, Hanoi was also paranoid about the power of ethnic Chinese within Vietnam, and wanted rid of them. It decided to allow them to leave officially, but at a price: ten *taels* of gold for an adult, five for a child.

On a low-level cadre's state salary, the rate of which was set according to those in the north, one *tael* of gold was equivalent to three to five years' earnings. Corrupt cadres saw an opportunity to profit by exacting bribes. The official procedure was that those wishing to go had to register at a southern coastal public security bureau, provide the correct papers, pay the official fee, then wait in a containment camp for a departure date and a seat on a state-sanctioned boat. The boat, with a security official onboard, would be bound for a coastal containment camp but ultimately for an island off the country's southern tip. Once a boat arrived

there, the occupants were left on their own to push off onto the high seas.

The effect of registration was to single out families for surveillance and as targets of vengeance. It gave vindictive authorities time to deny them higher education, to strip them of their livelihoods, homes and possessions. Leaving unofficially at least gave one a chance to hide gold or smuggle it out of the country.

Thus began the ordeal of the boat people. Over the next two years, some 400,000 ethnic Chinese and, as well, Vietnamese, using fake Chinese identity papers, pushed off in all manner of unseaworthy boats from Vietnam's shores into the perilous South China Sea, hoping either to reach international waters and be rescued there, or land in Thailand, Malaysia or anywhere between Hong Kong and Australia. More than 40,000 would perish at sea. The total escaping Vietnam by boat would exceed 1 million before the exodus all but ended in the late 1980s.

The two years of the peak from 1978 to 1980 coincided with grim shortages in both the north and south. Annual rice harvests since the takeover had been poor, the result of bitter cold in the north, and heavy rains, floods and typhoons in the south. Since war's end, the state rice-purchasing agency in the south had fallen far short of its target, meeting only half of it the first year. It would worsen year by year, so that in 1978, when the black market price was thirteen times that of the state price, the agency met only 12 percent of its target. Farmers continued to hoard supplies for their own families and for the black market. The economy was grinding to a standstill. The state had little hard currency—imports were four to five times the value of the country's exports—to buy fuel, machine parts or raw materials for its factories. Life stretched thinner as food, medicines and medical equipment and funds were reserved for Vietnamese soldiers fighting in Cambodia and others guarding the country's 797-mile northern border with China.

By the fall of 1978, several army divisions moved through Tay Ninh, amassing for a full-scale invasion of Cambodia. Knowing that the loathsome Pol Pot quashed any resistance within Cambodia, Hanoi had concluded that its own troops would have to oust him. In late December, the start of Cambodia's dry season, Vietnamese forces attacked. Within two weeks, they were sitting outside Phnom Penh. Pol Pot and some of his Khmer Rouge soldiers, along with several hundred thousand Cambodians whom they forced to join them, retreated to jungle enclaves on the western border with Thailand, where they would wage guerrilla war. (Pol Pot led them until his death in 1998.) Hanoi gave the command to take the capital, then sent in soldiers to occupy the country.

China's retaliation came two months after the Vietnamese had overrun Phnom Penh. Having achieved normalization with the United States, it attacked without condemnation across the border with Vietnam. Announcing that their purpose was "to teach the Vietnamese a lesson," for sixteen days in February 1979 Chinese troops cut a vicious swath along the border, leveling several Vietnamese villages, factories and coal mines. Ultimately, China's actions would send Vietnam decisively into the Soviet orbit of Sino-Soviet rivalry. Its military occupation of Cambodia, where it installed a regime sympathetic to Hanoi, and its fight against the guerrilla Khmer Rouge would stretch into a decade, further straining Vietnam's already bare treasury and turning into its own "Vietnam," a term that has come to mean a protracted and futile military struggle.

VIETNAMESE PEASANTS LOOKING FOR SOLACE in what they saw as the baldness of their poverty had a saying: "The Communists control you only if you have hair on your head." Security cadres had become more zealous and menacing in

their unannounced rounds from house to house. Possession of an electric fan was evidence enough for authorities to raise taxes or assess household duties. Impostors at the door became a problem, as security uniforms could be had on the black market: no one dared confront someone who might have legitimate authority.

No security cadre suspected hidden wealth at Ngoc's household. When he and Tho had a second set of twin girls, yet more of the household was relegated to sleeping on the floor. That did not mean that the neighborhood cell leader did not visit and linger. And he could more often than not be counted on to show up just as the household was sitting down for a meal. It was essential to greet one's cell leader with not just any smile, but an *ardent* one, to show one's enthusiasm for building socialism.

"Have you eaten?" Tung would ask. "Please join us."

"Oh," the cell leader would say, adjusting the face-saving toothpick stuck between his teeth, "I've had my meal—but, sure."

Worst off was the low-level cadre on the state payroll, who was paid as little as thirty to forty *dong* a month. On the open market in the south, a pound of sugar was twelve *dong*, a pound of rice eighteen. His household ration booklet did give him some privilege. However, because of more severe rice shortages in the south, Hanoi had cut the monthly rice ration there to one-half the level set in the north, itself set at a near-famine level, only one-fifth the international standard of grain consumption for individual subsistence (four to six kilograms of rice, compared to the international standard of thirteen to fourteen).

Nu's profits at the noodle shop, about one *tael* of gold every one or two months, was some twenty times what a low-level cadre made. But on that income she fed ten adults and children plus Tho's four babies. As well, she did what she could to help the two widows, Grandmother Tao and Loan. The war with Cambodia had brought some opportunities: Tung and Ngoc sometimes dealt in imported cigarettes smuggled from Cambodia. Despite

Nu's entreaties, Tam, the second son, dropped out of high school and did not go on to technical school. Instead he tried to cash in on Tay Ninh's swelling refugee population with a business of transporting goods with his bicycle. A collision he had with a truck damaged the sight in one eye; Tam's impairment was not, as Western reporters would later report, from the napalm attack that injured Phuc.

Phuc looked with envy at families able to live in more comfort. As she saw it, they were the ones who lived in decent houses with decent furniture, regularly had enough to eat and could keep their children in school. She assumed that they were able to save and hide gold. Or that they were lucky enough to have a relative who'd made it out to the United States at the end of the war in the south and was sending either money or items that the family could resell.

ON THE EVE OF A FEAST HONORING AN anniversary of the death of Great Uncle, Phuc and Tam took a late-afternoon bus to Trang Bang to bring back what Nu had prepared. She herself planned to arrive the next day. It was late evening by the time they returned to Tay Ninh with hampers of rice, cooked dishes, fruit, fruit-peel wine and cigarettes. And it was long after midnight when Tung and Tho laid out the family's finery reserved for such festivities and, exhausted, joined the rest of the sleeping household.

"Phuc! Wake up!" It was a younger brother. "Thieves came in the night! They stole everything!"

The ancestral altar was bare; gone were the dishes for the feast, their best clothes. The thieves had cleared the broken armoire by Tung's bedside, taking his radio, his watch, all his *dong*. They had made off with every item of daily use: every last dish and utensil, every jute bag of clothing, everything but furniture. The family dog lay outside as if drugged; the most

underfed of the household, it had undoubtedly been thrown laced meat. Phuc's youngest brother recalled that at about nine o'clock the previous evening he had dismissed a noise under the bed as the scratching of the dog; in hindsight, it must have been the thief waiting for the family to go to sleep.

Nu arrived to find the house filled with tears and misery. Replacing even the basics would take weeks of effort, scouring the markets and chasing down peddlers. For one month none of the family had anything more to wear than what they had slept in the night of the robbery. Finally, Nu sent two bolts of mate-rial—the printed one was for the girls, the plain for the boys—and extra money to give the tailor to "put wings" on his sewing machine.

Tung was distraught that the thieves had also taken the suit-case containing mementos of Phuc's injury, knowing that its con-tents—the album with the picture and clippings, the medical records—would fetch nothing on the street. *Everything about me is gone*, Phuc thought, feeling nevertheless unaffected. However, the loss of her bicycle was painful to her; the thieves had taken all three. She would not own another while she lived in Tay Ninh. To cut her walking time under the sun to and from school, she now took a shortcut through the fields, though she fretted the whole time about running into "bad people" out to mug those alone. Despondent, she wept bitterly to Tho. "We are back to having *nothing*," she said. Her sister-in-law lectured her with words that Phuc would take strength from in the years ahead whenever she felt defeated: "If you kneel down, life is a mountain; if you stand up, life is at your feet."

SAVE FOR THE ELDERLY, IT WAS A SAFE GUESS that any and all—even perhaps Communists—who were unhappy contemplated escape by boat. The preparations were

complicated. A cover had to be found for activities such as selling off possessions to raise money to buy gold to pay for a seat on a boat, arranging false Chinese papers, preparing lemon-juice-soaked sugar cubes as sea rations, sewing makeshift life jackets. One also had to leave a relative with enough gold, in the event the attempt failed, to pay a bribe to secure release from jail or ensure less harsh treatment. Security cadres lectured against attempting escape. They warned that one could have all one's property seized if caught. They spoke of what awaited those who got beyond the rifle range of seaside patrols: death by starvation and thirst at sea, rape, kidnapping and murder at the hands of Thai pirates, cruelty in refugee camps. This did not come as a surprise; those with shortwave radios had heard survivors' accounts on the BBC World News. What mattered was that some *made it*. And those without a future in Vietnam preferred to risk death at sea rather than remain behind.

Because the state had means of overseeing young people, either through school or registration in the military, they found it harder to attempt or carry out escape. Nonetheless, there were telltale absences at Phuc's high school. Following a discreet exchange of looks between classmates, one would ride his bicycle by an absent student's house. If somebody unfamiliar occupied it, word spread furtively: *They are gone out.* Once, police promptly arrested a student who had returned after a brief absence. Someone had reported his tan, which aroused suspicions that he had got it from being out on the open sea.

Phuc kept private her wish: *It is my dream to escape.* Outwardly, one's only ambition was to live happily under the Communist regime. She saw no use in saying anything to her family; even if they had the money to gamble their hopes of escape on one member, there was none among the family who was a good swimmer or who had experience on the water. Partly on a whim, but only with the certainty that she was not addressing someone

likely to be an informant, she once raised escape as a question. Phuc was away with her father attending the anniversary of the death of someone on his side of the family, and after a shaman conducted a séance, she later visited the old lady in her home.

"I want to know about my future," Phuc said.

"What do you want me to look for?"

It was not the first time Phuc had dabbled so. As children, she and her siblings would be given a few coins by their parents to ask a fortune. As teenagers, she and friends would enjoy it as an entertainment. Phuc didn't take these consultations seriously, never using them, as Auntie Anh or her parents did, as a means of keeping in contact with the dead.

Phuc was clear in her reply: "I want to go to another country."

The old lady tied a red scarf over her head, knelt and began to pray aloud.

Finally, she turned back to Phuc.

"Two old people will appear in your life to help you," she said.

"Will they help me to go out?"

"Yes, yes, you will go out—but, you will come back."

Phuc wanted to understand: "I will not go out for the rest of my life?"

The shaman smiled. The consultation was over. "Your destiny is that there will always be good people to help you," she said.

Phuc pressed some money into the old lady's hand. *What she said was good news*, she told herself. Then, shaking off the burden of false hope, she added as an afterthought: *I don't believe in fortune-telling, so I won't be waiting for those two people.*

BY THE FALL OF 1979, VIETNAM FACED A mounting national economic crisis and near-famine conditions in both the north and south. In the south, supplies bought by the state rice purchasing agency fell for the fifth consecutive year; in

that fifth year, farmers sold only 10 percent of the agency's target. Hanoi had little choice but to reintroduce some free market capitalism back into the south and relax its doctrinaire approach there. It introduced cautious liberal economic reforms: it raised state agricultural prices and permitted limited free markets for producers outside the state plan; it allowed handicraft cooperatives and family businesses such as hog farming, which like other businesses had been forced to buy supplies from the state, to both buy directly and sell surpluses on the open market; and it closed down highway checkpoints that regulated the commercial movement of goods. Over the next two and a half years, these reforms would be gradually extended and would be enough to begin to turn around the rice shortages and stave off economic collapse.

In her final three years of high school, Phuc experienced her own rejuvenation. Not since before she had been wounded had she felt as healthy or strong. Headaches still troubled her, but less frequently. She examined her changing teenager's body and saw that as her breasts grew, the burn scars that once reached from her back round to her front seemed to be shrinking. Her shoulder-length hair and long sleeves covered any scarring. The singeing on one cheek had long ago faded from a blackened spot to a blemish and, finally, had disappeared. She had perfected mannerisms to hide any sign of deformity: to disguise the shortness of her left arm compared to her right, when standing, she hung her right arm naturally, but rested her left on her hip. And when writing, she adopted an angular posture, resting her right arm far enough ahead on the tabletop to hide the stiffness from her neck to right shoulder.

She looked to enliven her life outside the home. On Saturday evenings, a neighbor who owned a television would open his doors to the neighborhood, and often Phuc would wander over. If it was the usual Soviet revolutionary programming, a showing of a Stalinist film classic such as *How the Steel was Tempered*, the

crowd evaporated. If it was Vietnamese traditional music or opera, Phuc stayed around, along with the mostly older crowd. Like the majority of her classmates at school, she resisted entreaties from the leader of the Ho Chi Minh Communist Youth League to join, or at least participate in its discussion groups, social events and volunteer work in the community. Finally, afraid of repercussions from repeated excuses, she accepted an invitation to a gathering at his house. His parents were there, hosting ten of her classmates to tea and fruit. She was the lone one among them who was not a League member. Noticing the boy being attentive only to her, Phuc was ashamed that he would behave so in front of his parents. That decided her; she would not join the League.

Though pleased that boys were paying attention to her, Phuc constantly checked herself with a reminder that, because of her wound, she would never be able to compete on the basis of either beauty or strength. She would never have either. *One way that I can make myself feel better and stronger*, she told herself, *is to become a deeper believer in Caodai*. Of her siblings, she was the only one to join Tung, Ngoc and Tho at the four daily rituals at the temple in Gate Seven hamlet. Only on the three or four major annual religious holidays would Tung insist that the entire family go to the Holy See. It was an ever-smaller pilgrimage; never was there any overflow into the great temple's upper balconies. Other adherents were deterred by heavy police presence, the strength of their belief losing out to their fear of the Communists' disdain for religion. The interior of the temple mirrored the sad state of the religion; police had early on smashed the standing gong, along with other decorative accoutrements: vases, figurines, cranes, phoenixes and dragons. Vandalism and theft were constant problems. There was no money for upkeep; the tiles in the marble floor defining each of the nine ascending levels to the altar were badly chipped, as were the eight plaster columns entwined with

dragons supporting the dome at the far end. Ever since the Communists had dismantled the Caodai administration, each temple relied solely on volunteers to fill all positions, from priests to caretakers.

Phuc signed up for the all-female choir at the local temple. One of its members became her closest friend in Tay Ninh. For the first time since the end of the war, Phuc allowed herself to share confidences, though only within the security of her home or her friend's. Ten years older, Lien was the oldest of six children from a family who lived in a house behind Ngoc's. Because their father had not returned from reeducation, the girls had had to quit school to keep the family going. Mother and daughters did piecework, sewing buttonholes and cuffs by hand. Both Nu and Lien's mother were volunteer heads of females of their respective parishes. The position, which carried the rank of a ritual servant, required them, once a month, to preach at their local temple and to visit and pray with the females of every household. Lien and Phuc did their mothers proud: they donned their white *ao dais* and chanted prayers with the choir once daily, and, depending on when Phuc finished her homework, together attended the evening service at six or at midnight. On weekends, they attended all four daily rituals. "I *enjoy* it," Phuc told her family, borrowing a word not used since early childhood days in Trang Bang.

"MA, YOU SAW THAT THE CAMBODIAN driver was in today?"

In the summers when school was out, Phuc went to Trang Bang as often as possible, trying to share a daily life with Nu. The hour for mother and daughter to talk began long after the bamboo blind had been pulled down over the doorway, behind the last customer of the noodle shop. Sometimes, long since having gone to sleep on Nu's narrow cot, Phuc woke when her

mother joined her there, usually after midnight. Lying against the softness of her mother's breast, Phuc felt the security of childhood that had been cut short. The two would steal from Nu's sleep to talk, their conversation punctuated by the glare of headlights from passing truck traffic.

The Cambodian driver was a regular customer, stopping in on his way to Ho Chi Minh City with a load of dried fish in his truck and, on the return, with a load of rice. Nu had remarked before that every time he came in, he looked for Phuc.

"He told me today: 'I love you.'"

"Be careful," Nu warned. "Truck drivers have no home life. They leave a wife behind and keep girlfriends on the road. It is not safe to marry such people. That kind is not for you."

Never had Nu worried about her first two daughters when it came to boys, but with Phuc, she was strict and protective. She need not have fretted; Phuc herself stood on emotional guard. "I don't love him," she said of any and all who sought her attentions and wanted her company. She had given thought to both marriage and children; she wanted but expected neither. *Boys see me as normal,* she had told herself, *but once I become close enough to marry one, he will have to see my scars. Once a boy sees me as ugly and weak, how can he still love me?*

In their nightly conversations, Nu sought to guide Phuc by painting pictures with words to invite her daughter to make choices best for her life, and to discourage her from making others. Often, Nu recounted the grim news in her parish. She was deeply troubled by the stillbirths and deformed fetuses, which village talk blamed on *chat doc mau da cam.* What the Americans called Agent Orange the Vietnamese called a "deadly poison to the skin of the color orange," a term they also used to embrace every contaminant of the arsenal of war that they feared they had been exposed to, from herbicidal sprays seeping into their wells to buried shrapnel pushing at the roots of vegetables in

their gardens. Neither Nu nor Phuc gave voice to their worst fear: the effects of a napalm burn on one's ability to have children, or even survive pregnancy. Nu did not shy, however, from speaking of unhappy marriages, of divorce and women left on their own. One had to be strong and beautiful, she said, to start over, to remarry.

Nu would steer talk to the order of the universe beyond her own earthly existence. "Before your father and I go to our next lives," she would begin, "we want to know that you are looked after." Gently, but persuasively, she spoke of women who chose in their old age to devote themselves to the temple. She praised two she knew who were living out their lives at local temples: one was poor, born into nothing; the other, formerly wealthy, had donated all her land and monies to the religion. Spiritually, they were equal. Neither had any worry of earthly needs: the temple gave them shelter, and the followers fed them. Nu herself stopped in often with rice and fruit, leaving behind two envelopes of money, one for the temple and one for them. She described such "nuns" of the religion as "angels" who brought comfort in their prayers for the sick and for the dead.

Phuc's mind floated easily towards that beatific image. As a doctor, she would bring medical care to people in need. And in her old age, she would work for a temple, living there if need be.

On her eighteenth birthday, on which, by Caodai religious law, a child passes into adulthood, Phuc made the choice to follow Caodai for life. In keeping with Nu's wishes, she returned to the temple in Trang Bang, so that her mother herself could conduct part of the ceremony to formally induct her into the religion. As Phuc prostrated herself on its cool marble floor, she felt contentment. "I will try to do good," she pledged, "for myself, for my mother, for my family and for my religion."

EVERY YEAR, STUDENTS WHO GRADUATED from high school in the south could sit for the university entrance examinations, mid-summer in Ho Chi Minh City. One's acceptance depended completely on the score assigned by the Student Recruitment Bureau. Each student's final score was a sum of points in two parts: results in the examinations (by subject, including compulsory examinations in political indoctrination and socialist morality); and the bureau's assignment of points, plus or minus, to one's revolutionary history going back three generations. Consequently, no matter how high one scored on the examinations, the "wrong" revolutionary credentials could ruin one's chances of getting into university.

Upon her graduation in the summer of 1981, Phuc went to the local bureau and registered to take the examinations with hopes of getting into medicine. She also filed a Certificate of Confirmation of Identity regarding her revolutionary history. That summer, Nu gave her money to hire a private tutor. The examinations were difficult; it was not uncommon for a student to take two or three tries to get even the minimum grade. Depending on that year's professional quotas set by the government, the lowest acceptable score might get one into the least-valued faculty (teaching) at the least prestigious college. Even after they got into university, some rewrote the exams year after year in hopes of improving their score so that they could transfer into a better faculty (such as engineering or medicine), or a better school.

For the first time in years, Phuc's headaches returned. To keep up the pace of studying, she had to take three or four painkiller tablets daily. *What would it be like to study like a normal student?* she wondered. Because she kept her head down all summer, the usual late-summer tradition of watching for blooms on her mother's favorite flowering plant almost passed her by. The plant had been a gift from Tam, uprooted from the forest. A truck he was driving broke down there, and while waiting to walk out at

dawn he was bewitched by a fragrance. He traced it to a plant with large snow-white flowers, its petals like two open palms, its tall stamens like ancient sailing ships. It was the famed *quynh hoa*, exalted in traditional Vietnamese literature and art. The plant's buds open only in darkness and usually after midnight. When they do, it is as if nature's perfume is spilling from a bottle. The buds on Nu's plant opened on average once in three years. Times she was summoned home for naught, she was philosophical: "The plant will bloom when the family's time has come," she would say.

This summer, the plant had a multitude of buds. As the first of the buds began to open, Nu woke the sleeping Phuc.

The family turned to Nu. "Ma, what good fortune shall you ask for?"

Were they scholars or artists, they would have been sipping wine and putting pen to paper, writing poems or rendering a painting. Nu raised a cup of tea: "The noodle shop will have many customers and Phuc will score a high mark in her examinations."

All in all, there were ten blossoms that year, the most that plant would ever produce.

The bureau sent Phuc her final score. The highest attainable score was in the low twenties; Phuc was assigned a score of twelve, two short of the minimum standard that year. Phuc was pleased; her goal was within reach. Her score seemed to confirm that the bureau regarded her revolutionary history as neutral. She herself had thought that nothing she reported in her Certificate of Identity worked for or against her. No one going back the requisite three generations had been a Viet Cong fighter, none was on the state payroll, and she had not joined any Communist organization. On the other hand, neither had anyone in her immediate family worked for the French, the Saigon regime or the Americans, and none had been a government soldier. She had thought

to add a line about her singular brush with war: "When I was nine years old, I was wounded by a napalm bomb."

Among Phuc's graduating class, the student who, from the sixth grade on, had won the highest academic honors scored well below the minimum. Three more times that student would write the examination; never would the bureau score her higher. When their time came, three younger siblings, also excellent students, also failed to attain the minimum. "That family has no future because of what their father did before Liberation," others said. Not so for Phuc: the province of Tay Ninh notified her to report that fall to a "pre-university" school in Tien Giang province in the southern Mekong Delta. Such regional schools prepared students to retake the university entrance examinations in the coming year.

THE FIRST LEG OF THE DAY-LONG BUS TRIP from Tay Ninh was to Ho Chi Minh City. From there, Phuc took a pedicab across town to another bus terminus and boarded another bus south to Tien Giang, the capital of the province by that name, and the name of one of the major branches of the Mekong River that empties into the South China Sea. The city was picturesque; its houses were built on stilts over hundreds of inlets. At first, Phuc was repulsed by the smell of tidal flats and by the brackish, brown water that came in with the tide, gathering in stagnant pools during the rainy season. However, the tides set the rhythm of the town, each house relying on them to fill their individual cement reservoirs with water.

The school in Tien Giang served students from some ten provinces. Home provinces paid their students' tuition, as well as providing a dormitory and a monthly stipend for food, books and other expenses. Tay Ninh was one of the poorer provinces; its monthly stipend wasn't enough to live on. Every weekend, Phuc took a same-day round trip to Trang Bang—Tay Ninh was out of

reach in a day—bringing with her laundry to wash in the cleaner well water there and returning with cooked food and money from Nu. Often she saw both parents there, her mother at the shop, her father at the outbuilding of the temple. Having seen Phuc through high school, Tung now considered his fatherly obligations mostly discharged. By the conventions of the Vietnamese family, a parent's job is to raise the younger children until older siblings take over the responsibility. Nu kept her fold-out cot at the shop and Tung hung a hammock at the temple in exchange for some caretaking there.

The six-month course was anything but onerous. Phuc enjoyed making new friends and did so easily, especially because they were all from the same province and, typically, of the same religion. By day, she and her friends liked to cross the "monkey bridges" over the inlets, named for the agility needed to navigate the spindly poles lashed together. A favorite entertainment was to gather at midnight in a crypt at an adjacent cemetery to ask resident ghosts for predictions about future loves and next year's entrance examination results.

Phuc's closest friend was her roommate, whose ambition was also to study medicine, and they made a pact to try to attend the same school. Trieu was as carefree as she was pretty. Phuc was always cheerful and laughing, but ever mindful of the task at hand: to study. Trieu had a boyfriend, and Phuc found herself fending off more than one hopeful. Most eager among them was an older student, respected by the teachers for his grasp of all subjects, which was superior to their own. The military had interrupted his engineering studies to send him to Cambodia, and he was now hoping to transfer into medicine. Though amused to hear he was warning others "Kim Phuc is mine!" Phuc hardened her heart against him when he sent her a love letter. "I want to be with you and love you," it began. It offended her sense of propriety.

From the start, Phuc kept from her classmates and teachers, Trieu and her nine other roommates, the secret hidden under her long hair and her long sleeves. They thought she had a passion for coconut milk; she drank it because she thought it was good for her skin. During a chemistry lecture about the burning qualities of phosphorous, she kept to herself the question on her mind. In class, "*napalm bomb*" blared in her mind, against an image of her body afire and canteens of water being poured over it. Later, she went to her textbooks. From what she read there, she concluded that the water would have fueled the napalm still burning on her body. She kept her silence: *I am smiling on the outside*, she told herself, *but I'm sad inside*. Not until the second to last week of the last term at Tien Giang did her classmates get any inkling that she was a student *not* like any other.

IN LATE APRIL, A BLACK CAR PULLED OFF Route 1 in Trang Bang and stopped in front of Nu's noodle shop. Two men stepped out. They were looking for the "Tung" for whom the shop was named according to the sign above it. The man they addressed themselves to was not, as they thought, Tung, but his second son, Tam.

"Do you have a daughter named Kim Phuc?" they asked.

"She's my sister," Tam replied.

"Was she wounded by napalm in the war?"

When he said yes, they produced a letter from the government of Hanoi that was an order to officials in Ho Chi Minh City to find her. The two were from the information ministry of the People's Committee—the formal governmental authority from Hanoi on down—of Ho Chi Minh City.

Two days later, Phuc was summoned from her mathematics class. She stepped outside to meet four men standing in the hallway. They stared, saying nothing.

"Yes?" she asked politely, smiling.

Finally, one spoke. He sounded skeptical. "You are Kim Phuc?"

"Yes—I am Kim Phuc."

"*You* are the girl in the picture?"

A memory flashed into Phuc's mind: a newspaper, maybe a magazine, being passed from hand to hand among neighbors crowding the veranda of the big house, as if it were a marketplace. "*You* are the girl in the picture?" one of her chums asks.

"Yes," Phuc replied to the men. "I am the girl in the picture."

"You are the *real* Kim Phuc?"

She laughed. "Yes, yes—I am for real!"

"But, you look very—*normal!*"

Phuc understood. She drew up the sleeve on her left arm.

She returned to class, amused by the conversation in the hallway, but also puzzled. Why would the government be interested in someone wounded so many years ago? In the dying days of the term, she reflected on the picture. She had not given it a thought since, along with the other reminders of her past that her father had kept stored in the suitcase, it had gone with the thieves who'd robbed their household as the family lay asleep. She acknowledged that, when first published, the picture had attracted some attention. But she saw it as a pebble thrown into a pond. The ripples on the surface had long since disappeared. *So much has changed since the end of the war*, she thought. *Why would someone want to pluck that pebble from the bottom now?*

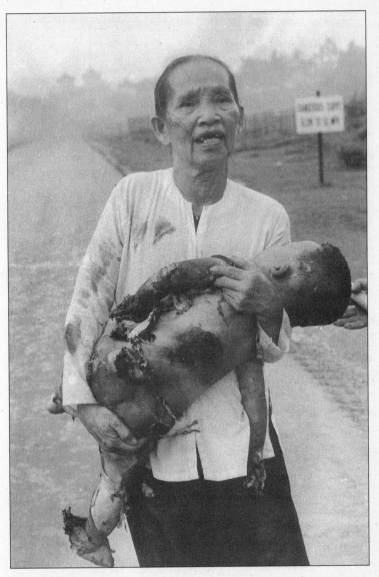

Aftermath of the napalm strike, June 8, 1972, Trang Bang, before Kim Phuc runs out. Grandmother Tao carries three-year-old Danh.

[Nick Ut/AP]

Stars and Stripes, Pacific Edition, June 10, 1972.

Tung, Nu (holding a granddaughter) and family, Trang Bang, 1973
and (bottom) Kim on Route 1, seven months after the napalm strike.

[Perry Kretz/*Stern*]

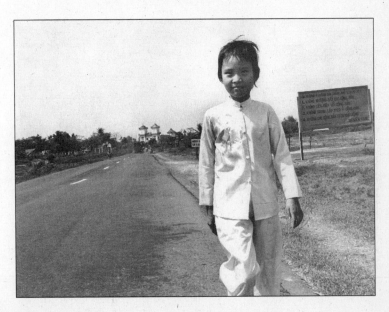

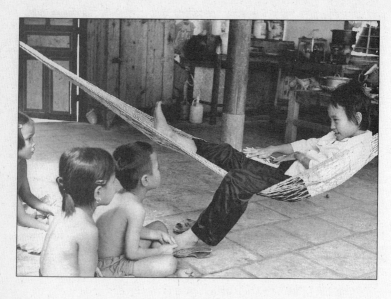

Kim at home, Trang Bang, 1973.
[Perry Kretz/*Stern*]

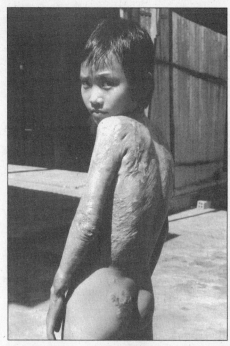

*Kim baring her
wounds for the camera,
and (below) seeking
pain relief with
a shower, 1973.*

[Perry Kretz/*Stern*]

Kim, aged twenty-one, in front of Caodai temple, Trang Bang, en route to Germany for medical treatment.
[Perry Kretz/*Stern*]

Accompanied by Perry Kretz, she arrives in Bangkok.
[AP]

Kim and Nick Ut, reunited in Havana, 1989.
[Jim Caccavo]

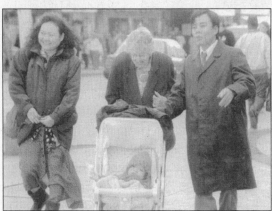

Kim and Toan with Thomas, and Nancy Pocock, Toronto 1995.
[Shannon Sweeney/ *Mail on Sunday*]

Nu, Tung, and their son, Tam, Trang Bang, 1996.
[author photo]

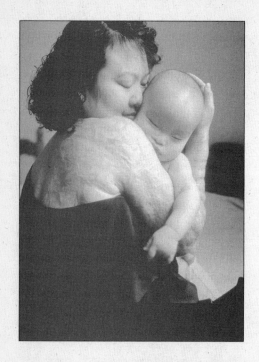

Kim and Thomas,
portrait for Life, *1995.*
[Joe McNally/*Life*]

Kim after ceremony
at Vietnam Veterans
Memorial, 1996.
[AP]

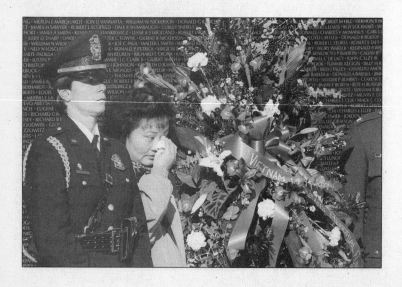

CHAPTER NINE

IN 1980, THE FIFTH YEAR SINCE IT HAD taken over the south, the leadership of the Communist Party in Hanoi promoted into its ranks a career diplomat with knowledge of the West. Born in the north to a peasant family and once jailed by the French for resistance activities, Nguyen Co Thach had served North Vietnam on diplomatic postings, including a stint in India, and had risen by 1960, at thirty-five, to the rank of deputy foreign minister. His role as chief aide to North Vietnam's negotiator at the Paris peace talks sent his star on the ascendancy. Thach himself later led the Vietnamese side of the talks in New York that brought Vietnam and the United States to the brink of normalization.

In 1980, when Thach became foreign minister and an alternate politburo member (the first English-speaking member after Ho Chi Minh, he would be promoted two years later to full member and, as well, made deputy premier), postwar Vietnam was seeking to break its isolation from the West. Its purpose was pragmatic: to get the United States to ease the trade embargo

against it. The world's third-poorest country by per capita income, Vietnam was in desperate need of aid and investment. As well, the country wanted to offset its economic dependence on the Soviet Union. The Soviet *ruble* underwrote the Vietnamese economy to the extent of about one-quarter of its gross national product. It delivered such foreign aid by purchasing at higher than world prices Vietnamese exports (mostly crude oil, wood and sugar cane) and, in turn, sold Vietnam more petroleum than it needed so that it could turn around and sell the surplus to earn hard currency to buy food and other critical imports from the Soviet trading bloc.

Considered a moderate in domestic affairs, Thach had an ability to interpret the West's views to the Party leadership, and the astuteness to see that the foreign press could help influence Western public opinion in Vietnam's favor. In dropping Vietnam's demand that the United States honor Nixon's promise to pay war reparations, Thach had recognized the unpopularity of asking Americans to honor a commitment made by the discredited president. Similarly, he accepted that Americans' reactions to Vietnam were emotionally charged. In December 1981, his foreign ministry invited the first ever delegation of American veterans to Hanoi to discuss two issues that were contentious in America: the health effects of Agent Orange and the fate of 2,477 American servicemen officially listed as missing in action (MIA) in Indochina (most in Vietnam, a few hundred in Laos and a handful in Cambodia). Two months later, Richard Armitage, the most senior American official to visit Hanoi since normalization talks were cut off in 1977, came to discuss the MIA issue. No one foresaw that this subject would come to dominate America's agenda with Vietnam for the next ten years. Well financed by right-wing interests in the United States, the issue fed on grudge and hatred left over from America's defeat in Vietnam and preyed on the emotions of relatives of MIAS. Thach foresaw something different:

"Tell your people we are friends," he told visiting veterans and the foreign press in 1981, "not enemies."

FOR MANY AMERICANS, THE MENTION OF Vietnam brought back the shame of America's defeat there. Reminder of that came 3 million times over in its veterans. Having treated them with indifference at best, more typically reproach and scorn, not until almost ten years after the last American troops had left Vietnam did America pause to acknowledge those who had served and died there. For one week in November 1982, thousands of veterans, many in wheelchairs, gathered in Washington for vigils and ceremonies, culminating in a march on Veterans' Day to dedicate the new Vietnam Veterans Memorial. The monument's design was itself the subject of dispute: a thin, angled wall of polished black granite, set in a grassy knoll, listing 58,044 names beginning with the first American to die in the conflict and ending with the last. (Eventually other, more traditional monuments would be built and names of more known dead would be added to the wall.) That America had unresolved feelings about Vietnam was evident in the thin crowds lining the route of the march, the antiwar protesters that tagged behind, the heart-wrenching notes and mementos left at the wall, the suicides that would take place in its shadow. It has been said of monuments that they are a way for the living to have a dialogue with the dead, they who have seen the unspeakable.

IN THE YEAR LEADING UP TO THE TENTH anniversary of the signing of the Paris accord, and the tenth anniversary of the subsequent departure of the Americans from Vietnam, the Western media began to visit Vietnam in droves.

They had blinders on, intent on doing the predictable "decade after" stories. Returning Western correspondents had covered the war from the point of view of the Americans and South Vietnamese, and only in the south; they had not reported from the Communist side. A chosen few had covered the departure of the last American prisoners of war from Hanoi, but most were seeing the north now for the first time. They remembered the former Saigon as freewheeling, where anything from the West could be had in its street markets, so they were taken aback to find Hanoi empty of cars and motorbikes, backward and impoverished, its street peddlers selling single envelopes and single cigarettes, ballpoint pens that they had refilled with hypodermic needles. When the journalists came south to Ho Chi Minh City, they looked anxiously for contradictions to what they had seen in the north, especially anything that might invoke their nostalgia for the former Saigon. That one could still buy croissants from a French patisserie or Kodak film on the black market figured prominently in their stories.

One journalist returning for the first time since the war was the German photojournalist Perry Kretz, with *Stern* magazine. In Ho Chi Minh City, he submitted himself to the obligatory interviews with whichever subjects his minders trotted out. Journalists were escorted to the former Caravelle Hotel. During the war, the hotel, built by the Catholic diocese, had been the city's most modern. It now housed the information ministry, which shepherded foreign journalists. The point of these interviews, as Kretz knew, was to give the Communists' version of the war. He did not expect that his line of questioning would end up hitting so close to home.

Kretz was sent two veterans—a man and a woman—to interview, and was told that both were "revolutionary heroes." *Communists*, he said to himself, noting the severity of the woman's clothing and hairstyle, the absence of make-up. Told she had been

in the resistance, he turned to her first, asking, "Why do you have so many decorations?" She replied that she had been a "courageous guerrilla fighter" during the resistance. It came out that her "great victory" was a 1971 bombing that had killed twenty-seven and injured forty at a Saigon bar on Dong Khoi—the street known to Americans as Tu Do and to the French as Rue Catinat. She herself had thrown the grenades from her motorscooter.

"You missed me," Kretz said to the decorated woman.

That spring, after a grueling week in the central highlands covering American troops, during which they had run into a Viet Cong ambush, Kretz had been relieved to be back in Saigon and at the Continental Palace Hotel. He had showered and changed and enjoyed dinner with a colleague at a French restaurant. On their way later to a bar down the street, they were accosted by a beggar, who'd lost both legs. Kretz's colleague dropped some coins into the outstretched hand, only to have them flung back. "I tell you," said Kretz, "that's bad luck." The bar was crowded. Feeling hemmed in, the two moved to empty seats against the back wall. Minutes later, the blast came. Kretz and his colleague were among only three who escaped death or serious injury; the other was a waiter. Kretz's colleague was the only one to walk away—he went on to another bar that evening—while Kretz would suffer permanent damage to his hearing.

Before leaving Ho Chi Minh City, Kretz took a walk down Dong Khoi. He was nostalgic for the days when it was Tu Do, when pretty bar girls walked arm-in-arm with tall, good-looking American soldiers. Now, girls sat on the backs of the motorscooters of their Vietnamese boyfriends, waiting for something that would never happen. He saw that there were still street urchins pestering foreigners like him to buy something, but where they had once been Vietnamese, now they were outcast Amerasians, born of Vietnamese mothers and American fathers.

He found the former location of the bar where he had survived the woman's attack; the shabby state cafeteria there reminded him of ones in East Germany.

BACK AT HOME IN HAMBURG, KRETZ LOOKED for and found two articles in his files: a Saigon newspaper clipping about the terrorist attack on the bar, and one from his last assignment in South Vietnam, about ten-year-old Kim Phuc, the napalm victim, home from hospital. *Another miracle,* he said to himself, comparing their escapes from death.

When he had first begun in journalism, Kretz's attitude towards his profession had been: "You cover it as you see it, and you move on." From Vietnam, he had gone on to cover the conflict in Nicaragua between left-wing Sandinista rebels and the American-backed right-wing government. Yet, perhaps calling up the empathy he felt as a parent—Kretz's son was now nine—he had found himself prey to tugs of emotion, from time to time discreetly taking dollars out of his pocket and putting them into the hands of a poor Nicaraguan mother.

The fade of Kim Phuc's smile during their shoot together that day in Trang Bang replayed in his mind. He recalled his self-apology: *I should have been a doctor.* Now it rang as excuse. He was decided: he would find her and see how she had fared.

Kretz contacted the Vietnamese representative in the liaison office in Bonn (West Germany and Vietnam had not restored full diplomatic ties). In charge was an English-speaking woman named Dr. Nguyen Lam Phuong. She was not a medical doctor; she used the title to emphasize her Western education. Kretz thought she looked less like a north Vietnamese cadre than a cabaret singer in a Paris music hall, what with her deep bangs, pageboy hairstyle and stiletto heels. But most atypical was her inclination to be helpful. Kretz did as she suggested and

composed a request on *Stern* letterhead for her to pass on to
Hanoi. In it, he explained his wish to see again the girl in the
famous picture, whom he had met a decade earlier.

More than one year passed without reply. Finally, in the
summer of 1982, Phuong brought word that Kim Phuc had been
found. What seemed an inexcusably long process had in fact been
expeditious by the standards of Vietnamese bureaucracy: Phuong
had kept from Kretz the fact that her contacts in Hanoi were at
the highest levels: her father was the foreign minister, Nguyen Co
Thach. Still, it would be some months yet before Kretz could free
his schedule to go to Vietnam.

TWO DAYS AFTER PHUC LEFT TIEN GIANG
and arrived home in Tay Ninh, ready to put her mind to retaking
the entrance examinations later that summer, the same four men
who'd showed up at her school arrived in a van. They came to
take her to see their boss in Ho Chi Minh City. Quickly, Phuc
changed her clothes, ran a comb through her hair and climbed
aboard. As the van passed by the noodle shop in Trang Bang, she
longed to stop to share with her parents the excitement of being
escorted to the city.

At the information ministry Phuc was shown to the office of
someone named Thach (no relation to the foreign minister). An
interpreter for visiting foreign journalists, he also wrote for the
Communist daily. Thach was talkative, explaining animatedly to
Phuc that the search for her had begun upon a German journal-
ist's request to Hanoi. "He met you ten years ago and he could
not forget you." Hanoi's order to the information ministry in Ho
Chi Minh City was this: find the girl. The order came to Thach.
When cadres in Trang Bang reported that the girl's family had
moved from there at the end of the war, Thach broadened the
search to towns and hamlets throughout Tay Ninh province. The

break had come one year later, when his officials saw the sign above the noodle shop in Trang Bang.

Thach and two security cadres escorted Phuc to the former Majestic Hotel, once the city's most prestigious and elegant wartime hotel, popular in its day for the view from its rooftop terrace of the busy Saigon River. There, three foreign journalists awaited. Phuc would remember one to be Japanese. The others she thought were "Americans"—in south Vietnamese eyes, Western foreigners were all Americans; to the Vietnamese in the north, Western foreigners were all Russians. The journalists wanted to know what she remembered of the napalm attack and her hospital stay later, and what she was doing now. She spoke of her dream to study medicine.

The details that Phuc could not wait to tell her family concerned not the interview itself, but rather the lavish lunch that followed in the fifth-floor restaurant. She ate little, as the food did not suit her vegetarianism. In any event, all she could think was that Ngoc's household could eat for a month on what the meal must have cost. What impressed her most was Thach's delight that he'd finally been able to tell Hanoi that he'd found her. He laughed himself at how he'd had authorities broadcast her name over neighborhood loudspeakers. "It was very hard for me to find you," he told her, "but I was very determined. If I'd had to, I would have looked under the sea and over the mountains." Phuc smiled broadly. *I am nothing, I am nobody, and now I am that important?* She asked no questions; a good citizen under Communism asks nothing.

The summer was enlivened a second and third time when a car and driver and, as always, a minder came to collect Phuc from Tay Ninh for an interview and lunch in Ho Chi Minh City, and to bring her back afterwards. Phuc's family was pleased for her. The one unpleasant side of talking about the napalm bombing was that it stirred up memories so vividly that her nightmares of war

recurred. She had not had them since the war ended; the Cambodian war had not provoked them, perhaps because there had been no airplane strikes or bombing.

Otherwise, the summer was a repeat of the summer before, a routine of studying and attending rituals at the local temple. She no longer went with Lien; her girlfriend was among the growing numbers staying home because of what Ngoc called "trouble in the religion." It had begun with the government's closure of the Holy See for daily worship. It was now allowed to open only for the three or four major religious holidays in the year. Those in the delegation that went to appeal the government's decision disappeared and were rumored to have been arrested. Like Ngoc, Phuc was unafraid. "My belief is strong," she told him.

Late that summer, Phuc sat once again for the entrance examination. The bureau scored her three points higher than the year before, enough for her to get her second choice, a medical college in Ho Chi Minh City. Trieu got her third choice: a nursing college there. That October, Phuc moved to Ho Chi Minh City. Loan, recently remarried to a widower, had invited Phuc to live with them. Loan had met her new husband at the noodle shop, when he was on his way to the Cambodian border area where he worked as a forestry engineer. Because his employer was in Ho Chi Minh City, his *ho khau* was for there. This all-important residence permit was necessary for everything from owning or renting a home, starting a business, attending school and seeking employment to getting medical care and registering a motorscooter. The couple and Loan's teenage daughter lived in a small flat in central Ho Chi Minh City, on a quiet street behind the old American embassy.

Nu met Phuc's expenses: tuition, books and pens, food and clothing, medicine. Students in the city received a monthly rice ration which they could purchase at the rice distribution center at their school. Nu replaced the bicycle taken by thieves in Tay Ninh; Phuc would need it in the city, where local bus service was

almost nonexistent. From her opening day of school in October 1982, Phuc settled in for serious study: the requirement for a doctor's diploma was five years of university, followed by one year's residency in a hospital. Loan did her the favor of going to Trang Bang to collect her weekly allowance of food and money from Nu. *I have a future*, Phuc told herself happily—something only a privileged few in Vietnam could say.

To Phuc's profound disappointment, however, once she started school her interviews with journalists did not stop. What had been an entertainment in the summer was now an aggravation and unwelcome intrusion. And gone was Thach. New officials took responsibility for her, according her none of the same respect. A cadre named Hai Tam from Tay Ninh province took over Phuc's interviews. It was his prerogative; she was a permanent resident of Tay Ninh province and therefore under its jurisdiction, and as an interview subject, she was the responsibility of the propaganda office, which Tam headed. Where Thach had been young, in his early thirties, Tam was older, in his late fifties. Where the former was educated and refined, having lived a dual life in Saigon during the war, the latter had spent years in the forest after no more than a couple of years of primary education, emerging at war's end to claim the reward of a job.

In Phuc's first month of school, Tam summoned her one afternoon a week for an interview. Without notice, a minder or two from the province would show up at her morning class to spirit her to Tay Ninh. At Tam's bidding, foreign journalists wishing to interview Kim Phuc had to come to Tay Ninh, bringing in tow a minder and a government interpreter, provided by the information ministry in Ho Chi Minh City.

From the start, Phuc disliked Tam but feared him more. Others under his authority, small-voiced minions all, fairly tripped over each other to fall into line. Short and hollow-cheeked, coarse and overbearing, Tam had a smile he could

switch on and off at will. Puffed up with self-importance, he would first address visiting journalists on the subject "Building Vietnam under Socialism." Then, in the brooding presence of several unidentified security cadres, the interview with Phuc would proceed. Once it was over, Tam would lead the entourage to another building within the walled complex of the People's Committee of Tay Ninh for a reception, where waiters stood ready to offer Vietnamese cola, juice, beer and wine. All such services, as well as transportation and interpretation, were paid for by "representation fees" the Vietnamese government charged to the journalists.

Afterwards, Tam would call Phuc into his office. His smile in the off position, he would admonish her. "Don't say this!" or "Don't say that!" He lectured her for embarrassing the regime by speaking of the difficulties of life in postwar Vietnam, of times when, in her own family, there had not been enough to eat. In her first interviews earlier that summer, overseen by the interpreter Thach, Phuc had spoken freely along those lines, and without censorship. She would learn quickly what passed Tam's approval: she could make as much as she liked of her physical suffering from her napalm burn endured in the American war, but she was *not* to portray the people as having suffered under the new regime.

After each interview, Phuc had to find her own way back from Tay Ninh to Ho Chi Minh City. Wanting to avoid the long bus ride back, as well as the expense, Phuc found the nerve to ask: might she catch a ride back to the city with the foreign journalist, whose car and driver were going that way anyway? "No!" Tam's tone was as much reprimand as accusation that she was trying to associate with foreigners, which was strictly forbidden. Once, among the interpreters, she saw the familiar face of Thach. She longed to exchange more than a smile, but she saw in his meek manner an acknowledgment that the hour and jurisdiction were Tam's.

Phuc began to feel as if she were leading a dual life, as student and as war victim. By November, one month into her school year, interviews were more frequent, at least twice weekly. Tam took to scheduling them for the morning instead of the afternoon, so his minders would have to come to collect her from Loan's house the evening before. They seemed to have no qualms about the lateness of the hour, once showing up at one in the morning. Often, on the way there, the car broke down—a common problem, what with road upkeep and repair starved for public funds. Initially, they would take Phuc to Ngoc's to spend the night, but finding it bothersome to have to come to collect her the next morning, they took to dropping her at the complex of the People's Committee, expecting her to sleep on a couch outside Tam's office. The days were long; the receptions that followed the interviews became midday banquets of hot and cold dishes, served at tables decked out with white tablecloths and floral centerpieces. Phuc would take no more than a glass of cola or juice and a slice of bread on which she sprinkled salt. The longer the day dragged on, the more consumed with worry she would be about missing yet another entire day's classes.

She tried to make up for missed lectures by borrowing classmates' notes. But she was also missing sessions in the laboratories, at clinics and hospitals. Phuc spoke to her professors, trying to both apologize and explain.

"This situation is impossible," replied one.

"It is not my fault," she pleaded.

"I'm scared," Phuc told Loan. "I don't want this any more!" She did not understand how she had got into this predicament. "Why all this attention for one picture? There are other victims of the war against America, why choose *me*?"

By December, Phuc was more often in Tay Ninh than in class. She grew anxious about the upcoming end-of-semester examinations. During the long car rides to Tay Ninh, she would

pointedly ignore the driver and minder and bury herself in her books.

One evening, a frustrated Phuc could bear the interruptions no longer. "Please, I don't want to go!" she begged the minder standing at the door. "Let me study, please!"

"My job is to pick you up." The minder returned to the waiting car.

To retaliate, Phuc contrived to make life difficult for Tam. *I will travel like a bird*, she decided. She took to staying overnight with different friends of her sister's. But no matter where she alighted, she could not elude Tam's people. This dangerous game might indeed have provoked him. What his associate said one day to Phuc perplexed her. "We want you to come back to Tay Ninh," he said. "We can find a job for you." Instantly, she was afraid and she hastened to reply: "I don't want to work in Tay Ninh. I want to study." On another visit, he took her to the radio station, where she read a script put in front of her into a microphone. "You have a good voice," the associate said later. "I wouldn't want that job," Phuc replied. "The career I want is to be a doctor."

She was nervous enough about what lay in store to risk, during a banquet following an interview, a question of an interpreter from Ho Chi Minh City. She cloaked it in a tone of innocence, so as not to arouse the suspicions of any who might overhear. "Why so much attention to my story?" she asked. "You are 'hot' news," he replied. It was not an expression she understood.

IN JANUARY, AS THE FIRST SEMESTER'S CLASSES drew to a close, the dean called Phuc in. She had been expecting a meeting, knowing that the college and she would have to come to some accommodation. Better that they do so before the upcoming examinations.

"You can no longer stay at this school," he announced.

Phuc was in shock.

"Tay Ninh has removed your *ho khau* back to the province."

Phuc cried out. "Why did you let them do that? *Why?*"

His tone became apologetic. "You are from Tay Ninh. By the rules, after your schooling, you would have to go back to Tay Ninh anyway. People try to break the rules, but . . ."

The official population of Ho Chi Minh City was 3 million, but unofficially it was closer to 4 million. The city hid many who had "escaped" either the new economic zones or their home provinces, where their *ho khau* dictated that they live. Whole families squatted under the city's bridges, preferring the life of a beggar to that in the harsh frontier. Others were in hiding from authorities, on the move from one apartment to another while plotting to escape the country by boat or trying to hasten their legal departure. As of 1980, the regime allowed those with relatives abroad to apply to leave under a program for orderly departures sponsored by the United Nations (stalling on the part of Hanoi meant it would not function as intended until the late 1980s), to stem the flow of the boat people and to alleviate overflowing refugee camps in Southeast Asia.

"Please, can you help me to stay in school?"

Phuc was asking the impossible. To get one's home jurisdiction to relinquish one's *ho khau* required untold bribes, as cadres suspected a plan to escape from the country. It was difficult to get another jurisdiction to grant even visiting status for more than one week at a time; and even then, the person had to furnish proof that he could bring enough rice to feed himself.

"Tay Ninh says that you have become an important person in Vietnam." The dean tried to explain his predicament. "They say Ho Chi Minh City is not safe for you. They are right. What if something should happen to you? You could be kidnapped. The school cannot protect you. It is better that you live in Tay Ninh."

There was silence on both their parts.

"I can do nothing," the dean finally said. "You are a special student."

"*Special?* How special?" Phuc was in tears.

For the next few days she continued to go to class, though she knew it was futile. Finally, she took a bus to Tay Ninh and went directly to the offices of the People's Committee. The guard, so used to seeing her, took her identity booklet without bothering to call ahead.

In Tam's office, she waited for him to speak first. The floor fan in the corner whirred loudly. Finally she broke the silence, but politely. "Please, why did you take my records?"

"You cannot go to Ho Chi Minh City to study. You are an important victim of the war. I want you here. Your job is to answer the telephone and type for me."

"I wish to say thank you—but I want to be a doctor."

Tam was affronted. "A job in the propaganda office is a good job. It is not hard work. A lot of people would want it and can't have it!" He was yelling now: "Why don't you want it?"

Phuc looked him in the eye and borrowed from a Vietnamese proverb: "When I am healthy, I want rice. When I am sick, I want soup. I know a lot of people want to eat rice, but I need soup!"

Tam's face darkened ominously.

PHUC BROKE HER RETURN BUS TRIP IN Trang Bang. She told her parents about Tam wanting her to work as his secretary. Nu had barely begun to question her when Phuc cut her off. "I don't have another breath for that man," she said. "I'm going to escape from Tay Ninh."

As her daughter left, having collected the usual weekly packet of money and food, Nu was shaking her head. "Phuc will drop dead in any job," she said to Tung. While the family had been cheered to see her take to studying—"What else would Phuc do?"

they asked each other—Nu had remained convinced that her wounded daughter could never work enough to support herself.

Some days later, a familiar black car pulled up to the noodle shop.

Tam or his minders had shown up before. Sometimes they came to take Tung and Nu to Tay Ninh to put them on display to foreign journalists. However, they were there to be seen, not heard. If an interpreter put a journalist's question to either or both of them, Tam lashed out in admonishment: "You do not ask the mother or father; you ask the People's Committee." Or they were there to be a receiving line. Once, a visitor had a gift of a carton of cigarettes for Tung; another offered a tin of candies. "These are not for you," Tam said, confiscating both. "They are for the people's government."

Tam plowed out of the car. Even as he approached, he fixed them with a stare and wagged his finger. In Vietnamese culture, making eye contact is socially impolite, and finger-wagging is particularly rude and demeaning, a reprimand appropriate for a dog.

"You must convince your daughter to come back from Ho Chi Minh City to Tay Ninh as I want," he said sternly. "What is she doing there?"

"We do not know what Phuc wants to do," Nu replied.

"Order her to come back!"

"She is not a child. She is old enough to decide for herself."

Tam walked backwards towards his waiting car, his finger going maniacally. "If something happens to her, both of you will go to prison!"

PHUC SAW NO POINT IN RUNNING; TAM HAD proven he could find her. She saw her choices as limited. She was not physically up to working in the noodle shop; she could not

return to Tay Ninh, as that would be admitting defeat; that left staying in Ho Chi Minh City with Loan. Above all, Phuc wanted to study. But college and university—and therefore a career in medicine—were now out. She settled on learning English and signed up for a course at a private language school, three nights a week, thinking that maybe one day she could work as an interpreter. Illegal year-round schools and tutoring in English had sprung up in the wake of the exodus of the boat people. Others planning escape believed that English would help them in international waters when they were looking to be rescued from a boat, and later, in their new life abroad.

Phuc found English harder than any subject she had encountered. She could not follow the teacher's lectures well enough to take notes and always had to borrow and copy the notes of fellow students. For extra practice, she purchased the school's tapes and played them on a used Panasonic cassette player bought on the black market. For every hour fellow students studied, she had to put in two. Frustratingly, she could study no more than one hour without bringing on the familiar headaches and dizziness. Her marks were disappointing.

And still, Tam held the upper hand, continuing to bring her back to Tay Ninh for interviews. The unspoken tension between them kept taut the lie that she was a medical student in Ho Chi Minh City. He needed her, and she herself was not going to "make noise" and invite the unpredictability of further punishment or vengeance.

The pace of interviews did not abate; it intensified. To capitalize on the continuing interest of the international media in the "decade after" stories, Hanoi hosted an international medical conference on the effects of Agent Orange, which brought yet more journalists Tam's way. In addition to interviewing Phuc, they would view films showing vast forests of the province denuded by American herbicides during the war. Afterwards,

Tam would show them a display of large jars of pickled fetuses, typically missing mouths or chins.

One driver taking Phuc to Tay Ninh passed on office gossip that, clearly, he relished. Talk was that Western news media had reported that the Kim Phuc the Vietnamese government was showing off was fake: "They say the real one is in California."

"What?" Kim was astonished.

"But Tam knows he has the real Kim Phuc," the driver said. "He says you have the scars to prove it." That spring, the government's Vietnam News Agency issued the statement that, contrary to "sensation-mongering Western newspapers," Kim Phuc was indeed a student in Vietnam. It quoted her: "I am studying medicine because I wish nobody ever has to endure what I have endured."

Vietnamese journalists were finding their own way to Phuc, and in increasing numbers. They did not have to seek prior approval from the foreign ministry and were able to bypass Tam in Tay Ninh. Just as the regime was easing its controls on the state-run economy, so too was its government-controlled media experimenting with ways to convey the official line other than by regurgitating turgid Party policies and directives. Vietnamese journalists saw in Kim Phuc a genre of story new to them: "human interest." One Hanoi-based photographer took Phuc to a government day-care center to photograph her there. He explained why: "The war against the Americans almost destroyed you. They tried to kill you with the bomb, but you did not die. So now we will photograph you with children, to show you embracing life again." Phuc looked for and picked up a cute baby. One year later, the photograph would win an international prize, and it was subsequently much reproduced in Hanoi, with the caption: "*A decade later: Kim Phuc and her baby daughter.*"

Phuc, with idle days, had nothing to keep her from interviews in Tay Ninh. That spring, there was one visit from foreigners that

she rather enjoyed. Dutch television came for several days to film a documentary. Phuc—surrounded by film crew, interpreters and minders—was its star. She was ferried between Tay Ninh and Trang Bang to film on location: at the noodle shop, at the temple, on the highway where she had been struck by the napalm bomb. Phuc went along with the dramatization: yet again she bared her burned back to "her" doctor and played the role of a medical student. As Tam ordered, she donned a white blouse, the uniform of girls attending a nursing school in Tay Ninh. "Give it back to me at the end of the day," he told her. The cameras rolled while Phuc, sitting with "fellow medical students" at a long table, listened attentively and took notes on a lecture about the spinal column. She thought bitterly how she'd already learned that and more in her anatomy course at medical college. Nonetheless, on the last afternoon of the last day of the shoot, Phuc lost herself enjoying the sunset. As the red sun was about to drop from the sky, she felt relaxed enough with the cameraman to convey a request through the interpreter: "Oh, can he shoot that please?"

One year later, the Dutch film would win two second prizes at international film festivals, one in the category of short film documentary at Leipzig, and another for reportage at an important annual television festival in Monte Carlo. The Dutch journalists were credited with being the first to discover Kim Phuc after years of obscurity.

PERRY KRETZ'S SECOND POSTWAR TRIP TO Vietnam was finally underway. After the usual four-month wait to get Hanoi to approve his journalist's visa, in early 1983, he was in Tay Ninh to fulfill his personal mission.

"Kim! *Jee*-sus Christ!" He held his arms open. The girl walking towards him could not help but walk into them. He hugged her and, in the European style, kissed her on both cheeks. With

no idea who this well-tanned, gray-haired "American" was, Phuc heard him tell of their meeting ten years earlier. The story of Kretz being under house arrest awaiting expulsion in two days, and making the trip to Trang Bang in pursuit of her story, when translated into Vietnamese, turned into him coming to Trang Bang to see her one last time at war's end to say goodbye as he'd "never been able to forget her."

Only as he flipped through a stack of large black-and-white photographs that he'd brought along did Phuc begin to realize who this journalist might be. Each was of her, and each was taken in Trang Bang: at the house, in the hammock with her cousins at her feet, a book in hand—she recalled it had been a gift from a nurse at the Barsky—perched on a stool doing schoolwork, catching a ball outside. There were others, taken at the temple and on the highway.

"Do you remember me?" Kretz asked.

"A little," she replied. She had a fleeting image of him insisting that her grandmother shake his hand, ignoring the fact that hers were soapy from washing clothes. As far as she could recall, this man named Perry Kretz was the only journalist, foreign or Viet-namese, to have visited her after the napalm attack. In fact, there had been many; Carl Robinson had come several times, and so had Nick Ut, the "Uncle Ut" whom her parents had spoken of as kindly.

Suddenly, Phuc understood. This was the German journalist who had sparked Thach's year-long search for her. Without thought or recrimination for the way her life had subsequently been turned upside down, she registered only that this person was someone who cared enough to come back to see her, though ten years had passed.

"How *are* you, Kim?" he kept asking, adding, "I feel like a father to you." Before he left, he made sure to give her his business card. It was the only one from a visiting journalist that she would keep.

During the visit, Phuc repeated the lie that she was a medical

student in Ho Chi Minh City, and acted the part of a happy, twenty-year-old woman, though still bothered with pain and headaches from her napalm wound. Throughout, a discordant soundtrack ran in her mind: *They took my schooling away. This is a lie!*

BACK IN HAMBURG AT *STERN*, KRETZ FILED a story from Vietnam, but wrote nothing of his visit with Kim Phuc. He had come home troubled. While other foreigners might have seen a typical Vietnamese schoolgirl, one with an irresistible smile, he had detected an awkward stiffness in her posture and carriage, and a decided unhappiness in her expression.

Kretz took his pictures of Phuc to the Oggersheim clinic, a renowned West German accident and burn clinic in Ludwigshafen, whose most famous former patient was Niki Lauda, the Austrian Formula One racing car driver and then reigning world champion who had been taken there after a fiery crash in Nürburgring in 1976. Kretz spoke with Professor Rudolf Zellner, the plastic surgeon who headed the clinic, a teaching unit affiliated with Heidelberg University. Kretz asked: could he give advice on Western medicines that could be sent to her? Zellner was unequivocal: nothing could be done from afar, a burn victim had to be examined firsthand. "This is a chance to help," Kretz told his wife, "and I'm going to grab it." Even as he had been meeting with Kim Phuc, he'd made up his mind. He'd said nothing then; no sense getting anyone's hopes up, as much depended on getting the cooperation of the Vietnamese.

THE YEAR 1983 MARKED THE START OF A LONG, irreversible slide in the fortunes of Nu's noodle shop. After two and a half years of liberalized economic reforms in Vietnam,

the inevitable backlash came from the orthodox among the Communist leadership. Hanoi put the brakes on reform and curbed the resurgence of private trading, which it regarded as "capitalistic excess." It targeted "non-essential businesses" like cloth merchants and restaurateurs with harsh taxes, as high as 90 percent of revenues, in hopes of forcing them to shut down. Whenever Nu could not meet her monthly tax bill, the tax official slapped a sticker on the shop door, barring the business from opening until arrears were paid. Many owners in that predicament lost their businesses to the state, as it hoped they would.

Nu blamed her woes on the location of the district tax office. As it was directly opposite, it enabled the cadre to claim he could keep an exact count of her customers, right down to the bowls of soup served. Nu bemoaned the state's onetime takeover of her shop, allowing him to also claim knowledge of her margins of profit. Phuc saw Tam's vindictiveness in the waning income from the shop. She said nothing, humbled by her mother's capacity to endure suffering. *She pays for me without question*, she told herself, as she picked up another weekly packet of food and money.

That fall, as her former classmates in medical college started their second year, Phuc could think only of the sham that her life had become compared to theirs. She had avoided them, so as not to be tormented with envy. One exception was Trieu, who would invite her out for an ice cream. But she found she now had little in common with her lighthearted friend. Rapidly, Phuc slid deeper and deeper into unhappiness until she was mired in a severe depression.

When speaking to journalists, Phuc stepped into the spotlight and played the part of the happy student, the life she wanted; when they departed, she was left in darkness, with the life that had been forced on her. On the bus back from Tay Ninh, she railed in silence: *They have destroyed my life. Why do they do this to me?*

212

Why? Phuc found solace the only way she knew how, by turning inward to her Caodai faith. She accepted that whatever wrongs she had committed in her past lives had not yet been atoned for, not even by the pain and suffering inflicted by the napalm bomb. Caodai's will was that she endure more. Seeing herself without a future, Phuc had but one wish for her day-to-day existence: to feel the happiness that was once so naturally part of her character. In her prayers, she bypassed the numerous gods, saints and spirits of the religion for the heavenly being of Caodai itself: "Please, please, bring me happiness." Her despair grew only darker. Phuc was confused: *I am a strong believer; why is nothing happening from my prayers?* One day, on the bus back from Tay Ninh, her spirits at their lowest ebb, Phuc wept. *I don't want to live.*

She took to leaving the house by day. She did not want Loan to see her moping about. Her sister had enough worries; Loan had never got over the death of her first husband, and she and her second husband, whose own teenager, a daughter, was being raised by grandparents, were saddened that they had been unable to have children together. As well, family relationships were strained, what with Loan's teenage son recently returned from Danang to be reunited with his mother.

Without much money to spend, Phuc had only limited ways to pass the time. One day, she wandered into the American War Crimes Museum. She saw on a wall the famous image of herself. She paused long enough to read the caption: it did not identify her. She felt an emptiness. Day by day, she narrowed the range of her footsteps, until eventually she did nothing but patrol the few blocks around the house. But one day she came upon a library, and for the first time in months she felt motivated to find something to keep her mind active. She pulled from a section on world religions—as yet untouched by state censorship, though not for long—a book on Buddhism, another on Taoism, one on Hinduism, and she went through them one at a time.

It was a copy of the New Testament of the Christian Bible that absorbed her attention. The novelty of the questions in her mind kept Phuc coming back day after day—she could read for no more than an hour without tiring. Surprised at first, she soon came to feel affronted. The Bible's contradictions with Caodai rankled: why did the Bible say that God had delivered meat—"beast, fowl and fish"—for man to eat? Caodai said eating meat was dirty; she had become a vegetarian to purify herself! The Bible said Jesus died and rose again. Caodai said Jesus had been reborn in its pope, the *Ho Phap*. Since the *Ho Phap* was dead, could Jesus be reborn again? She read on. She reeled at what she regarded as the Bible's most ludicrous claim: that Jesus Christ could pay for one's sins, that going to heaven could be a certainty. Phuc was offended: how could they say that? By her Caodai beliefs, if she died tomorrow, she would not necessarily go to heaven.

BY COINCIDENCE, ABOUT THIS TIME, A HAND-some young man who was an assistant pastor at a Christian church round the corner from Loan's became a regular visitor. A relation of Loan's first husband, Anh was five or six years older than Phuc. His visits became daily when Loan's teenage son was hospitalized for an operation. Knowing Phuc's days to be idle—except when she was in Tay Ninh—he invited her to accompany him to the hospital to provide the boy's nursing care. The two addressed each other in the familial way, as brother and sister.

During hours of chat in ten days of going to the hospital, the two discovered and appreciated their similarity of temperament. Both believed in a quiet life and were uninterested in what others their age did—going out at night looking for entertainment, smoking, drinking. It was some days before Anh himself brought

up religion. Religious belief was a subject one raised only in trusted company. Contrary to what she had been told by Loan, Anh was not of the "different" religion, but the "new and good" religion; the former was how the Vietnamese referred to Catholicism, the latter a reference to the Christian Church of Vietnam. Anh asked Phuc if she read the Bible, and did she believe in Jesus Christ? Phuc blurted out: "Oh! I have lots of questions!"

He brought her a Bible as a present, and they read it together. Their daily discussions centered on its teachings, and in particular on whether Jesus could atone for a man's sins. Phuc held to her Caodai belief that one had to pay for one's own sins, that atonement came only through suffering, penitence and good deeds, and worship of the spirits of ancestors and saints and gods in hopes of appealing to their benevolence and avoiding their wrath. Anh said the gospel of the Bible had simpler truths: "Before God, a man is only a man, nothing more, nothing less. God gives you salvation as a gift. You don't have to do good things to earn it; you can't earn it. No matter what you do, God will save you."

They both held resolutely to their beliefs. Anh preached that God sent Jesus Christ to save the world, and that he took to the cross the sins of all. "Those that do not follow Jesus Christ," he said, "will spend their afterlife in hell."

"I cannot believe that," replied Phuc.

"I invite you to hear my pastor's sermon."

Phuc was firm. "Impossible," she said. "I cannot go. If I betray my religion, my soul will wander with no resting place. Heaven has no room for followers who betray Caodai."

"If you are not ready to go to church, why don't you try praying to God? Bring your burdens to God, see how you feel."

Phuc confided to Loan that her fervent prayers to Caodai were going unanswered. She asked her opinion about Anh's suggestion that she pray to the God from the West. Her sister saw no

dilemma. "His religion is from the West, but you are unhappy," she said. "Why not try something else?" Phuc did so tentatively, deciding to give the Western God a test in her prayers: "I will go to visit Anh's church, but I will be alone there. Can you show me a friend?"

Some days later, she stood outside the small white flat-roofed building with the cross on top. The door was open. Phuc went in and stood at the back. *I should not be here; I should be in a Caodai temple,* she kept telling herself. There was a lone figure inside the church, a woman sitting in a middle pew. Mustering her courage, Phuc approached. "Hello," she said softly. The middle-aged woman responded warmly. *God has answered my prayer!* Phuc's heart swelled with happiness.

The two women began to meet daily at the church to read the Bible together, to discuss its teachings and the truths to be found within it. After two weeks, Phuc was ready to attend Sunday services. Regularly, Anh inquired how she was feeling about the church and about Jesus Christ. She reiterated that she would attend his church but pray only to Caodai. In her newfound happiness, Phuc wondered if, for the first time in her life, she was falling in love. She asked Loan if Anh had a girlfriend and discovering that he did not, asked him shyly: "We can be boyfriend and girlfriend?" He replied gently: "My life is devoted to God." Inspired, Phuc was ready to test God a second time. "Dear God," she prayed, "my sorrow is too great and too heavy. I need help."

THE PASTOR WAS MID-SERMON. "THERE WAS a man who tried to do only good in his life . . ."

That is me, thought Phuc.

"Before God, this man is no different than any other man. Before God, everyone is a sinner. Each and every one of us has burdens to carry."

THE GIRL IN THE PICTURE

The pastor is speaking to my case.

"Why do you have to carry it alone?"

I pray to Caodai, I try to do good, and yet, I suffer, I carry a burden.

"Let Jesus help you. Open the door to let Jesus Christ in. If he knows you have opened the door, he will come to help you."

My sin has been to be caught between Caodai and Christianity; I have not allowed God to do his work.

"He will deliver you from your sins and bring you peace and eternal light from heaven . . ."

When the pastor called for people to come forward to accept Jesus Christ as their savior, Phuc stepped into the aisle, her face wet with the tears of salvation.

IN THE EARLY SPRING OF 1984, THE FAMILY gathered in Tay Ninh for Tet. Before going to Ngoc's house, Phuc passed by the local temple. It was as she'd already known: her heart was cold, her spirit dead to it. At midnight on the eve of Tet, the feast with the ancestors began. Phuc declined every dish passed her way. "No, I don't eat that," she said, smiling. She felt strong. "You have to eat something!" her family cried out. In reply, Phuc went to the kitchen and came back with a soursop on a plate. She cut the fruit in half and began chewing its white flesh, spitting out its hard, black seeds. No one commented—a bad temper can mar the clean slate of good luck for the new year—but Phuc saw the hurt on her mother's face.

The next morning, everyone prepared to go to the Holy See to pray together for health, happiness, prosperity and longevity. Making the pilgrimage there was the extended family from Trang Bang and other distant relations, all of them gathering later at Ngoc's for a feast grander than the night before. Nu presented Phuc with a new white *ao dai*. Smiling, Phuc said, "I don't wear

that any more." Her voice was quiet, controlled. "I no longer practice Caodai. The Bible says that I cannot eat food used to worship the spirits or go to a temple that worships other gods. I respect our ancestors, but I no longer worship them. I only follow Jesus Christ." With that, she left the house. Her mother's angry words chased her: "You are not my daughter any more! I am ashamed to have you! You will pay dearly for your betrayal of your religion!"

That evening, Phuc again refused to partake in the feast. She saw her mother's eyes well with tears. *She knows she has lost me*, thought Phuc. On the third day of the holiday, she decided to return to Ho Chi Minh City. The inevitable showdown came. Nu spoke first: "As your mother, I love you. You have been a good and obedient daughter. You have made your parents and your family proud," she said, "but now you have flouted the laws of the ancestors and of Caodai . . ." Nu broke down, "and in front of family and neighbors!" Ngoc spoke to Phuc. "In all your life, you have never done anything bad. You can make amends to our parents, and to Caodai."

"I no longer practice Caodai." Phuc was unwavering. "I am Christian."

Nu tried reason. "That religion is foreign. Caodai is bigger than the religions from the West. If you want Jesus Christ to save you and forgive you, you must pray from the top." She took a gentler approach. "We have had many troubles and Caodai has helped us. The family must stay together in one religion so that we can be in heaven together."

Phuc addressed her entire family: "You do as you like. I pray to God for all of you every day, because I want my family to be saved. I hope it will happen."

"If you want to follow God, ask *him* to feed you! Ask *him* to give you rice!"

At those hard words from her mother, Phuc left.

As the bus rumbled down the highway, she felt stronger than ever about her change of faith. Her father's parting words had been kinder than her mother's. "Okay, Phuc," he had said, his hand on her shoulder, "you go to Jesus, but I will pray for you." Though she was taking back no packet of money or rice or food from her mother, Phuc was not resentful. *I forgive my mother*, she told herself. *I have an understanding of sin and forgiveness now. With forgiveness, there is renewed hope of a future, where there was none before.*

CHAPTER TEN

PHUC DROPPED OUT OF HER ENGLISH course, figuring she wouldn't be able to pay the next semester's tuition anyway. Outside of the interviews in Tay Ninh, the focus of her life was church: she attended the morning and evening services on Sundays, and, with no objections from Loan, took her niece and nephew to the weekly youth social programs and to the Sunday school. She concerned herself only with preparing for her baptism, two Sundays away. For the past several weeks, she had been attending Pastor Anh's twice-weekly pre-baptism course.

On the day of her baptism, Anh accompanied her across town to the city's largest Christian church, located on the major thoroughfare, Tran Hung Dao Street. Anh led her to the uppermost floor, to a room with a baptismal font, where she joined some twenty others, drawn from the handful of Christian churches across the city, for a baptism ceremony conducted by the pastor of the main church.

Phuc had managed to put aside a little money each week from

the amount her mother gave her, by scrimping on what she ate. It was a paltry sum, though, and it quickly ran out. Her situation turned desperate. Had she lived in the country, there would have been ways to scrounge. One could always help oneself to the ubiquitous banana plants, put fish traps in drainage ditches or pull river spinach. In the city, staying alive without money reduced one to begging. Phuc faced the reality that Loan and her husband could not feed her, that to include her at the table only left everybody hungry. It was also a matter of pride that decided Phuc to move; she didn't want her family to see her struggling to survive on her own.

With her few possessions—two or three items of clothing, her last remaining tablets of painkillers and her Bible—in a small plastic bag tied onto the handlebars of her bicycle, Phuc pedaled across town. The address she had in hand was that of a relative on her father's side named Huong, a woman she had never met. Tung and Huong were siblings of sorts; Huong's parents had daughters only, and they had adopted Tung as a stand-in son, since his family had one to spare. Nu had done this family a favor: in the earliest years of the American war, she'd taken in two siblings for a couple of years while their bomb-damaged house was being repaired. Huong's father had taken the teenage Huong and the other older daughters and gone north to join the Communists, leaving his wife on her own with the younger children. Huong had spent the war years in the jungle nursing wounded Communist soldiers and Viet Cong. Despite only a primary school education, after the war she was rewarded with a spot at Hanoi University, where the offspring of the Communist leadership were enrolled. She struck up a relationship with her married physics professor, a Party functionary named Dai who could boast a Communist indoctrination in Moscow and Beijing. Dai had the Party transfer him and Huong to Ho Chi Minh City. He was assigned a job at a college; she became a doctor at a

city hospital—part of the regime's policy of replacing southern doctors with those who had the correct revolutionary credentials. Dai then divorced his wife and married Huong.

Phuc passed through the gates of one of the city's hospitals to a low-rise concrete dormitory in the rear of the compound. A pretty woman, who looked hardly older than Phuc, and a short, older man answered her knock. Phuc introduced herself. As she had hoped, Huong and Dai took her in. Their one room was small and barren, the floor covered with linoleum, the walls of unpainted concrete. In one corner, a curtain enclosed an area around a drain. Beside that was a small sink. There was no toilet; each floor had one communal toilet. In another corner was a hotplate and a couple of pots and dishes. There was a bed in the middle of the room. Phuc slept on the floor until Huong was able to find a folding bamboo cot. To gain a measure of privacy, the couple strung a curtain round their bed.

The appearance at the door of a terribly thin, sallow-faced woman, her hair hanging limp, with little more than the clothes on her back, had suggested to Huong and Dai someone beset with poverty. They were surprised, then, by her cheerful disposition and absence of complaint. They thought that those qualities probably endeared her to other occupants of the building or else friends in the city, from whom they assumed she begged money and food. If ever they had extra, they invited her to share it, but they almost never did. Phuc relied not on anyone in the building but on four friends: Trieu; Trieu's older sister, a nurse; the teenage daughter of Loan's husband; and Anh. When they could, they sacrificed a handful of rice. Anh, who had less to spare, would buy her a bowl of noodle soup at a stall.

Huong or Dai often came home to find Phuc crying, sitting on a stool and lifting the back of her blouse to waft air up her back. Her painkillers exhausted, Phuc could not afford even ice. The first time the couple saw her blackened striations of scar

tissue they were shocked. Whenever she was driven to seek relief under the shower—fortunately, the hospital's water supply was unlimited—one would look to the other, exchanging the same thought: "What a pity." Neither knew the picture of which Phuc spoke, but they quickly became accustomed to the knock at the door that announced Phuc's minder from Tay Ninh. They themselves politely greeted the official, anxious that Phuc not keep him waiting.

As for her family, Phuc consciously adopted a Christian attitude, as if all were "normal" between them. However, when in Tay Ninh, she rarely stopped in at Ngoc's to see her siblings and nieces, and only sometimes did she break her return trip to see her parents in Trang Bang. Tung and Nu asked nothing of how she lived in the city; they knew about Huong and Dai—"Communists," in Nu's mind. Phuc asked for neither money nor food, and Nu offered her none. No one spoke of religion. On one visit that coincided with a religious holiday, Nu brought out Phuc's white *ao dai*. She looked to her daughter's face for an answer. "I don't wear that any more," came the reply once again. The spells between visits lengthened. Aside from her spiritual detachment from her family, Phuc was, increasingly, too fatigued to manage a stop in Trang Bang.

VIETNAM RESIGNED ITSELF TO THE UNITED States government's insistence on a one-issue agenda with Vietnam: American MIAs from the Vietnam war. However, Vietnam hoped to use the issue as a lever of goodwill to get the United States to soften its stance on Vietnam's military occupation of Cambodia, thus reducing another obstacle towards the lifting of the American economic embargo. Hanoi refused to make concessions on withdrawing from Cambodia; it saw holding sway over Cambodia as vital to Vietnam's security against China. But,

on the economic front, despite the benefits of liberal reforms, Vietnam's outlook remained bleak. Starved for capital, it staggered under the burdens of outside debt and a military budget worth half its national wealth.

In looking to the United States, Vietnam also wanted elbow room with the Soviets. To repay debt held by the Soviets and other eastern bloc countries, Vietnam was obliged to send more than half a million "guest workers" to work for reduced pay in their factories. Never was Hanoi comfortable with the Soviet Union's influence in its affairs. Only grudgingly did Hanoi allow a Soviet buildup at the American-built former naval base at Cam Ranh Bay (the world's best natural harbor after Sydney, Australia). Certainly the Vietnamese people had a distaste for anything Russian. They turned off their television sets when Russian programming came on, stayed away from the cinema when Russian films were showing and didn't enroll in Russian foreign language courses. They regarded Russians as rude and overbearing and privately ridiculed the Russian technical experts and military advisers in Vietnam, referring to them as "Americans without dollars."

Of the two issues that Hanoi thought could entice Americans to keep talking with its regime, one dropped from view in May 1984. A class action lawsuit, representing many U.S. veterans and their survivors, had been launched against seven American chemical companies that manufactured Agent Orange for use in the Vietnam war, alleging detrimental health effects. The case was settled out of court with the establishment of a $180 million compensation fund.

That left the issue of the American MIAS. Successively higher-level American delegations came to Hanoi to discuss it. The total was small compared to other wars: in the Second World War, some 79,000 American servicemen were listed as MIAS; in the Korean war, 8,000. The number in the Vietnam war was 2,477. In truth, the likelihood of finding remains dating back to the 1960s was remote. In the hot jungle climate, remains decay within days.

Vietnam had long since abandoned its search for the remains of at least three hundred thousand of its own missing in action during the wars with the French and the Americans. In the south, the death toll of Vietnamese in the American war included more civilians than soldiers. An estimated 183,000 South Vietnamese soldiers and 415,000 civilians died in the south. The death toll among northern soldiers was estimated at 925,000.

The American accounting of its MIAS from the Vietnam war began in earnest in 1984, when Hanoi turned over remains—bone fragments—of eight bodies. Over the next two years, Hanoi would sporadically turn over more remains (by 1992, the number would be whittled from 2,477 to 2,202). However, with each shipment or subsequent attempt on Hanoi's part to remove the issue of MIAS from the table, Washington would reaffirm its policy that any move towards normalization was out of the question until there was a full accounting of *all* MIAS. Yet, the American military knew conclusively that half the total had been killed in action, and another fifty-five were known to have been alive and held in captivity. Of the remainder, whatever American officials believed privately, publicly they kept alive rumors that Hanoi had not turned over all prisoners of war in 1973 and that it was still holding live Americans captive. Ultimately, in the MIA issue the United States had a convenient tactic for stalling the softening of its stance on Vietnam. As long as the issue of MIAS was in the forefront, America's recrimination about why it had become involved in a war without meaning, and its resentment over its defeat there, were redirected towards the enemy that was Hanoi.

RECOGNIZING THE POPULARITY OF KIM Phuc's story with the foreign press, the information ministry in Ho Chi Minh City took to assigning the same interpreter to cover her interviews. Considered one of their best, Viet was both adept

at English and effective in his dealings with Western reporters; they found him affable, helpful and sensitive to the demands of their profession. Phuc recognized in him the southerner's warmth and openness that she had seen in Thach, who had conducted the search for her. Unlike Thach, Viet was neither cowed nor cowering in Tam's presence.

Phuc warmed to Viet and he to her. The two southerners were artful in their tandem performance: she, the schoolgirl explaining her ambitions as a medical student in Ho Chi Minh City; he, animatedly and subtly translating it. As they played to journalist after journalist, Phuc was nagged by the urge to tell Viet the truth. She longed to confide in someone; her instinct was that he was someone she could trust.

One afternoon, she showed up unannounced at his office in the information ministry. He was welcoming, and Phuc did not hold back: "It is not true I am in medical school."

"No?"

"I lost my school."

She recounted how Tam had removed her records because he wanted her to return to Tay Ninh. Without mentioning that her mother had cut off her support, Phuc told of the precariousness of her life in Ho Chi Minh City: "My family has to pay high taxes at our noodle shop . . . I have no job. I have no money. How can I live?"

Viet was visibly upset. "Something is wrong. People who are powerful are using you." But, in the end, he could offer little more than sympathy. "You are from Tay Ninh. Your records are not with our city. Even if we in Ho Chi Minh City disagree with Tay Ninh, we can do nothing." He shook his head in regret. "We are powerless to help you."

The knowledge of Viet's tacit participation in her charade plunged Phuc back into darkness. After every interview, when he, together with the journalists, left in their van for Ho Chi Minh

City, she made ever more wearily for the bus, slumped ever lower in her seat. She saw her life to be without shape or purpose. She pondered the naiveté of once praying to Caodai for happiness. She yearned for something far more complex than happiness: goodness. Knowing the Western God had answered her once, by delivering the woman in the church, she put him to a second test: "Dear God, I need someone to rescue me, a savior." Who could that person be? She could think of no one in Vietnam who could help her. Then, the name Perry Kretz came to mind. *He cared about me enough to come back*, thought Phuc. She wrote him a letter, an appeal for sympathy as much as for help. Even after she'd posted it, she feared arrest, worrying that it might have fallen into the wrong hands.

The weeks passed without a reply. Phuc's health deteriorated. She had trouble sleeping. She had relied on the banquets in Tay Ninh to keep herself fed, and she had developed stomach problems, which she attributed to eating meat again after several years as a vegetarian. Huong could offer only pity. Though assigned to be a doctor, she was not yet qualified; she was learning on the job and attending night courses that the regime had set up in the south for those who had sacrificed their education for the revolutionary cause. As Dai pointed out, had Phuc a *ho khau* for Ho Chi Minh City, she would have qualified for a health examination booklet, which allowed one to see a doctor for a small fee and obtain prescriptions for medicines and painkillers. This was all academic; she had the money for neither. Weeks turned into months. Whenever there was a knock at the door, Phuc gave up hoping it was the postman with a return letter from Germany. It was only ever the minder from Tay Ninh.

PERRY KRETZ SAW THE DOCTOR'S REFUSAL TO diagnose burn wounds from afar as suggesting the obvious: Kim

Phuc must be brought to the doctor. Kretz put the proposition to his publisher at *Stern*: "We've run her picture and done stories on her many times. Why don't we do something for her? Why don't we get her over here and see what we can do?" The publisher was wary, worried that such a mission would lay the magazine open to the criticism that it was in it solely for the publicity. If done, it would have to be in absolute secrecy. "Find out how much it would cost," he said.

Taking that as a yes, Kretz negotiated the three-way cooperation of *Stern*, the burn clinic and Dr. Zellner, and the Paris-based humanitarian aid agency Terre des Hommes. He then brought the proposal to Phuong in Vietnam's liaison office in Bonn. She passed it on to Hanoi.

Once every week or two, Kretz called to check on a reply. Months went by without so much as an acknowledgment. Phuong, herself frustrated, pledged to facilitate his future dealings with Vietnam when she was in Hanoi—she was due to be posted back in a year. For Kretz, a consolation for the delay was the chance to talk to Phuong at length about Vietnam. It gave him cheer to hear her decry the Communist way of categorizing southerners as good or bad, depending on whether they had the right or wrong revolutionary past.

A full year had passed without word from Hanoi when Kretz received a letter from Kim Phuc. *Dear Papa*, it began. After platitudes of greeting, it ended cryptically: *I am sick and I have no money.* Kretz rang up Phuong. He was blunt: "*Jee*-sus Christ! A person could die waiting for Hanoi to decide!"

It was mid-July 1984 before Phuong notified him that Hanoi had given its go-ahead, that Kretz could go collect her. By his own precondition, he and Kim Phuc would leave Vietnam for West Germany unaccompanied, with no minder from the Vietnamese government.

VIET APPEARED AT THE DOOR OF HUONG and Dai's flat. "I am taking you to see my boss," he said to Phuc. The top official in the foreign affairs office for Ho Chi Minh City was a man named Vu Hac Bong. On the way there, Viet scooped Bong's news: Ho Chi Minh City had received an order from Hanoi to prepare papers for Phuc to go to West Germany for medical treatment. Gleefully, Viet recounted what had transpired when Ho Chi Minh City had advised Tay Ninh: "They were very afraid," he said. "They did not want you to go. They say to Hanoi: 'If you let Kim Phuc go, she will never come back!'" Phuc was silently grateful for God's divine intervention. In this second test, God had answered her again; he had sent Perry Kretz to be her savior. *This is God's way of opening a door to a better future for me*, she told herself, with all the certainty of faith.

ON ONE SIDE OF THE TABLE SAT KRETZ, VIET, Phuc and her parents; on the other, Tam and his usual contingent of aides and security cadres. Tam spoke first, asking Kretz accusingly: "Why are you here?"

"Why am I here? I've come to pick up Kim Phuc, that's why."

"Explain why."

"What the hell is this about?" Kretz was indignant. *I'm being treated like a prisoner of war*, he thought. *I will not be interrogated.* "You know why. I met her for the first time during the war, then I came back because I wanted to see her again, and now I'm going to get her medical help in West Germany."

"We can do it in Vietnam."

"If you can do it in Vietnam, then why haven't you? Why have you waited so long?"

Tam asserted his dominance in the only way he knew how. "You Americans think that your ways are superior, you always

think you know better. You think that your government in the United States—"

It was Kretz's turn to interrupt. "I live in West Germany. I don't know what you're talking about." He glowered at Tam. "Look, I came here to help. I'm here with the backing of *your* government in Hanoi."

The room fell silent; the Vietnamese had not seen such defiance. Phuc felt sick with panic. *God has opened a door*, she thought, *and Tam is going to slam it shut.*

Finally, Tam spoke. "You must understand our attitude. She is a daughter of Tay Ninh province. The government of Tay Ninh wants only the best for the girl . . ."

Kretz abruptly pushed back his chair. "Come on, Viet. Let's get the fuck out of here."

"Please, please!" Tam gestured at them. "Sit down, please."

Tam barked out an order in Vietnamese, and someone scrambled forward with some papers. He turned back to Kretz. "If you think that you can help her, then we can proceed."

Kretz affixed his signature to the papers, undertaking to guarantee Kim Phuc's security en route to Germany, and to guarantee her return to Vietnam. He stood up. "Kim, let's go. We gotta go." Phuc's parents and Viet stood up with them and headed for the van that would take them to Ho Chi Minh City. Tam sent two minions scurrying after them.

KRETZ LOOKED IN DISBELIEF AT PHUC'S ripped black vinyl shoulder bag. In it she had packed one change of clothes and several packages of dried soup noodles that Nu had insisted she take.

"That's all the luggage you have?" Kretz asked. "You have no purse?"

Phuc laughed. "I have no money!"

On the highway, Viet turned to look behind. "They sent somebody after us," he reported.

In Trang Bang, Kretz stopped for pictures first at the noodle shop, then at the Caodai temple. Each time, the van behind pulled off and the two minders jumped out. At the temple, Kretz was posing Phuc in front when one of them came running forward, yelling to Kretz: "No, no. NO!" Then, to Viet: "Tell the American he cannot take pictures here!"

"Why can't he?" Viet demanded to know.

"We are following orders! He cannot do it!"

"It is only a temple," said Viet, "not a military installation!"

"You do not give orders!"

The minder put his hand in front of Kretz's camera. "No!"

That was not the move to persuade Kretz; the minder was now in some peril. Kretz leaned down so that he could look him in the eye. "If you don't move away from me, if you interfere with me, I'm gonna kill you." Despite his menacing tone, the minder did not move. Kretz straightened. In his posture and stocky build was the measure of his ability to use more force than the average person. "You better move away, or something is gonna happen in this town." The minder took a step back.

Kretz turned to Viet: "I don't want to see either of those two"—he waved his hand at the pair—"ever again." There was an exchange in Vietnamese and, minutes later, the vans headed down the highway in opposite directions.

THERE WAS ONLY ONE COMMERCIAL FLIGHT from Vietnam to a non-Communist country, and it left once a week: Air France's Thursday morning flight from Ho Chi Minh City to Bangkok. Phuc and her parents spent Wednesday night in a hotel in Ho Chi Minh City. Neither Tung nor Nu was uneasy that their daughter was traveling on her own with a foreigner;

both were elated that she would receive Western medical treatment and medicines.

The next morning, two dozen family members, neighbors and friends turned up at Tan Son Nhut airport to see Phuc on her way. She was *going out*; that she would return did not take away from her celebrity in their eyes. She posed for pictures outside the departure gate, then, gripping Kretz's hand, nervously boarded the airplane for her first ever flight.

The flight attendant greeting passengers surprised Phuc by recognizing her. "You're the girl in the picture!" The plane taxied on a runway still scarred by shelling from the final days of the war; several runway bays had fallen into disuse, their concrete veined with weeds. Once the plane was airborne, Phuc's nerves gave way to wonderment at the perspective on life below.

In Bangkok, Kretz had Phuc wait for all the other passengers to deplane. To avoid setting foot in the crowded terminal, where he feared she might be recognized, he had arranged for the Vietnamese embassy there to expedite her arrival through diplomatic channels and to have a car standing by on the tarmac. To his disappointment, a gaggle of journalists awaited on the tarmac, cameras at the ready. As he and Phuc appeared, a smiling Vietnamese embassy official bounded up the airplane's steps with a bouquet of orchids. It was Thach, the one who'd found her for Kretz, and it was he who had notified the local press. The next day's *Bangkok Post* carried the story on the front page. The headline: "*Napalm girl seeks cure for scars of the terror.*" Underneath were two pictures: the famous one; and another of Phuc, in sandals, a floppy cotton hat, and a tired-looking blouse hanging out over loose-fitting black Vietnamese trousers, clutching a bouquet while reaching for Kretz's hand.

Kretz checked himself and Phuc into two rooms at the Siam Intercontinental, one of Bangkok's five-star hotels. Normally, the regime required all Vietnamese traveling abroad to stay in the

guest quarters of their diplomatic compound, where they could be overseen by a minder. Without benefit of an interpreter, Kretz conveyed his strict instructions to Phuc: she was not to answer the telephone; and should anyone knock, she was to look first through the peephole, and to open the door only to him. He also arranged a round-the-clock security guard outside her room.

The Siam, set in twenty-six lush acres of a former royal estate, was unimaginable luxury to Phuc, from the marble lobby and the pianist playing there to the bedside console with its remote controls and the brass faucets that delivered hot and cold water. In Bangkok, Kretz had one priority: "I'm taking the poorest girl from the poorest country in the world shopping." From a department store, Phuc chose a couple of crisp blouses, slim pants and a wide-brimmed straw hat. Kretz picked out for her a small rattan suitcase, trimmed in red leather.

In Bangkok, Kretz and Phuc merited no second glances; in a city notorious for selling sex as tourism, the pairing of a German man in a safari suit with a smiling younger Asian woman was commonplace. Phuc eyed the modern towers and shops and the smartly dressed and well-fed people coming and going, and recalled the crumbling brick and stucco and beggars of Ho Chi Minh City. Since the end of the war, Ho Chi Minh City had been getting poorer, more backward, she realized. (Thailand overtook South Vietnam in economic development during the war; while South Vietnam squandered its subsidized wealth on consumer luxuries, Thailand channeled the wealth of its fast-changing rural economy into the development of a manufacturing and services sector.)

Kretz granted Thach's request to entertain Phuc at the Vietnamese embassy one evening. He introduced her there to the ambassador. "Your voice is familiar," the ambassador said. "Have we met before?"

"No—this is the first time." Phuc smiled demurely.

"I know who you are!" the ambassador exclaimed. "I saw you in the Dutch film!"

"Oh!" Phuc beamed. "May I see it, please? I have never seen it."

Thach cued up a videocassette. Phuc was mesmerized by the twenty-five-minute film entitled *Kim Phuc*, dubbed in Vietnamese. The narrator began with the Vietnam war and told of the napalm attack that injured her, and how, ten years later, she was a medical student in Vietnam. Never having seen herself on film, Phuc was proud of her performance: she was articulate, her voice was lilting, her smile bright. She was pleased to see in the film Perry Kretz's black-and-white photographs, the ones he had brought to their reunion. She enjoyed the soundtrack that played over those pictures of her as a child, a children's song that she knew by heart:

> Last night I dreamed of Uncle Ho
> His beard was long, his hair was gray
> I kissed him tenderly on both cheeks . . .

The credits rolled over a red sun dropping in the day's last light. Phuc turned to Thach: "I love it!"

Thach signed them both up for the staff's evening meal. It was Phuc's first taste of Vietnamese cooking from the north. The cuisine of the north is decidedly less colorful and spicy than that of the south—chili peppers, fresh herbs and lime do not grow well in the cooler northern climate. Phuc had no taste for it, and she particularly disliked the sour fish soup. She much preferred the Thai food in the restaurants where she and Kretz had dined.

When Thach returned Phuc to the hotel, a worried and angry Kretz was pacing about. "I'm supposed to be responsible for her!" he reminded Thach. The Vietnamese official was two hours later than promised. Meanwhile, Kretz had been ringing the embassy. Because it was after hours, nobody had answered.

KRETZ DELIVERED PHUC TO PHUONG IN BONN. The liaison office was located in the leafy suburb of Bad Godesburg, a former spa town on the eastern bank of the Rhine River and the favored location for diplomatic missions. Visitors to the Vietnamese compound had first to pass by a guard at the gate, then through the building's reinforced steel door, the entrance monitored by closed circuit television.

Dr. Zellner had come nearly two hundred miles from Ludwigshafen to examine Phuc. He was impressed by the quality of her skin grafts and by how well her body had adapted, twelve years on. Almost always, burn victims require follow-up surgery. Transplanted skin is thin and unstable, fusing unevenly and giving rise to contractures of the skin, joints and soft tissue. Surgical release of those contractures often eliminates the pain burn victims complain of, which comes mostly from trying to extend stiffening joints. Normally, such surgery is done one to three years after the initial skin grafting. The longer one waits, the more the contractures harden into an armor-like plate. The release of skin contractures is routine surgery; contracted joints are hardest to release. The doctor found that Kim had skin contractures, but no joint contractures. Releasing them would allow her to move her neck freely without moving her body, give her near full extension of her arms above her head and lengthen her left arm so that it would be almost as long as her right.

Phuc was transferred to the clinic. On her second day there, she went into surgery for two and a half hours. Dr. Zellner did two surgical procedures: first, he removed a large band of scar tissue near her left armpit and then covered the resulting wound with transplanted skin from her buttocks; and second, he made two incisions to release one band of scar tissue on her upper right arm and another that stretched from the left side of her neck to her ear, stretching nearby skin over the incisions. At a press conference afterwards, he described the surgery as routine and the

patient as recovering well. One week later, he had to redo Phuc's first skin graft, this time using donor skin from her thigh. He scheduled her discharge for the end of the third week.

Phuc's recovery room afforded a view of the extensively land-scaped grounds and a helicopter-landing pad. The recovery from surgery was painful. Daily, Kretz called from Hamburg, and she had company in the next bed, arranged by Phuong in Bonn. Hang, a few years older than Phuc, was fluent in German, and ostensibly there to translate with doctors and nurses. Though Phuc immediately concluded that the real reason she was there was to keep an eye on her, the two fell into easy conversation. Years ago, Hang's parents had sent her to West Germany for her high school education, and after the war, she had stayed on. Now she lived in Ludwigshafen with her boyfriend, also Vietnamese, and neither had any wish to return.

Envy cast a pall over Phuc. She contemplated what life in the West must be like, and found herself achingly searching the night skies, imagining space without limit. One word began to dance across her mind: *escape*. Her heart pounding, she prayed silently and in secret: "Dear God, I want to go. But how? There are so many people around me." She remembered the papers Tam had made Perry Kretz sign. *If something happens to me*, she told her-self, *Perry Kretz would have to pay*. Resigned to returning to Viet-nam, Phuc put her fate in God's hands. While freedom was not to be hers, she remained convinced that God intended this trip as a way to change her future for the better.

One day, a postman came to the room to deliver an envelope addressed to Kim Phuc. He asked her to sign to verify receipt of the contents: one thousand German *marks* (about three hundred and fifty American dollars). The sender was identified only by a German postal box number; there was no name. Hang witnessed the entire transaction. "Keep it," was all she said to Phuc. "Don't let them know." The amount was equivalent to what the average

southerner would earn in a year, someone in the north in two.

To mark their brief friendship, Hang proposed to give Phuc a goodbye present, to replace her Vietnamese plastic sandals with a new leather pair. She had her boyfriend bring a car round and she smuggled her charge, who still had on surgical dressings, out of the hospital. Hang herself drove to a downtown department store. With their purchase in hand, they were heading for the down escalator when two German customers, both men, stopped, staring at Phuc. "Are you Kim Phuc?" one asked. Phuc smiled enigmatically. Casually linking her arm in Phuc's, Hang led her away to browse a rack of clothing. Once out of the men's sight, she pushed Phuc behind it. When she thought it safe, she hurried her back to the car. As Hang drove back to the hospital, Phuc stifled her wish: *Take me away. I want to escape!* Hang made a nervous joke: "Carrying you around is like carrying around a bomb!"

In consultations with Dr. Zellner, Phuc was deeply respectful, adopting the reverential demeanor of the nurses. At their final visit together, she had one question: "My dream is to help people, to become a doctor. Could I manage that with my health?"

Like others who'd read of his famous patient, the doctor thought Phuc was studying medicine in Ho Chi Minh City. Upon meeting her, he'd formed an opinion, though, that she didn't seem to be of the caliber of a medical student. "A doctor has to be mentally strong when he comes face to face with a patient who is in pain," he told her. "It would not be good for you, who has to endure pain, to see others in pain, and not good for the patient."

Phuc was hanging on his every word. He had more to say: "You have to love your career to be a good doctor. When you are needed, you have to go. Even if you have worked all day, if you are needed in the middle of the night, you have to go." He suggested that she choose something less demanding. "How about English? You could work as a teacher or tourist guide. As long as you love

your career, you can realize your dream to help people and give them happiness."

Dozens of journalists crowded into the final press conference at the hospital. Phuong came from Bonn and served as Phuc's interpreter. Reading from the prepared statement Phuong had given her, Phuc began by thanking those who had made her treatment possible. The statement went on: "My hope and dream is that a hospital can be built for burn patients in my country who do not have an opportunity to go to another country for treatment. There is not only one Kim Phuc in Vietnam, there are many." As planned, a German corporation announced its inaugural contribution of 1 million marks. Phuc added of her own accord: "I hope the burn hospital in Vietnam can be named after me." In closing the conference, Kretz made it clear that her ongoing itinerary was private.

PHUONG ESCORTED PHUC BACK TO BONN. Until she left, almost three weeks later in the first week of September, she would stay in the Vietnamese compound. It was accepted practice among Vietnamese leaders, diplomats, workers and students traveling abroad to take extra weeks, even months, after official business (work or medical care or study) to "enjoy oneself"—more precisely, to shop. The obsession of traveling Vietnamese, who were typically on the state payroll or from the north, was to stuff cheap nylon bags with whatever imported goods they could get their hands on. Some profited blatantly. Airport authorities in Moscow once found one diplomatic bag in transit from a Vietnamese embassy in eastern Europe to contain eight hundred pairs of jeans and two thousand digital watches. One politburo member regularly counted his baggage by the number of lorries that pulled up to airplane cargo bays, unloading goods like mirrors, electric irons, pressure cookers, water

pumps, replacement elements for hot plates, and sewing machines—anything in high demand at home.

In Bonn, because it was in the West, only a northerner or a trusted revolutionary from the south would be permitted to go outside the compound without a minder. Assigned to Phuc was Quang, the driver. Phuc had no desire to spend her cache of German marks, nor did she feel up to going out. She had left the clinic in pain, which would worsen before it would get better, and she had come out thinner and weaker than she had gone in. Pain had sapped her appetite. Quang did the favor of going out to buy her painkillers and medicated cream. As she asked, he also purchased four cartons of "555" brand cigarettes, which she intended for her father and brothers.

Most of Phuc's time was spent idly in a staff room. Quang always kept her company. He was affected by her tears and sensitive to her needs, ready to massage her back when pain announced. He was as startled as Phuc when Phuong's voice one day cut like a squall through the room: "Don't cry! If you cry, you will be the stone that blocks other deserving victims from getting treatment!" Others at the office who told of Phuong's connections at the highest levels did so with palpable fear. Phuc was more frightened of her than she had ever been of Tam in Tay Ninh. Later, as Phuc dabbed at her eyes, Quang offered comfort. "She's bad to all of us," he said. "We can do nothing. We are lightweights and have no power. But," he added, "I feel better whenever I meet another person who is not like her."

As she languished inside the compound, Phuc was vaguely aware that, outside, her fame was growing. Staff had collected the German-language newspapers and magazines with stories of the arrival, stay and treatment of the "*Napalm-Mädchen*." However, she had neither the energy nor interest to look at them. A few gifts—plush animals and fancy toiletries—came into the office, but Phuong took them away. "These are not for you," she said to

Phuc. "They are for others." When one elderly German gentleman came to present her with a small gift-wrapped parcel, Phuong humiliated her: "Say thank you!"

Kretz came from Hamburg to say goodbye. He took Phuong and Phuc for lunch. Phuong chose a restaurant on the terrace of a thirteenth-century castle on a promontory of the Rhine. After, at Kretz's suggestion, they strolled along the promenade, and he bought Phuc an ice cream at the famed Capri soda shop. His parting gift was to send two women from *Stern* to take Phuc shopping. Phuong and two minders came along to the department store. "What would you like to have?" asked one of the *Stern* women as the six of them shopped from floor to floor. Phuc thought it too forward to reply.

It was Phuong who finally found something. "This is good to buy for her," she said, selecting a floor-length quilted bathrobe of purple silk. Phuc's retort was trapped in her throat: *I don't need that—maybe people who live in Germany need that, but not people who live in the south of Vietnam.* One of the women from *Stern* looked around for a cashier. Catching sight of a green hand mirror, Phuc pointed to it, and said aloud: "I need this. I like this." The second woman took the entire toiletry set, which included a comb, soap dish and toothbrush holder, as well as a blue plush teddy bear that was part of the display, to the cash.

On the morning of her departure, Phuc was packing her small rattan suitcase. She was sorting what she had room to take of magazines and clothing that Kretz had sent from Hamburg— Phuc said she found the summer nights in Germany chilly, and he'd had his wife send something from her own closet. Phuong came in and stood over her. Phuc offered her the blue plush teddy for her young daughter. "If you have more than twenty kilograms of luggage, you will have to pay money," Phuong warned. "You do not have money." She picked up the quilted purple bathrobe. "In the south, it is hot. You wouldn't usually use this. Give it to me,

and when I return to Vietnam, I'll give it to you." At Phuc's last lunch with the staff, Phuong summoned the cook before them. "You are such a bad cook!" she said, shoving the offending dish at him. "I can't eat this!" Inwardly, Phuc wept. *Why, why? She has a high position, she has everything. Just who are those* others *my gifts are for? Why is she so bad? Why are there people like that in the world?*

UNABLE TO ACCOMPANY PHUC HOME, KRETZ proposed that *Stern* route her on Air France, from Bonn through Paris to Ho Chi Minh City. "No security," said Phuong. She had Quang and a minder drive Phuc to Berlin; from there she would fly to Hanoi. Phuc spent a week at Vietnam's embassy in East Germany. Phuong's husband was kind enough to treat her to an evening at a Berlin beer garden. Then, after seven weeks out of the country, on September 11, escorted by a returning "guest worker," Phuc boarded a plane for Hanoi. She was unexcited about seeing for the first time the north of Vietnam; there were other countries she'd sooner visit.

At Hanoi's sleepy Noi Bai airport, Phuc presented her papers to the official. He recognized her immediately. "You are Kim Phuc coming from Germany," he said. "I've seen you in the newspapers and on television."

"Really?" Phuc was flattered.

A driver and minder picked her up. She was surprised at the airport's rural setting; cows grazed in adjacent fields. Cyclists on the road appeared to have little knowledge of cars. The poverty was more desperate and harsher than anything Phuc had ever seen; she saw the roadside bamboo huts as hovels, what passed for clothing as rags. Even in central Hanoi, people walked list-lessly. In the funereal silence of the moving cyclists, she sensed a knowledge of suffering, of sacrifice.

Her minder took her to the Thong Nhut—the state named one hotel in every city "Reunification." Formerly the Metropole and once a stunning example of a *fin de siècle* French colonial hotel, it was dingy and drab with neglect, shabbier than the unimpressive hotel in Ho Chi Minh City that Phuc had spent the night in on the way out. It had telltale Communist fittings, from the small Russian air conditioner in the window to the Chinese thermos bottle filled with hot boiled water on the floor beside the bed. The restaurant's menu of northern cuisine offered little; most items were crossed out.

Phuc's stay there was not as quiet as she'd expected. Her arrival in Hanoi had coincided with the regime's celebrations marking thirty years of liberation from the French. The minder from the foreign ministry in Hanoi repeatedly came to collect her and to bring her back to its offices for yet another interview with yet another journalist, Vietnamese or foreign.

Foreign ministry officials believed that, since the university fall term did not begin until mid-October, Phuc was available until then. In her second week in Hanoi, Phuc moved into a private home belonging to the widow of a north Vietnamese army captain. The rotund woman was the mother of a friend of Quang's, the driver in Bonn. As a favor to Quang, Phuc had carried a letter from him for the woman to keep for her son, Minh.

Minh had been with a group playing volleyball in the compound of the Vietnamese embassy in Bangkok, and Thach had interrupted their game to introduce Phuc. Minh was someone who made an impression: in his twenties, he had the brashness to go along with his movie-star looks. As he'd explained to Phuc then, he was in Bangkok "enjoying himself" on his way home to Hanoi from Manila, where the foreign ministry had sent him to study with a renowned Filipino healer. Minh was surprised that Phuc did not know of his own fame.

In Hanoi, it was Minh's mother who was surprised to receive

a visitor as famous as Phuc. She showed Phuc a stack of Vietnamese newspapers and magazines with stories and photographs of her time in Germany. She asked solicitously after Phuc's comfort at the hotel. Hearing her displeasure over the food in the restaurant and the rusty water that came from the taps, the widow arranged to have the foreign ministry pay her to house and feed Phuc instead.

The widow gave generously of her time, taking Phuc sightseeing on the back of a Japanese motorscooter. They walked around the legendary Hoan Kiem Lake in central Hanoi, named for a fifteenth-century warrior who had been enjoying a boat ride when a golden turtle rose from the water to retrieve and return to heaven the sword he'd used to drive out Chinese invaders. They visited Ho Chi Minh's mausoleum. Like other historical sights, it held little interest for Phuc.

The quiet atmosphere in the widow's home was shattered when Minh returned. Everything about him was loud: the volume at which he played his music, the way he dressed—his pirated music cassettes and flashy cotton shirts and leather shoes were purchased in Bangkok—the way he partied. The entertainment changed: night after night, he took Phuc on the back of his motorscooter to the narrow alleys of old Hanoi, where they dined out at restaurants with his numerous friends. In addition to a power to heal, Minh claimed an ability to sense the presence of money or valuables on a person's body or mind. He cajoled Phuc into giving him three of her four cartons of "555"'cigarettes, and managed to leave her each time with the restaurant tab—though he always found someone to change her German *marks* at favorable black market rates.

As Phuc's departure loomed with the opening day of the fall university term, Minh found a way to have her stay extended. A thyroid problem that she had had as a child flared up, showing up in an enlarged goiter on her neck. Minh received permission from

the foreign ministry for Phuc to stay another week so that he could treat her. "Vietnam's two most famous people getting together!" he said. Phuc dismissed Minh's claims of healing powers, despite having witnessed the desperation of others who believed. Several strangers bearing gifts of rice and fruit had rung the bell at the gate of the compound. They would plead with Minh to heal their sons or daughter or relatives suffering from cancer. He rudely turned all away, anxious to entertain Phuc instead.

Phuc herself was in no hurry to return to Ho Chi Minh City. Unbeknownst to anyone in Hanoi, nothing awaited her there. Eventually, what was left of her German *marks* would run out. *I will be back to no schooling, no money and no rice*, she told herself. As the last vestiges of the euphoria of her trip abroad faded, she wondered, how had God intended her trip to Germany to be a door opening on her future?

The answer to her question was fashioned from comparisons of her own life with that of Minh and his family. The widow's army pension and Minh's state salary were low, yet this was a family who lived *as if* rich. Minh's travel abroad gave him access to foreign-made goods and foreign currency: as proof, the family had three foreign-made motorscooters parked outside, and inside both houses a television and a stereo, and an electric fan in every room. What determined who suffered and who lived a comfortable life? Phuc understood: what separated one from the other were *connections* to others holding positions of power and privilege. Phuc saw her next move with clarity: *I must tell the truth to somebody more powerful in Hanoi.* Suddenly, she saw divine reasoning to her having been routed home through Hanoi instead of flying direct from Bonn to Ho Chi Minh City.

Opportunity came with a reception at the foreign ministry held in her honor to meet visiting Japanese journalists, hosted by the senior Vietnamese official in the ministry responsible for

receiving foreign journalists. In his mid-fifties, Minh (of no rela-
tion to the healer) had received Phuc earlier. She had noticed that
he commanded respect from those who worked for him, that he
wielded authority without menace. She had an instinct, again,
that this was an official she could trust.

She conspired to sit beside him while taking dessert and tea.
In side-by-side comfortable armchairs, slipcovered in white, she
hesitantly began a conversation. He interrupted: "Do you have
something to tell me?"

"Yes!"

Minh was deeply perturbed by what he heard. "Nobody
knows this," he said. "This is wrong, very wrong." At his instruc-
tion, she wrote a letter to prime minister Pham Van Dong, repeat-
ing what she had told Minh—that two and a half years earlier, Tay
Ninh had removed her records from school in Ho Chi Minh City,
that she was living there in limbo. Minh promised to personally
deliver her letter into the prime minister's hands. He told her to
wait in Hanoi for a reply.

Two days later, an aide from the office of Pham Van Dong
came to the widow's house with a message for Phuc: the prime
minister wished to invite Kim Phuc to dine with him at his villa
that evening.

CHAPTER ELEVEN

IN CENTRAL HANOI, NOT FAR FROM HO
Chi Minh's mausoleum, were several com-
pounds composed of elegant nineteenth-century villas, painted
ochre with green-shuttered windows, set in spacious gardens of
bougainvillea and dahlias. They were home to members of the
Vietnamese politburo, along with their aides, guards and domes-
tic staff. The house that had once belonged to France's colonial
governor was now occupied by Pham Van Dong. His wife, who
was under the care of nurses, was housed in a separate building
in his compound. Their grown son, Duong, had a career in the
army and lived on his own in Hanoi.

In the eyes of the Vietnamese people, the seventy-eight-year-
old Dong, along with the brilliant general Vo Nguyen Giap, who
created the Viet Minh fighting force that defeated the French in
Dien Bien Phu and commanded forces against the Americans,
were their link to the thought and traditions of Ho Chi Minh.
Though Dong and Giap were more than a decade and a half
younger than Ho, the triumvirate had been loyal and close. All

three had been educated in French at the National Academy in Hue and had been together at the founding of the Indochinese Communist Party in the late 1920s. All three had survived imprisonment on Poulo Condore (the uninhabited island in the South China Sea that the French turned into a penal colony for political prisoners) and years of a guerrilla life.

Dong emerged from years of Communist Party work in south China to become one of Ho's top lieutenants in the Second World War. He gained international prominence as Ho's foreign minister when he represented the Viet Minh in the Geneva talks that settled the war with the French. One year later, in 1955, Ho made him prime minister, a position he still held. Dong's reputation was as a conciliator, and an able, if cautious, administrator, but he was most respected for the moral authority he commanded— that is, when he had the will to exercise it, and where the rigid system left room for such considerations.

His personal life set a moral example in the Party. The long fight for independence had separated cadres like him from their wives for years, and divorce and remarriage were common. Dong had lived apart from his wife since the early 1950s, but he refused to divorce her. Many older cadres remembered her as the beautiful teenage girl who worked at the Zephyr ice cream parlor across from the restaurant pavilion on the banks of Hoan Kiem Lake. Upon marriage, she had joined Hanoi's underground movement against the French, and Dong had returned to a life in hiding. Shortly after the birth of their son, she was stricken with severe headaches that marked the onset of mental illness, which would leave her incapacitated. Dong had to send their son to Saigon to be raised by his southern relatives.

Dong differed in other ways from his colleagues in the politburo. Where they were gray, austere and aloof, he was warm and affectionate. Passionate about his country, he was known to become emotional when talking about the wartime fate of its

women and children. Suffering from diminishing eyesight in his later years, he enjoyed listening to the radio, or having someone read aloud to him from the works of Victor Hugo or Anatole France. Every evening, he had Duong join him for dinner, and on Saturdays, his wife joined them as well.

On the evening that Phuc came for dinner, the prime minister's personal aide showed her in and Duong received her. His father greeted her with a kiss on both cheeks. After dinner, Duong left and would not reappear until the end of the evening, to give her a ride home on the back of his motorscooter. In a sitting room, fragrant with cut dahlias, Dong and Phuc had their private chat.

Dong took her hands in his and addressed himself to her plight. He wanted to hear, in detail, of the pain she had suffered as a consequence of the napalm bombing, and of her treatment in Germany. He asked about the pain that still bothered her. Except for her mother, never before had Phuc so freely confided in anyone. She saw in Dong's physical demeanor the image of an angel. Tall for a Vietnamese, he had intense, deep-set eyes which were set off by a high forehead and thick white hair. In his manner, she sensed empathy, and in the way he spoke of her injury, a long knowledge of her picture. He asked to see her burns, and when he felt the angry ridges of scar tissue, his tears fell freely.

I can see that he is a great man, Phuc told herself.

She felt compelled to explain why she had told the lie that she was a medical student to journalist after journalist. "I am scared. I don't want a conflict. So, I say nothing," she said. "When the journalists are gone, I just cry at what has happened to me."

In conclusion, Dong asked what she wanted to study. She recounted the advice of the doctor in Germany to give up medicine for a career less demanding. "I recognize that I cannot work hard," Phuc admitted. "But in my heart, my wish is to help people. I cannot give up that dream."

"The doctor is right. What you can study depends upon your health," Dong said. "It is better to choose another subject. English is a good choice."

Before Phuc left for Ho Chi Minh City, she returned to dine with Dong and his son again. She took away with her a letter of instruction from the prime minister to his aides in his office in the city. As he requested, they wrote the same letter to authorities in Ho Chi Minh City and Tay Ninh, which read, in part:

> . . . Kim Phuc left for the Federal Republic of Ger-
> many for treatment for burns from a napalm bomb-
> ing caused by the Americans and returned to Hanoi
> on September 11, 1984. However, she still had trouble
> with her mental health and a growth on her neck, so
> the authorities agreed to let her stay in Hanoi until
> October 20, 1984 for treatment.
>
> During her time in Hanoi she had a chance to
> meet with Mr. Pham Van Dong who asked about her
> condition. He told her to do well in her study and
> labors. To realize the advice by Mr. Pham Van Dong,
> we recommend that the local authorities pay atten-
> tion to her case, and help her with her studies at her
> wish, so that she can become useful to society in the
> future . . .

On Hanoi's orders, Tay Ninh transferred Phuc's *ho khau* to a university in Ho Chi Minh City. She enrolled in a five-year course towards a degree in English. The university waived her tuition and accepted her even though classes were already in their third week.

Phuc would have a chance to express her gratitude to the prime minister the following summer. It was the practice of high-ranking officials in Hanoi to leave the city's sticky summer heat

for the drier heat of the south, combining work in Ho Chi Minh City with retreats to the beach at Vung Tau and the evergreen forests and mountains of Da Lat. When at his villa in Ho Chi Minh City, Dong would regularly invite Phuc to dinner.

WHENEVER PHUC HAD AN INTERVIEW WITH foreign journalists, minders from Ho Chi Minh City came for her. She rejoiced at the thought that she would never again have to set eyes on Tam. *He has lost me*, she told herself. *I have escaped.* Her parents could not say the same. After she had left for Germany, Tung had asked Viet, the interpreter, for help in seeking relief from what seemed like a punitive tax burden on the noodle shop. Viet arranged for Tung and Nu to see his boss, Vu Hac Bong, in the foreign affairs office, the same official he'd once taken Phuc to see. Nu did the talking. "The government does not like the family," she said, asking Bong to use his influence with officials in Tay Ninh. The kindly, hale and robust Bong, a respected intellectual, gave Nu a letter to take to the Tay Ninh authorities: ". . . please consider the case of the mother of the victim of the napalm bombing who is now in Germany. Because of the special condition of Kim Phuc, we at foreign affairs are very concerned . . ."

Tay Ninh must have looked upon the letter as Ho Chi Minh City meddling where it had no authority. Even had there been no antipathy between Tam and Kim Phuc, hungry tax collectors, with few places to turn to, could still have targeted the noodle shop in the knowledge that it had a steady clientele and therefore made money. Moreover, the provinces, particularly poorer ones like Tay Ninh, had little financial room to maneuver, what with crippling over-taxation by cash-strapped Hanoi. During Phuc's sojourn in Germany, Tam had ordered her parents brought to his office to receive a foreign delegation wishing to make a donation

to them of *dong* equivalent to about two hundred American dollars. "This money is for the whole city, not for you," Tam later told Tung and Nu. If cadres in Tay Ninh believed Phuc and her parents were profiting from her travel abroad and contacts with foreigners, it was because, in their shoes, they would have done the same.

When she moved back in with Huong and Dai in Ho Chi Minh City, Phuc's living conditions improved for several reasons. Huong and Dai had a new baby, and therefore they had been allowed to move from the hospital dormitory to a larger flat. Phuc also had her German *marks*. Realizing that having a source of money unknown to the authorities would be dangerous for her, to say nothing of compromising her aunt and uncle, Phuc presented herself to Bong as needing support: "The government should support me, because it was the government that took away my schooling." He agreed: "That is how it should be. You shouldn't have to worry about anything except your studies." Monthly, Phuc came to his office to collect a small stipend that was just enough to keep her fed. Each visit, he would reach into his own pocket to put a few extra *dong* into her hand. If he was not there, he left an envelope. The extra sum bought her painkillers, and maybe an ice cream cone or a new pen.

Apart from school, Phuc's urgent need was to hear Pastor Anh preach. Some months before she went to Germany, the pastor of Anh's church had been arrested and Anh had taken his place. Phuc went to the church on the first Sunday she could. The sidewalk outside was ominously empty. The door was locked. Gone was the sign with the name of the church and times of services.

She hurried to Loan's house and found Linh, Loan's daughter, there. "What has happened to Uncle Anh?"

"He has gone," Linh said. "The government closed the church."

Other Christian friends confirmed Anh's arrest. Word was

that authorities had found Anh with "reactionary" leaflets in his possession. Phuc wanted to visit him in prison, but he had conveyed his wish to have only God as company.

Anh's church had been one of several Christian churches closed in a sweep by authorities. The leaders had been arrested and the usual accusations leveled: the churches had used the "mask of religion" to preach against the state, plan acts of sabotage, infiltrate spies and accumulate weapons. This recent crackdown came as Hanoi feared that among the growing numbers of those who had escaped Vietnam for the West were plotters planning subversive activities against the regime and coordinating them from afar.

From time to time, Phuc went to Sunday service at the church where she had been baptized, which the authorities allowed to remain open. Daily, she took time to pray and read the Bible. *You lose money, you can replace it,* she told herself. *But if you lose something spiritual, you are hungry in your soul. What can you eat?*

BEGINNING IN THE SPRING OF 1985, THE PACE of Phuc's interviews with foreign journalists intensified as never before. Media the world over were taking a renewed interest in the subject of Vietnam with the approach of another tenth anniversary of the war: that of the fall of Saigon. That there was a greater willingness in America to publicly examine that chapter of the nation's past was apparent in the number of visitors drawn to Washington's Vietnam Veterans Memorial. The granite wall ranked second to the Lincoln Memorial among the capital's most visited sights. The first audible, if faint, chorus of voices from the former antiwar movement and from the community of former South Vietnamese living in the United States called for friendship with the countries of Indochina. Speculation concerning a breakthrough in relations between Hanoi and

Washington came that spring when Hanoi allowed American military officials to step up visits to investigate the MIA issue, from four to six times a year.

Phuc's professors and classmates got used to reporters, photographers and film and television crews coming into their classrooms to photograph her and, as well, interview them. Some one hundred and fifty foreign journalists, mostly American, came to Ho Chi Minh City to cover the official celebrations leading up to the anniversary on April 30. More than once, Phuc found herself one of several interview subjects: once she was paired with the widow of the subject of another famous photograph of the war, that of the Viet Cong suspect being shot in the head by a South Vietnamese general. Phuc avoided saying anything to the widow, seeing "Communist" written on her stony face.

Of the multitude of interviews Phuc gave, one stood out in her mind, not for the interview but for what happened after it was over. The correspondent was NBC's Arthur Lord, who had reported on the napalm attack that injured her thirteen years earlier. When Lord asked Phuc if she had ever seen the original news item, she said no. Though she had seen some of the footage as part of the Dutch documentary it had made no lasting impression, perhaps because it was in black and white, with the original sound muted so the narration could be run over it. She expressed curiosity. Somebody popped in a videocassette. Watching it with Phuc was her interpreter friend, Viet, who said he had never seen it either.

Phuc watched the opening shot of the napalm bomb exploding on the road, then the sequences of the survivors running out of the black smoke. She saw Auntie Anh's young baby—the cousin who died some weeks after the attack—in the arms of a villager. *He doesn't look so badly injured*, she said to herself. Into the frame came her grandmother, struggling forward with the blackened body of Danh.

"*Nguoi oi!*"

Her grandmother's voice seemed to come from a depth and darkness unknown. It cut like shards of glass in Phuc's heart.

"*Chay di dau nhu vay ne troi? Chay di dau nhu vay ne troi?*"

Phuc cringed at the sight of chunks of skin dropping from Danh's burned heels.

Then she saw herself in her nakedness, running out, with two of her brothers and other cousins. She answered her grandmother's question on behalf of the dying Danh: "Grandma, I could not run out, not with my heels burned like that."

The screen went black. Phuc sat in silence, her cheeks wet with tears. Viet was shaking. "Terrible," he kept saying. "Terrible." Viewing the film was for Phuc the death and resurrection of her memories of the napalm attack. The hundreds of interviews she had given had focused solely on her plight. With no awareness of the events as captured on film, she had recounted only what she saw in her mind: turning her head as she ran from the temple to see the bombs falling from the airplane, fire becoming her world. Then, her only concern had been to run, and to keep running.

Never before had Phuc considered what had happened to others caught in the napalm attack in the time elapsed before she emerged from it into the camera's eye. Those missing moments were a metaphor for Phuc's understanding of the war itself; she didn't know how it had started, who the enemy was, who was fighting whom, who was winning or how it would, or could, end. Now she understood that her two cousins had come horribly to their deaths. *Why*, she asked herself, *why should a baby, a child, have to suffer like that?* The film crew was packing up, putting the videocassette away. *Now that I see the film*, Phuc told herself, *I understand why the people in the United States feel for my pain. Now I know what I myself suffered through.* She understood why she had emerged alive from the fire of the napalm—to be a living symbol of the horror of war. *The film, the picture made me into a*

*moment of history. It is only me in that moment of history. I know
I am not the only victim of the war, but others don't have the evi-
dence. I have the film, I have the picture and I have the body.*

IN JUNE 1985, PHUC'S ACADEMIC SUPERVISOR
called her in. The university had received an order from Hanoi:
Kim Phuc was to travel the following month to Moscow. Once
every four years, a Communist or socialist bloc country hosted a
world youth festival on socialist issues. This year's festival in
Moscow had as its theme "anti-imperialism and anti-war." One
year earlier, Vietnam had begun a nomination process to select
one hundred "committed sons and daughters of the socialist rev-
olution." Like other youth organizations, Phuc's university had
already put forward its one name. However, Phuc had been
invited by the festival's hosts; Komsomol, the Soviet youth coun-
cil, wished her to be a speaker and panelist.

"If you want to go to Moscow, you have to join the Commu-
nist Youth League," her supervisor said. "Only members can go."
The form he put in front of her was normally used for high
school students.

Phuc laughed. "Okay!"

Moscow was scrubbed and gleaming in readiness for the
eight-day festival. Colored holiday lights had been strung up;
locals had washed their cars; a million Muscovites had been
shipped off to vacation camps, and local sales of vodka had been
cut off. Banners proclaimed "For Anti-imperialist Solidarity,
Peace and Friendship." On opening day in late July, before a
crowd of more than one hundred thousand in Lenin Stadium,
and as hundreds of doves were released, the Soviet leader Mikhail
Gorbachev declared the festival open. Eighteen thousand dele-
gates came from one hundred and fifty-seven countries; the
American delegation was three hundred strong.

The Vietnamese organizers excluded Phuc from participating in the parade of nations and cultural performances because she was at the festival as a guest of the hosts, not as part of the Vietnamese delegation. From the stands, she admired the flowing white *ao dais* and the conical hats of the Vietnamese women. She herself had a hectic schedule of appearances. Her venues ranged from a classroom to a theater, her audiences from a few dozen to several thousand; her events included everything from friendship meetings with other delegations to "tribunals" on subjects like imperialism, militarism and colonialism, and peace and disarmament. The latter was much in the news, as Physicians for Social Responsibility, led by the Australian activist Helen Caldicott, had won that year's Nobel peace prize for its advocacy of nuclear disarmament. Typically, Phuc was one of several victims of war showcased. Another story given prominence, recounted by an American religious worker, was the 1980 murder in El Salvador of three American nuns and a lay churchworker by security forces from the American-supported military regime.

Phuc had faced countless journalists, many of them hardened war correspondents, but never before had she experienced the sympathy of a live audience. When the audience realized who it was who was standing before them, a floodgate of emotion would be opened. Even the moderator and interpreter, and finally Phuc herself, would falter. Sniffles would give way to unabashed tears.

Question: "What are the lasting effects of a napalm burn?"
Answer: "I continue to suffer much from both physical and emotional pain. Sometimes I thought I could not live. I suffer from headaches and deep pain inside my body ... I do not know if my health will allow me to marry or have any children."
Question: "Do you hate America?"
Answer: "I never use the word hate. I *never* hate the people,

because the people have nothing to do with the war. I consider Americans friends, and I want to talk about the war with them. That is why I am studying English, so that I can understand them and they can understand me."

Question: "If you could meet the pilot who dropped the napalm, what would you say to him?"

Answer: "I want to meet him, but I don't want to talk to him about the war. The war is in the past. We cannot change history. War is terrible and I want to stop war, not just in Vietnam but in the world. I want to say to him that we have to do something to build peace."

At the end of every session, hands would reach for Phuc as if seeking absolution. People wanted her autograph. Phuc would remember one American veteran in particular. Wheelchair-bound, having lost a leg in the war, he was convulsed in tears even as they went to embrace. "Sorry," he kept saying. "I just want to say sorry." *The New York Times* published an account of a youth worker from New York meeting Kim Phuc. "I wanted to leave right then," he told the reporter, "and jump on a plane to tell my friends, 'Hey, that girl in the photograph.'"

By the time the festival concluded, Phuc felt propelled onto a world stage. As if in confirmation, when the Vietnamese delegation assembled to leave for Hanoi, authorities singled her out. "You are to remain behind," they said. Komsomol had chosen her to enjoy a month-long holiday in the Soviet Union, an annual privilege granted to four Vietnamese.

WHILE WAITING FOR THE THREE OTHERS to arrive from Vietnam, Komsomol settled Phuc into the modest but comfortable Lenin Hotel, near Red Square. Some three weeks

later, a woman and two men joined her. All were in their late fifties or older, all senior Communists. The woman was a minister of the central committee in Hanoi, responsible for labor, invalid soldiers and social welfare; the men were army officers and editors of army publications. Phuc recalled the woman's name from her high school lessons on the north's revolutionary heroes. The woman had a recurring eye problem that sent her to hospital in Moscow, and the foursome became three.

Their itinerary included the major tourist destinations—the sights of Moscow, including Lenin's tomb; the architectural showpiece Leningrad; Kiev, the pretty capital of the Ukraine; and Sochi, the famed resort on the Black Sea—and sights off the beaten track, Tashkent in remote Kazakhstan and Yakutsk in Siberia. By day, their Soviet guide and interpreter took them sightseeing, with visits to libraries and museums, and by night they went to cultural performances, including the Bolshoi and the Kirov and concerts of Tchaikovsky.

What was most enjoyable for Phuc was not the travel across the vast Soviet Union but freedom from a Vietnamese government minder. She was able to relax in the company of her northern companions, who were as anxious to meet a southerner as she was to meet them. The talkative three quickly became friends. Phuc sought the opinion of one of the men about the bullying ways of Phuong. "She's the daughter of the foreign minister; she has everything. Why did she have to treat me, who has nothing, so?" The reply that one of the men offered gave her much to reflect on. "A socialist state has not only good people, but also bad people," he said. "Lift your eyes over those who have wronged you. Don't let Phuong occupy your mind. Hang on to relationships with those you judge to be good."

At the end of September, Komsomol asked Phuc to stay on several months longer to visit its branches across the country. "Soviet young people today want only to be consumers," they

explained. "They grow up without knowing about war and suffering. We want you to make them aware so they won't forget." Since Hanoi had sent her to Moscow in the first place, Phuc readily agreed, giving no thought to the fact that the academic year was about to get underway.

Her schedule for the next weeks would rival that of a campaigning politician. Using Moscow as her base, she traveled to many of the same cities she'd already been to, staying up to a week in each and visiting schools, factories and farms. Her hosts rewarded her with an interlude in late October of two weeks at one of Sochi's more than two hundred medical and therapeutic clinics and spas. Elsewhere in the Soviet Union, the weather foreshadowed winter's chill, but in Sochi, which lies protected from northerly winds by mountains hugging the Black Sea coast, daytime temperatures in the fall can reach into the low seventies (low twenties Celsius). The view from Phuc's world-class luxury hotel was of palm trees and the beach. Twice daily, a driver ferried her to and from the clinic, where, under a doctor's care, she would undergo a daily regimen of bathing, water massage and cream applications. Her scar tissue went from rigid to supple; her burned areas lost their patchy blackness and turned a translucent pink. Relaxed sleeps and long walks along the seaside and into the mountains revived her appetite. She put on much-needed pounds. *One day when I have money, I will come back*, she promised herself.

Her return to Moscow in December, while she was between engagements, was a cold shock. The city was in winter's snowy grip. Had she been home in Ho Chi Minh City, Phuc would have been enjoying December and January as the most pleasant months of the year, when the eighty-degree daily average temperature (about twenty-five degrees Celsius) is a couple of degrees off the peak of summer. Phuc's hosts took her to the upmarket GUM department store off Red Square and outfitted her with a jacket, fur hat, boots and gloves. However, Phuc fell

abruptly ill. She found it difficult to breathe and she was felled by excruciating, unrelenting headaches.

Never was Phuc so fearful of the illness brought on by her burn wounds. Soviet authorities admitted her to a hospital outside Moscow, where top specialists took care of Party brass and foreign dignitaries. The woman minister from Vietnam was still there recovering from an eye operation. Doctors tried various methods of pain relief, including acupuncture, on Phuc. They were slow to take effect, as her body needed mainly to acclimatize to the extreme cold. Apart from her burned skin having left her body short of pores to regulate its temperature, her lungs had likely been damaged from the searing heat of the fires of napalm and were unused to drawing cold air. Shock may have left her internal organs permanently damaged or vulnerable to weakness. By the end of January, however, the rest and the comfort of well-heated rooms, excellent food, and attentive specialists and nurses had improved Phuc's health to the point that she was ready to be discharged.

Days before her final discharge, her weekly visitor, a minder from the Vietnamese embassy in Moscow, came to take her to a Soviet guest house for the evening. Prime Minister Pham Van Dong was staying there while on a trip to Moscow and had extended a dinner invitation. Among the twenty guests, some Vietnamese but mostly Soviet, Phuc had one of the seats of honor beside Dong. They chatted throughout dinner. When she told him of the headaches that had landed her in hospital, he asked questions that a doctor might have asked: where was the pain? how did it feel? It brought to mind for Phuc his grief over his wife. Once, while Phuc was strolling with Dong's son Duong around the gardens of the villa in Ho Chi Minh City, they had come across his mother reading the day's newspaper. Phuc had spoken to her, and by her reply, she'd seen that she had the mentality of a child.

Dong addressed himself to Phuc's minder, seeking details of her treatment at the hospital and of the opinion of doctors there. "I want you to get better," he told Phuc.

He turned the conversation to the resumption of her studies upon her return to Vietnam. Unexpectedly, he put forward a proposal: "Would you like to stay on in Moscow? Go to university here?" He spoke enthusiastically of the university's high academic standards and of the privilege of receiving a degree from Moscow.

Phuc smiled. The cold was the least of her dislikes of living in Moscow. She had the same prejudices against anything Russian that most Vietnamese had. In five months in the Soviet Union, she had made no effort to say anything more in Russian than "*spasibo*" to express thanks. From city to city, the Komsomol guide had bought newspapers and magazines with articles about her visit; Phuc had kept not a one. The only affinity she had for anything Russian was caviar, and only because she'd had time to acquire a taste for it in reception after reception.

She fashioned her reply carefully. "I have not seen my mother and father since last summer. If I were to stay here to study, I would be away for five or six years. That is too long a time. I want to go back to Vietnam."

Dong smiled, heartened by her reason for returning.

When the cheese course came, he helped himself generously. "You don't eat cheese? Did you know that Pham Thy Hang eats a lot of cheese?" he asked her, naming a beautiful Vietnamese film star. "You should try to eat cheese," he said. "It's very good for the skin."

In late January, Phuc flew back to Hanoi. The cold there proved another unwelcome surprise. The same northern winds from Siberia that had brought snow and hail to Moscow had brought an ill-tempered, dark rain to Hanoi. Though the mercury in Hanoi climbed to about sixty degrees (about sixteen degrees Celsius), the air was damp. Phuc had to remain in Hanoi

until she could secure the return of her identity papers, surrendered upon leaving the country.

With the concurrence of the foreign ministry, Phuc stayed with Minh's mother. On this week-long visit, Phuc was not in a congenial mood. The house was unheated. Its walls were flimsy and there was no glass in the windows. Phuc had none of the padded jackets and layers of clothing that others in Hanoi wore indoors; it occurred to her that she could now use the quilted purple robe that Phuong had kept for herself. Instead, Phuc huddled indoors in her Soviet winter gear.

Phuc had seen Minh during the three weeks she'd spent in Hanoi being briefed for the youth festival, but their friendship did not pick up where it had left off. Then, he had been such a frequent presence at the dormitory that others referred to him as "Kim Phuc's boyfriend." Phuc was peeved to hear from others at the foreign ministry that he was broadcasting his intention to marry her. He did poorly against Phuc's measure of a prospective husband. She thought him slovenly, he expected his mother to pick up after him, and he was petulant when he couldn't get his way. One time he'd turned his reggae music to full, deafening volume; another time he'd roared off on his motorscooter. When Phuc left for Ho Chi Minh City, she was glad to leave behind not only her Soviet clothing, which Minh took off her hands, but Minh as well.

PHUC'S FIRST PRIORITY WAS TO SEE HER academic supervisor. It was February and three weeks into the start of the second semester. She had to reinstate herself in school to once again receive her stipend from the foreign affairs office. She needed money urgently; after a year and a half, she had exhausted her German *marks*. "I hope I can return without any problems," she said politely.

The supervisor's reply caught her by surprise. "The university should not accept your return at all."

"But, but—" she stammered. "I received an order from Hanoi to go to Moscow . . ." She was prepared to beg to be allowed to come back to school.

"I saw the festival in Moscow on television and your activities there." He made it clear that he was only grudgingly accepting her return. However, he had another surprise. "You cannot go into your second year," he said. "You must go back into first year. If you were not so famous, we would not accept your return at all."

The near loss of her status as a student painted for Phuc the folly of her dual life. The pampered life while abroad had allowed her to forget the reality of the struggles of life at home. She was forced to admit that the university was being more than reasonable in allowing her back at all. As she rejoined classes, she thought dejectedly of her friends in the middle of their second year. She was twenty-three and in first year, back to where she had been, albeit studying medicine, when she was nineteen.

Three months later, in June 1986, an aide from Ho Chi Minh City's foreign affairs ministry let slip to Phuc what he thought to be exciting news: Hanoi had accepted a private invitation for Phuc to go on a speaking tour to the United States, and had ordered Tay Ninh to prepare her papers for travel.

Weeks before this invitation, there had been hope of warming relations between Hanoi and Washington, until the Reagan administration dampened the mood by yet again asserting its policy on MIAS. Yet, eleven years after the end of the war, there *was* some desire in the United States to find closure for the painful past that was Vietnam for Americans, evidenced by the creation of grassroots groups there, such as the Indochina Reconciliation

Project, whose aims were not so ambitious as to seek normalization, but only to prepare Americans for reconciliation. Such an objective would have held appeal for Hanoi.

Phuc hid her profound dismay at yet another dictate from Hanoi. *My health problems, my money situation, my interrupted schooling, Moscow, and now—this!* She feared an absence of weeks, possibly months in the United States. And what if she fell ill again? She saw her academic setbacks replaying themselves. Phuc spoke firmly to herself: *It's time to get serious! No more fooling around, no more wasting time. I must focus my attention on finishing school.*

Late in the summer, a minder from Tay Ninh delivered a letter to Phuc from Thuong, the president of the province. It was a summons for her to see him. The midday scheduling of the appointment infuriated Phuc.

Thuong was brusque: "Kim Phuc, we have an order from Hanoi to prepare your papers to go to the United States." He launched into a lecture. "This trip is not for medical treatment, like your trip to Germany. This trip is not a holiday either, like your trip to Moscow. This time, you must *work*."

For years, Kim had been torn between what she was required to say and what she wanted to say. As a rule, she would have feigned happiness to hide unhappiness inside. Not this time. Her voice held firm. "I do not want to go."

His shock at her audacity quickly turned to anger: "What? WHY?"

"Because I am worried about my studies. When I returned from Moscow, I was in trouble with my school. They did not want to accept me back. Had it been anyone other than me, they would not have been so lenient. I had to beg to be let back in!" Her voice betrayed exasperation. "And now? I have to go again? It is not fair! If I leave again, I will have to return again to my first year."

Her last card was desperation. "Please, leave me alone to study! When I finish my studies, I will do whatever you want. Or I will go after my studies. Whatever you ask then, I will say okay!"

The president was adamant. "This trip to the United States is *work*! You have to go!"

"Please, understand me."

"This is an order from Hanoi. You must obey!"

"No." Phuc's refusal stunned Thuong. She continued. "I am in trouble with my school."

"It doesn't matter!"

"I cannot go. I have to finish my schooling first."

"You have to go! These are orders from the government. You are under the school; your school is under the government. It cannot make trouble! You will await orders about when to travel!"

A dispirited Phuc boarded the bus back to Ho Chi Minh City. It bumped along the highway, the breeze and dust of hundreds of rides just like this one blowing through the open windows. Phuc thought of the accident of fate, of how Vietnam had many war victims who did not receive the attention of journalists, who did not travel abroad for the best of medical care, who did not get to go on all-expenses-paid vacations. Others resented her for being the beneficiary of what they saw as privileges. Phuc had overheard gossip. "Why choose her?" someone in the Vietnamese delegation had asked, resentfully, when authorities had singled her out to remain behind in Moscow for a vacation. Then, she had gloated. Now, she wanted to say: "Okay, let me change my position for yours. I am just the victim. I was just a child. I didn't do anything wrong. I don't want to be chosen. I don't want it any more!!"

THE CHURCH WAS THE ONLY RECOGNIZABLE signpost in Phuc's confusion. She went there daily to pray: "Dear God, I have to finish my studies first. Please, help me, find a way to let me study." She felt a need to confide her discouragement in someone and looked to Huong and Dai for sympathy. "I travel, but I still have to come home," she said. "At home, I am still only a student, with no money and little rice." They shrugged. *Nobody cares*, Phuc thought. *I have to decide my life for myself.*

For three days and nights, she did not sleep. The worries about her future lengthened with the night and clung to her like the heat in the day. On the fourth morning, she had arrived at a decision: she would write to Dong in Hanoi and do as he might bid. She would put herself in his hands.

Phuc did not trust the post, fearing that the letter would either not get into his hands or get there too late. She found a ride going north; a friend of Minh's in Ho Chi Minh City knew of someone ferrying a foreign ministry car back to Hanoi.

"I have business in Hanoi," Phuc informed her supervisor, giving him warning that she might be late for registration for the coming university year.

The drive north was slow. They were four in the car, including the driver and two others who were catching a ride like Phuc. The poor condition of the roads ruled out night driving, and the heat of the day drove them to cool off with swims at coastal beaches. None of them had any interest in historical sights of the distant or recent past, from the Hindu temples in Phan Rang, dating from the reign of a thirteenth-century monarch, to the battle-scarred highways of the Vietnam war. Phuc herself was cheered by the vistas near the nondescript coastal town of Ha Tinh in the former North Vietnam: hills carpeted in wildflowers, framed by clouds above and the sea below that reminded her of the backdrops of the romances she had read before they were banned.

The further north they went, the more Phuc worried about stretching her *dong*, as the price of food and drink rose. A week after they set out, the travelers arrived in Hanoi. Phuc installed herself at the widow's house. She delivered her letter to the prime minister's aide. In it, she explained why she did not want to comply with the order to go to the United States. "I don't want to waste time away from school. I have lost so much time already. I need peace and quiet to finish my studies." She made a request of Dong: "Please, can you help keep life quiet for me? Do not bring so many people so often to meet me or see me. Please, keep the journalists away."

The last line raised an idea that she hoped she could discuss with Dong in person. "Let me study in Vietnam or abroad, just let me alone," she wrote. She knew her marks might be an impediment to going abroad, as they were only average. However, she felt that she deserved to go. *The government has made enough money off me*, she told herself. Phuc thought the chances were good that Hanoi would send her abroad, if only because Dong himself had suggested Moscow. But Moscow was the last place she wanted to go; she counted on Hanoi being too embarrassed to ask Moscow to accept her as a student after she had cut short her tour there. Her hope was that she would have the opportunity to express to Dong her preference for going to study in the United States. This idea occurred to her after Ngoc's excited mention of a Vietnamese newspaper reporting that, in the wake of her appearance at the festival in Moscow, three American universities had offered to have her as a student.

On the day she delivered the letter, Phuc received an invitation to dine that evening with the prime minister and his son. Once she and Dong were alone, she waited for him to respond to her letter.

Gently, he told her why she had to carry through with the invitation. "There are people in the United States waiting to hear

when you will be coming. I have already agreed with our govern-
ment that you should go." He tried to give her comfort: "I always
tell your hosts, 'Take good care of Kim Phuc,' and I make sure
they do take very good care of you." He addressed her disquiet
over the unwanted public attention. "People learn that you are a
famous victim of war. When they see you, they develop a con-
nection between themselves and you," he said. "The government
cannot change that." By his tone, she knew that he had concluded
what he had to say.

Phuc said softly, but firmly, "I have to finish my studies."

The prime minister smiled with pride. Her desire was sincere,
her intentions were honorable.

"We will decline the invitation to the United States and, as
long as you are in school, we will keep journalists away from
you."

Phuc took her chance. "I have seen a newspaper report in Ho
Chi Minh City that three offers have come for me to study in
America."

Dong's reply came swiftly. "Forget that; don't think about
those offers." What he said next to Phuc was victory enough: "We
will find someplace else where there is security for you."

It was October, and in most countries the university year was
well underway, so Hanoi had to make haste with its inquiries.
Phuc waited in Hanoi to hear where she would be sent. During
that time, every two or three days she joined Dong for dinner. He
spoke as if he were her father, knowing he would not see his
daughter for some time; these were parting words.

"How is it between you and Minh?" he asked once.

The truth was that she had closed her heart to the healer.
Once in Hanoi, she had asked Minh to post a letter to her parents
that told of her safe arrival there. One week later she saw it was
still in his satchel. She pulled it out. "Ma! I asked your son to send
a letter to my parents. Twice I asked if he did it. Twice he said yes."

She slapped the envelope on the table. "The letter is still here. Your son is irresponsible!"

The widow broke down. "It is my fault. I spoil him. I want you to be my daughter-in-law, but I love you enough to tell you to be my adopted daughter only."

"Don't worry, I'm not so stupid as to marry your son," Phuc said under her breath.

Phuc realized that Dong must be hearing gossip. She spoke seriously, wanting to set the prime minister's mind at ease. "I need a good man to love me," she said. "Because of my health, I am not an ordinary girl. Minh has the immaturity of a boy. He is not the man of my dreams. Marrying him would not make for a happy marriage or family."

Still, he asked that she bring Minh along next time. At that dinner, Phuc was at her most relaxed, chatty, laughing, her appetite healthy. Minh was nervous and ate almost nothing. The next time Dong dined with Phuc, he told her he was satisfied with her judgment in love. "However," he added, "I want you one day to have a boyfriend." He went further in his counsel. "You must ask of a boyfriend who may be a future husband: 'Will you be happy in marriage even if we were unable to have children, or maybe to have only one child?'" It was not the first time they had spoken of children. She had once shown him the magazine cover showing her with a baby girl, who the caption said was her daughter. Though they laughed at the mistake, Dong had gone on to speak of the singular joy of becoming a parent.

"God will help me in love," Phuc replied. "I cannot go in search of it."

"Okay." He smiled. "I am concerned only with your happiness."

After a wait of two weeks, the prime minister's aide brought word: Hanoi and the government of Cuba had agreed that Phuc would attend the University of Havana. She was to fly immediately from Hanoi, via Moscow.

Before leaving for Cuba, Phuc wanted to spend a few days with her parents, sure that they would miss her. "I am the last daughter of the family," she explained to the aide. He arranged a return air ticket to Ho Chi Minh City and wished her well in her new life. "The weather in Cuba is so wonderful!" he said.

CHAPTER TWELVE

Phuc's flight landed in Havana at three in the morning. She stepped out into the refreshing night air and lifted her face to a soft rain. Two other Vietnamese passengers, both from Hanoi, shed layers of clothing, and Vietnamese minders took the three arrivals to the guest quarters at their embassy in Havana. The Vietnamese couple working as caretakers there, expecting the travelers to be hungry after their long flight, had prepared a snack. It was *pho*, the noodle soup of the north, where the stock is made from beef rather than the pork used in the south. Though the hour was late for conversation, Phuc could not resist a question about the new country where she had come to study.

"How is it in Cuba? How is life here? How do the people live?"

The husband responded. "Well, they speak Spanish—"

"Spanish!" Phuc was both stunned and crushed.

WHEN TOLD SHE WAS BEING SENT TO CUBA, Phuc had seen the move as anything but a backwards step. She knew almost nothing about Cuba, except that Fidel Castro was its leader and that Vietnamese guest workers sent there worked in sugar mills. However, she thought of it as a boat ride away from the United States, and therefore assumed that Cubans, like Americans, spoke English. Kim did not know that the two countries had been locked in mutual antagonism and paranoia ever since Castro and his guerrilla band had overthrown Cuba's president, strongman Fulgencio Batista, in 1959, ending American corporate domination of Cuba's economy. The botched Bay of Pigs invasion followed in 1961. One year later, Washington and Moscow nearly ignited World War III with the Cuban Missile Crisis, a thirteen-day standoff over Soviet deliveries of nuclear warheads to its missile sites on Cuban soil. America subsequently imposed a trade embargo against Cuba.

Successive American presidents hardened the anti-Cuban line. What the American public knew of Cuba came from Miami, where most Cuban exiles lived, having fled there in the wake of Batista's fall. Few Americans contemplated travel to Cuba. Since 1983, the United States had banned flights to Cuba, and any Americans who did travel there not exempted beforehand by their government could have difficulty reentering the United States, and were subject to possible fines and confiscation of their Cuban-bought goods.

In the socialist fraternity, Vietnam and Cuba were regarded, after the Soviet Union and China, as the elite guardians of socialism. The Vietnamese triumph over French colonialism was hailed as a historic defeat of a Western power, and the Cuban revolution was admired for having succeeded without Soviet help. Non-aligned countries in the Third World saw in Castro's Cuba a nationalistic, anti-imperialistic victory. During the American war in Vietnam, Havana hosted the sole North Vietnamese embassy

in the western hemisphere. The Cubans also staged noisy anti-American and pro-Vietnamese demonstrations in Havana and, upon the north's victory, renamed streets and schools after Vietnamese revolutionary heroes. Vietnam and Cuba had an American trade embargo in common, and they were both members of the COMECON Soviet trading bloc. Cuba joined in 1976, two years before Vietnam. The *ruble* also underwrote Cuba's economy, with Cuba paying its debt to the Soviets in refined sugar and guest workers.

Phuc was devastated to find out that her daily life and her education would be conducted in a new language. Just when she had thought, finally, that she would be able to focus exclusively on school, she found that she would have to drop yet another year behind, this time while she tried to attain proficiency in Spanish. She did not know that in Hanoi, Spanish was a popular language to study; many northern students hoped that the regime would send them to a Cuban university. One reason was Cuba's climate. The prevailing northeast trade winds temper the effect of warm Gulf Stream currents. Just as the day's temperatures start to rise, the trade winds conveniently begin to blow, and they caress the city through to the pre-dawn hours, so that even in summer, the Cuban city's tropical clime feels refreshing.

The University of Havana, which had graduated a young Fidel Castro in law, was Cuba's most prestigious. The person responsible for the comfort and welfare of its foreign students was Maritza Yip. Short and round, with glittery nail polish her nod to feminine glamour, Maritza was like a den mother. She had a particular empathy for students of Asian origin, because she herself was the daughter of a Chinese immigrant father and a Cuban mother. She was also used to dealing with the health problems of war victims, as the university's policy was to accept students from countries embroiled in civil war, or where Cuba

had intervened with troops and aid, such as Ethiopia, Angola and Nicaragua. Maritza made the rounds of teachers, staff and Kim Phuc's future roommates, taking with her a copy of the famous picture, which she herself knew well: "The American atrocities were well publicized in Cuba." In Havana, Phuc became known by the first name Kim. Except in Vietnam, Phuc herself adopted Kim as her name.

Late in the fall of 1986, Kim became the fourteenth Vietnamese studying that year at the University of Havana. Not only was she the only new student and the only southerner from Vietnam, she was also the first female student in years. While Hanoi frequently sent female guest workers and diplomats to Cuba, it feared that female students would be a corrupting distraction to male Vietnamese students, who might more easily succumb to the relaxed sexual mores there and forget that they were in Cuba to "study hard to come back to serve the country." The university enrolled Kim in its preparatory faculty to study Spanish. The university was conveniently located in the district of Vedado, the heart of modern Havana, but the language institute was in the district of Siboney, a suburb at the city's westernmost edge. Most students there were Cubans in their final year of high school studying a foreign language in hopes that Cuba would send them abroad to study.

KIM HADN'T BEEN IN HAVANA TWENTY-FOUR hours when the abrupt climatic change landed her in hospital. What had happened in her first exposure to snowy Moscow recurred in her first experience of Havana's frequent daily fluctuations in air pressure; she was felled by extreme fatigue, headache and pain. Frightened, her minder had her brought by ambulance to Manuel Farjardo Hospital for foreigners. Doctors there were able to control her pain, and the rich hospital diet of meat, milk,

yogurt and cheese improved her strength. After a few weeks, Kim was discharged healthier than when she'd arrived. Her body had acclimatized, and her bouts of pain were no more than the occasional headache or deep itchiness. In Cuba, she could go pain-free for as long as three weeks, and she was to have none of the sudden heat attacks that in Vietnam would send her running for the shower.

Maritza felt an instant and lasting affection for Kim. Years later she would still marvel at her. "Somebody who has met death up close can be so full of life? Smiling all the time, with everyone?" The main student residences were also in Vedado, on the Malecón, Havana's four-mile-long seafront boulevard, which stretches from the harbor entrance, along the Bay of Havana and westward along the Atlantic. The residences were a pair of Cuban-built, Bulgarian-designed, stark but well-maintained concrete towers, each twenty-four stories. The first three floors accommodated offices, including those of Maritza and her staff, and the cafeteria. The next floors were assigned to females, the upper ones to males. Maritza installed Kim on the fourth floor. Upper floors had the view of the sparkling azure sea, but the advantage of being lower was the shorter climb up the windowless stairwell whenever both elevators were out of service, which was often. Kim moved into a room with seven roommates. Each floor had three rooms of eight, and each floor shared one common room and one wash-room with one toilet, one sink and one shower.

Hoa, a tall, balding man in his forties, was Kim's new minder. In her time at the Manuel Farjardo, he had been her sole visitor. She had appreciated his weekly visits as she'd had no one else with whom to speak Vietnamese. On her discharge, Hoa had collected her and, en route to the student residence, stopped at the embassy to pick up a glass, a hand towel and a plastic pail, saving her the expense of buying them. A pail (better-off students owned two) was a necessity of residence life; daily, one had to take

water from the floor's cistern for showering and washing. Water at the residence was turned on twice daily for one hour each time, the responsibility for filling the cisterns on each floor rotating among its residents.

Early kindnesses on Hoa's part were tainted by what Kim saw as his true mission: to snitch should she put a foot wrong. Three days into her stay at residence, a roommate reported that he had come round asking pointed questions about what Kim Phuc had been up to. Having escaped life at the end of a string, Kim was in no mood to be reeled in. Accordingly, for the duration of her stay in Havana, she took to "visiting" her minder herself every two or three days. The Vietnamese embassy was a ten-minute bus ride away, in the once upscale district of Miramar, on one of its wide streets lined with fig and palm trees and decorated with Greco-Roman planters. Up close, like all the other old mansions, the embassy showed a dearth of maintenance: it was shored up in places with wooden braces, and the sidewalk in front was an obstacle course of cracked and broken pavement and puddles of leaking water.

After classes were done for the day, Kim would go to the embassy, press the buzzer at the high, locked gate and wait for the guard to admit her. It did not escape Kim's notice that other Vietnamese students came and went from the embassy as they pleased. She noticed also that they had, if not relatives, then at least close friends working at the embassy.

Kim and Hoa would then retire to a room furnished with a table and four chairs, adjacent to a larger one with a television, a couch and a ping-pong table.

"What have you been doing since the last time?" was always his opening question. Often, one or two others from the embassy would join them and occasionally slip in a question.

Kim thought Hoa to be genuinely concerned, always inquiring after her health, always asking, "Is there anything that you

need?" But he was also prying, asking what company she was keeping, asking for names. Kim kept up her guard. *They don't love me without reason. They know I am famous, that I am a witness to the war.* When she felt she had volunteered enough information, she would rise from the table, push back her chair and announce: "Well, I'd better go back to study!"

TRAVELING ABROAD HAD BEEN A PERK; LIVING abroad was another matter. Homesickness almost did Kim in. Isolated by the Spanish spoken around her, she had been weepy with longing for her family even in hospital. In the residence, her roommates were all Cubans, few of whom spoke English, the only language she could converse in until she had vocabulary enough in Spanish. Whereas Kim believed in a "quiet life," her roommates were boisterous, and communal life was noisy—American rock music competed on several cassette players, and roommates chattered, mostly about boyfriends, far into the night.

However, Kim had planned and looked to anchor her new life in the Christian faith. She counted on making her friends in the new church that she would join. Christmas was approaching. Not only was it an opportunity to become active at a church, but Kim looked forward to seeing Cubans in a festive mood. In Ho Chi Minh City, even those who did not celebrate the birth of Jesus Christ used the excuse to take to the streets.

"Please, where may I find a church?" Kim asked a roommate.

"There are some in Old Havana."

East along the Malecón from the residence she found the former fortress town, with its baroque façades, Greek columns and Romanesque arches dating from the sixteenth century. It remained a maze of narrow streets lined with former mansions and naval warehouses. On one of the cobblestone squares, Kim discovered the famed Cathedral of San Cristobal. There was a

service going on, but the five or six people taking part were all elderly, and easily outnumbered by the tourists wandering through.

There was no sign of decorations for Christmas on the streets of Havana, and Kim was bewildered. She inquired of a room-mate, only to learn that, like Hanoi, the Cuban government had eliminated Christmas as a national holiday.

"Where can I find practicing Christians?" she asked.

"Nobody practices religion," came the reply. "Nobody can disappoint the government."

Cast back onto the shoals of a foreign environment, Kim struggled to find a comfortable footing. Unbeknownst to her, the hospital diet, which offered best-quality foods served in quantity, was the exception. The low standard of the daily fare in the student residence came as a surprise. The daily staple was rice, with red or black beans and soups made of the previous day's leftovers. Kim was not alone in turning up her nose at the food on offer. Students left mounds of uneaten food on their plates, especially on nights when they were given fish, often served with egg, both of which Cubans traditionally dislike and try to disguise the taste of by adding oil.

Kim hid from Maritza her growing loneliness and homesick-ness for family, friends and the Vietnamese way of life. For much of her first six months in Cuba, she spent an inordinate amount of time sleeping. Four male Vietnamese students roomed together on one of the uppermost floors, and Kim would encounter them from time to time in the cafeteria, but she kept a polite distance. On her first day, one had been welcoming, showing her the routine in the cafeteria, telling her to mark her pail with her name and offering help should she need it. When he heard talk that she was homesick, he made efforts to include her on outings, but Kim always declined. For one thing, Kim regarded them, being northerners, as unworldly, living in a cup

of Vietnamese Communism, Cuba their first glimpse over the edge. For another, she saw in their friendliness more of Hoa's prying. She was sure all other Vietnamese students looked at her suspiciously, because, normally, southerners were not sent abroad. And they had to wonder about her connection with Pham Van Dong; on Tet, he'd sent her, care of the embassy, a basket of candied fruit, roasted melon seeds dyed red and a couple of the paper lanterns usually given to children, in the shape of a fish and a star.

Added to the pressure of feeling like an outsider was the deafening silence from her family and friends left behind in Vietnam. On visit after visit to the embassy, she would check the list posted there of mail being held for Vietnamese living in Havana. Only one person wrote to her: the healer, Minh. Kim did not reply to his letters, put off by their demanding tone. "I am your fiancé," he wrote. "Send me a ticket to visit you." Though Kim never heard from her family, she continued to write into the growing void. She swung between frustration and worry. Didn't her parents care enough to write? Had something gone terribly wrong with the noodle shop? With their health? Kim grew afraid, convinced that Tam in Tay Ninh had found some way to take vengeance for her escape from him on those left behind.

KIM'S MOVE TO CUBA BROUGHT AN IMMEDIATE improvement to her quality of life in two areas: health care and education. Both were free; both were the crowning achievements of the Cuban revolution.

In pre-revolutionary Cuba, only the rich could afford good medical care, and when Castro took power, half the country's doctors fled. Two decades later, Cuba could boast that it had no shortage of medical schools, doctors or hospitals, and medical care was free. In quality of health care, Cuba ranked first in the

Third World; Havana had some seventy modern hospitals and specialized medical centers. Cuba, in keeping with its reputation as "a little country with a big heart," had in the year of Kim's arrival accepted for medical treatment children injured in the accident at the Chernobyl nuclear generating plant.

Where pre-revolutionary Cuba had an illiteracy rate of 24 percent, Castro's Cuba had virtually wiped out illiteracy. Where once 40 percent of the population had never gone to school, it now had one of the highest per capita rates of university graduates in the world. University tuition was free, along with textbooks and pens and notebooks, and so was university housing. Moreover, the Cuban regime paid students a monthly stipend, starting at twenty *pesos* (about five or six American dollars) and rising with each year that they were in school. With careful budgeting, it met their other expenses, such as bus transportation, clothing and personal items. And there were other comforts that came with student life. At Kim's residence, students weekly exchanged dirty sheets for clean ones, and monthly collected their individual allotments of soap, toilet paper and toothpaste, and, for women, sanitary pads. Her building shared four televisions, assigned according to which floor won the monthly competition for cleanliness and order. Cuban television carried Castro's speeches and other revolutionary programming, but it also regularly aired American movies and rock concerts.

Everywhere Kim turned, what she saw of the Cuban revolution impressed her. Havana and its distant suburbs were well served by public transit that was both cheap and efficient. A wait at a bus stop, where a concrete roof offered protection from sun and rain, was five or, at the most, ten minutes. In Cuba, since everybody worked for the state, there were no unemployed. Everybody had a salary and everybody had the essentials. The homeless and dispossessed, the begging and squalor of Ho Chi Minh City were sights unseen. *Every* Cuban household had a

ration booklet giving *equal* privileges to buy what they needed at the ration stores, from food to shoes, from toothpaste to a television. Foreigners, including foreign students, shopped in "parallel stores," paying about three times the price for the same goods sold in the state stores. But foreign students also received a stipend three times that of domestic students.

Whereas in Vietnam everyone was driven to the black or the open market, and everyone was obsessed with devising legal and illegal ways to buy and sell, cynically flouting the regime's dictates, Cubans prided themselves on the purity of purpose of Castro's revolution and held their leader in steadfast awe. So strong was allegiance among youth to *Fidelismo* that students shunned any foreign student fingered by the rumor mill to be privately trading or dealing.

In Cuba, teachers and students alike held themselves to the highest standards of conduct. Teachers tolerated neither absenteeism nor lateness. Students were mindful of both their academic and revolutionary performance, seeking to avoid any black mark on their dossiers that could affect their job placements. Kim preferred even the propaganda in Cuba to that in Vietnam. Cuba's teachings were steeped in centuries of diverse history and rich in intellectual culture. Vietnam's were strung with slogans about the sacrifices and deaths that had been necessary to achieve the final victory in 1975. Though Maritza got Kim excused from the three weeks of "voluntary" farm labor required each semester—and the weekly student exercise and sports programs—to be bused out of the city was not a sacrifice. Living in tent barracks was uncomfortable and harvesting vegetables was back-breaking, but returning students exalted the good food and the rum and the music of late-night partying.

As fate would have it, the year that Kim arrived in Cuba— 1986—would be the end of what Cubans considered the country's "golden years." She came six years too late. In the early 1980s,

when Vietnam was crawling back from the brink of economic collapse, the opposite was happening in Cuba. Helped by Castro's experiment with farmers' free markets, the Cuban economy turned in year after year of impressively strong growth. However, in 1986, Mikhail Gorbachev's *perestroika* and *glasnost* were forceful winds of change that reversed Lenin's legacy and sent shudders through the Communist world. Countries dependent on Soviet aid took a new lesson from an old joke—Moscow says "Tighten your belts," to which the reply is "Send belts"—when the Soviet Union began drastic economic restructuring and political reform that included deep cuts in foreign aid and shipments of subsidized oil. Some eastern European countries and, as well, Vietnam saw the imperative of bringing in their own programs of reform. In December 1986, the Vietnamese Communist Party held a landmark congress that popularized the Vietnamese term *doi moi*, heralding "renewal." Hanoi began to free the economy from state control and to eliminate state subsidies. And, in its most dramatic change in Party leadership in the fifty years since its founding, Hanoi retired three men from its politburo, among them eighty-year-old Pham Van Dong (who also retired as prime minister but remained as an adviser to the regime), sending a signal of its intention to rejuvenate the Party from the top down.

Cuba was the sole holdout against reform. Castro condemned the others, accusing them of engaging in "capitalist backsliding." In 1987, he announced a Cuban campaign of "Rectification of Errors and Struggles Against Negative Tendencies" beginning with the shutdown of the successful experimental farmers' markets. Every Cuban would pay a price for Castro's retrenchment to Communist orthodoxy. The reappearance of lineups at ration stores, which had nearly disappeared in the early 1980s, would mark the start of the economy's downward skid. In contrast, Vietnam would keep its sights on shifting towards a market economy, which would ultimately restore growth after a decade of decline.

KIM'S SENSE OF ISOLATION FROM FRIENDS and family eased some seven or eight months after she arrived in Cuba. One of her Spanish teachers arranged for her to move to a residence in Siboney, a stately old home with a large shaded garden, among the many in Havana left vacant by fleeing Americans when Castro took power. The main house accommodated thirty; Kim shared the quiet of the double room in the coach house, which also had its own private bath. Her Cuban roommate was Yamilen Diaz, a girl with cascading red hair, who was in her last year of high school and studying Russian. Her family's love of Cuba under Castro had nurtured her ambition to study at the most elite of universities in the Communist world, in Moscow.

From the start, Yamilen took to bringing Kim home on weekends. Her family lived at the opposite end of the city in a working-class neighborhood in east Havana, reached by taking the tunnel under the harbor channel. The Diazes were a close-knit family. Yamilen was the elder of two daughters. Her parents were not much older than Kim's eldest sister, Loan. The father, Manuel, a mechanic at an oil refinery, and the mother, Nuria, vice-principal of a primary school, made a handsome couple. He was dapper, with his slicked black hair, white socks and polished shoes; she was elegant, made up to perfection, her hair red one day, black with a strand of white at the forehead the next. The family's home—a modest two-bedroom house that Nuria inherited from her grandparents—gave the Diazes a leg up on the average Cuban household. They could buy what few Cubans could afford, a car. Manuel jury-rigged parts and repaired the engine of a 1957 Ford to working order, applied a coat of paint to the body and sacrificed the pigpen for a carport. His car joined the vintage pre-revolutionary American vehicles that dominated Havana's roads, outnumbering newer Russian Moskvitch sedans and Ladas.

The family's nervousness at the prospect of hosting a for-

eigner in their home for the first time evaporated upon meeting Kim. The bond was immediate, warm and enduring. Cubans are physically affectionate, and the Diazes found Kim the same. Kim called Nuria and Manuel *Mami* and *Papi*, and they regarded her as the spark that reignited their enthusiasm for life. She herself loved to sit in the garden under the mango tree and listen to the chirping of the canaries. Manuel had some two dozen, housed in a cage so large it held smaller cages inside.

Kim's only talk of Vietnam was of the ache of distance from her family. "Your family is so far; consider ours as your own," the Diazes told her. It would be almost a year before Kim received a letter from her family. To Kim's dismay, her father's news was stale, the letter written almost a year earlier. She read that her girl-friend, Trieu, had married. *She could have had a baby by now*, Kim thought, *and I wouldn't know it!*

Shortly thereafter, Kim met a Vietnamese military attaché posted to Havana. She warmed to him, delighted to hear a south-ern accent. He spoke of his wife and children in Ho Chi Minh City—as an economy measure, families accompanied diplomats on postings only at the level of ambassador—and Kim's question popped out: "Do you receive letters from your family often?"

"Oh, a letter from them," he replied, "can take up to a year to get to me." Kim understood. The mail of southerners was held to be read by Vietnamese authorities before it was passed on, if at all. Her mail, like her life, was under scrutiny.

The Diazes understood Kim to be a famous war victim. While they deliberately avoided the subject of the war, they did not ignore her burn wound. They all took turns applying cream to her scarred back and easing the pain with massage. Kim her-self had no shyness about handing Manuel the cream and seat-ing herself on his lap. But what Nuria noticed was that Kim regarded her burn scars as a burden of ugliness. She made it her mission to give Kim the self-confidence to see herself not as a

burn victim but rather, first and foremost, as a woman like any other.

In an offhand manner, Nuria began to cajole Kim to join the family on an outing to the beach, the Cubans' favorite playground. Even older women, with ample hips like Nuria's, wore bikinis. "You must come with us for a swim, or at least a picnic!"

Few Vietnamese students in Cuba were keen on swimming. They went enthusiastically on the annual two-week *campismo* organized by the university, but they would opt out of going to the beach by day. They saw the beach as a place to go at night to hunt for crabs.

Time and again, Kim put Nuria off: "It's too much sun for my body. I will burn."

Coached by Nuria, the family persisted. "Just put suntan cream and a hat on." Or: "We'll go at the end of the day, when the sun is less hot."

"I can't go. I don't know how to swim." She had other excuses: "I don't have a bathing suit to protect my burn." Or: "I have to ask my parents to send me one with long sleeves."

Almost a year later, Kim came around. She did not know that the family had deliberately picked the least attractive beach nearest Havana, at Guanabo, for their first outing—a place where old men reel in fish from the surf. Once Kim was in the water, it was hard to get her out, and going to the beach became her favorite day trip. The Diaz women bought her a new bathing suit, a dance leotard in white accented with fuchsia flowers. Kim herself bought a pair of oversized white-framed sunglasses to match.

Kim's blossoming confidence in her sexuality was bolstered by another female friendship she forged in Cuba. She met Helen Le, a student a couple of years older than herself, at *the* social event on Havana's diplomatic calendar in 1988. The newly posted Vietnamese ambassador, Do Tai, and his wife hosted a party for one thousand at their home. The new face of the Vietnamese

bureaucracy in the era of *doi moi*, Tai was erudite, educated and only in his forties, still raising a family.

Helen was a vivacious beauty and a second-year computer-programming student at the University of Havana, and she and Kim hit it off. The two communicated in Spanish; Vietnamese ws Helen's fourth language after Punjabi, Spanish and English. Born in Danang to a Pakistani businessman and a Vietnamese mother, at war's end she fled with her father and family to Pakistan. When he died, his widow moved to Ho Chi Minh City and took a job there as the cook in the Cuban consular office. Helen ended up in Havana using the connections of a Cuban tele-communications expert. She boarded with the family of a high-ranking Cuban army commander but spent her weekends with her Syrian boyfriend, Mohammed Haitzam. He would come four hours by bus from Santa Clara, where he was studying dental technology, and the two would take a room at the twenty-five-story Habana Libre, formerly a Hilton hotel, built in the 1950s, overlooking the Gulf of Mexico. Mohammed had the foreign currency to pay for it; he was well supported by his father, a wealthy retailer in Damascus.

Together with Helen and Mohammed, Kim enjoyed two favorite Cuban pastimes. One was going to Coppelia. Castro's regime had built the ice cream emporium in 1966 on Vedado's La Rampa, a street formerly of hotels, nightclubs and casinos that had epitomized the Havana of the swinging 1950s, a time of mob-sters and high-rollers. To demonstrate Castro's promise of a better life under socialism, the state heavily subsidized bread and ice cream; in Batista days, only the well-to-do, cosmopolitan families could enjoy either. Set in a park of the same name, Coppelia was shaped like a flying saucer and decorated with oversized ballerina legs dancing on pointe. It served some thirty thousand customers a day and had indoor and outdoor seating for several hundred. The second diversion was going to the cinema. Havana had 170

theaters showing Cuban and international films. Yara Cinema was steps from Coppelia. Both were popular with students looking for an evening's entertainment. The price of admission to a film and the price of a two-scoop bowl at Coppelia was the same: one *peso*, a price unchanged at Coppelia since its opening day.

The greatest influence of these women on Kim's life was a remaking of her self-image. In Helen, Kim found a model of independent womanhood allied with impulsive flamboyance. In spite of a steady boyfriend, Helen was given to uninhibited declarations about love. As Cubans, the Diaz women came to that naturally. Encouraged by Nuria's sensitive motherly ways, and admiring the strength of her marriage in a society where divorce and remarriage were common, Kim brought Nuria her timorous questions about love and sex. Nuria and Yamilen tried to impart to Kim the feminine mystique that Cubans call *swing*. Ultimately, Nuria triumphed. Kim came to use perfume and to curl her hair, often pinning it to one side with an orchid, and she began to brighten her face with rouge, lipstick and eyeliner. She shed an image of herself as weak and ugly, and started to think in terms of strength and beauty. Years ago, in the dark of the noodle shop, Nu had taught the teenage Kim that tragedy had dimmed her prospects for love, if not marriage. Where Nu had seen a normal life for her daughter as something already stolen from her, Nuria showed her that it was still within reach.

AFTER THE PERIOD OF *DOI MOI* BEGAN, Vietnamese returning from visits home were abuzz about how things were looking up there. People had rice all the time, they were eating meat again, and they could even afford to go to restaurants. The price of the move away from state control was runaway inflation (from 1986, when the program of *doi moi* began, until 1988, annual inflation was a brutal 700 to 1,000 percent), but

where once the old guard in the politburo would have put the brakes on, the new leadership in Hanoi did the opposite and stepped on the accelerator. In measures aimed at increasing production of food, consumer items and goods for export, Hanoi ambitiously moved to further cut state subsidies, allow limited private business, reduce centralized planning and open up the country to foreign investment. Western governments, sensing commercial opportunity, began reappraising their policies towards Vietnam (except the United States, whose embargo remained in place).

Within the walls of the Vietnamese embassy in Havana, there was wishful talk of wanting to bend the ear of Fidel Castro about the benefits of reform, to laud how Vietnam had turned a rice deficit into an exportable surplus. Outside the embassy, such talk was unthinkable among Cubans. Complaint about Castro or of conditions in Cuba was hushed. What with a policeman on nearly every street corner, one could be arrested as a counterrevolutionary, charged with "lying about the economy."

Castro continued to turn the clock back. By 1987, to meet its commitments to the Soviet Union, the Cuban government had to *purchase* sugar, the "white gold" that had brought unrivaled prosperity to colonial Cuba. Cubans saw the economic deterioration as a call for solidarity; it was not the first time that the Committees for the Defense of the Revolution (the equivalent of the neighborhood "cells" in Vietnam) had called on them to rededicate themselves to the Revolution. First, it had meant enduring lineups. Next, an expanded list of rationed goods; then, poorer-quality goods in the state stores. The first signs of growing paucity at the university residences showed up in the food service. At first, less variety in the menu; then, shrinking portions.

Yet Kim's own outlook was more positive than ever. Because of her mid-term start at the language institute, she did not leave

there until the end of the following academic year. With new confidence in her language skills, and renewed confidence in her health, Kim decided in the fall of 1988 to take back the dream of a career in medicine. Conceding that she was not up to the demands of a career as a doctor, she enrolled in the faculty of pharmacology, planning on something she thought next best, dispensing medicines to the sick.

One day, not long after Kim's arrival in Havana, there was an electricity brownout at the residence. Students had to line up with their pails on the ground floor, where an emergency generator pumped water, and carry their filled pails back up the stairs. Without electricity, the elevators weren't working either. Kim put her back out. Her roommates sent her by ambulance to hospital, then sent word to the student who was head of the Vietnamese contingent.

Appointed to that position by the embassy, Bui Huy Toan was a third-year student of English and Spanish in the faculty of foreign languages. His reputation for being helpful—he was the one who had approached Kim on her very first day in residence to show her the ropes—and his proficiency in Spanish had brought him to the attention of Vietnamese delegations as a good contact in Havana. Often such visitors, more frequent under *doi moi*, were afraid to leave their hotels for fear of getting lost.

Toan visited Kim in the hospital. "Next time," he told her, "wait for me to come back from classes to help you."

He was sincere in his concern for her welfare. When Toan heard Kim tell of how her burn wounds regularly brought on headaches and deep pains, he began to come by after classes several times a week to massage her back, which helped prevent their onset. The fourth of six children, Toan had learned responsibility from the age of six upon the death of his mother after complications in childbirth. She had delayed making the trip to a doctor one village over because there'd been no one to mind the younger

children, what with her husband working miles away and the older children at school. Her death forced the older siblings to leave school so they could fish in the river to help support the family, leaving young Toan to care for his two younger siblings. He remembered those early years as a time when there was never enough to eat, when the younger ones owned neither pants nor shoes and no other shirts than the ones on their backs.

Dropping her guardedness about befriending northerners, Kim accepted Toan's invitations to join him and his friends. They were charmed by her smile, and mesmerized by her southern accent. Toan called her "*Mei jin,*" as if she were the spice that enlivened the all-male contingent. When residence authorities transferred Kim to the building's other tower, he asked to follow so that he could be nearer to her should she need help.

Toan was twenty-eight years old, three years older than Kim. In conversation with her about lives they'd left behind in Vietnam, he spoke of a girl in Hanoi waiting to marry him upon his return. On Toan's part, what began as concern blossomed into love. He told Kim that it was not a betrayal of the girl in Hanoi; he had not heard from her for more than a year. One week later, a letter did arrive.

Privately, Toan agonized. *I cannot love two at once.* After nights of sleeplessness, he was decided: *I cannot bring any more suffering on to Kim.* He penned a letter to his girlfriend in Hanoi. He tried to give solace, saying that others who went to Cuba fell for "rich, beautiful Cuban girls" but such had not been the case for him. Rather, offering a helping hand to "the girl who was a victim of the napalm bomb" had, unintentionally, turned his heart to love.

Toan's own experience with the war was living under its nervous skies. His family was from the desperately poor fishing village of Vi Thanh, thirty miles from Hanoi. American planes came back repeatedly to strike two bombing targets: a railway just

over a mile away in one direction, and the engineering faculty of a university two miles in the opposite direction. Various faculties had moved from Hanoi universities and colleges to escape the bombing there. Only once was the village struck, when a rocket, thought to have fallen from the skies during a dogfight between planes, killed a mother and her three children who had just sat down to their meal on the ground in front of their hut.

But for Toan's disobedience to his father, he might never have been a university student. When an older teenage brother left to join the North Vietnamese army, the father ordered Toan to quit school to help support the family. Caught sneaking off to school, Toan persuaded his father to allow him to fish half days and go to school half days. He was spared from the army by his father's pleas that he did not want to lose a second son to the war—years had gone by without word from the older brother, and the family feared him dead (two years after the north "liberated" the south, he returned, severely ill with malaria). Toan was the only one of his siblings to graduate from high school, and one of only three from his high school to pass the entrance examinations. The regime gave him a scholarship to Cuba.

After her move to Siboney, Kim began to bring Toan around to the Diazes. He enjoyed Manuel's company. The two often played dominoes and shared cheap, but good, rum and cigars. Sometimes, Kim and Toan bought what Asian ingredients they could find so that Toan could cook the family a Vietnamese dish; once he made mango soup of a harvest from their tree. He retold a morality tale from the north of Vietnam: a husband frets all day about his pregnant wife's craving for a mango, but one mango costs one month's salary. Finally, he comes home empty-handed, and finding out his wife has miscarried, is thankful for the money he has saved.

The Diazes teased Kim about her new "boyfriend." She was coy: "He is my shield-bearer." She confessed otherwise in a letter

to Pham Van Dong. He wrote back: "I am so happy to hear you have a BOYFRIEND!" The word meant something altogether different in Vietnam than in Cuba. In Cuba, it had everything to do with a rite of passage. Many Cuban families would throw a coming-out party for their daughters when they reached fifteen, the age when they may openly begin their sexual life without family recrimination. In the student residences, women and men stayed in each other's rooms when roommates were away. It amused Kim to hear her Cuban roommates declare "I'll love you forever" to their boyfriends, only to throw them over for another the next week. In Vietnam, a boy and a girl could ride around together on motorscooters, but public decorum demanded that the only affection displayed publicly was holding hands, and only if the couple were engaged. Vietnamese in Cuba, especially during the tenure of Ambassador Tai, had become openly romantically involved with Cubans, even despite wives and family left behind in Vietnam. However, Kim remained determined to save herself for the night she married. She had feelings of desire for Toan, which she ascribed to "loneliness." She prayed to God: "Stay with me and keep me away from the devil." Her own watchfulness reined in temptation. *What if I became pregnant? What if a boyfriend abandoned me?* She had only to remind herself: *My case is special.*

IN HER FIRST SEMESTER STUDYING PHARMA-cology, Kim worked hard to turn in an average performance. Then, in the new year, during the break between the first and second semesters, she went to see the nurse in the residence about a rash in her scarred areas. The nurse sent her to a specialist. His opinion was that Kim's burn injury might have left her skin sensitive to chemicals encountered in her laboratory work. Barely was she back in school when she suffered a second, much more serious health problem.

One morning, Kim accompanied Helen to a dress fitting at a private tailor's. Private business was illegal in the nationalized economy, but Helen had all manner of such connections—tailors and beauticians who practiced in their homes; doctors who dispensed advice off-hours; sources of imported fine foreign silks and cottons that were unavailable in Cuba. Kim had availed herself of Helen's contacts with Cuban advisers going to and from Vietnam. Rarely now did she use the post to mail letters to her family, instead relying on Cuban experts headed for sugar mills in Tay Ninh province, whose travels up Route 1 would take them by her mother's noodle shop in Trang Bang. Kim took early advantage of this mail system to send words of caution to her brother, Ngoc. His letters were a rant against cadres in Tay Ninh, a litany of complaint as he recounted his latest failed effort to earn enough to support his wife and children. "If you have a big mouth, out will come anger," Kim wrote. "Anger is no help at all; it will bring danger to your life."

On their way back from the tailor, Helen and Kim stopped for ice cream at Coppelia. In better times, the midday wait had been fifteen minutes. But as Cuba's economic slide continued, and prices rose while quality fell in the ration stores, the one-*peso* bowl of ice cream looked like an ever-greater bargain. That day, the line snaked out of the park. After a two-hour wait, when Kim and Helen finally had a table, they were determined to make the most of it. Kim, who had not had either breakfast or lunch, downed ten bowls of double scoops. So did Helen. The student record was fifty scoops at a single sitting. The two left the shop giddy, on a sugar high.

In the pre-dawn of the next morning, as usual, the stirrings of the first residents trying to beat the rush for the bathroom woke Kim. In midwinter, when the humidity coming off the sea in the morning carries a slight chill, Kim's routine was to gather her sheets around her and turn over to catch more sleep. This morn-

ing, she was startled to feel her sheets soaked with perspiration. Kim sat up. She felt her legs cramp. The room began spinning. Afraid, she called out to the girl in the upper bunk. Her voice was slurred. Her roommates sent for an ambulance.

Doctors diagnosed diabetes. The telling symptom was Kim's profuse sweating caused by plunging sugar levels. The absence of pores and sweat glands in her extensive skin grafts trapped heat inside her body—thus the cramps. The medical opinion was that Kim's diabetes was a consequence of the massive shock to her system of the napalm burn, and of the type where symptoms don't appear until years after the actual onset. Two weeks later, Kim returned to classes, managing her diabetes with daily injections of insulin. Two months later, she returned for a checkup at an institute specializing in the treatment of diabetes. Specialists concluded that she was a good candidate to manage hers by diet. She stayed at the institute for three weeks, leaving with a diet plan of foods low in fat and high in protein, which required her to snack frequently. Provided she followed it rigorously, she could dispense with insulin injections and avoid another attack.

Adhering to the regimen was impossible with the residence's set mealtimes and fare. In better times, students arriving late for the meal service had just gone to the kitchen for leftovers. Now, food ran out before the posted hour of closing. Meat and fish, infrequently served to begin with, became rare. If ever fish was served, students no longer shunned it. The only highlight was the days, about once a month, when *hamburguesas*, bulked up with grapefruit rind, were on offer. The limit was one. Once the students reached the front of the line, they wolfed down their burgers and then rejoined the line, hoping to reach the front again before supplies ran out.

Had Kim been Cuban, the state would have provided her with the necessary ration coupons to meet her diabetic needs. Maritza stepped into the breach, giving Kim use of the staff's hotplate,

and she arranged for the residence chefs to set aside for her, every couple of days, food, rice and oil. Toan taught Kim the basics of cooking. "Your mother is famous for cooking," he teased, "and you don't even know how to cook rice?" However, the residence could only regularly offer Kim some rice, corn and pumpkin, but none of the protein she needed.

She appealed to the Vietnamese embassy. Hoa took it up with Ambassador Tai. The ambassador approved an arrangement allowing Kim to shop at the *diplotienda*, the one-stop shopping stores, which were well stocked with best-quality local and imported foods, including frozen chicken re-exported from the United States, frozen fish from Canada and cheese from Europe. They also carried all manner of goods, from Cuban decorative arts to toothpaste and clothes, stereos and televisions. Each had a restaurant on the premises. As the *diplotienda* took only red *pesos* (Cuba's currency of foreign exchange), the embassy would exchange half of Kim's monthly stipend of domestic *pesos* for red *pesos*, and every two or three days she would accompany an embassy worker there who could pay for what she picked out. Besides buying meat, cheese, eggs and yogurt, Kim sometimes also splurged on cucumbers, lettuce and tomatoes. The other half of her stipend she spent at the parallel stores on plantain, bananas and beans, and the cookies and candies necessary to keep handy for diabetic emergencies.

She noticed herself that, because of her diabetes, her stamina was not what it used to be. Maritza, having her usual lunchtime chat with the security guard on duty in the lobby, saw too that Kim frequently returned after her morning classes to lie down for a rest. When she didn't reappear in time for her afternoon classes, a worried Maritza sent someone to check. Sometimes, Kim didn't rally until her evening laboratory class. And one nagging health problem remained—Kim's rash; doctors continued to suspect exposure to chemicals in her laboratory work as the cause.

Kim came to a decision. *I surrender!* she told herself. *I love medicine, but it is not my destiny.* Knowing that she was not going to remain in pharmacology, she did not complete the semester. She set her sights on the coming academic year, planning in the fall of 1989 to enroll in the faculty of foreign languages, to study English. Once again, she would be a first-year student. She was twenty-six. She saw no more diversions, no more doubling back, in the path to her future. In five years' time, she would return home to Vietnam. *I will get a job, maybe get married, maybe not; I will build my life normally there,* she told herself.

CHAPTER THIRTEEN

EARLY IN THE SUMMER OF 1989, Ambassador Tai summoned Kim. His announcement was brief, their meeting short. "Some people in the United States want to invite you to visit. The government of Vietnam believes this would be good, so we agree to let you go. You will wait for us to prepare your papers. We will let you know the travel date."

True to the word of Pham Van Dong, Kim's life in Cuba had remained "quiet" of foreign journalists, which was not difficult given the fact that virtually no Americans visited there. But her presence in Havana was no secret to the Cuban public; there had been, early on, a front-page article in *Granma*, the Communist daily. That interview had originated with a request from an Angolan student journalist, and Kim—with, as usual, Hoa present—had obliged her Cuban hosts without a second thought. Kim was front and center again for an appearance on a Cuban children's television show celebrating International Women's Day, and giving remarks at a reception honoring a Cuban

filmmaker. But for her nervousness about her imperfect Spanish, Kim rather enjoyed those engagements. Cubans were curious to meet someone from Vietnam, and they were charmed, though perplexed, by her dazzling smile and laughter, even when speaking on the topic of war.

She had guessed, however, that foreign interest in her had not ended. In the past three years, three or four times, in her twice- or thrice-weekly regular visits to Hoa, he had put before her on the table the original of a letter from abroad, and alongside it a draft reply, which he asked her to sign. All were proposals from the West, usually the United States, and each sought her participation in, or asked her to lend her name to, a humanitarian project. Kim didn't bother to read the letters through, noting only the line that invariably opened her replies: "I regret that I cannot interrupt my schooling . . ."

Kim suspected that the embassy in Havana had been inclined to refuse all invitations, but that this time Hanoi had decided that she would accept. The last time it had given such an order for her to travel to the United States, she had not wanted to go because she was at her wits' end, unable to bear another interruption to her studies. However, in Cuba, time and again, she had faced setback after setback, first with having to learn Spanish, then with her health, so that, academically, she was hardly any further ahead than when she had first arrived. This time, Kim welcomed the order.

Except for the one time in her first interviews when she had dared ask an interpreter why her story attracted so much media attention—his reply had been that she was "hot news"—she herself had not looked for answers to explain the regime's dictates. But then, in a regime where asking questions could be considered reactionary behavior, remaining close-mouthed is a matter of self-preservation. Kim had also long since mostly abandoned intellectual curiosity regarding the question "Why?" Spiritually renewed by her experience of her first prayers to God, she had

put a new cast to her victimhood. The napalm bomb was unknown, unexpected, and an "accident" but she came to believe that God, when he saw need, would deliver other "accidents" in her life to offset the suffering and evil wrought by the bomb; these "accidents" would be good people, strangers to her, wanting to do acts of goodness. The first proof was Perry Kretz; the second was Pham Van Dong. This trip, Kim was certain, was a heavenly sign that it was again time for a door to be opened in her life, so that things in her life and her family's could change for the better.

Kim left the ambassador's office, her mind alive with possibilities. Any Vietnamese traveling or living abroad took whatever chances they had to improve their lives and those of their families before it was time to return. For all Kim's dreams of helping people, in her time in Cuba she had not been able to help her loved ones at home. "Send money or anything small," Ngoc wrote repeatedly. She ignored his request; better that than to have to refuse. Ngoc persisted, chastising his younger sister: "You have a duty to take care of your family!" *How can I make him understand*, Kim asked herself, *that no Cubans send money or goods out of the country? That they rely on relatives in the United States to help them?*

Ngoc was the one she wrote to when she wanted to share with her family the good news of her upcoming trip. As she awaited the order to travel, her anticipation grew: once Americans heard her tell of the difficulties of her health and of her family, their help would be forthcoming. However, when she was with the diplomats at the embassy, she checked her outward enthusiasm. *Of course*, she reminded herself, *I go under their control*. Whatever good came her way, better that to Hanoi she appear blameless, a victim of goodwill. She also reminded herself that her trip undoubtedly had the blessing of Pham Van Dong. She vowed she would not let him down: *I will do my best in America.*

ONE AFTERNOON IN LATE JULY, FROM AN upper-floor window of the Habana Riviera on the Malecón, Kim stood watching the parking lot below. The marble-and-glass twenty-floor hotel, casino and nightclub had been built in 1958. With Ginger Rogers as its opening act, in its time the hotel was a model of modern architecture, with an interior intended to outstrip the glitz and flash of Las Vegas.

Kim had been waiting at the hotel since nine in the morning. Finally, she saw a van drive in and park. Among its passengers were two Westerners, two Cubans and three Vietnamese. Of the latter, she recognized two to be from the embassy. It was the third man she was interested in. His broad but compact physique suggested someone from the Mekong Delta, in Vietnam's south.

Among the arriving group were three American journalists. Cuba had granted them twenty-four-hour visas, with, as usual, barely notice enough to grab a toothbrush and head for the airport. The threesome had arrived in the middle of the night, taking the long way around from Los Angeles because of the ban in the United States on flights to Cuba. The Vietnamese embassy had scheduled their interview with Kim Phuc for nine o'clock that morning, but had not said where. Being a Sunday and, as well, the Cuban holiday of the Day of the Martyrs of the Revolution, it was hours before the journalists' telephone calls to the embassy were answered. Finally, at half past two in the afternoon, they made for the Riviera.

Two of the journalists represented *The Los Angeles Times*, one a writer, one a photographer. The newspaper had organized the trip as if it were a covert operation. Its biggest fear was that other media traveling might recognize the third journalist. He was Nick Ut, a photographer from the Los Angeles bureau of the Associated Press, and the newspaper was taking him to Havana to unite him, for the first time since before the end of the Vietnam war, with his famous subject, Kim Phuc.

"Oh! I need to meet that man!" Kim had said excitedly when the embassy told her. She said she wanted to thank him for saving her life by taking her to the hospital, not realizing that, though she had no recollection of the occasion, he had met her again in Trang Bang after the napalm attack.

"Uncle Ut, I'm so happy," she cried. "I've waited seventeen years to see you!"

Nick was too choked up to speak for several minutes. Normally smiling and affectionate with anyone he knew and liked, his gestures magnified by his diminutive size, on this day, Nick was nervous, even skittish in the presence of the two Vietnamese minders. *Dangerous guy*, thought Nick of one of the northerners.

Over dinner, a relaxed Kim spoke of her comparative anonymity at home. "In Vietnam, they say that I am nobody special, that a lot of people were injured in the war," she said. "I have seen other pictures of the war. But this is *my* picture." When it came time for goodbyes, she hugged the journalists in turn. In the embrace, it was impossible not to feel the tightness of scarred skin on her back. *I know she's unhappy. I can see it in her face*, Nick told himself.

"THE GIRL IN THE PHOTOGRAPH: 17 YEARS LATER" was the headline story on the cover of the August 20, 1989, edition of *The Los Angeles Times Magazine*. It reported that Kim Phuc would embark in September on a six-week trip that would take her across America.

> It's the magic hour in Havana, when the sky goes iridescent indigo before the light drops. The young woman poses for the photographer on the low wall of the esplanade above the sea, with racing clouds as a backdrop. The young woman loves the camera,

and the camera loves her. She's a Vietnamese Marilyn, wrinkling her nose, giggling and tugging at her skirt. She flirts with the photographer (Nick), wants to pose rubbing her cheek against his, giggles and tosses hair caught back by an orange and silver flower. . . .

"If I ever see those pilots who dropped the bombs on me—or any American pilots—I would say to them, 'The war is over. The past is the past.' I would ask those pilots what can they do to bring us all together. There's such a connection between Vietnam and America, but it should be one of friendship. Not bitterness. Not enemies. But I'm not coming to America to talk about the war. I'm coming so Americans can meet the girl in the photo and to tell them I'm alive and about my life and what's happening to my family. . . ."

[S]he told Nick Ut that the seafood dinner he had treated her to cost more than what her family could live on for several months. . . . [S]he hopes that her trip to the United States will raise money for her poverty-stricken family and for her return to the United States to study and get medical treatment. . . .

War calls many things out of people—crusading zeal, crushing sadness, mysticism, martyrdom, victimhood. From Kim Phuc's wounds have sprung a passion to be normal. "I want to live my life, marry, have children." She admits that Nick Ut's photo enshrined her as a symbol of agony. "But I'm alive and now I'm happy!" "A joyful young woman," says her interpreter from the Vietnamese Embassy in Havana. "That's the symbol now . . ."

IN JANUARY OF THAT YEAR, NICK HAD MADE his first return trip to Vietnam, fourteen years after he'd left on an evacuation flight from Saigon. He went on assignment, accompanying Saigon's last bureau chief for the AP, George Esper. They had each been granted one-month journalists' visas to cover the return of six former Marines journeying there to make their private peace with the past.

While Hanoi had no luck securing economic aid from the United States, there had been a breakthrough in expanded American relations in the fall of 1987. The United States amended its trade embargo regulations to permit private charitable and humanitarian aid to Vietnam in exchange for greater cooperation on unresolved MIA cases. In the spring of 1989, Hanoi removed a second longstanding obstacle to normalization when it announced that, in the fall, it would unconditionally withdraw its fifty-thousand-strong combat troops from Cambodia. However, yet again, Washington stalled, seeking from Vietnam a guarantee of peace in Cambodia, an impossible demand.

Upon his return from his assignment in Vietnam, Nick got a telephone call from New York from a woman he'd never met. Merle Ratner and several Indochinese activists were raising funds to bring Kim Phuc on a speaking tour of the United States. In Hanoi, Nick and George Esper had known from the AP's files that Kim was in Cuba, but they'd been put off by her minders whenever they'd asked after her. According to Merle, Hanoi had already approved Kim's visit.

Merle was an antiwar activist who, when the war ended, had directed her efforts to getting America to help rebuild war-torn Vietnam. She'd been a teenager when her father took her on a "dentists for peace" march, and she happily gave up a chance at a singing career to yell at demonstrations. After the war, she and a handful, toiling out of their apartments, sought to pressure the United States to honor Nixon's pledge for war reparations.

Realizing that government negotiations were going nowhere, they turned to people-to-people ties. In the late 1980s, working directly with Vietnam's delegation to the United Nations, Merle led visits of American activists to Vietnam and hosted Viet Cong combat veterans on visits to the United States.

Merle had met Kim in Vietnam. In 1986, she and her fiancé, Ngo Nhan, had gone to Hanoi to be married there by a top Party official. Nhan had met Kim at the youth festival in Moscow. A member of the American delegation, he had interviewed her for the American magazine *Nguyen Thai Binh*, named for a fallen student leader. Expelled by the United States in 1972 for his anti-war speeches, Binh had left for Saigon aboard a Pan American plane, and was shot to death before it landed, purportedly for threatening the captain with grenades unless he diverted the plane to Hanoi; the grenades turned out to be lemons in aluminum foil. Like Binh, Nhan had been handpicked by the CIA to be a leader of the next generation in South Vietnam, and had been brought to America as a scholarship student.

A decade and a half after the end of the war, homegrown Indochinese issues and concerns were cropping up in the 800,000-strong community of Southeast Asians in America: it wanted the United States to allow Amerasian children and political prisoners who'd worked for the United States or the former regime during the war to emigrate from Vietnam, and as well, to allow the reunification of families separated between Vietnam and the United States. Among Merle's network, talk turned yet again to how to influence the rest of the American public to turn away from the issue of MIAs. Someone mentioned the picture of the napalm girl: "That picture has instant recognition among Americans." Someone suggested they bring Kim Phuc to America. "There's no more powerful person to speak of healing the wounds of war," was Merle's view. "If she can forgive, why can't anyone?"

Merle made a request of Nick. Would he speak about his famous photograph to a small, select audience in Los Angeles, who would donate generously for the privilege?

Vietnam and the war had shadowed Nick's life in America. He did not travel without his cassettes of Vietnamese antiwar folk songs. He listened to them in his hotel rooms and wept. On damp days, he was bothered by shrapnel imbedded inside one thigh. Some months before the end of the war, he and another AP photographer had chased reports of fighting on Route 1 near Trang Bang. Upon hearing artillery fire, they had pulled off the road and started walking in opposite directions, Nick towards the Caodai temple there. While chatting with villagers out front, he'd spied two government soldiers on the balcony beneath the large, mystical eye. He raised his camera. At that moment, a shell came whistling in. Nick tried to run but his legs wouldn't move. He looked down, expecting to see blood. His clothes were pinpricked with ash instead, and there was a hole in his camera. He tried again to run but collapsed from a painful heat deep in his thigh. Doctors in Saigon decided to leave the shrapnel where it was. Fearful that his luck might have run out in Trang Bang, Nick stayed away from the town for the remainder of the war.

Many times, shaken awake by his wife from a nightmare, Nick would look around and recognize by the television in the bedroom that he was in his home in Los Angeles and not on a battlefield in Vietnam. In the years since he'd left Vietnam, he had felt helpless to make a difference to the lives of his mother and siblings there. Their letters were piercing cries for help: "We are very poor. Your brothers need help. We don't have jobs, food or medicine. We have no money to live." He did what every overseas Vietnamese did: he stashed bills inside seams of clothing, toothpaste tubes and bottles of toiletries sent home. And he hoped that thieves would be as careless as prying authorities, who opened letters and haphazardly taped them shut. In his own letters to

friends and family, Nick censored himself, afraid of jeopardizing his chances of returning to Vietnam to see his mother before she died, and maybe, to live out his life there.

Before the month was out on his return trip, Nick had gone to his home village of Long An. The visit with family and friends was filled with the tension of not being able to speak openly and freely. They whispered caution against saying "wrong things." Two brothers refused to speak of their time in reeducation. One friend had still not returned. When Nick left Vietnam, he smuggled out more than one hundred letters to be posted in America.

Some thirty people attended Merle's fundraiser, held at the home of a socialite in Beverly Hills. Nick noticed three or four Vietnamese among them. One was author Le Ly Hayslip (whose memoir of the war, *When Heaven and Earth Changed Places*, published that year, would be made into a movie of the same title by Hollywood producer Oliver Stone). The others had northern accents. *Communists, or friends of Communists*, Nick thought, avoiding them. He showed slides of a sequence of photographs from the day of the napalm attack in Trang Bang, ending with the famous picture. As a soundtrack to his presentation, he had selected "The Song of the Yellow Skin," a popular antiwar song once banned by the South Vietnamese government. It starts with the haunting lament of a mother, who sings a song of love to the cold body of her dead child in her arms.

KIM LOOKED AT HER SOUVENIRS OF THE journalists' visit: an 8 x 10 print of the famous picture and a T-shirt emblazoned with Mickey Mouse. The shirt was from an airport shop, the best that Nick could do on short notice. Kim did not know that he had looked for but found no opportunity to slip her some American dollars.

After their emotional sharing of memories, Kim was puzzled:

Why did Uncle Ut never come back to rescue me? If Perry Kretz could come back for me, why not Uncle Ut? Kim perceived only one difference between her world and that of those who lived in the West: she lived under control; they did not.

IN EARLY SEPTEMBER, KIM'S MINDER accompanied her to the Interest Section of the United States government in Havana. (Cuba and the United States had established these offices in each other's capitals in 1977, to facilitate communication between the two governments.) All was in order: her visa and airplane tickets. Then, one week before her departure date, Ambassador Tai called Kim in. He was his usual smiling self: "How are you? How is everything?"

For weeks, Kim had maintained an appearance of calm. "Fine, thank you," she said.

Then he dropped a bombshell. "Kim Phuc, I called you here today to let you know that the trip to the United States is canceled."

Kim's eyes widened. Her mind raced with fear: *What happened?* Obviously, she had made a misstep. But how? A moment too late, she realized that she had to tame her fright and stem her welling emotions. Tears would be seen as misplaced affection for the United States. Or worse, she might blurt out something that would reveal how much she had wanted to go.

Her faced cracked painfully into a smile. "Why?"

"You will understand you cannot go for two reasons. First, there is the problem of your health, and second, your studies." The ambassador knew she was shocked.

"SOMEBODY SHOULD GO TALK TO HER," someone said to Merle, "get her to change her mind." Trip

organizers and sponsors, spread over fifteen cities, were, in a word, irate at the abrupt cancellation. The fundraising had been entirely at the grassroots level. No foundation approached would contribute. However, the media's *blitzkrieg* of interest had inspired the fundraisers; network television shows had lined up to interview Kim Phuc and Nick Ut.

Merle could not think what might be standing in the way. There had been but one small uncertainty about whether the American government would grant Hanoi's request for a second visa, for someone from the Vietnamese foreign ministry to accompany Kim in the United States. But certainly Hanoi understood that the American government preferred to see her trip as an unofficial visit.

It took two weeks for Merle to get a twenty-four-hour visa to Cuba. At the embassy in Havana, she found Kim waiting for her. Their embrace broke Kim's seal on her emotions and she wept openly.

They were three around the table: the minder, Merle and Kim. Kim guarded her tongue; she noticed that Merle wore a *khan ran*, the signature woven and fringed, black-and-white checkered scarf worn by Viet Cong guerrillas during the war. While Merle read Kim's tears as disappointment, she was convinced that the reasons Kim gave were her own. Kim spoke of her unstable diabetic condition and how she did not wish to interrupt her schooling. "School is the most important thing in my life," she kept insisting, and she signed a letter to Merle saying the same. From what the minder added, Merle was left with the impression that Vietnamese and Cuban authorities considered Kim's marks to be "problematic," that quite apart from jeopardizing her health, the tour would imperil her studies.

The minder allowed the two to spend the rest of the day together without him along. *Merle is a daughter to them*, thought Kim, cautioning herself to watch what she said. Over lunch, Kim

spoke of worsening times in Cuba, how everybody had less money, less to buy, less to eat. At the residence, she opened a drawer to reveal a stack of letters. Each, she said, was a demand from her family for money. "They think I am rich, that I live in heaven."

Merle asked Kim if she had what she needed to treat her burn scars. Upon hearing that she couldn't afford to use her Nivea skin cream every day, that she had to conserve it as massage cream when she needed pain relief, Merle was insistent: "Let me take you shopping." At the *diplotienda*, Kim bought only one jar. "What else do you need?" Merle asked. "I can send you something from New York." Later, she would send a pair of long evening gloves, an item favored by women in Ho Chi Minh City to shield their arms from the sun while riding their bicycles.

When the two parted, Merle gave Kim one hundred American dollars. She also took the gold chain from around her neck and slipped it around Kim's. In return, Kim bestowed on her a ring of fake gold that had been her mother's.

Some weeks later, for the first time ever, Kim's minder asked her opinion before drafting a reply to a letter. It was from Merle. To which humanitarian causes did Kim Phuc wish to distribute the money raised for her tour? Among the choices were a school and a hospital in Vietnam. The sum was a few thousand dollars. "It doesn't matter," Kim said, smiling.

SINCE THE CANCELLATION OF HER TRIP, KIM had cried into her pillow nightly. *Why? Why, why, why?* Thinking her anger un-Christian, she prayed for it to subside. *Keep quiet, keep friendly*, she cautioned herself. By day, she donned her smiling mask.

After weeks of misery, Kim sought sympathy by confiding in Helen and the Diazes. "Take it easy, Kim," was all Helen would

say. Manuel and Nuria shrugged. *It doesn't occur to them that I might be upset*, thought Kim. *They love Cuba too much; they don't understand.*

THE REVERBERATIONS THROUGHOUT THE Communist world that had begun with Gorbachev's *perestroika* in the Soviet Union led ultimately to a dramatic collapse of the Soviet bloc. The beginning of the end of the Soviet empire came in November 1989, when the Berlin Wall was breached.

Castro turned his back on what was seen elsewhere as the inevitability of political change. In January 1990, he sent Cubans once again to the defense of his revolution. He proclaimed a "Special Period in Peacetime" and brought in draconian economic measures to severely ration consumer goods, fuel, electricity and food (monthly ration booklets henceforth provided enough food for only twenty days). "¡Socialismo o muerte!" was the new slogan that ended his interminable speeches; death as an alternative to socialism appeared to be a grim possibility.

Cuba's economic crisis turned calamitous overnight when the Soviet Union, to stave off its own collapse, stepped up its economic restructuring and further tightened foreign aid and exports of subsidized oil. As the Berlin Wall came down, Cuba lost its Communist trading partners in Eastern Europe. Within a year, West and East Germany were reunified. Hungary and Poland elected democratic governments. The Communist government of Czechoslovakia collapsed. Romania's dictator was executed. Cuba's imports from former Soviet bloc countries fell by half in 1990, and in 1991 virtually ceased, dropping to 7 percent of 1989 levels. The cutback in cheap Soviet oil left Cuba without a surplus to sell to earn hard currency to replace imports from the former Soviet bloc. Sensing Castro's regime to be on the brink of collapse, the United States responded by

widening its embargo, including a ban on shipments of food and medicine.

The Special Period marked the end of any and all normal practices in Cuba. Immediately, gas was in short supply. Without raw materials or fuel, factory production was disrupted. Water pumps could not pump. Farm machinery couldn't run. Trucks couldn't bring food to the cities. Garbage collection was haphazard. Hospitals ran short of medicines. Without parts from Hungary, city buses could not be repaired. Without East German powdered milk, Cubans could not make butter; without Czechoslovakian malt, beer. Within weeks of the proclamation of the Special Period, all consumer goods in the state stores were of worst quality and in short supply, from clothing to shoes to cooking oil to shampoo.

The once comfortable life at the student residence on the Malecón was no more. Electricity was turned off for four hours a day. One elevator was cannibalized for parts to service the other. Water could stay off for as long as two days at a time. The stairwells were wet from students sloshing pails up from the ground floor. Plugged toilets took on a bad smell. Garbage piled up; students on upper floors took to throwing it out the window, and the wind carried it through windows below. Dormitory sheets went unwashed. The university handed out newspaper for toilet paper, salt for toothpaste. Fortunately, Kim had Toan and her privileges at the well-stocked *diplotiendas*. And her minder allowed her to do laundry at the embassy, where an emergency generator kept a regular water supply.

Within months, there was such an alarming rise in respiratory ailments among the population of Havana that Castro himself would publicly criticize the poisons spewing from city buses. In bad repair, they wheezed along the streets, belching thick clouds of noxious, black fumes. Like others in the residence, Kim began to have sneezing fits. A specialist confirmed an asthmatic

condition brought on by allergies. Whenever Kim had an attack, unless she could calm herself enough to release the tightness in her chest and ease her breathlessness, she had to be rushed to hospital.

IN THE YEAR SINCE THE REGIME HAD canceled her trip to the United States, Kim's anxiety over what had gone wrong had not lessened. Each time she felt her suffering trying to force its way up, she swallowed, so that as the months passed, she was bloated with it. She felt her life to be in limbo, her future uncertain. She wondered if Hanoi would ever again allow her to travel to the United States. She came to one conclusion: *only one person can tell me if I have freedom in my future, and that person is Pham Van Dong.*

At the end of her first year studying English, Kim bought a ticket for a one-month visit to Vietnam. She financed her trip with Merle's one hundred dollars and by borrowing another five hundred from Toan and several other Vietnamese students. At a parallel store, Kim bought several T-shirts imprinted with photographs of Cuban beaches for her brothers, and *guayaberas*, the traditional Cuban dress shirt decorated with embroidery and favored by older men, for her father and Pham Van Dong. At the *diplotienda*, she bought French perfume and Cuban cigars for her parents, and a watch for Duong, whom she counted on to take her to see his father.

The Westerners on Kim's flight to Hanoi were a sign of *doi moi* at home. Hanoi had partially put the brakes on economic reforms in 1989, but it had less to do with domestic concerns than with what had happened in China, with the fledgling democracy movement that ended with the bloody crackdown in Tiananmen Square. Still, Hanoi had succeeded in reining in inflation (from 1,000 percent in 1988 to 30 to 50 percent in 1989

and 1990). Kim had noticed people she presumed to be Western businessmen on her flight, and on the road in from the airport, she thought that the rural poverty looked less harsh than it had four years earlier.

The maid at Duong's house in Hanoi told Kim she was in luck: by this time in July, the son was ordinarily already in the south with his father and mother. That evening, Duong showed up on his motorbike at the address Kim had given the maid. As yet unmarried, he had retired from the army to head his own company. Besides arranging an appointment for Kim with his father, he would take her sightseeing, and as well, pay for a return plane ticket to Ho Chi Minh City.

The former prime minister was still living in his government villa. The eighty-four-year-old Dong had little vision left, but his eyes shone brightly, and in Kim's, he appeared ever more angelic. They embraced and held hands. He wanted to know of her life in Cuba, but nothing that she said of the growing difficulties of daily life there appeared to be news to him. When the topic turned to her Vietnamese boyfriend, Kim commented on the differences between Vietnamese and Cuban attitudes towards love. "In Cuba, people change partners so easily," she said. "To them, love is as normal and ordinary as eating a meal." He laughed. "Cubans are good people," he said, "but when it comes to love, they are very free."

After dinner, Kim felt the time right to put the question on her mind. "Uncle, I want to ask you why the government canceled my trip to the United States."

He waved the question off. "Don't think about it any more, it doesn't matter."

"I'd feel much better if I knew the reason."

In the silence that followed was Kim's persistence, and finally Dong's willingness to trust her with the truth. "The people had reason to believe that you had ideas about staying behind in the

United States after the trip," he said. "The people feared that your family told you to take advantage of the opportunity of the trip."

Kim asked no more.

As soon as Dong had uttered "family," she'd fingered her brother, Ngoc. She knew what had incriminated her. "When you go there," Ngoc had written her, "take advantage of your trip to stay. Do not come back to Vietnam." Kim was bitter. *That is Ngoc's problem, always saying what is on his mind.* She had received this letter from a contact of Helen's; he must have given her the same advice in another letter intercepted by authorities. Kim saw that she had paid gravely for Ngoc's stupidity. *They don't believe in me. I never had it in my mind to escape. I never had it in my mind to make a scandal. They thought I was going to betray them. Now, I will never have freedom living under their control.*

As soon as she arrived in Ho Chi Minh City, Kim left for Tay Ninh. She found Ngoc at home in the dilapidated house on Future Road, as disillusioned as ever about the Communists. His latest failed venture had been buying bamboo blinds from small suppliers for export. Buyers rejected the blinds for their poor quality, leaving him holding inventory and in debt to a northerner. Three years later, Ngoc would go to jail for eighteen months for failing to repay the loan, the principal amount equivalent to about forty dollars American.

Kim tried to explain to Ngoc why she'd been unable to respond to his pleas for help. She characterized Cuba as so poor that, though surrounded by sea, it had to import salt. Then she said what she had come to say, lecturing in a way that reversed their roles, as though she were the older sibling, he the younger. "The government canceled my trip to the United States because of you." After she'd explained, she realized that Ngoc was as saddened as she had been hurt. Feeling a debt of gratitude for the

sacrifices he and his wife had made in raising her and her siblings through some of the darkest years of deprivation, she softened her tone. "We have to be very smart. If you say something stupid like that, and they hear you, it is not good. They won't believe in you; they'll try to control you more."

Ngoc was not to be deterred. He later wrote to Merle Ratner and Nick Ut. Neither replied. Merle thought Ngoc's letter, written in English, to be calculating. "Since you are trying to help Kim Phuc," he had written, "could you please help us?" Knowing times were improving in Vietnam, Merle asked friends who knew of Kim Phuc to make inquiries about her family, and they reported that they were not in the desperate straits that Ngoc's letter made them out to be.

Ngoc would also write a letter of appeal to Pham Van Dong to relieve the tax burden on his mother's shop. In his reply to Ngoc, Dong expressed affection for Kim Phuc, but added: "I cannot help you. You live in Tay Ninh and you must appeal to them." Shortly afterwards, the district tax official in Trang Bang ordered Tung and Nu before him. "We received a telegram from Hanoi," he said. "The people are very sorry for you; we will see what we can do." As Nu had to get back to the shop, she instructed Tung not to leave until he got on paper a promise of relief. He returned empty-handed. Vindictiveness aside, Nu's problems might have been indicative of the regime's failure after four years of economic reforms to make the breakthrough to the next plateau of making radical changes in tax assessment and collection policies.

During her three-week stay in Ho Chi Minh City, Kim stayed once again with Huong and Dai. They now lived behind the walls of a colonial villa, occupying its main room, which was so large that Dai had partitions built to divide it into bedrooms. The couple and their son also had a live-in maid.

Kim made three day trips to Trang Bang. She was pleased to

see old Grandmother Tao for a last time; she would die two years later. There was no room for Kim to stay overnight at the noodle shop, as Loan's two children worked and slept there. Kim saw that her mother, as ever, could not take a day off work. "Home" was two hammocks strung in the outbuilding behind the temple, where her parents lived without electricity, carried water from a well and used an outhouse. Nu continued to support many on the earnings of the noodle shop. Kim was particularly rankled by the idleness of her thirty-year-old brother, Tam, who had playboy ways and a gambling habit. The youngest sibling was eighteen, and though he had passed the university entrance examination, Nu had not the money for him to go. When Kim said goodbye, she gave her father some American dollars. "Hide it," she told him. He put it in his shirt pocket. "There is no security at the temple," he said. "Anyone can come and go."

Loan's daughter was able to get word to Anh that Kim was visiting from Cuba and wished to see him. Since she'd last seen him, he'd spent three years in reeducation; the pastor of their church was being held still. Of his time in prison, Anh, who had aged beyond his years, would say only, "It was because of my religion."

Though the authorities had allowed the large church at Trung Hung Dao to remain open, because Anh could not risk being seen by authorities, he took Kim to an underground Christian church service. The services were held in private homes, and never in the same house two Sundays in a row. Kim reveled in hearing the word of God with her Christian friends. She did as they, prayed in a low voice and sang in a murmur hymns chosen for their subdued tempos. One sad note for Kim was to see that none of her Christian friends was better off, but for the few with relatives gone to the United States.

KIM DINED A LAST TIME WITH PHAM VAN Dong in his villa in Ho Chi Minh City. When he asked after her family, she bemoaned their plight. They remained poor, she said. Her mother still had a business, but no house, and she labored under the burden of debt and onerous taxes. Kim made a woeful comparison: "Officials in Tay Ninh live like kings!"

Dong shook his head. "Some in government have done wrong by the people," he said. "Innocent people suffer. It saddens me, but I can do little; I am only one man."

Since their talk in Hanoi, Kim felt the air had cleared between them. She had one remaining mission. "Uncle, I want to share with you my experience between me and God."

In her resolve to make a testimonial to Dong, Kim had considered that she might never see him again. Who knew how much time an old man had? She cared deeply about his soul and that it should be saved, and thought that, being a northerner, he probably had no religious beliefs.

"Jesus Christ came to the world to die on the cross to pay for our sins. Only if we believe that can we go to heaven."

Dong did not stop her. *He's open to hearing me out*, Kim thought. She continued: "Jesus said, 'I am the way, the truth, and the life.' I believe in and I pray through Jesus Christ. God opens the door for me and gives me faith to overcome my burdens. You see that I am not sorrowful. I am not complaining. I think only of the present and the future, not of the past. I live with my faith, because without my faith I am nothing.

"You need to be saved. I know that people who die and are not saved will go to hell like the fire of the napalm bomb. So I pray that people will be saved and go to heaven."

He was still listening politely.

"I receive blessings because I was burned badly. You see me? I look normal. My face and my hands were not burned. My feet were not burned in order that I could go out of the fire, and have

my picture taken. That gave me a chance to receive rescuers and saviors to help me."

Dong chuckled kindly. "That religion is from America."

"I will keep praying for you," Kim said.

"Okay," he said.

Never was Kim filled with more respect and admiration for Dong. *Keep me in your hands and I can escape their control; I can do anything*, her inner voice told him.

BEFORE LEAVING VIETNAM, KIM SHOPPED IN the free markets of Ho Chi Minh City. She bought several chiffon scarves and handfuls of trinkets and hair barettes. The scarves were gifts for Cuban friends; the trinkets and barettes would fetch two or three *pesos* apiece in Havana. Since the onset of Cuba's Special Period, such dealing in the student residence, once unthinkable, was spreading, every student accepting that each did what they had to to make a few *pesos*. Fortunately, as Kim was out of practice at bargaining, and as well was unused to shady practices, she had the company of her girlfriend, Trieu. Trieu was biding her time in Vietnam waiting for her husband to send for her from Canada; the two had planned to escape by boat together but had been able to raise only enough gold for one. After making a deal for Kim on some fine leather goods for Toan, Trieu caught the seller trying to wrap up an item of lesser quality. For herself, Kim brought back from Vietnam a gift from Anh of a new Bible and hymnbook, in a white leather zippered case.

Back in Havana, Kim saw in the *diplotienda* a large rectangular picture, embroidered in sunset colors, of the face of Jesus Christ, with angels hovering in the four corners. Toan helped her frame and mount it on the wall above the head of her bed. In that first year of the Special Period, Castro had relaxed his attitudes towards religion. While Castro's Cuba was officially

atheist, religion had never been banned, but the practice of it, never strong to begin with, had virtually disappeared. However, that year, Castro allowed papal emissaries to visit. For the first time in thirty years, Cuban radio and television began playing religious music, and religious art and icons appeared for sale in the *diplotiendas*.

Neither Kim nor Toan was shy with the other about their differences of beliefs.

"I am Christian and I pray for you," she would say to him.

"I am Communist," he would reply.

Toan, able to quote the teachings of Ho Chi Minh, Lenin, Engels and Marx, regarded the crumbling of the Soviet bloc as the result of serious mistakes by the Communist parties in those countries. Kim would bring such discussions to a quick end by saying: "We disagree—forget about talking about politics."

Talk of the growing privations of daily life in Cuba came to a similar end. "Cuba's socialist brothers have let Castro down," was Toan's opinion. "We pray for the people," was Kim's final word.

Neither did they have a meeting of minds on the future of their relationship. Toan's first concern had been to seek his father's approval. As their village had neither newspapers nor television, the father knew nothing of Kim Phuc's fame as a war victim and was taken aback that his son should be friendly with a southerner. When Toan wrote to describe the effects on her health of the napalm bomb, his father wrote back: "You are an adult. You can decide the matters of the heart for yourself."

On Kim's recent visit with her own family, she had deliberately mentioned Toan in Cuba—whose family she visited on a day trip from Hanoi—and Anh in Ho Chi Minh City. Neither Tung nor Nu said anything—better that a daughter had more than one male friend; one alone would cause raised eyebrows from a parent. As ever, Ngoc was opinionated. Kim played up Toan's virtues in hopes of overshadowing the fact that he was a

northerner. "He is a wonderful friend. He is sensitive to every-one." Ngoc had cut her off. "I know he is from the north. He is better for you than Anh; better that you marry a Communist than a Christian."

After Kim's return from Vietnam, Toan proposed. She wouldn't say either yes or no. "You are very good to me," she replied, "but I cannot decide about marriage at this moment. I have to think of my health, my studies and my future."

THE END OF KIM'S SECOND YEAR AS A student of English approached, the furthest she had gone in her academic endeavors. One day, in May 1991, a letter addressed to her at the residence arrived in the post. Kim used the embassy's address for her mail; nobody had ever written to her at the residence. The postmark was Germany. Kim's heart pounded with excitement. It had to be from a *stranger*.

The letter was from Zweites Deutsches Fernsehen (ZDF), a television station in Mainz, Germany. It proposed to send a reporter and a cameraman to do a day-long shoot in Havana for a short documentary updating Kim's life. Immediately, Kim realized that this letter had not taken the usual diplomatic route. Normally, the interview request would have been made to the foreign ministry in Hanoi, which would have forwarded it to Havana.

The letter went on: of course, ZDF would pay her for her participation. If she agreed, she should sign and return the attached one-page contract, which provided for payment of five hundred American dollars.

Five hundred dollars. Since her return from Vietnam the previous summer, Kim's prayers to God had been mostly for help to find ways to repay the five hundred dollars borrowed from Toan and other Vietnamese friends. And she longed to relieve the plight of her parents. Seeing them had left her overwhelmed with

disappointment at how their lives had turned out, how they would probably have to work to their dying day. A recent letter from her father told of her mother's shop being assessed yet another special levy. He had gone to the district tax office seeking an explanation. "Because your shop has been very famous for forty years," the official said. *It is famous because of* me, Kim thought.

Kim wrote "YES!" on the bottom of the ZDF contract, signed it and walked to the central post office in Havana to mail it.

One morning in June, just past nine, two German men arrived in Havana, rented a private car and driver on the black market and drove to Kim's residence.

"How did you get my address in Cuba?" was Kim's first question.

Their response was offhand: "We telephoned the Vietnamese embassy in Bonn [the liaison office had been upgraded to an embassy upon the reunification of Germany] and asked, 'Where is Kim Phuc?' The man who answered said you were in Cuba. We asked for your address and he gave it to us."

Kim was thankful that the day's classes had begun; the residence had long since emptied of students. After filming there, the threesome went to the university and filmed Kim inside a classroom, and outside, against the backdrop of the neoclassical architecture, and on the university's immense stone staircase, famous for its wide steps that appear to rise from the Gulf of Mexico to the height of the campus.

At the end of the day, the two ZDF journalists gave Kim, in cash, five hundred dollars. They explained that the documentary would promote a new program to be launched that summer on ZDF entitled "Photographs that Made History." One of them had an inspiration: "Would you like to come to Germany to the television studio to introduce your picture? We will take care of everything—"

"Yes! I would!" Yet again, Kim saw God opening another door to her future.

Immediately, she saw in her mind that the request would first have to get through the labyrinth of the Vietnamese foreign ministry bureaucracy. "But," she advised, "you must ask permission for me to leave Cuba." Her mind clicked over, looking for the path to success. "Ask the Vietnamese embassy in Bonn."

For days, Kim remained nervous that word would get back to the Vietnamese embassy that she had been seen with foreign journalists. She had told Toan, but trusted him to say nothing. The days passed without repercussion. Then, Kim was seized by a greater fear, that the ZDF's approach in Bonn would reveal to the regime that she had gone behind its back. That she could not afford; the regime already viewed her as a security risk, thinking she had intended to defect to the United States. Kim realized that, in all likelihood, Hanoi would refuse the German invitation.

She saw what she had to do. She wrote a letter to Pham Van Dong, choosing her words carefully to demonstrate her loyalty to the regime. Without mentioning the shoot in Havana, she wrote of the ZDF invitation to go to Germany to present her famous picture. "I would very much like to visit there," she wrote, "to say 'Hello' to the German people again." She ended her letter solemnly: "I promise to return." She posted the letter at Havana's central post office.

Two weeks later, Kim's minder confronted her. He angrily waved a piece of paper, reading aloud from it: "The government has accepted the invitation from German television"—his next words were spoken through clenched teeth—"*according to the wishes of Kim Phuc.*"

Spittle shot from his mouth. "Why did you write to Hanoi? Why?"

She did not answer.

"How did Hanoi know about this? How did they agree?"

Inside, Kim was laughing. Hanoi had given an order and there was nothing that he, or for that matter the ambassador, could do to change it.

Because her minder had said nothing about helping to arrange her paperwork, she proceeded on her own to the German embassy. Kim found that ZDF had taken care of all the details: waiting were her visa, airline ticket and itinerary. Days later, the Diaz family—except for Nuria, who disliked goodbyes—drove her to Havana's airport.

CHAPTER FOURTEEN

In Mainz, a town famous for the invention of the printing press and the printing of the Gutenberg Bible, Kim spent a relaxed few days in early July—without a Vietnamese minder in sight. A ZDF producer collected her from her hotel daily and took her sightseeing and to tea with her own mother, and, at week's end, brought her into the studio. Before a live audience, Kim appeared with the host of "Bilder, die Geschichte machten," a weekly program of ten-minute segments examining a photograph that made history, to introduce the inaugural film, "Das Mädchen aus Vietnam." At the post-show party, the program's photographs were on exhibit. Kim was familiar with three others: the execution on a Saigon street of a Viet Cong suspect; a Russian soldier raising the flag of the hammer and sickle atop the gutted Reichstag; and an American sailor kissing a nurse in Times Square on V-J Day. At the end of the evening, the producer had her sign a contract and paid her, in cash, one thousand American dollars. Though Kim's obligation was fulfilled, ZDF invited her to stay on as its guest for several days longer at the hotel.

There was no debate in Kim's mind: she ought to check in with the Vietnamese embassy in Bonn. The next morning, she dialed from the telephone in her room. She mentioned ZDF's invitation.

"*We* invite you to come to Bonn," was the embassy's response.

Kim planned a one-month stay in the guest quarters of the embassy in Bonn, the length of stay paid for by what ZDF gave the embassy as the equivalent cost of a few extra days' hotel and meals in Mainz. Within the compound in Bonn, she was back within the regime's control and conducted herself accordingly. While at ZDF, she had asked someone to contact Perry Kretz on her behalf, but no one had got back to her before she left for Bonn. Once in the embassy, quite apart from being intimidated by the German spoken at the other end of the telephone, she dared not risk being overheard trying to contact the journalist.

The month was uneventful, except for one unexpected visitor. A young German man, her age, had seen the documentary shot in Havana, which had aired earlier that summer, and then her ZDF studio appearance. Realizing that Kim had to be in Germany, he pleaded with the station to put him in touch. He had come to Bonn, four hours by train, in hopes of meeting her.

The two struggled in English. He was lovesick. "I want you to be my girlfriend."

Kim giggled, amused. "I am in Cuba, you, in Germany. How can we get boyfriend and girlfriend?"

"We can write to each other."

"We are friend, is okay. We can write letter, but boyfriend and girlfriend, no."

The embassy arranged one meeting, between Kim and the administrator who headed the project that Kim herself had launched seven years earlier, in 1984, at the press conference on the day of her discharge from the burn clinic in Ludwigshafen. Finally, a burn facility was about to open in Ho Chi Minh City. It

was to be part of the existing Cho Ray Hospital, the same hospital where the Barsky unit had operated until 1975. The administrator blamed delays that had plagued the project on Vietnam repeatedly sending individuals for training in German hospitals that Germany had to reject as unqualified.

"Will the burn hospital be named after me?" asked Kim.

"Well, the Cho Ray Hospital already has a name," replied the administrator.

With enough money to indulge in a small shopping spree, Kim bought herself and Toan leather shoes, tracksuits and Adidas running shoes, and for herself, a Nikon camera and a supply of film, and a bathing suit in a leopard skin pattern. At an Asian food store, she found a Vietnamese delicacy, cooked sausages stuffed with the meat of shellfish, the pungent smell of which was not appreciated by her seatmate on the flight home.

With the money earned from ZDF, Kim cleared her debts to Toan and other Vietnamese friends, and was also able, finally, to send something to her parents and her brother, Ngoc. Looking for "something small" they could resell in Vietnam, she settled on Cuban-made glass syringes. She sent a boxful, along with two hundred dollars, with one of Helen's couriers. None of the syringes arrived intact.

BACK IN HAVANA, KIM WAS MOVING YET again. The residence authorities had had to close down the uppermost floors of the twin residences on the Malecón. The shabbiness of the ground floor betrayed the building's poor condition: the security guard's desk was broken; the decorative pool had long ago emptied of water; and the dry dirt in the planters in which plants had once thrived now blew everywhere. Scheduled daily electricity shutdowns had escalated from four to six hours, then to every other day. To make matters worse for the residents

of the upper floors, the out-of-service signs on the elevators never came off.

The university left its Cuban students on the Malecón and transferred its foreign students to east Havana, where a block of Soviet low-rise apartment buildings had become empty upon the Soviet Union's abrupt recall of its workers and advisers. Life there was not much of an improvement over the Malecón. These buildings were stark outside, dark and stifling hot inside. Built of Soviet prefabricated concrete and designed to withstand a Soviet winter, they had few windows and no balconies. The only nod to landscaping in front of Kim's building was a bust of a Cuban martyr, set in a now empty flowerbed. These residences had no security guard checking for student passes, so any laundry left hanging to dry, from sheets (students with *pesos* to spare forsook the university's threadbare sheets and bought material to make their own) to underwear was bound to be stolen.

Emerging from the tunnel into east Havana, one had a favorable first impression because of the gleaming new sports facilities and the athletes' village built for the 1991 Pan-American games. When the games were over, the athletes' accommodations were to be converted into hotels for international tourists—part of Cuba's plan to have tourism help lead the Cuban economy back from the brink. The games, held in August, were a success, buffing Cuba's self image and rejuvenating its pride. However, on closing day came international news that stunned. An attempted coup against Gorbachev signaled a disintegrating Soviet Union. In October, bracing Cuba for the aftershocks, Castro proclaimed it each Cuban's "sacred duty" to save the Cuban Revolution. And, to reinforce his singular grip, he stepped up the harassment and rounding up of dissidents.

At the onset of the Special Period almost two years earlier, Cuba had prepared for its impending gasoline crisis by calling on farmers to substitute oxen for farm machinery and for the people

of Havana to use bicycles—until the late 1960s, virtually unseen in the city. In 1991, the first shipments of 1.2 million Flying Pigeon bicycles from China began to arrive for Havana's population of 2 million, and on May Day that year, Cuba's armed forces paraded on bicycles.

A disadvantage for students reassigned to residences in east Havana was having to rely on the bus to get to classes. Nonetheless, Kim and Toan took up the university's offer of a Chinese bicycle at a subsidized price of sixty *pesos*, payable in monthly installments. Five minutes in one direction from their residence were the converted Panamericano hotels, and five minutes in the other were the Diazes. Cycling into central Havana, however, was impractical: at the entrance to the tunnel under the harbor channel, cyclists had to dismount and load their bicycles onto special buses for the crossing. Before the Special Period, the wait and ride from east Havana into the heart of Vedado had been fifteen to twenty minutes. In the Special Period, the wait alone in east Havana could take up to one hour. Buses failed to appear, or passed by too full to stop. The chaos at the bus stops, with a crush of workers trying to get to work, intimidated Kim. An orderly lineup would be maintained only until a bus stopped. And getting on board was only the first hurdle; buses often stalled or broke down altogether.

The lights went out on the city's entertainment. Electricity blackouts would darken the cinemas. Often the cafés and restaurants closed because they had run out of supplies. Even Coppelia took on an air of "waiting for Godot." People would stand in a line that didn't move or sit at a bare table for as long as five hours, on the off chance that the emporium would receive a delivery of milk allowing it to resume making ice cream. Foreigners with red *pesos* could always go to the tourist hotels and nightclubs, but with few to spare, Kim rarely indulged.

She was enthusiastic, however, about a suggestion from

Helen's boyfriend, Mohammed, that she join with him and Helen—the couple were now living together—to buy a car. Mohammed had an international driver's permit. A car would not replace the bus for getting to classes; the supply of gasoline was not that reliable. Rather, the purpose of a car was to relieve the boredom and grimness of life in the city, to allow outings to the beach and to forage for food in the countryside. It was Mohammed's idea that Kim tell her minder that riding public buses jeopardized her health. The embassy agreed and provided her with a paper authorizing her to purchase a car.

There was one red *peso* car lot in Havana. The cheapest car they found there was a 1984 Lada. Its chassis was broken, the body scratched and the front windshield shattered. Bargaining was illegal in Cuba. The broken-down Lada, in American dollars, cost $1,200. The manager recognized Kim. "You are famous," he said, recalling the story and picture in *Granma*, "and I want to help you." He took it upon himself to replace the windshield and add a coat of turquoise paint on the body before selling it to them.

Manuel Diaz got the car in running order. Mohammed paid for the gasoline, and a tire lock to guard against theft. More often than not, the car sat parked, its tank empty. When Mohammed could find gas to buy, the foursome went on day trips and weekends away, lodging with families who illegally rented beds in their homes, and dining on black market meals. Like other students, they had the opportunity to go on the annual *campismo*, but in the Special Period, without enough food brought along, two weeks of living in tents and battling mosquitoes was more ordeal than privilege.

The Diazes kept an open door to Kim and her friends, and even entertained Ambassador Tai and his wife to celebrate Tet. Kim relied on the Diaz house as a place to do her laundry, to shower and cook. Rarely was there any interruption to their residential electricity or water supply. Manuel managed to keep their

Russian-made washing machine running, but for the hopelessly broken wringer, and clothes could be left unguarded drying in their back garden. In return for these favors, Kim took small gifts of soap, shampoo, toilet paper and laundry detergent, items always in stock at the *diplotienda* but, more and more often, either unavailable in the state stores or of such poor quality that Cubans shunned them. Every late afternoon, the family dog sat with its eyes fixed on the horizon, watching for the approach of a figure on a bicycle. A plastic bag hanging from the handlebars meant that the rider, Kim, was bringing fare from the student residence—a treat, at least for the dog.

GORBACHEV'S RESIGNATION AT THE END OF 1991 marked the formal breakup of the Soviet Union into independent states. The kingpin among them, Russia, grappling with economic dislocation and inflation (which would soar to 2,500 percent over the next year), abruptly halted subsidies and demanded world prices for its oil and payment in hard currency.

Immediately, the oil pipeline to Cuba dried up. To compound Cuba's economic woes, the buying power of its sugar exports dissolved. World prices plummeted to levels that would stay depressed for the next several years. The crop also shrank, as Cuban farmers could not get fertilizers, pesticides or gasoline. By early 1992, the Cuban economy had contracted so drastically under the Special Period that it brought scourges reminiscent of the Batista era: high inflation, joblessness and shantytowns outside Havana. The signs on some state stores said they were closed for inventory, though their shelves were empty. Repeated electricity blackouts disrupted or shut down factories. To ease demand for electricity in downtown Havana, the regime shortened the workday by canceling lunch hours for office workers. It mobilized

tens of thousands of city workers to "voluntarily" work extended
stints on state farms. Yet everywhere was more breakdown and
deterioration. Shoving and fistfights broke out in lineups. Older
people took on interlopers: "Comrades, comrades, respect the
lineup."

Kim took measure of the Special Period only in terms of
human suffering. People bore the appearance and smell of decay,
their bodies and clothing reeking with stale perspiration. She
appreciated that she had privileges Cubans did not. She said yes
to her classmates who, pleading hunger, asked for a single candy,
knowing she kept them on hand for diabetic emergencies. When
some had a few precious *pesos*, they asked her a favor of buying
on their behalf, the next time she went shopping at the *diplo-
tienda*, a single egg. Policemen would knock at her door in the
residence, knowing a foreigner lived there. "I am checking to see
if you are safe," they would say. "There is so much theft in the
Special Period." Eventually, they would work up the courage to
beg something. A biscuit? A few flakes of soap, enough for a
shower? A capful of shampoo? Never did Kim refuse; the requests
were small.

At the university, hunger and fatigue diminished energy and
dinted enthusiasm for both teaching and learning. Teachers and
students who relied on public transportation were haphazardly
late for class. Some teachers, themselves reduced to begging food
from students, devoted class time to organizing car pools and
coordinating efforts to find food. Electricity blackouts between
six and ten at night forced the cancellation of evening classes.
Students wanting to study had to stay up past ten. Few had the
energy to stay up late and rise early. In the morning crush to get
into the city, some young men scrambled to grab onto the out-
sides of the buses, hanging by one hand to the edge of the door
or an open window. Inevitably, some fell to their deaths.

Toan, who was close to graduating, kept his zeal for studying.

Not Kim. Drained of ambition by the travails of daily life, she cared only that she avoid failing grades. She grew concerned for her health. Privileges at the *diplotienda* counted for less, as prices rose sharply and shelves were not restocked. Sometimes, Manuel Diaz, using up his precious ration coupons for gasoline, would drive her and Toan into the countryside in search of rice and eggs, and a chicken or, if they were lucky, two. Yet still her health suffered. Her sneezing fits worsened. By night, to ease her breathing, she took to sleeping upright in a chair.

A sudden and dramatic loss of hair worried Kim enough to go to a hospital. She was taken aback by Cuba's changed circumstances when she was asked to pay a fee to see a doctor, on account of being a foreigner. As ever, Helen came through, with a moonlighting doctor. Cubans using Dr. Abdala's services would pay him a loaf of bread, or remember him at New Year's with a few slices of roast pork; Helen's foreign friends paid with small luxuries of shampoo and detergent. More than once, the doctor, an orthopedic surgeon, helped Kim through diabetes and asthma attacks. He acknowledged the illegality of his moonlighting by expressing his gratitude for payment silently, by lightly tapping his fingertips together. The doctor saw himself as having paid his dues to the revolution in the Cuban government's repeated refusal to permit him to leave for the United States, where his wife had fled in 1960. Some foreign students tried to broach the topic of Castro's intransigence, but Dr. Abdala would not be drawn in. "Talk doesn't resolve problems," he would say.

UNEXPECTEDLY, AN OFFICIAL FROM HO CHI Minh City dropped in on Nu at the noodle shop. The son of Pham Van Dong would be paying her a visit; she should prepare to receive a seven-car delegation. Calculating upon four or five people per car, Nu readied herself to serve, that day, her famous

banh trang, and to go with the rice-paper wraps, tea. On the appointed hour, the motorcade slowed, then, inexplicably, sped off. Some days later, Nu received a letter from Dong's son. He apologized for not stopping; district officials with his motorcade had advised him not to, "because there is no security at your shop."

Nu had yet another dispute with local authorities concerning the widening and rerouting of Route 1 through Trang Bang. During the weeks of road construction, she had been forced to close the shop. The authorities denied her request for compensation of lost income. When she appealed to them, pointing out that the road widening had eliminated the parking on which her business depended, she was met with reproach. "Kim Phuc received much help to leave this province to go to Cuba. In her years there, she has done nothing to help Tay Ninh. She should have asked for help from overseas to build a school or a hospital for her home province."

The news that Kim feared and hoped never to hear came in a letter. It was from Linh, the daughter of Loan. After more than forty years, Nu's shop was no more. "Your mother could not meet her creditors, so I have bought the shop," the letter said, "and now your mother is working for me." It continued: "If your mother gets a chance, maybe one day she can buy the shop back." Kim wondered where her twenty-three-year-old niece got the money to buy the shop, and could think only that her boyfriend from Ho Chi Minh City was behind the deal. The purchase of the shop marked the beginning of a family feud. The niece would resell the shop, and three years later, in another location in Trang Bang, she and Kim's brother, Tam, would open competing eateries side by side. Shunned by Linh, Nu cooked for Tam. *This, from my own grandchild*, she would tell herself, *whom I carried out of the napalm attack.*

Worse news of her parents' plight was yet to come. Tung

wrote Kim that in the spring of 1992 her mother had stopped working because of health problems. Ngoc wrote with characteristic bluntness about their parents' appalling living conditions. "Phuc, our parents are getting old and living in a very poor and decrepit condition. Unless you can find a way to make money and help them, they will live out their lives in a mud hut." Tung and Nu had to vacate the outbuilding—parishioners tore it down as part of their rebuilding of the war-damaged temple. The parishioners took pity on the aged couple and built them a bamboo hut behind the temple. It was barely large enough for one bed, a small round table and two stools. Nu cooked outside, on the ground. Tung wrote Kim of the flimsiness of the hut in the wind and rain. "Study hard and return from Cuba to find a good job," he told her. "Perhaps you can find a job as a tourist guide, and save enough to build your mother and myself a decent house." Where once Kim had seen such letters as hounding her for money, now she saw them as a plea for some dignity.

IN THE SUMMER OF 1992, AS HER THIRD YEAR of studying English drew to a close, Kim was rapidly losing heart for life under the Special Period. By naming it so, Castro had implied that it would last only a limited time, but now no one seemed to know where it would all end. For Kim, it was unthinkable that she might have to relive the desperation of the early postwar years in Vietnam, when she and her siblings' stomachs were bloated with animal feed and Great Uncle lay wasting away.

Kim found it ever more difficult to believe in the reason she had gone to Cuba in the first place—to secure a future for herself. Instead, the difficulties of daily life weighed ever more heavily on her mind. She knew that, as a foreigner, she could stay one step ahead of ordinary Cubans. She'd received the blessings of good fortune—namely, hard cash. But she could not count on that to

come again. And she didn't have rich parents like Mohammed's, or connections like Helen's. The two years of study that stretched out ahead of her—presuming her health could endure the worsening deprivations—seemed like punishment, like climbing a mountain of sand that was ever sliding underfoot.

She tried to envisage the life that awaited her at the end of it all, upon her return home to Vietnam. She saw clearly only one thing: that once back in Vietnam, she would be more firmly in the grasp of the regime. She told herself that "they" would decide the choices in her life, before she herself learned of them, if at all. Kim foresaw that any opportunity for her to go to the United States would be kept from her attention. Chance mail and visits, the way it had happened with the German television station, might happen in Cuba, but not in Vietnam.

They hate me, Kim thought to herself. She saw in the regime's cancellation of her trip to the United States a change of heart towards her. *They hate me, yet I cannot change that; I cannot correct that.* She thought of how there were no saviors left to appeal to; she had gone as high as she could, to Pham Van Dong. On her last visit with him, together, in private, they had lamented each their own powerlessness, facing the reality that no individual came before the regime.

Without my faith, I am nothing, thought Kim. Yet, as she continued to feel herself losing ground in Cuba and dreading her future in Vietnam, the all-too-familiar suffering returned. With each trying day, each anxious night, it kept building, building in her, to the breaking point.

Then, one day, the pressure to contain it quite simply *vanished*. At that moment Kim came to the realization that she alone had to seize control of her future from the regime. Her epiphany came when she brought to mind a parable told her by Merle Ratner's husband, Nhan, in Moscow. It was about a beautiful bird that lived in a forest. A hunter fancied it for its plumage and song,

trapped it and kept it in a cage. At the time, Kim saw Nhan offering the tale as warning that she was that coveted bird. Then, she was flush with her success on the international stage. Now, she interpreted the tale more ominously. She had known who the hunted was, but now she saw the hunter clearly: the Vietnamese regime. Kim was resolved: while in Cuba, she would find a way to open the door of the cage and slip out. *No more*, she told herself, with enormous relief. *I do not have to suffer any more.*

Kim became singularly focused on exactly what the Vietnamese regime had suspected her of three years earlier: planning escape to the West. Outwardly, she betrayed nothing. She had faith that at the right moment, God would open a door of escape; her mission was to create opportunity for God. Indeed, faith is sometimes not enough on its own. It can only be realized through experience; it has to be tested.

On one typical Saturday afternoon that summer, between her third and fourth years of English, Kim was one of a crowd of students dropping in on Ambassador Tai. His wife welcomed the students on weekends, and enjoyed spoiling them with her cooking. In a conversation with their seventeen-year-old son, Kim learned that he was going later that summer on a three-week holiday to Mexico City. It had become common for Vietnamese families posted abroad to send their children to holiday at Vietnamese embassies in foreign cities.

Kim's first thought was: *Mexico shares a border with the United States!* She decided to ask the ambassador then and there for permission to go herself. *How can he say no to me*, she reasoned, *if he allowed his own son to go?* She was right. Within days, she had a visa and an airline ticket. She confided only to Helen and Nuria. "Do not worry if I do not return," she said cryptically. "If I have the opportunity, I will go forever."

Mohammed, together with Helen and Toan, drove Kim to the airport. As the plane took off, Helen turned to Toan. "Your

girlfriend might not be back." He chuckled. It was Cubans who often joked about leaving and, if they could manage it, not coming back.

KIM'S MINDER FROM THE EMBASSY IN MEXICO City escorted her on a sightseeing trip on a city bus, politely pointing out attractions. From the windows, she saw the contrasts of life in the world's most populous city. The same city entertained the rich—gliding past in shiny, long cars along broad avenues lined with modern skyscrapers, shopping at elegant boutiques and dining at lively international restaurants and sidewalk cafés—and accommodated the beggars, who sang for coins on street corners and tried to sell chewing gum and tortilla snacks to drivers while the stoplights were red. *People here are free to do what they want*, Kim concluded. Her heart jumped when the bus passed by the American embassy.

"We want to help you enjoy yourself." Two of Kim's minders took her on a day trip to Teotihuacan, an Aztec ceremonial center. The day they went, July 25, was one of the two days each year when the sun appears to set exactly on the points of the Pyramid of the Moon and the Pyramid of the Sun, which are aligned along a great Avenue of the Dead. Kim pointedly asked a minder to take her picture against the backdrop of the pyramid, and when they perused the souvenir stalls, she dutifully showed enthusiasm for buying costume jewelry.

Into the second week of her three-week stay in the guest quarters of the embassy, Kim fretted that her minders were never going to let her out unaccompanied. All she needed was a few moments on a telephone *outside*; she dared not use any inside the embassy. Her nightly prayers grew anxious. On her knees, with her face wet with tears, she made a desperate appeal: "God, I'm scared. How will I escape? Please, find me a moment."

On the second to last day of her stay, by which time the ambassador's son had arrived for his holiday, Kim casually expressed a desire to her minder to visit a friend from Havana, a Spaniard who once lived in the same student residence as her. He and his Cuban wife were visiting relatives in Mexico City. "Go ahead," said the minder, asking only that Kim leave him their names, their address and the time by which she would return.

Kim was in luck. The couple were there, and the house had a telephone.

Suddenly afraid, Kim confided her intentions to the Spaniard and asked his opinion. She felt compelled to give an apologetic explanation: "I cannot stay in Cuba. I cannot study, I'm not eating well—"

"It is not easy to claim asylum in Mexico. It might work, it might not. The Mexican government might turn you back to Cuba." His tone was cautionary but his manner sympathetic.

Kim dialed the telephone.

"Hello? Please, can I speak to Nick Ut?"

The person who answered gave her a new number. She re-dialed.

The answer disappointed. "Nick's on vacation. Won't be back till next week."

Back in her guest room at the embassy, Kim found comfort in prayer. "God, I am disappointed, but I am not angry. You know more than me. Please carry my burden for me, and I will turn back to Cuba."

KIM WAS STRUCK BY HOW HAPPY TOAN WAS to see her, and how much more demonstrative he was with his affections. *God was telling me to turn back to Toan*, she told herself. He mentioned Helen's joking that she might not come back. Kim laughed. "I'm here!" she said. "That did not happen." The

Spaniard paid her a visit upon his return from Mexico City. In hushed tones, he commiserated about the hardships of life in Cuba. He issued a word of caution. "Be careful," he said. "Be very, very careful." Kim concluded that it was best to guard the idea of escape, that her strategy would be to be ready for it but not to plan for it, that being both difficult and dangerous.

Toan was enjoying the summer, and wondering if it might be his last in Cuba. He was celebrating having earned his baccalaureate degree in English. The university had already accepted him into a two-year graduate program in computer programming; he was awaiting a decision from the Vietnamese embassy about whether he could stay on.

He decided to take the chance of proposing to Kim a second time. Since the first time, when she'd declined to give him an answer, he had written both his father and Kim's parents, asking their opinion about marrying Kim while they were both in Havana. Toan's father had been disapproving. "Finish your studies before you marry," he'd instructed. "Do not marry in Havana. The family must be present at your wedding." No reply came from Kim's parents. When Toan spoke to Kim of the silence, she said only that her family found it difficult to accept her friendship with a northerner. To his second proposal, Toan got from Kim the same ambiguous response.

Toan remained upbeat. To celebrate his graduation, he organized an outing to Tropicana to take in the nightly show, a flamboyant extravaganza of more than two hundred performers, mostly near-naked showgirls singing and dancing on an open-air stage, a show essentially unchanged since 1939. Finally, the Vietnamese embassy decided Toan's fate. He broke the news to Kim that the Vietnamese government could not afford to pay for his graduate course, that in the fall he would have to return home.

She wept uncontrollably. "If you go home, I don't know how I can live here. For sure, for sure, I cannot finish my studies."

Seeing her despair, Toan investigated the cost of staying on in school. He found out that the university was charging the Vietnamese government nothing for his course. He made a personal appeal to Ambassador Tai. "Think of Kim," Toan begged. The ambassador relented.

On a Saturday night late in August, ten or so of Kim's friends gathered in her residence room to cook a meal. The dinner was Helen's idea—a belated welcome home from Mexico to Kim. Just as they started to cook, the power failed. The group abandoned the darkness of the residence for the lighted bar at the nearby Hotel Panamericano. Yamilen Diaz—who had failed in her ambition to study in Moscow—had a job there.

The evening wore on through several rounds of beer and rum—in Kim's case, orange juice. The cigarette butts piled up in the ashtrays.

Helen, with her usual impulsiveness, tossed out a question as if it were bait. "Kim and Toan, why don't the two of you get married?"

Helen is like a child, thought Kim affectionately.

"How long are we going to have to wait?" Helen played the part of an auctioneer to an eager crowd. "I'll pay for Kim's wedding dress!" she declared. She knew a Cuban with a closetful of bridal gowns for rent, all imported from the United States.

Mohammed was next in. "I'll pay for their honeymoon: one week at the Habana Libre hotel." Contributions came in fast and furious. Yamilen had Toan's tuxedo. Someone was taking care of the beer and wine. Rum. Food. Flowers. Decorations. Even the printing of the invitations.

Toan looked bright-eyed and hopeful. All eyes turned to Kim.

"Okay, yes!" She laughed, enjoying the game. "I'll get married then!"

A startled Toan fell to his knees at her feet. "Yes? You are saying yes? Is it true?"

"No—it is not true. I mean, yes. No, I change my answer to no."

Everyone, Kim included, felt for Toan. Someone said: "You have to say yes or no." The court of opinion declared that she had three days to say one or the other.

Of the men she had been closest to, Kim saw that Toan was the most considerate and generous, in contrast to the healer and playboy Minh. But yet, she and Toan did not share the bond of a knowledge of God, which she had known with Anh. For that reason alone, Kim had been unable to elevate her relationship with Toan beyond friendship. She simply could not see how she could live with someone who did not follow Jesus Christ. From the start, she had taken stock of Toan's moral weaknesses. He drank. And he smoked. "Every cigarette you smoke burns one minute of my love for you," she had told him. Three times he had tried to quit, without success. She put the question to herself again: *Can I suffer every day living with someone who does not have the same faith as me, who I will see smoking and drinking?* A saying her mother told her came to mind: "If you love a man, even his shit smells good."

Kim decided to ask God to help her decide. She decided a sign from him that she should say yes was if, at the end of three days of prayer, she felt at peace and had no nervousness about marrying Toan. After three days, she had her answer. *God has given me a good man*, she told herself.

Ten days later, on September 11, three hundred guests came to the wedding, held at the home of Ambassador Tai. Never before had there been a wedding in Havana's Vietnamese community. Both Kim and Toan were in white, in the style of a Western wedding: she was in a floor-length gown that showed her shoulders and arms through lacy tulle; he was in a white tuxedo, accented by a red bow tie and pocket-handkerchief. Toan's only expense had been the purchase of his white shoes, Kim's, having her

make-up and hair done through another contact of Helen's. As the bride and groom arrived, threatening thunderclouds opened up. "You will have a life of gold and silver!" said the ambassador, repeating a Vietnamese belief in good luck should it rain on a bride and groom.

Traditional Vietnamese wedding ceremonies unite two families; the bride and groom speak not a word in the ceremony. Accordingly, Ambassador Tai spoke for Toan's and the embassy's highest-ranking military officer spoke for Kim's. After they had signed the marriage documents, the banquet, prepared by the Vietnamese students, began. Two roast suckling pigs were Manuel's contribution, which he'd had to drive far into the countryside to buy. Tables were set inside in the salon, and outside on the patio and in the landscaped gardens. Kim and Toan took away with them wedding gifts of money totaling four hundred American dollars, thirty of which was from the Vietnamese embassy.

Mohammed's gift of a week at the Habana Libre was no luxury. Plumbing worked intermittently, corridors were musty from air conditioners long since shut off, and the pool was empty. In what was formerly the ballroom, now a cafeteria, the ceiling leaked during downpours; and in the restaurant, table service was a minimum three-hour wait. At the week's end, Toan vacated his room at the residence and moved into Kim's. Their first days were taken up with well-wishers dropping by. Among them was a friend from the embassy.

"Why don't you two go to Moscow for a honeymoon?" he suggested. "Many people go there to have fun." The city had become a popular travel destination for Vietnamese posted abroad, as well as students. Under the reformer Boris Yeltsin, free markets had sprung up in Moscow. Vietnamese travelers spoke of being able to buy everything from grapes and watermelons to T-shirts and jeans.

During the newlyweds' week at the Habana Libre, Kim's

undergraduate classes had begun, and one week later, so too had Toan's graduate course. While Toan, ever the diligent student, had notified his teachers that he would be a few days late in starting, Kim had not bothered. Most of her teachers had attended the wedding, and she knew Maritza and her staff expected her to take time to set up her married life.

As soon as Kim heard the suggestion of a trip to Moscow, her mind registered one thing: *opportunity!* Cubana Airlines returning from Moscow to Havana refueled in Canada. She had heard it said: "Canada is very open, it is easy to stop there." Rumor had made its way through the university several times about Cuban students on scholarship to Moscow supposedly recalled by the regime but never showing up back in Cuba. The Vietnamese wife of a Cuban, supposedly unhappy with her husband's philandering ways, had taken their daughter on a visit to Hanoi; on the return flight she was known to have been in transit through Moscow, but she too never showed in Havana. Rumor and speculation was that those students, and the woman and her daughter, had stopped in Canada, for good.

"Oh—honeymoon in Moscow is a *good* idea!" Kim said of the friend's suggestion.

This is a gift from God, she told herself. How she and Toan would manage to escape, she realized she had no idea. She calmed herself: *God will take care of that. Just take it easy, and go.*

The response of the Vietnamese embassy to the couple's travel request was perfunctory: "Toan can go. Kim cannot. You went to Mexico City and so you have already been outside Cuba once this year."

"What? My husband go *alone* on his honeymoon?"

Kim laughed and laughed, and those at the embassy did too. Within days, she and Toan had tickets on Cubana Airlines departing September 29 and returning October 15. Kim set her sights on overcoming the next hurdle: to get transit visas from

the Canadian government. She saw the visa as helping to open the door of her cage, so that she could escape—with or without Toan—from those who would control her.

AT TWO IN THE MORNING, KIM AND TOAN were number three and four in line at the Canadian embassy. Every Western embassy in Havana was besieged by Cubans clamoring to apply to leave the country. Canada, with its liberal immigration policy and generous social assistance, was regarded as a highly desirable place to live. In part because of growing numbers of defectors off international flights, and a rise in the international smuggling of people across borders, Canada had imposed visitor and transit visa requirements on nationals from selected countries. The task of keeping out visitors whose real intent was to remain in Canada fell to Canadian immigration officers abroad.

Kim and Toan's interview was short. "Where are you going? Why?" In short order the Canadian officer refused them, providing, as was his perogative, no explanation. Kim was as unperturbed as Toan, but for different reasons. She told Toan confidently, "The Vietnamese embassy in Moscow knows me and will help us." Normally, airlines made sure passengers had the transit visa for the return flight home before allowing them to board the outbound flight, but Cubana was lax about the requirement for Vietnamese passengers, knowing they often obtained readily the necessary visa in Moscow.

Never had Kim felt so strong, so in control in her life. Prayer helped her maintain an outward calm. She confided her intentions to Nuria: "*Mami*, I have decided that, if I can get a visa to Canada, I am going forever, even on my own. If Toan can get a visa, and he wants to come, then we will go together."

Kim packed her small rattan suitcase, as did Toan, with

clothes for a two-week vacation. In her purse, she put her cosmetics bag, painkillers, a Nikon camera and two souvenirs of her past life: the negatives from their wedding; and the green mirror from the toiletry set that she had picked out in the Bonn department store.

Nuria surprised the rest of the Diaz family by insisting that she was coming to the airport to see the couple off. "But you never go! You hate saying goodbye!" Yamilen remarked. Of the small crowd there, Nuria was the only one weeping. Kim hugged her. "*Mami*, don't cry." Kim turned to chat with the others, hoping by her laughter to divert attention from Nuria, who was behaving as if distraught. Kim called to her sharply: "*Mami!*" Then, more gently, "I am only gone for two weeks!"

"WE WILL HELP YOU TO SPEND TIME IN Moscow," minders at the Vietnamese embassy said to Kim and Toan. If it wasn't a minder's presence keeping Kim from divulging her plans to Toan, it was somebody within earshot—an embassy worker or one or several other Vietnamese travelers. Even in the privacy of their guest room at the embassy, Kim dared say nothing, for fear the room was bugged. However, she efficiently took care of the business of getting transit visas: she quickly got in hand a letter, arranged by their minder at her request, from the Vietnamese embassy to the Canadian embassy, introducing Kim Phuc and Bui Toan. A receptionist at the Canadian embassy took their passports and told them their visas would be ready in twenty-four hours.

Later that day, on a walking tour of Red Square, Kim maneuvered Toan and herself away from the group. "If I get the visa, I want to stay in Canada," she told Toan jokingly, testing his reaction. He took it that way; Cubans on their flight had joked in the same manner.

When they collected their passports with the transit visas stamped inside, Kim prayed in silence: "God, help me to explain to Toan my goal." On one of the last days of their stay, their minder took them to a free market, helpfully pointing out bargains and gifts worth taking back to Cuba. Toan went on a shopping spree—a Walkman, jeans, T-shirts, souvenir Russian dolls that nestle one inside the other. He didn't understand why Kim tried to discourage his purchases. He had to insist several times: "But I like this!" Kim forced herself to join in the buying, though playing in her mind was an image of her rattan suitcase, packed with these new purchases, sitting unclaimed in Havana's airport.

At the airport in Moscow, Toan was held up at passport control. Had not a Russian-speaking Cuban student intervened, he would have missed the flight. The student later explained that the Russian official was trying to extract a bribe before letting him pass.

Kim and Toan occupied two seats in a row of three: she was in the middle, he in the window seat, a Cuban in the aisle seat. Kim checked: the closest Vietnamese passenger was three rows away. Even if he could overhear, Kim was not worried, knowing that he'd married a Cuban and that he and his wife had chosen to remain in Havana.

"I cannot continue my life in Cuba," was how Kim began her talk with Toan. By her words and tone, she displayed a formidable will and resolve that few outside her family knew she had. Her characteristic smile and laughter were nowhere. One moment she was forceful: "For certain, I do not want to go back to Cuba, or to Vietnam. I really want to stay in Canada." The next, tender: "Even though we are husband and wife, if you don't want to go—if you don't want to stay with me—that is okay."

Toan, his nerves still frayed by the experience at passport control in the airport, was shocked, then in torment. He felt as though he was being asked to choose between his country and

family, and his wife. He could not bear the thought of being banished from Vietnam. His family respected and idolized him, depended on him to return to help them. But what of his future with his new wife? "A husband and wife should not be separated," he argued.

Kim was reprimanding: "Why do you want to return to Cuba or to Vietnam? Life is *nothing* in Cuba or Vietnam." Then, reassuring: "Don't worry about the future. One day we will go back to Vietnam. Not now, but one day. For now, we will sacrifice much. We will lose everything in Cuba and we will suffer from missing our families. But, once we are in Canada, we will still try to help them."

Toan was afraid of the repercussions of a failed escape attempt. What if the Canadian government turned them back to Cuba, or Vietnam? He saw himself in jail. Even *if* Canada accepted them, how would he and Kim fare without family or friends? Or money? They calculated; between them they had three hundred dollars left. What did either of them know about Canada? Toan said he knew nothing. Kim knew it was cold, that its flag had a symbol of a red maple leaf—she had coveted such a pin on a student at the Moscow youth festival. But regardless, Toan could not see past the difficulty of finding out *how* to stay in Canada.

Kim spoke with finality: "My number-one goal is to stay in Canada. I don't have a number-two."

For the next several hours, until the end of the flight, the two sat in silence. Toan kept to himself his thought that the best outcome would be that the difficulty of escape would force them to turn back. Kim made one last effort to influence her husband's choice: "If you return alone from your honeymoon, people will say you are crazy!"

Noticing that the seat next to the Vietnamese passenger three rows away had been vacated, Kim sat herself down there. "I have

an idea," she began. She elaborated, telling him that her life as a famous victim of war was probably not what he imagined, that because of her fame the regime sought to control her life. She ended by asking what she desperately needed to know: "Do you know how I can stop in Canada?"

The Vietnamese man reeled. "Why do *you* want to stop in Canada? Other people want to, and do, but *you*, you should not. If you do, it will cause Vietnam great embarrassment!" He was returning from a visit there, and he spoke enthusiastically about how Vietnam was thriving and opening up to foreign investors. He said it was not the poor or isolated country Kim had left years ago. "You are a very important person," he told her. "You can bring Vietnam and Cuba closer together."

"If Vietnam is so much better, why are you staying with your family in Cuba? If you don't believe in going back to Vietnam, why should I? You chose Cuba; I will stay in Canada." They both laughed.

The plane began its descent into Gander, Newfoundland, Canada's most easterly province. At the terminal, there was a delay in opening the plane's doors. It seemed the flight attendants had intended only Cubans to deplane, but some Russians had protested, insisting that they had a right to do some duty-free shopping in the airport. The captain announced that no one could remain on board during refueling, ending the dispute. Kim uttered an instruction to Toan: "Leave your bag behind so that they think we are coming back." Still maintaining his silence, he complied, leaving behind a bag packed with his Walkman, a camera, and the light clothing he'd planned to change into upon arrival back in Havana.

THE DEPLANING PASSENGERS MOVED DOWN a wide hallway with several turns. Kim took hold of Toan's hand.

She was certain someone among her fellow passengers must be thinking about staying and knew how. *Everyone looks nervous*, she thought, choosing finally to keep her eye on a Cuban father holding onto the hand of his daughter, perhaps four years old. The hallway ended at double doors leading into a huge concourse, with a duty-free shop and food counters. On the wall at one end, oversized letters spelled CANADA, above a flag with a red maple leaf. At the other end, large clocks displayed the time in Gander, Montreal, New York, London and Moscow.

Seeing the Cuban and his daughter standing around, apparently waiting out the refueling stop, Kim left Toan to investigate the concourse. It was crowded with passengers coming and going. From time to time, she spotted Royal Canadian Mounted Police officers patrolling it, but she was afraid to approach, thinking that, as in Vietnam and Cuba, they could be state security agents. Time passed; their flight to Havana would be called soon. Suddenly, Kim felt despondent. *I can't go back. It will be terrible if I turn back now.* She looked around for the Cuban and his daughter. She could see them nowhere. She fought to control her panic. *I cannot rely on anybody*, she told herself. *I am going to have to find my own way.* She signaled to Toan, who was chatting with a Vietnamese passenger, that she was going to the washroom. In a locked cubicle, she contemplated, briefly, staying hidden there.

Back outside, she closed her eyes and prayed: "God, please open a door, please." When she opened them, she noticed a set of double doors, not the same ones by which deplaning passengers had entered the concourse. On the other side she saw, in the midst of seven or eight Cubans and Russians, the Cuban and his daughter.

Kim pushed through the doors, and asked the group, in Spanish, what they were doing there. "*¿Que estan haciendo aqui?*"

"*Queremos quedarnos aqui en Canada,*" several replied in unison. They wanted to stay.

"*¡Yo quiero tambien!*" Kim was exultant. "*¿Que tengo que hacer ahora?*"

"*Usted tiene que dar su passaporte a ese hombre.*" In telling her what to do in order to, like them, stay in Canada, someone pointed to a gentleman behind a window. Kim went back out the double doors and called out to Toan.

Kim took two passports and pushed them towards the man. She switched to English: "I want to stay."

"Welcome to Canada." The Canadian customs agent used the greeting dictated by Canadian regulation for foreigners entering Canada. As he was instructing Kim and Toan to wait with the others, one of the Cubans broke from the group and lunged at the window. He asked for, and got, his passport back. Kim, tension drained from her body, spoke gently to the Cuban. "Why are you crying?" His voice breaking, the Cuban said he would miss his family in Cuba. "You can sponsor them later," Kim urged. "Staying here is the best way."

Some minutes later, a Canadian official led the group, minus the Cuban who'd changed his mind, into a small waiting room. Its windows on one side looked onto the hallway through which they had entered the concourse, on the other, onto the runway. Kim watched the passengers from their flight pass along the hallway, then reappear to board the Cubana aircraft on the tarmac. Behind the last passenger, the door closed, and the plane taxied and took off.

CHAPTER FIFTEEN

N ANCY POCOCK WAS MYSTIFIED BY the message left. Her staff said a Vietnamese woman who spoke Spanish—Nancy's office help answered her telephone in that language—had called from Gander, Newfoundland: please call back. *Must be a mistake,* Nancy thought.

And now the woman was calling back, speaking this time in English. "You know about the girl in the famous picture from the Vietnam war—the little girl running in the picture?"

"Yeah!" Nancy's voice was low, gruff. "I've been to Vietnam, and I know the picture." How many times had she seen it, and the same thought had crossed her mind: *I tremble at the wrong done to a child.*

"Well, I am the girl in the picture."

IT WAS MERLE RATNER WHO HAD SUGGESTED Nancy. Kim's first call from Gander had been to Merle in New

York, to ask her for a contact in Toronto. Having studied the wall map in the lobby of their motel, Kim and Toan had chosen Toronto as a city to settle in. The word from other refugees was that Canada's warmest city was Vancouver. But, seeing that Vancouver was at the other end of the country from Gander, and that the bus fare there would be more money than they had left, they had looked for something nearer the middle of the map. Kim's pronunciation of Toronto had come out *toronja*, meaning pomelo [grapefruit] in Spanish. "I like that sound," Kim told Toan. "We'll go there."

Though they had not met, Nancy and Merle were known to each other from the antiwar movement, when Nancy took in American draft dodgers and, later, Vietnamese refugees who landed on her doorstep. She'd since become just as well known for helping refugees fleeing El Salvador during the violent eleven-year civil war that began in 1979 when leftists clashed with government forces there. She had personally ferried several through the United States to a country that would have them, Canada. In Toronto, she established and ran several programs, mainly for refugees, under the auspices of the Quaker organization.

Kim and Toan's first concerns in Toronto were both urgent and mundane: getting on social assistance, finding somewhere to live, enrolling in a government-sponsored English course for new immigrants. Nancy was there every step of the way, and she guided them through the process of applying for refugee status and, eventually, citizenship. Unlike most who arrive in Canada claiming to be political refugees, Kim and Toan were spared a hearing to decide whether Canada would permit them to stay or would return them to their home country. The immigration lawyer Nancy found for them successfully argued that the Canadian government should grant quick and confidential approval on "humanitarian grounds." In the written application, the lawyer detailed Kim Phuc's strong objections to having been

made a propaganda tool of the Vietnamese regime, the upheaval and misery it had brought her, and her desire, in seeking a haven for herself and her husband in Canada, in her words, "to make my life quiet."

The one-year waiting period to obtain permanent papers after being granted refugee status came and went for the couple. Immigration officials shrugged off a few weeks' delay as normal. But the couple felt their idle lives to be on hold; residency entitled one to work—they could not afford a work permit—and to attend college at the lower tuition fees of a domestic, rather than foreign, student. Another six months passed, and still there was no sign of the papers. Finally, the immigration department concluded the family's file to be lost; the paperwork would have to be redone. Long before then, Toan had been reduced to pleading with the landlady not to go through with a rent hike that would put them out on the street, and lining up weekly at a charity food bank for food and clothing, including food and diapers for their new baby. Their son, born in April 1994, was named Thomas, a name Kim chose from the Bible. He was given a Vietnamese name as well, Hoang, meaning "good prospects."

Driven by their desperate financial straits and their guilt at being unable to send money to their families in Vietnam, Kim relinquished her plans to "stay quiet." With Nancy's introduction, she sought the advice of the lawyer who would become her agent, Michael Levine, who helped set up her first foray into publicity: a portrait in the May 1995 issue of *Life* magazine.

In the spring of 1995, the couple's permanent papers finally arrived. By this time, news editors from around the world were planning stories to mark the upcoming twentieth anniversary of the fall of Saigon to the Communists. One British tabloid, *The Mail on Sunday*, decided to try to revisit one of the war's famous pictures. Acting on information from a confidential Canadian immigration file obtained from a top-level American source, it

dispatched a reporter and photographer to Toronto, in search of a woman named Kim Phuc.

WHEN KIM AND TOAN WERE LATE RETURNING from their honeymoon, rumors that a defection to Canada was the reason reached the Diazes. Nuria kept her silence, but Manuel and Yamilen lamented that, had they known that the couple was planning to leave for good, they could have talked them out of it. Yamilen soon discovered that someone had been before her to Kim and Toan's residence room. The television, bedding, clothing and shoes, even personal papers, were gone. All that remained, other than a few books, was a Russian plastic roly-poly doll, with a Vietnamese chiffon scarf tied *babushka*-like under its chin. Its hands were broken. Yamilen gave a push to the lower ball that was its body, sending it rocking and clinking. She picked it up and headed home.

In early 1993, Tung and Nu in Trang Bang were visited by Tam, the hated bureaucrat from Tay Ninh whom they had not seen in years.

He wasted no breath on niceties. "Did you tell your daughter to flee Vietnam?"

"Phuc is in Cuba!" Nu was insulted. *Why ask such a thing?* she thought.

"She is in Canada!" Tam declared. "Speak to your daughter. Tell her to go back to Cuba. If she doesn't go back to Cuba, your whole family will go to jail!"

Some months later Nick Ut was in Vietnam, again with George Esper. Esper was reopening a bureau there for the AP, marking the news agency's return after an eighteen-year absence. Relations were opening up between the United States and Vietnam on several fronts, though mostly in readiness for Americans to invest and do business in Vietnam. The turning point for the

United States' attitude towards Vietnam had come the previous fall, in October 1992. Hanoi agreed to hand over archival documents and personal effects relating to MIA cases, and within two months, the United States had authorized American companies to sign contracts in anticipation of the lifting of the trade embargo (the United States would lift it in February 1994, and the two countries would grant full diplomatic recognition to each other in July 1995).

Though Nick knew Kim Phuc to be in Canada—"Uncle, I escaped," she'd said on the telephone, pledging him to secrecy—he wanted to hear what authorities would say if he asked where she was. "She is studying pharmacology in Cuba," was their reply. Later, in Ho Chi Minh City, a fellow diner in a restaurant, a policeman, recognized Nick as the photographer who'd taken Kim Phuc's picture.

"Where is she now?" Nick asked.

"She's a homeless lady in the city," the policemen replied, only to be contradicted by another patron, who claimed that Kim Phuc was a pharmacist working in the city.

About that same time, Vu Hac Bong, the kindly, hale official in Ho Chi Minh City who had arranged a stipend for Kim while she went to school there, asked Merle Ratner to relay a private message on his behalf to Kim Phuc: "Vu Hac Bong wants you to be happy." As Tet was being celebrated in early 1994, an official from Ho Chi Minh City delivered to Tung and Nu in their mud hut a large basket of candies and sweet cakes, and an envelope. Inside it was Vietnamese *dong* equivalent to several hundred American dollars. "This is from Pham Van Dong," the official said. "He loves your daughter Phuc very much."

THE MORNING OF NOVEMBER 11, 1996, IN Washington, D.C., was filled with bright sunshine. A crowd of

three thousand had gathered for the annual Veterans' Day Cere-
mony at the Vietnam Veterans Memorial. The veteran on the
stage, set against the backdrop of the cold, black granite panels
listing American dead in Vietnam, introduced the next speaker, a
Vietnamese woman named Kim Phuc. Her name had not
appeared on the program, but once the picture was mentioned,
there were few in the crowd who did not know who she was.

Included among them was forty-seven-year-old John Plum-
mer. Earlier that summer he'd been channel-surfing and had
come across a show on CBS entitled "Where are they now?" fea-
turing, among others, the photographer and the subject of his
famous photograph from the Vietnam war. Plummer was aston-
ished to learn that the victim of the napalm attack lived not in
Vietnam but in Toronto, a day's drive from Purcellville, Virginia,
where he lived. *If she could look into my eyes*, Plummer thought,
she would see my pain and remorse for what I did to her.

The first inkling Plummer had had that the picture was a
much bigger thing than one day's news in the *Stars and Stripes*
came some months after he'd returned from his second tour of
duty in Vietnam. Twenty-four, divorced and the father of three,
he was engaged to be married for a second time and was working
as a flight instructor in Fort Rucker, Alabama. One evening, his
fiancée and her friends were reading a magazine and it flipped
open to that picture. Plummer leaned over and said: "I'm the one
who put in that air strike." The reaction was revulsion. His fiancée
shot him a look as if to say, *How can you be proud of that? Why
would you boast about it?*

Over the years, Plummer had increasingly avoided talk of the
war. Those who found out he'd done duty in Vietnam usually had
only one question: "Did you ever kill anybody?" He had; he'd shot
dead a Vietnamese woman in her twenties, a figure in the night
running towards the perimeter of the base he was guarding.
American intelligence later concluded that the woman had been

captured by the Viet Cong to carry supplies, and that she had escaped and was seeking refuge with the Americans when she was shot. Plummer had kept a picture of the corpse, taken by a fellow infantryman.

Plummer's second marriage would end in divorce. His wife would claim he had "problems dealing with the war." *Bullshit*, he told himself. He accepted that he had a drinking problem; often he woke up in his truck, or on someone's couch, wondering how he'd got there. He admitted to no one, however, that there was one reminder of his experience in Vietnam that broke through his defenses every time: the picture of the girl wounded by napalm. It seemed to be everywhere he turned—newspapers, magazines, films on television, even in books on his own bookshelves. Each time Plummer saw it, he was stricken with remorse. It got so that her screams haunted his nightmares of war.

Only after the military grounded him, and with the support of the woman who would become his third wife, did Plummer start to pull himself together. A committed Christian, she had a brother who had been a helicopter pilot in Vietnam. In 1991, Plummer entered the seminary and four years later became pastor of the Methodist church in rural Purcellville. On the strength of his faith, he came to accept that God had forgiven him the pain he'd caused the girl in the picture. Though he slept better at night, the burden of the remorse he carried never got lighter.

Some weeks after catching the CBS television show that united the photographer and the girl, Plummer attended a Vietnam veterans' reunion for helicopter pilots and crewmen. He browsed a table of books, and there, again, was *that* picture, this time on display alongside a poem. Ambushed by his emotions, Plummer broke down. The poet was nearby, and without asking for explanation, shared a moment of prayer. It turned out the poet knew Nick Ut. Word got to a Canadian filmmaker who was making a television documentary on Kim (entitled *Kim's Story: The Road*

from Vietnam, it first aired in early 1997) and thus to Kim herself: the American commander who had "ordered" the napalm strike that injured her, now a church minister, had surfaced. Word was that the man was unwilling, however, to come forward publicly.

Now, on Veterans' Day, even as Kim Phuc was being introduced, Plummer was reeling. The veteran on stage said that while Kim Phuc had survived the attack, two of her brothers had not (again the mistaken identification of the dead as her brothers rather than her cousins). Plummer was in shock, believing he was responsible for a greater tragedy than he had known.

Kim stepped to the podium. "Dear friends. I am very happy to be with you today . . . As you know, I am the little girl who was running to escape from the napalm fire. I do not want to talk about the war because I cannot change history. I only want you to remember the tragedy of war in order to do things to stop fighting and killing around the world. I have suffered a lot from both physical and emotional pain. Sometimes I thought I could not live, but God saved me and gave me faith and hope. Even if I could talk face to face with the pilot who dropped the bombs—"

Plummer heard those words and felt they were also meant for him. He scribbled on a piece of paper: "Kim, I am THAT man," signing it Reverend Plummer.

"—I would tell him we cannot change history but we should try to do good things for the present and for the future to promote peace . . ."

At the conclusion of her brief remarks, Kim embraced a retired United States Air Force colonel and former prisoner of war in Vietnam. Jointly, they laid a wreath at the wall. Taps was played. Kim wiped away tears while many in the crowd wept openly, feeling that they had taken a step together along the road back from Vietnam.

The ceremony over, one of the hosts led Kim through a tangle of television cameras and boom microphones, pausing while she

stopped to shake the hands of veterans eager to touch her. As they reached the police cruiser waiting to take her back to her hotel, her host whispered in her ear: "Kim, you know that man you've been wanting to find?"

"Yes?"

"He's right behind you."

She turned around and looked into a face of pain. She held her arms out.

Plummer fell into them. "I'm sorry. I'm so sorry . . ."

"It's okay," she replied. "I forgive, I forgive."

A CONTROVERSY ERUPTED ACROSS THE United States among Vietnam veterans who took exception to Plummer's admission, "I am THAT man." Nationwide, the media had picked up the compelling story of one man's burden that had been lifted by his victim's forgiveness, first published in a religious magazine that reproduced Plummer's account posted on the Internet to his Vietnam veteran friends. The controversy finally subsided one year later when Plummer acknowledged that he hadn't, in the military sense, "ordered" aircraft into action. However, he maintained that he was part of the sequence of events that led to that air strike.

The truth about memory is that it is powerful, but flawed and only ever fragmentary. There are discrepancies between Plummer's account of the radio transmission of the air strike and those of journalists on the highway outside Trang Bang that day. One version has an Amercian advisor, one does not, one has no forward aircraft, one has one. Can these contradictions be explained? Does it matter?

One military historian summed up the Plummer controversy with this comment to *The Washington Post*: "I got the feeling [Plummer] was putting a lot of guilt on his shoulders when he

may have just been a cog in a wheel." Interviewed for the same article, Kim Phuc said: "Whether or not he played a major role or a minor role, the point is I forgive him."

"IT'S A PICTURE THAT DOESN'T REST," SAYS Horst Faas, when asked to comment on its enduring power. He explains his own reaction when he first saw it, which decided him on the need to bring it to the public. "Pain keeps you conscious," he says.

In the voiceless cry of the girl in the picture is the silence of guilt, of public and private flaws. War, any war, not just the Vietnam war, has dimensions of moral ambiguity. This picture is itself ambiguous: who or what the girl is running from is unclear, the extent of her burns is not evident, and whether she will live or die is an unknown. But the state of anxiety conveyed by the camera's eye concentrates the minds of us, the viewers, simultaneously dispatching each of us into our own personal history of darkness. We privately flail at our human limitations, failings and self-indulgence in the face of the chaos and wrongdoing of war. We who live in places that are "safe" feel chained by our individual helplessness to aid those who live in places that are not.

Americans were collectively and individually marked by sadness, and for some, shame and remorse, by the Vietnam war—a conflict much disputed, and one that offered few heroes. None of us is without flaws, but our hope is that we can be flawed yet still have a worthiness of character. We feel that when we are forgiven. Yet the power of forgiveness is realized only if it is sought. This was what the most famous victim of the Vietnam war, Kim Phuc, had to give.

The picture exerted its power on nobody more than her, its subject. She would be plunged into despair by those who manipulated her life as though the picture were the scaffolding of their

own. She suffered, victimized once by the napalm bomb, and yet again by those who would control her. Human nature is to seek redemption for a terrible wrong, and for some, suffering itself is redemptive. Kim Phuc did not find it so. The more she suffered, the deeper she fell into her solitary darkness. She recast herself spiritually, forsaking one religious faith and committing herself to another, and navigated her way out. In paying homage to her as a living symbol of wartime horror and suffering, others, religious or not, feel a hopeful sense of being able to mitigate the darkness together.

The cycle of war repeats and repeats, the girl in the picture is ever running. One lesson to be taken was perhaps foretold in the Vietnamese fable told to Kim, which she brought to mind when deciding to defect. Kim saw herself as the bird much admired for its plumage and song, and resolved to escape the cage she had been put into. *I just want to be free*, she told herself. However, the original fable has a twist in its ending: "Each little bird that met with archer Yi was sure to be caught. Such was his prestige. Since the whole world was his cage for them, there was no place where the birds could hide."

Kim Phuc will always be the girl in the picture.

EPILOGUE

SINCE KIM PHUC'S PRESENCE IN THE West became publicly known in March 1995, media interest in her has been intense and worldwide. For some time she concentrated on her participation in this book, and in the documentary then being filmed, *Kim's Story: The Road from Vietnam*. However, in early 1997, one reporter would find his own way to Kim and Toan's door and wangle an invitation inside. A front-page article and photograph subsequently appeared in *The Toronto Star*. It told of the famous war victim's life of poverty in Toronto, of how she, pregnant with the couple's second child, along with Toan and two-year-old Thomas, lived in a cramped, second-floor duplex. Readers responded by sending in cash donations, which Kim and Toan used for a down payment on a modest, three-bedroom townhouse, blocks from their church, in Ajax, Ontario.

Among those who saw the award-winning *Kim's Story*, which has been sold to some thirty countries, was the Canadian representative for the United Nations Educational, Scientific and

Cultural Organization (UNESCO). The representative was moved by Kim's story of war, and her forgiving nature as depicted in the film, particularly in the meeting between herself and John Plummer following her appearance at the ceremony at the Vietnam Veterans Memorial. In November 1997, UNESCO appointed Kim Phuc a goodwill ambassador for a culture of peace to "spread a message of the need for reconciliation, mutual understanding, dialogue and negotiation to replace confrontation and violence . . . " At that same time, Kim announced the establishment of the Chicago-based Kim Foundation to help child victims of war. She chairs it, and Ron Gibbs, a Vietnam veteran who was instrumental in the decision to build the Vietnam Veterans Memorial, heads it.

Kim and Toan became citizens of Canada in early 1998. Their second son, Stephen, born in 1997, also has a Vietnamese name, Binh, meaning "peace." Both pregnancies, but for Kim's diabetic tendency, were healthy. For the most part, Kim's health has been strong. The asthmatic condition that began in Cuba vanished upon arrival in Canada, but she continues to suffer pain whenever the weather changes abruptly. Her nightmares of war are rare. She and Toan, sadly, lost their closest friend, Nancy Pocock, who passed away in 1998. Their lives revolve around family; in the fall of that year, Kim's parents, Tung and Nu, came to Canada, their air tickets paid for by an anonymous Montreal businessman, their exit visas from Vietnam expedited by Ho Chi Minh City after months of equivocation by Tay Ninh province. Both have applied to Canadian authorities for landed immigrant status. Early in 1999, out of the media's eye, Kim, Toan and their two sons had a quiet, month-long visit in Vietnam with Toan's father and family.

Kim and Toan, their two sons, and her parents live together in Ajax. Toan holds down a night job, working at a group home, and a day job, taking daily charge of a mentally disabled

adult—while also taking Bible courses at the church. He hopes to become a minister. One month after escaping to Canada, while he and Kim were still installed in a motel, Toan accepted Jesus Christ as his savior, and some weeks later he was baptized in a church in Toronto. Kim's parents, who spend their time caring for their two grandchildren, go regularly with the couple to their church, and when at home read the Bible in Vietnamese.

Kim's life outside the home involves speaking and traveling the world on behalf of UNESCO. The position is voluntary. She also continues to bring to audiences, mostly in Canada, her message about her commitment to Jesus Christ. "It was the fire of bombs that burned my body. It was the skill of doctors that mended my skin," she says. "But it took the power of God's love to heal my heart." An Italian filmaker is making Kim the centerpiece of his film on Christianity at the end of the millennium. Meanwhile, a prominent Toronto artist has donated the proceeds of sales of his portraits of Kim, inspired by the famous picture, to a fund to pay for her two sons' education.

Two and a half decades on after the end of the war, U.S. veterans still find their way to the door of Nick Ut's home in California. "I just want to say thank you for taking the picture; your picture stopped the war," they tell him. Among those who fled Vietnam at war's end or in the later exodus of the boat people, some cannot bear to look at the picture. "That picture lost the war for us," they explain.

The former American War Crimes Museum in Ho Chi Minh City has been renamed the War Remnants Museum. On this author's visit there in late 1996, the famous picture that Kim herself once came across on its walls more than a decade earlier, was nowhere to be seen. However, there was an entire wall devoted to photographs of civilian war casualties. Among them is a color portrait of Kim and Thomas, which appeared in

Life magazine's May 1995 issue to accompany an article about the subjects of four Pulitzer prize–winning photographs who "struggle to be recognized not as icons but as individuals . . ." The picture shows Kim, her shoulders and back bared to the camera, looking at baby Thomas asleep on her shoulder. In the baby's smooth skin, her scarred skin seems reborn. The caption reads: "Mrs. Kim Phuc, once a nine-year-old victim of American napalm bombs. (She's now living in Canada.) A picture of her and her boy brought a World Press Award of 1996." The photograph is the centerpiece of that wall.

Denise Chong

For information about The Kim Foundation, please write:

The Kim Foundation
P.O. Box 81024
Chicago, Illinois 60681
United States of America

or

P.O. Box 31025
475 Westney Road North
Ajax, Ontario
Canada LIT 3V2

ACKNOWLEDGMENTS

THIS BOOK DEPENDED ON THE TRUST, generosity and courage of Kim Phuc and her parents, Tung and Nu, to reveal to and relive with me a past which, for the most part, they had not given voice to before. Those who brought Kim and myself together for the first time, in early 1995, were her agent, Michael Levine, and my own, Bruce Westwood, both of whom acted on the suggestion of my publisher at Penguin Books, Cynthia Good, and my editor, Meg Masters. This project gave me yet again the privilege of the insight, the encouragement and the caring friendship of Meg, and, at Viking in New York, of Mindy Werner. Thank you also to Wendy Wolf, who came later to the manuscript and was incisive in envisaging it as a book. And I was honored to have again as my copy editor Catherine Marjoribanks, who set the example to strive for. The maps were drawn by Molly Brass, and Susan James saw the book through production.

My early conversations with George Esper kept foremost in my mind the eloquent remembrances of those who reflect on Vietnam not simply as a war, but as a country and its people.

Without the fateful photograph having been taken and moved on the Associated Press's wire, there would not be this book; I depended here on the recollections of Nick Ut, Horst Faas and Carl Robinson. I am grateful also to Arlette Salazar, the widow of Huynh Cong La. At Horst Faas's invitation, I attended the launch of *Requiem*, a book he and Tim Page put together of photographs by photographers who died covering the wars in Indochina. There I heard, in George Esper's gracious company, the reminiscences of old Indochina hands.

Of journalists who once reported from Vietnam, I wish to thank, in particular, Fox Butterfield, who located his notebooks from the day of the napalm strike, and David Burnett, who retrieved from Contact Press his own photograph that appears on the back cover of this book. David Burnett, Nick Ut, and Kim's parents patiently indulged my use of models, drawn from my children's playthings, to reconstruct the town of Trang Bang and the events that led to the napalm strike. Others helpful to me had covered the strike or filed stories of Kim Phuc or of the war that came to Trang Bang. They were Peter Arnett, Arthur Lord, Christopher Wain, Michael Blakey and John Graham. Matt Franjola traveled to Trang Bang in the final days of the war and supplied me with details from that period.

Toan, Kim's husband, welcomed me in their home and was happy to be interviewed himself. Perry Kretz, ever generous, shared his recollections and archives. I also wish to thank several people who worked at the Barsky: Dr. Mark Gorney, Joyce Horn, Dr. My Tu Le and Dr. Norman Merkeley. Dr. D. Erdmann of the Oggersheim Institute was helpful. Among those who gave generously of their time to discuss their relationships with Kim were Merle Ratner and her husband, Ngo Nhan, the late Nancy Pocock, the Diaz family, Maritza Yip and Trieu. John Plummer kindly accommodated all of my questions. In Cuba, I benefited greatly from the interpreting and guide services of Gregory

Biniowsky. Mechthild Furlani was helpful with contacts in Germany and translations from German to English.

Most difficult of my research were the interviews I conducted in Vietnam. My traveling companion was my brother, Wayne, and together we coped under circumstances that were often tense. There were several people I interviewed whom I shall not name in the interest of protecting their identities. Both Wayne and I shall ever remember, in particular, one interpreter who bravely led me to stories she thought ought to be told and heard. She reminded me of my friend Frank Zhao. Bruce Levy gave me advice in Vietnam. Back in Canada, Tran Thu was a skilled interpreter who also shared insights on the life she had left behind in Vietnam.

I learned much about the Vietnam and Indochinese wars from published works, many by distinguished journalists, among them Neil Sheehan and Stanley Karnow. Newspaper and film archives proved invaluable. I also read moving and harrowing memoirs of the experiences of the Vietnamese during the war. Much less is available in English of the postwar years in Vietnam, and I was sorry that I did not read Vietnamese.

My dear friend Diana Lary and Mr. Yim Tse at the Asian Library at the University of British Columbia were determined to find the fable that concludes this book. Garth Goddard discussed with me my use of theological language in the manuscript. The Barr family let my papers take over their various kitchen tables in Toronto, at the point and on the south shore. Thank you also to Cory Samonte-Vidal, Phillip Winslow, Susan Hans O'Connor, Michael Schellenberg, Jim Caccavo, Neal Ulevich, Ronald Bedford, Ian Burney, Vo Suu, Tran Phuong, Fiona McHugh, Annick Hillger, Vo Giang and Shelley Saywell.

And finally, for all the necessary solitude involved in writing a book, the ones who are there from the beginning, and at the end, when all is not yet said but is done, are my family. Thank you Roger, Jade and Kai, with all my heart.